W9-DCB-026

Digital

FASHION

Photography

Chris Tarantino and Ken Tan, Foreword by Katrin Eismann

Important: Thomson Course Technology PTR cannot provide software support. Please contact the appropriate software manufacturer's technical support line or Web site for assistance.

Thomson Course Technology PTR and the authors have attempted throughout this book to distinguish proprietary trademarks from descriptive terms by following the capitalization style used by the manufacturer.

Information contained in this book has been obtained by Thomson Course Technology PTR from sources believed to be reliable. However, because of the possibility of human or mechanical error by our sources, Thomson Course Technology PTR, or others, the Publisher does not guarantee the accuracy, adequacy, or completeness of any information and is not responsible for any errors or omissions or the results obtained from use of such information. Readers should be particularly aware of the fact that the Internet is an ever-changing entity. Some facts may have changed since this book went to press.

Educational facilities, companies, and organizations interested in multiple copies or licensing of this book should contact the publisher for quantity discount information. Training manuals, CD-ROMs, and portions of this book are also available individually or can be tailored for specific needs.

ISBN: 1-59200-525-X

Library of Congress Catalog Card Number: 2004107998

Printed in Canada

05 06 07 08 09 TC 10 9 8 7 6 5 4 3 2 1

Publisher and General Manager, Thomson Course Technology PTR:
Stacy L. Hiquet

Associate Director of Marketing:
Sarah O'Donnell

Manager of Editorial Services:
Heather Talbot

Marketing Manager:
Heather Hurley

Acquisitions Editor:
Megan Belanger

Senior Editor:
Mark Garvey

Marketing Coordinator:
Jordan Casey

Development Editor:
Kate Shoup Welsh

Project Editor:
Kate Shoup Welsh

Technical Reviewer:
Schecter Lee

Thomson Course Technology PTR Editorial Services Coordinator:
Elizabeth Furbish

Copy Editor:
Kate Shoup Welsh

Interior Layout Tech:
William Hartman

Cover Designer:
Mike Tanamachi

Indexer:
Katherine Stimson

Proofreader:
Megan Belanger

THOMSON

COURSE TECHNOLOGY

Professional ■ Technical ■ Reference

Thomson Course Technology PTR, a division of Thomson Course Technology
25 Thomson Place ■ Boston, MA 02210 ■ http://www.courseptr.com

This book is dedicated to

Emily and Rachel

Foreword

Before you read this introduction, take a moment to look through this book. If you're like me and appreciate excellent fashion photography, I imagine you can't do it just once. You'll catch yourself flipping through the pages over and over again to study the lighting, composition, styling, location, depth of field, gesture, and model's gaze, to name just a few attributes that are highly considered in the making of a successful fashion photograph.

Just as fashion photography requires teamwork between the photographer, model, stylist, and art director, this book was born out of teamwork between Chris Tarantino, Ken Tan, and the many talented contributors whose stunning images are generously displayed in beautifully printed full- and double-page spreads. I know and have worked with both Chris and Ken and I trust their insights and experience to teach you about digital fashion photography. Both men are seasoned professionals who practice what they present in these pages. When Ken shares his tips about how to work with a model to make her more comfortable, he is speaking from many years of experience with fashion models

from the most highly regarded international model agencies. When Chris discusses how to retouch a fashion shot or addresses what a client looks for in a file, you can be assured that he uses these very same techniques when working with his most critical fashion and cosmetic clients. I've learned much from both Chris and Ken; by reading and implementing what is clearly featured in these pages, you will too.

Whether you are new to digital photography or are an aspiring fashion photographer, this book will open a door that until now was locked, bolted, and tightly guarded. In these pages, Chris and Ken unlock the door of professional fashion photography. Step through it, enjoy the education, and most importantly, start creating better images—images that will inspire all of us.

Katrin Eismann
www.photoshopdiva.com
Author of *Photoshop Restoration & Retouching* (New Riders) and *Real World Digital Photography* (Peach Pit Press)

Acknowledgments

Chris Tarantino

I wish to thank my wife Emily, and Edmund, Charles, and Christopher for their patience while their husband/father was mostly absent for the duration of creating this book. Tremendous thanks go to the photographers who participated in making the possibility of this book a reality. Without their generosity it would have been very difficult to make this happen. Thanks go of course to the many modeling agencies for their permission to use the images here. Thanks also to the many product manufacturers for their timely responses and help with putting together all that was needed for the book. Thanks, finally, to Charvi, Kristen, Jackie, and all others who encouraged me in all their unique forms.

Ken Tan

I wish to thank my wife, Rachel, for her support during the creation of this book, which coincided in part with the birth of my first child, Nicholas James. I would also like to thank all the models for their enthusiasm, tolerance, and willingness to give 110 percent; the stylists for their creativity and input; and the agents for supporting this project—in particular, Greg from Giant Management and Abbey from Wilhelmina. I would also like to sincerely thank Katrin Eismann for agreeing to meet me that first time at Starbucks on 53rd and Lexington to discuss my ideas, for encouraging me to follow my dream of writing this book, and for introducing me to Chris, my talented co-author and retoucher.

About the Authors

Chris Tarantino started adjusting color and retouching in the days of wet etching in the early 1980s and progressed through the ranks to become an expert at a piece of software called Adobe Photoshop. With the knowledge of Photoshop and pre-press at hand, he has lent his expertise to many in retouching and color management. His retouching skills have graced many fashion and beauty magazines worldwide, including *Vogue*, *Glamour*, *Cosmopolitan*, and *Harper's Bazaar*. He works with many leading photographers to help them achieve their vision in the new digital world, including Steve Meisel, Mario Testino, Melvin Sokolsky, and Enrique Badulescu. Chris is also the author of *Digital Photo Processing*, and a contributor to leading photography and creative magazines. Currently a consultant for color management and digital workflow, as well as a high-end beauty and fashion retoucher working in New York City, Chris can be reached at retoucherpro@mac.com.

Ken Tan has been a professional photographer for more than 10 years, focusing on fashion, beauty, and glamour photography. He grew up and is based in Melbourne, Australia, but lived and worked in New York for three years, with working visits to Brazil, Canada, and the U.K. His introduction to fashion was somewhat serendipitous, having been introduced to some New York models in the mid-1990s who offered to test with him. This led to introductions to agents, stylists, and designers, and has allowed Ken to continue to hone his craft and individual photographic style in a strongly collaborative environment. Ken continues to draw inspiration from past masters while chasing that next elusive photograph to define his work. Ken can be reached at ken@kentanphotography.com.

CONTENTS

3

Working with Models ..51

4

Studio Work ...65

5

Location Work ...121

6

Post-Shoot Image Selection, Transfer, and Storage153

Model: Nusa Senk @ New York Models Photographer: Chayo Mata

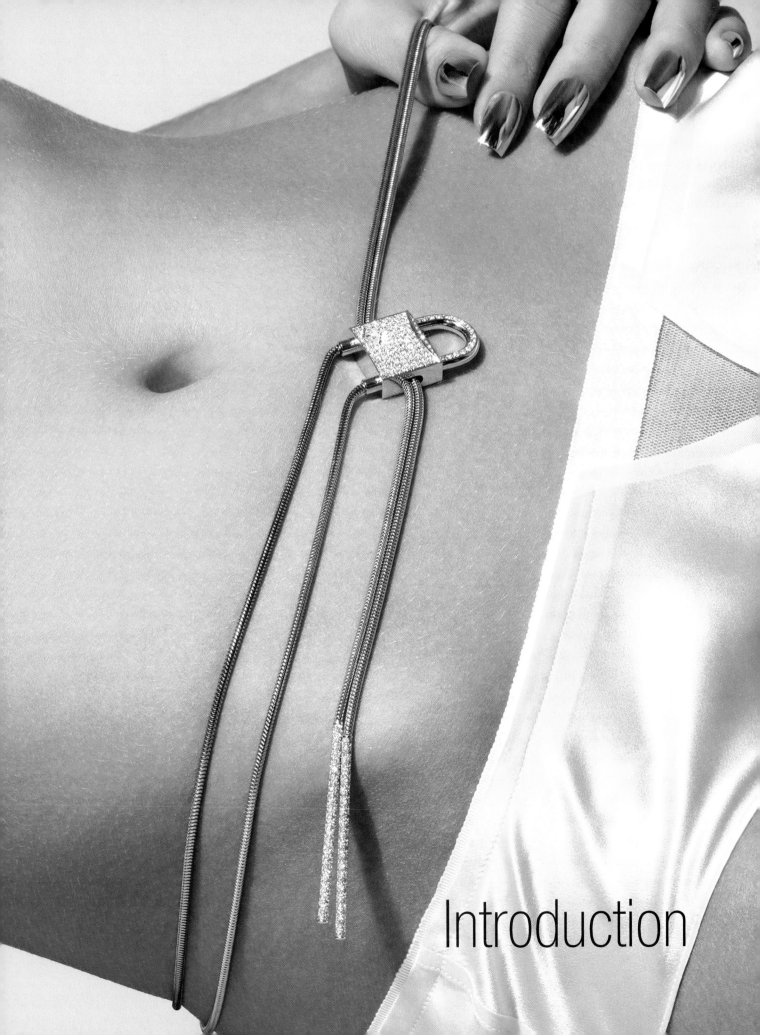

Introduction

Everyone wants to see exciting pictures of beautiful people and great products presented with incredible artistry. Nonetheless, the phrase *fashion photography* means different things to different people. Whether they are involved with the fashion industry or are just a viewer of the final results makes a difference.

To a photographer, fashion photography is a way to express himself, the models, and the product as one coherent piece of art. The fashion photographer strives to bring to all three a liveliness that transcends each one individually, and to simply make the viewer stop, stare, and think "Wow! I want to go out and buy that Valentino evening dress or that pair of Jimmy Choo pumps or that new Louis Vuitton handbag!" Although photographers may be limited by their budgets and by any reins that the creative director might place upon them, their goal is to invoke desire and passion in the viewer by creating a memorable shot. A photographer's vision is ultimately his or her own unique way of seeing things; this uniqueness can be so successful and so personal that one can simply look at an image by that photographer and identify who took it.

The client, or designer, has a different view of fashion photography: as a way to bring their creations to the masses. One's ability to become a world-famous designer is very much tied to the abilities of the fashion photographer. The result? Some of the most creative and memorable shoots are set up, sometimes at extravagant costs.

The final party involved with fashion photography is the public. After all, if no one admires these incredible shots painstakingly created by photographers and designers, what's the point? The fashion photographer influences the viewers' lives in so many ways—stoking in the viewer the desire to buy a product, and sometimes even creating fads that change the way an entire generation looks or feels about itself. Remember the first miniskirt, or when women finally gave up wearing corsets, or the half-dozen odd times over the past few decades that knee-high boots have been "in"? Fashion photography is also a way for the public to see what the rich and famous are wearing, connecting the public with the unreachable.

Ultimately, fashion photography involves informing viewers of what a product looks like, and what buying and wearing that product might convey to their friends. Therefore, the good fashion photograph accomplishes both. Depending on the product, the photographer, and the creative director, this can happen in myriad ways; there is no underestimating the power of combining beautiful people, beautiful clothes, and beautiful accessories like jewelry (commonly referred to today as *bling*), shoes, and handbags!

This basic three-pronged perspective on fashion and fashion photography provides a number of useful lenses for interpreting your own attempts at fashion photography, understanding the trade-offs a photographer has to make to achieve that fantastic fashion moment, and appreciating and analyzing the work of others to further inspire and improve your own.

Model: Svelta @ Michelle Pommier Photographer: Patrick de Warren

What about fashion photography today is different from the past? The key difference is that accessibility to interested photographers has dramatically improved as a result of the coming of age of digital photography. Over the past few years in particular, digital-camera technology has finally reached a level of performance that unlocks tremendous potential for every photographer to create successful and fantastic results—so much so that photographers can focus on creating a great image with the knowledge that the camera will flawlessly execute and even hide a few of the photographer's minor exposure errors.

The simple fact is that you can purchase a digital camera such as the Canon 20D (an 8-megapixel digital SLR) for about $1,500 as of this writing, plus the cost of a decent lens (say, another $1,000) and use it to do spectacular work as a professional photographer. Ten years ago a Nikon 1.3-megapixel digital camera cost about $25,000—about the same price as a 22-megapixel digital medium-format back today. Add to that digital SLR a PowerBook loaded with Adobe Photoshop and an inkjet printer by Epson, HP, or Canon, and the sky's the limit! With just these three pieces of equipment, you can shoot a national ad, not to mention catalogs and "fashion" style weddings—and many photographers do just that. For a modest investment of roughly $5,000 (not including lights, light control equipment such as reflectors, props, and even locations, all of which can be rented), you have all the tools necessary to make as much money as your creativity allows in the lucrative field of fashion photography. You can't even get a decent used car for that price!

In this book, we seek to present practical tips and a step-by-step guide to the basics of digital fashion photography—from planning to lighting to actually taking the photos and handling post-production tasks—all in a way that seamlessly integrates the use of newly available digital photographic tools with traditional tools, as well as the fundamentals of photography that remain essentially unchanged. It includes a distillation of our personal workflows, augmented by helpful insights from our colleagues.

Although many of the underlying photographic skills may be common to other genres of photography, included in subsequent chapters are many fashion-specific techniques that are rarely discussed, let alone published. Our goal is to help you to develop your own style and technique by drawing on our collective experience and by demystifying exactly what goes into producing a broad range of image types that are collectively referred to as "fashion photographs." Moreover, we want to help you move beyond the basic techniques in this book to focus on the aspects of fashion photography that cannot be taught as easily, and to develop your own unique fashion photography style and identity.

We hope you enjoy our book.

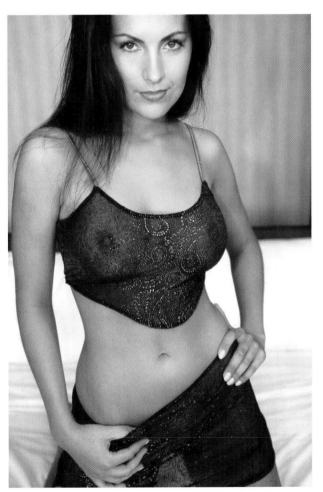

Model: Zdenka Photographer: Ken Tan

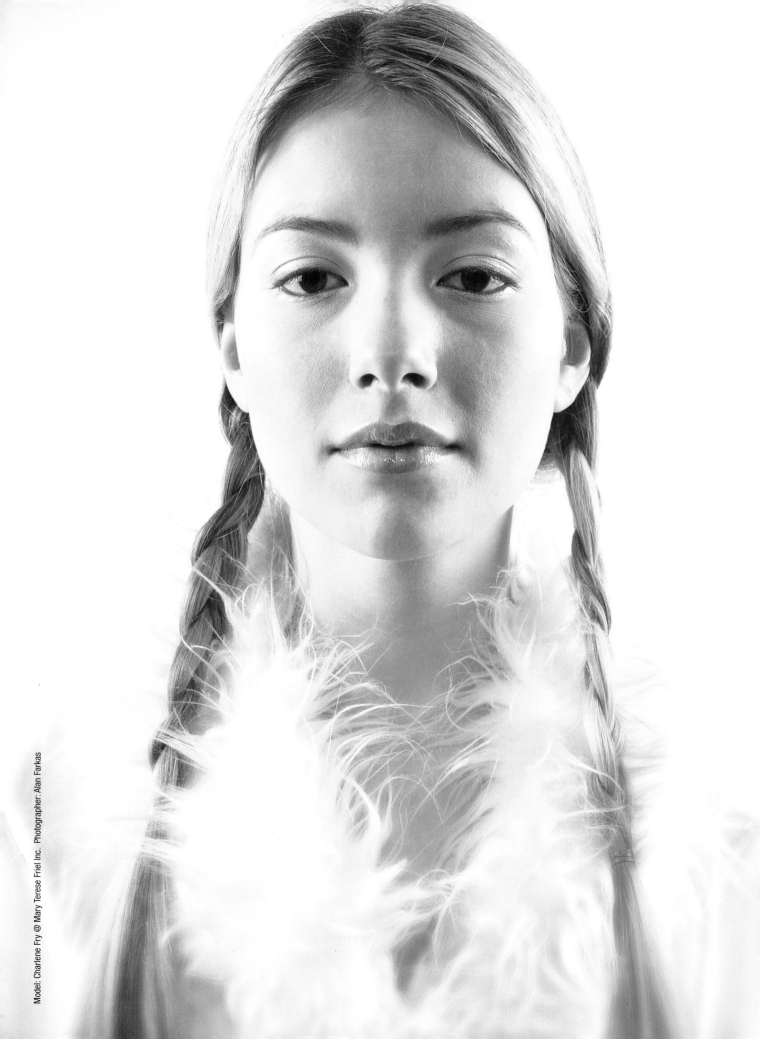

CHAPTER 1

From Film to Digital: A Brief Overview of Camera Technology

The science of photography was slow to develop. Chief among the reasons that photography took some time to catch on was cost. Indeed, it wasn't until the late 1850s that the importance of photography was affirmed. Even then, photography for fashion was still not viable because subjects needed to be still for so long. Only after better lenses were made that could accommodate faster shutter speeds could subjects move freely during a shoot. By 1911, Edward Stichen had begun taking fashion shots for *Art de Decoration*, and in 1913 *Vogue* started publishing fashion photographs by Baron de Meyer. From then on, fashion photography was a booming, artful industry.

The Birth of Conventional Photography

Although camera obscuras have been used for centuries to project real-life scenes onto the wall of an otherwise-darkened room or to project an image to the back of a box to allow for tracings, it wasn't until 1816 that someone— namely, a Frenchman named Nicéphore Niépce—thought to project the images seen in a camera obscura onto photosensitive paper. This did not happen right away, however. Mostly, Niépce was able to create images that stuck to pewter with exposure times equaling five days. Some 20 years later, a fellow Frenchman, Louis Jacques Mandé Daguerre, who was originally a painter, became Niépce's partner and expanded Niépce's idea by using silver-plated copper, plated with silver iodide and "developed" with warm mercury, to create photographic images. The images yielded by this process were ultimately dubbed *Daguerrotypes*. The first paper print was created in 1834 by Henry Fox Talbot, who used sodium chloride and silver nitrate. Then he reversed the image by making a contact onto another piece of paper. Fox patented his new process in 1841 and called it the *calotype*.

The development of the Daguerrotype and later the calotype brought about the use of the so-called "camera" as a way of creating portraits. Unfortunately, in order to obtain a clear image, the subjects of these portraits were required to sit perfectly still for 10 to 20 minutes at a time. Over time,

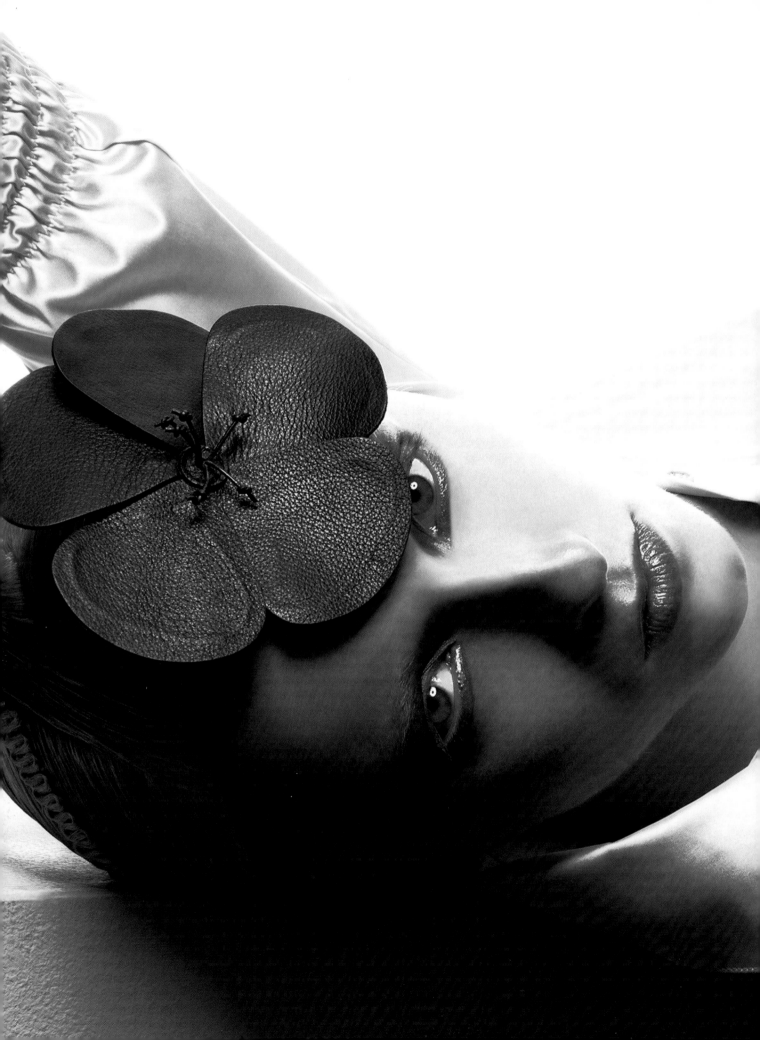

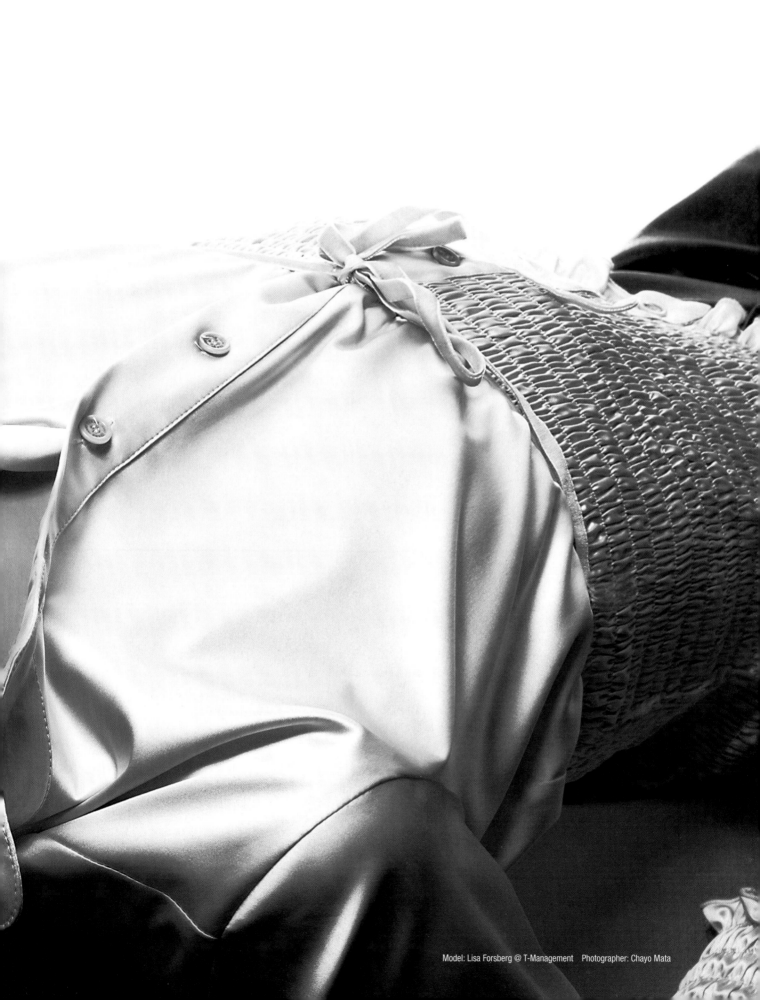

Model: Lisa Forsberg @ T-Management Photographer: Chayo Mata

however, better optics, faster f-stops, and other advancements made the technology more prevalent. In addition, improvements in printing processes helped to make photography available for more than just specialty images for the rich and famous.

It was in 1880 that photography really established itself; that was the year George Eastman established the Eastman Dry Plate Company in Rochester, New York. Eight years later, the company distributed the first Kodak camera, a bulky contraption that contained a 20-foot roll of paper. The next year, the system was greatly improved when Eastman replaced the 20-foot paper roll with a much smaller roll of film. This mass-produced Kodak camera was simple to use; suddenly, anyone could be a photographer.

Fashion Photography: The Early Years

As photography grew in popularity, so, too, did another art form: fashion. This was prompted in part by the development of a system of sizes and patterns, along with the invention of the sewing machine, both of which made it possible to mass-produce clothing. At the same time, thanks to the advent of the Industrial Revolution, factories could churn out textiles more quickly and more cheaply than ever before.

Even early fashionistas needed someplace to turn for the latest in style information—hence the publication of fashion magazines. Among the first was *Godey's Lady's Book*, which was first published in 1830. This magazine featured sketches of the latest in French fashions. The earliest issues of *Harper's* hit the presses in 1867; within a few months of its launch, *Harper's* circulation topped 30,000. With the aforementioned improvements in photographic technology came the use of photographs in lieu of sketches in fashion magazines. Although couturiers were at first wary about employing photographers to shoot their designs, fearing plagiarism, they quickly realized how powerful photographic images could be. In 1884, the use of fashion photographs extended to include catalogs.

While early fashion photographers focused simply on taking pictures that made both the clothing and the model look good, they soon evolved to view fashion photography as a great outlet for expressing their artistic viewpoints. For example, photographers in the early 20th century, such as Baron de Meyer, generated artistic effects by using a lot of backlighting and soft-focusing. Other photographers, such

as George Hoyningen-Huene and Cecil Beaton, used props. Still others, like John French and Irving Penn, created images that evoked their love for women. These greats inspired photographers everywhere—not just in the fashion industry.

The Advent of Digital Photography

The technology that led to the development of digital cameras has been around for decades—over 50 years, in fact. Indeed, it was the invention of the video tape recorder by Bing Crosby Studios in 1951 that set in motion the development of today's digital-imaging products. This video tape recorder captured electrical impulses and transferred them to magnetic tapes for television broadcast. Improvements on this technology remain in use by today's television industry. A second invention, in 1969, brought us ever closer to the invention of the digital camera: the *CCD*, short for *charged coupled device*. These days, CCDs are used inside digital cameras to capture light and to separate it into different packets of electrical charges. These charges are the red, green, and blue pixels that will eventually define how your image will look. The original CCD, dreamed up and designed in about one hour by Willard Boyle and George Smith, was pretty rudimentary compared to what we have today, but it was enough to spur Bell Laboratories to release the first CCD video camera in 1970. If not for this video camera with its CCD, the advances that we've see in movie cameras, TVs, and even satellites would have taken a lot longer to arrive.

Bell Laboratories wasn't the only group intrigued by digital images. During the 1960s, NASA took an interest and began converting all of its analog cameras to digital. These cameras were used in NASA's space probes, and were successful at sending digital images of the moon back to Earth, which were then stored on magnetic tapes. Their resolution was somewhat lacking, but NASA used emerging computer technology to enhance the images enough that they were useful. Of course, given that NASA was involved, then one way or another, so was the government. Indeed, its use of digital imaging in spy satellites helped advance the cause of digital imaging tremendously. Not much later, in 1972, Texas Instruments added to this knowledge and patented the first device to capture images without the use of film. Their patent would include syncing with a display to view these images.

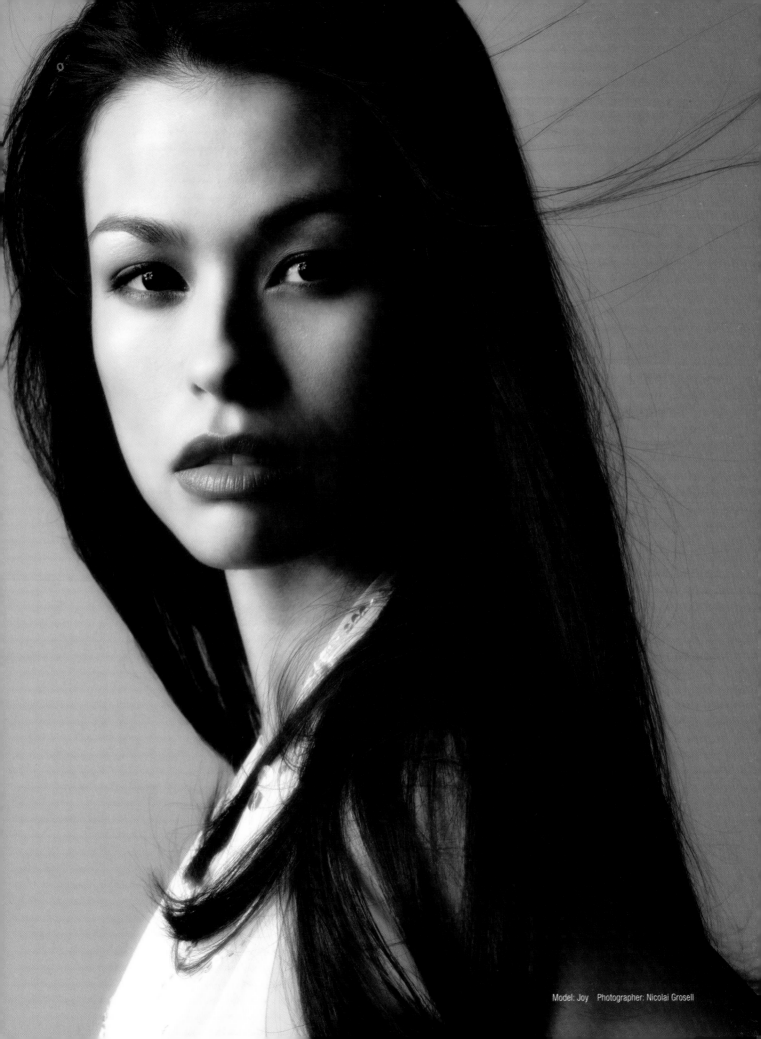

Model: Joy Photographer: Nicolai Grosell

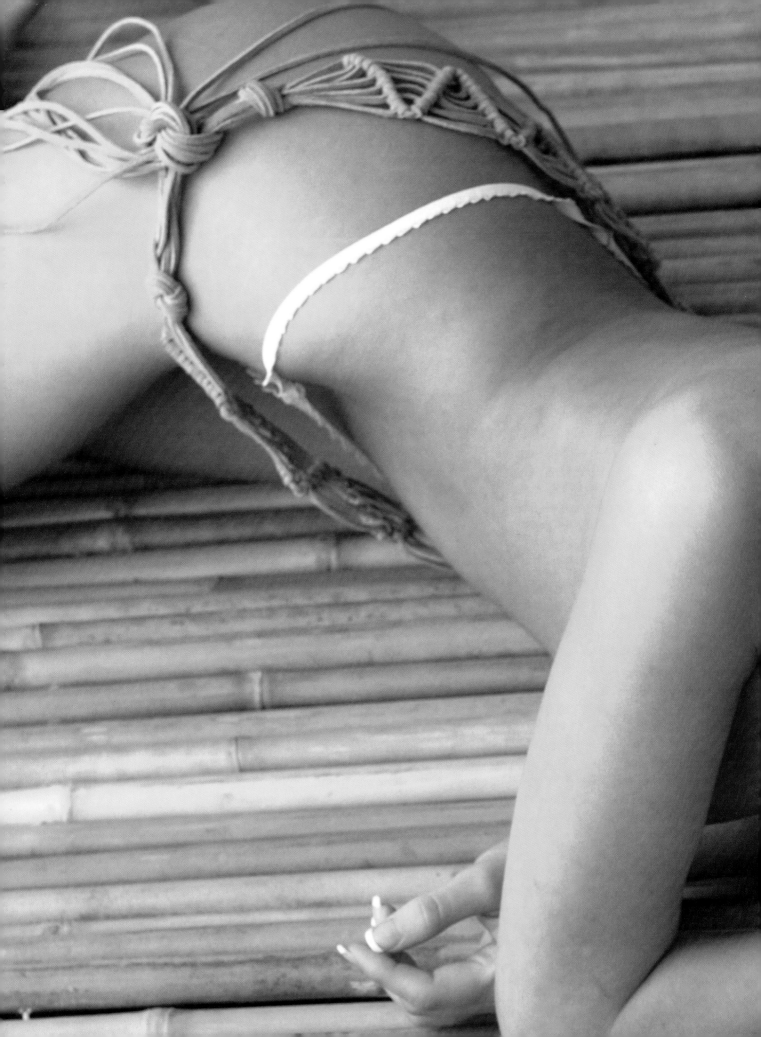

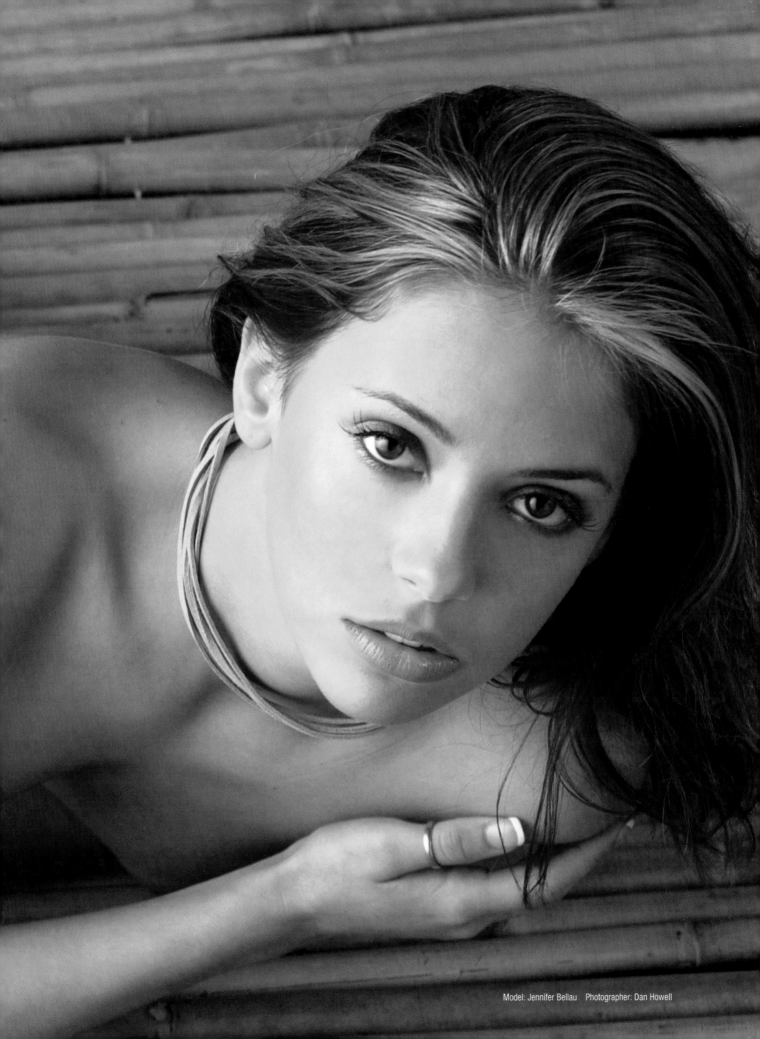

Model: Jennifer Bellau Photographer: Dan Howell

In 1973, Fairchild Imaging developed the first commercial CCD, a 100×100 pixel device that was ultimately used by Kodak to make its first operational digital camera—a black-and-white monster that weighed more than eight pounds. Developed in 1975, this camera took nearly 23 seconds to capture an image, and was probably good only for stills. Soon thereafter, Sony jumped onto the digital-photography bandwagon by releasing the Sony Mavica. This still-video electronic camera captured images to a floppy disk at a resolution of 570×490—a much higher resolution than offered by the Fairchild CCD. The disks were later viewed on a TV screen or on a compatible video monitor. Moreover, the Mavica, which used removable lenses and also included a zoom lens, could shoot pictures rated at 200 ISO with a shutter speed of 1/60.

Not to be left behind, Kodak forged ahead, releasing several sensors for professional use. These would also eventually find themselves in the consumer market. In 1986, Kodak invented the first "megapixel" sensor, a monster of a CCD capable of capturing approximately 1.4 million pixels. The resulting 5×7 image would not be considered viable today, but was miraculous then, yielding a "photo-quality" print as well as leading to the development of more cameras. Among these was the Canon RC-760, released in 1987. This camera was used by *USA Today* staff photographer Tom Dillon to take color photographs of that year's World Series; Dillon made history when he electronically transmitted the camera's output to *USA Today* headquarters in 12 minutes (although the images' resolution and quality left much to be desired). This spurred the Associated Press to start making the change from analog to digital—a change that would take longer than anticipated, but would lead the way to faster photojournalism—*faster* meaning that the wait time for receiving usable images was dramatically reduced.

In 1990, Kodak developed the Photo CD, part of a system to define a standard for how colors in the digital world should work. That same year, the company released the Kodak DCS-100, which boasted a resolution of 1024×1280, equal to 1.3 megapixels. The capture quality afforded by this camera model helped establish digital cameras as a viable tool among professional photographers. Based on a Nikon F3 body, it had interchangeable lens mounts, an internal storage space of 200MB, and an ISO of 100. Unfortunately, however, it was sold either as a color camera *or* a black-and-white camera—not both. Moreover, with its cables and accessories included, it weighed a whopping 55 pounds; you needed a suitcase to carry it. Its $30,000 price tag didn't help matters much.

The next year brought the release of the world's first professional-level digital camera, the Nikon F-3 with a 1.3-megapixel sensor, positioned for use by newspaper photographers and other photojournalists. Between 1994 and 1996, Apple Computer, Kodak, Casio, and Sony made inroads in the market by releasing consumer-level cameras averaging $900 in price. These cameras, whose image sensors yielded a resolution of about 640×480, were very similar; the one difference was that the Casio included a pivoting lens and a digital LCD viewer on the body of the camera. These features soon became standard among all cameras at both the consumer and the professional level. Camera makers went even further by adding visual controls for the camera to the viewfinder, providing photographers with information about camera settings at a glance. Some cameras even displayed histograms so photographers could eyeball whether they'd gotten a good shot.

In 1995, Kodak made a huge leap to a 6-megapixel camera, far superior to the 1.5-megapixel cameras offered by the company's competitors. The Kodak DCS-1 also brought a high rate of capture, 3.5fps for up to 12 shots, and the use of Canon speedlights. A second version based on a Nikon Body, the Kodak DCS 460, was similarly configured with the exception that it used Nikon lenses.

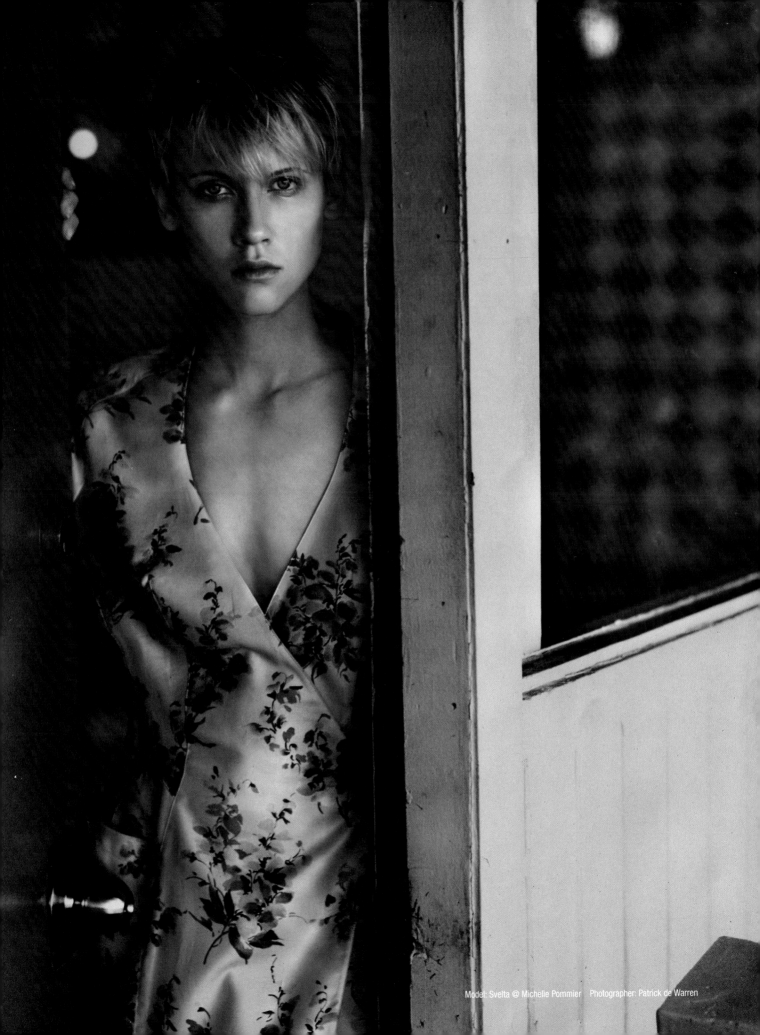

Model: Svelta @ Michelle Pommier Photographer: Patrick de Warren

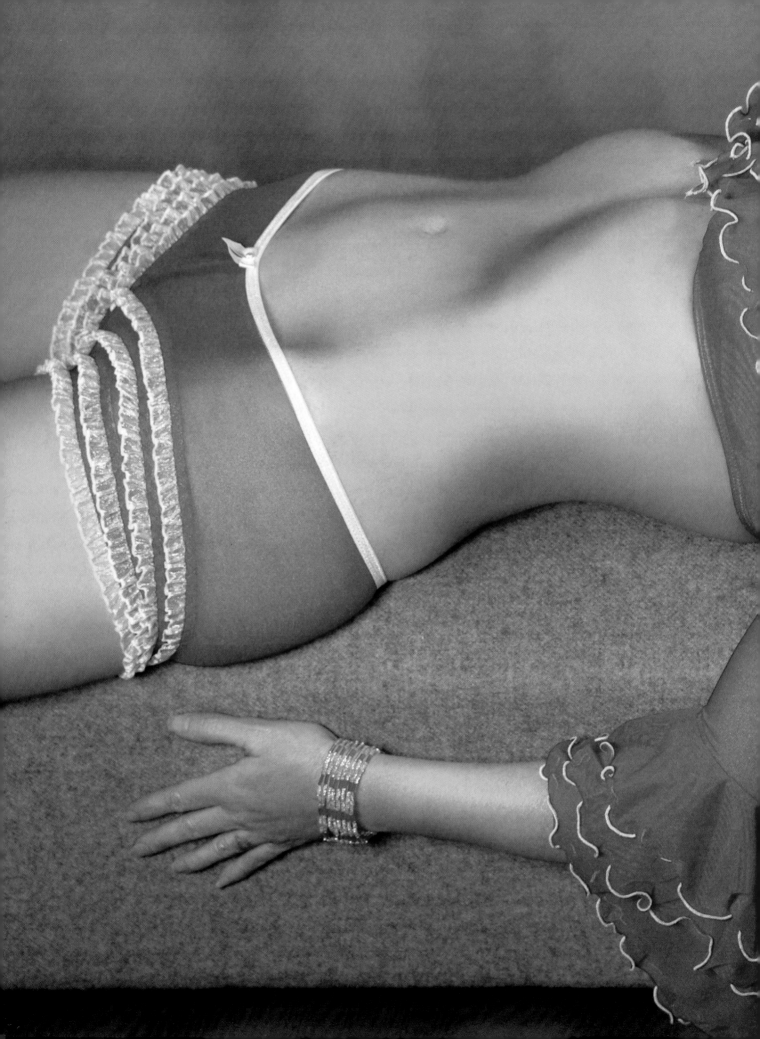

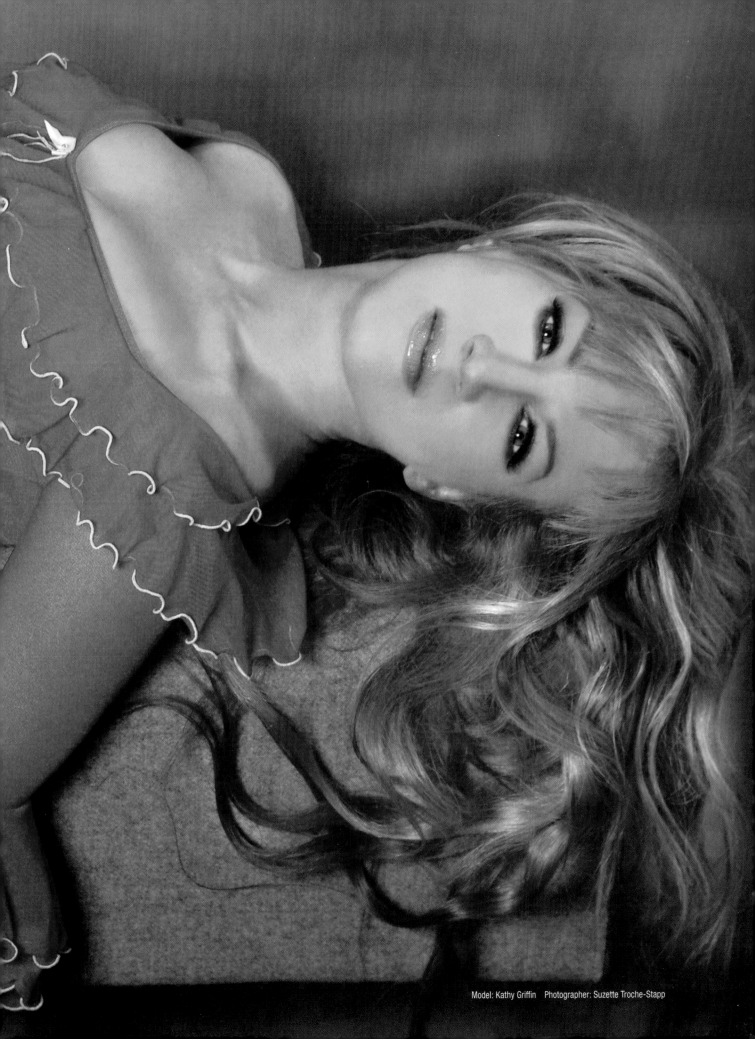

Model: Kathy Griffin Photographer: Suzette Troche-Stapp

The Development of Camera Backs

During the 1980s, as many companies scrapped to develop digital cameras, other larger medium-format camera manufacturers went another direction and developed digital camera backs. These ingenious devices allowed a digital imaging sensor to be attached to the back of a film camera and to convert what was seen into a digital file. These camera backs offered all the benefits of a film camera, plus digital capabilities, making them very desirable among fashion photographers. Unfortunately, as discussed momentarily, the costs associated with the earlier camera backs were even more difficult to absorb than the better, fully digital professional cameras.

The first of these camera backs to come to market was the Minolta SB-70S, launched in 1987.

This camera back had a CCD of 640×480 and was designed to attach to the Minolta Maxxum 7000 and Maxxum 9000 35mm cameras. Nowadays, this size CCD is good for about a 1.5×2-inch picture, but back then, this technology represented a big advance for those who did not wish to give up their film capabilities. In 1991, Leaf entered the market with its own high-quality backs; these were used in conjunction with the Hasselblad DB 4000 camera. One of the first viable digital capture devices, it was a very high-resolution camera, with a 2048×2048-pixel CCD, allowing the creation of a good 8×10 print. It also offered 14-bits-per-channel color capture. This was later converted to 8-bit color, but it still offered a tremendous range for a digital capture. This camera utilized a connection to an Apple computer via a SCSI 2 cable, offering a faster write rate for saving images.

It would be five years before a camera back would improve on the Leaf offering of 1991. In 1996, Dicomed launched an outstanding piece of equipment that offered for the first time a CCD that was larger than a 35mm aperture, but was also larger than a Hasselblad back. With a CCD of 4096×4096, the camera back was offered in three varieties: a black-and-white version for $35,000, a three-pass–capture version for $39,000, and a single-capture version for a mere $55,000. In this way, digital backs were like their fully digital camera counterparts: Both were very expensive.

Over time, digital cameras would become smaller, would become lighter, and would boast hugely superior capabilities, for a price that didn't put photographers in the poor house. In 2002, Canon released the Canon EOS-1D, a smaller, handheld professional camera with an 11-megapixel newly developed CMOS sensor; this unit was instantly popular with beauty and fashion photographers alike. And at only $6,000, it was also a lot easier on the pocket. The next year saw the release of 6-megapixel cameras by both Nikon and Fuji, sparking the war of ever-increasing image sensor size and ability, with Nikon offering a 12-megapixel camera later that same year. Kodak soon upped the ante by releasing a beautiful 13.5-megapixel camera, the Kodak DCS Pro 14n. These cameras were highly capable, portable instruments; as such, they became all the rage among professional photographers, even making headway into studio shooting.

Thanks to these advancements in digital cameras and camera backs, most higher-end photographers made the decision to jump on board. Nearly all cameras, including consumer-level offerings, are now equal or superior to 35mm film cameras. Their ease of use, ability to shoot multiple ISOs at a push of a button, interchangeable lenses, and

very affordable cost made them a win-win. And because they improved workflow, color accuracy, and the ability to produce images that could be repurposed according to a varied set of outputs, clients began asking for digital shoots instead of film-based ones.

Digital Versus Film

Now that digital cameras are equal or in some cases superior to their film counterparts, there really is no reason not to make the leap to digital. Consider the following:

- Digital cameras require much less equipment. Since you no longer need to haul a boatload of equipment around, it's much easier to shoot on location. You also can set up photo shots in locations that were formerly inaccessible with all that equipment.

- As another advantage, images shot with a digital camera can be sent to their final destination via the Internet. This is much faster than using regular mail or courier services. What used to take days now takes mere minutes; as a result, an image shot at 9 a.m. can be on press by evening. Compare this to the old days, when film had to be shot;

developed; sent to a pre-press facility to be scanned, color-corrected, separated into film, paginated, and sent to a paste-up artist; and finally sent to the printer. This could take days, or even weeks! Thanks to digital technology, these delivery speeds are only going to improve. Forthcoming are cameras with white balance and CCD/CMOS sensors that are so good you won't need to color-correct your images, and that have Wi-Fi capability built-in to enable you to send images right from the camera to the editing table in seconds. Indeed, some of the latest cameras can wirelessly transmit an image from the camera to a computer or even to a printer already. Moreover, soon you'll be able to use WiMax to send a 100MB image from New York to Los Angeles in only 30 seconds.

- In the past, photographers worked with three key parameters: speed, aperture size, and focal length. In the days of film, you had to change between rolls of different ISOs if the available light level dropped below a certain level or risk under-exposure. Today, most digital cameras—even point-and-shoot models—can change ISO ratings or sensor gain to allow you to capture images in different lighting situations. For example, if a photographer is not certain that the shutter-speed/aperture combination will correctly freeze the action in the image, he or she can simply dial up a higher ISO, choose a faster shutter speed, and shoot away.

note

Early-generation digital cameras brought the ability to change ISO at will, but higher ISOs (typically ISO 400 and above) were relatively unusable due to high noise. Since then, the low-light performance of digital cameras has advanced significantly, permitting the use of even ISO 800 without too much post-processing. It has gotten to the point that the average professional D-SLR produces lower-noise images at ISO 400 than did many older films of ISO 200 or below.

note

The basic steps of preparing for a shoot, capturing images, processing images, and creating final prints has not changed. The digital phenomenon has only shifted the boundaries of who or what performs which step in the process, and how a particular step is physically carried out. For example, you still develop the pictures under the digital paradigm, you just don't do it in a darkroom. Instead, the camera does it when it applies its on-board JPEG compression, white balance, and sharpness algorithms, or you do it in an image-editing application such as Photoshop. In many respects, digital photography has simply transferred many of the links in the image-making value chain to the photographer. Aside from the very few photographers who work in large professional studios that employ specialists—such as image technicians, color-correction experts, specialist retouchers, and so forth—to help with all aspects of image capture, the vast majority of professionals today capture their images, color-correct them, and even retouch them on their own equipment—aspects of the old process that were typically done and funded by photo labs and other service bureaus. All this is to say that digital photography at any reasonable professional level is going to require some investment by the photographer—both in time, to learn how to perform color-correction, retouching and so forth, and in money, to buy a reasonably powerful computer, a good monitor, a decent printer, and so forth.

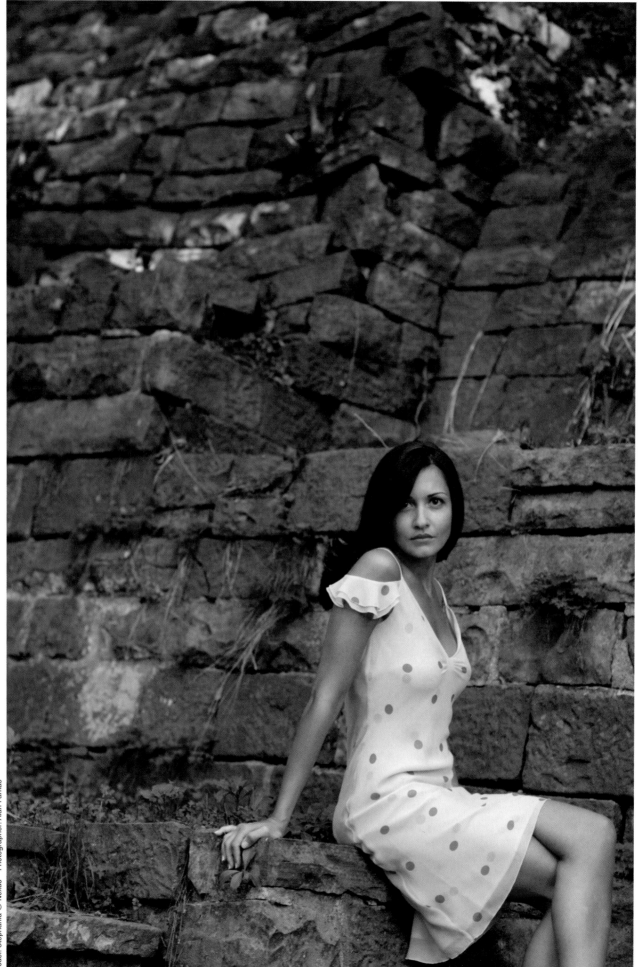

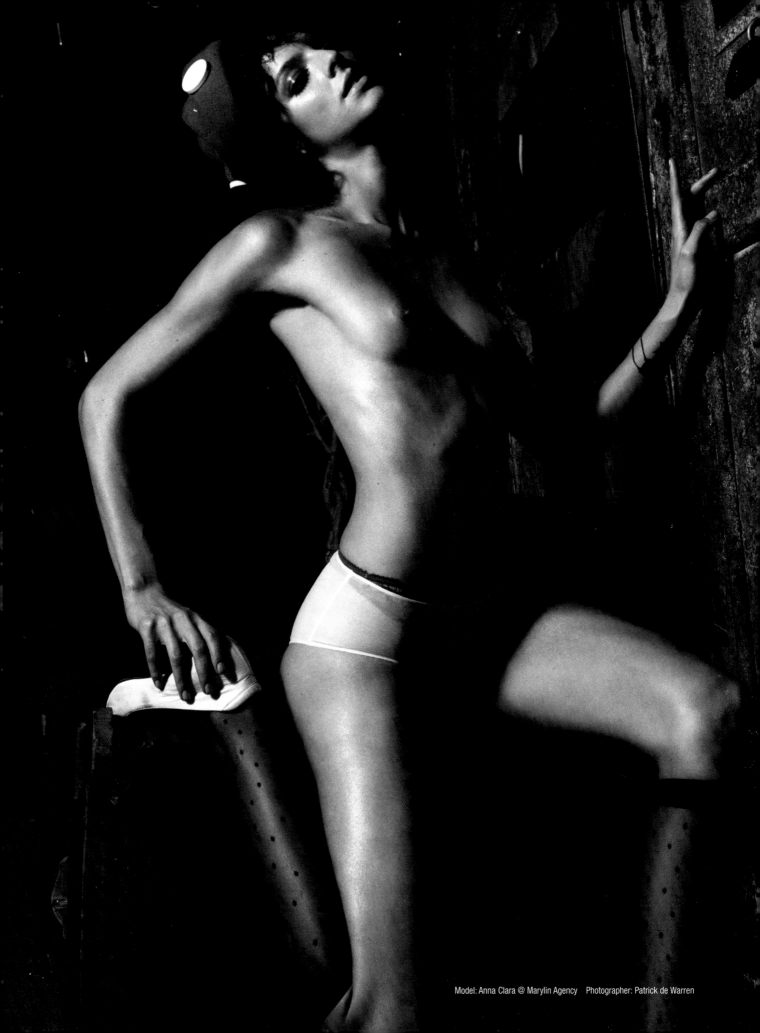

Model: Anna Clara @ Marylin Agency Photographer: Patrick de Warren

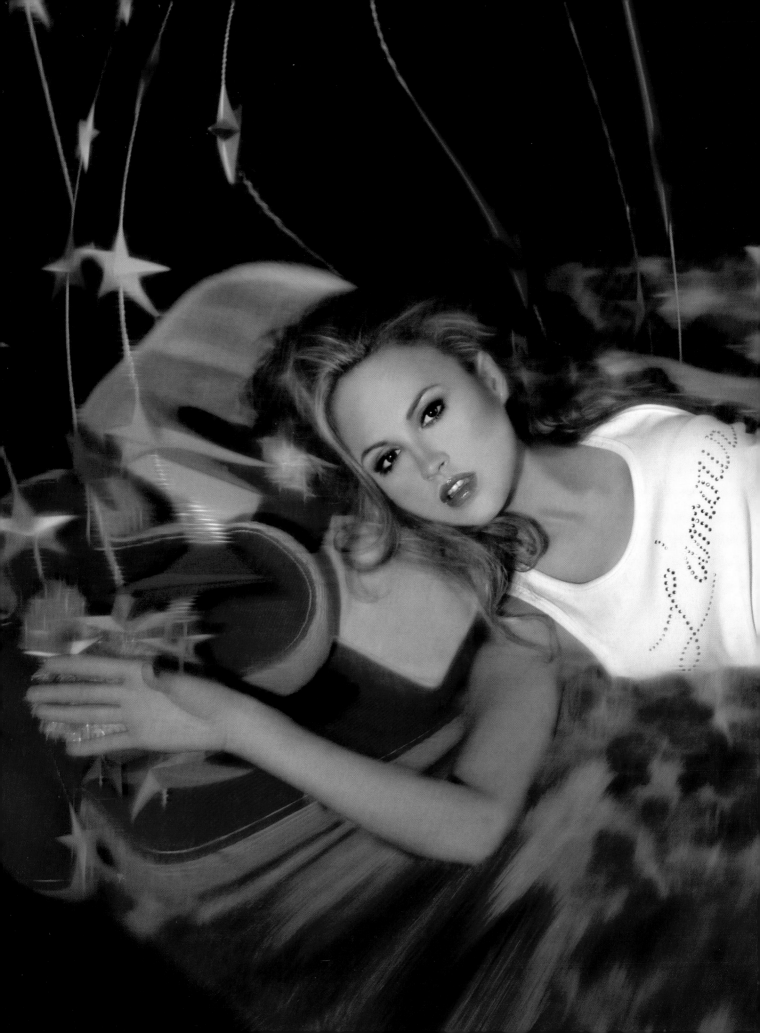

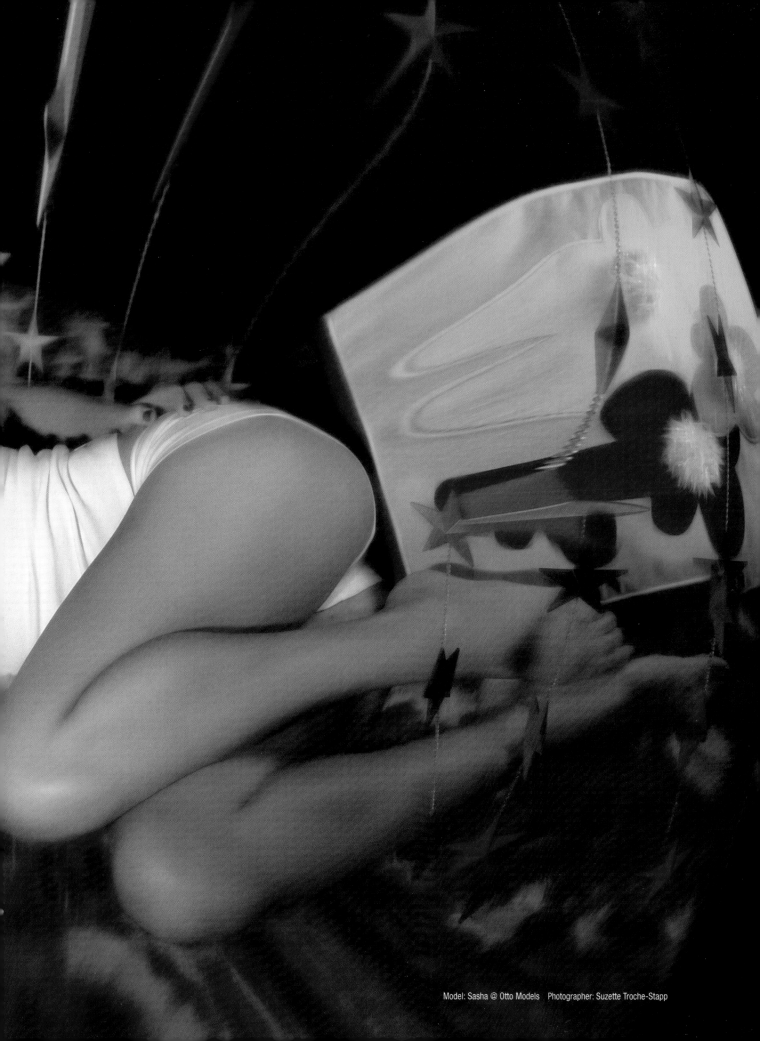

Model: Sasha @ Otto Models Photographer: Suzette Troche-Stapp

Popular Digital Cameras

The following cameras, in no particular order, are by far the most popular professional-grade digital cameras in use today. They are employed by more than just the fashion photographers whose work you see in this book; they are also used extensively by beauty photographers, portrait photographers, and even by some landscape photographers. Photographers' reasons for choosing a particular camera vary, but most make their selections after having the opportunity to try some out to see how they fit and feel. Some photographers simply stick to using one particular brand out of familiarity, while others switch brands based on improvements in technology.

Just because something better has entered the market doesn't mean you need to upgrade the camera you are using. One photographer I know uses a Nikon D100 6 MP, and has been quite happy and successful with it. Eventually he wants to move up to a Kodak Pro 14 mp, but he is in no great rush. Knowing the ins and outs of your digital camera—as opposed to dealing with technology that you only partially understand—is a huge plus. Nothing slows you down like having problems with new equipment when it comes to crunch time.

note

Digital cameras, while increasingly affordable, accessible, and reaching ubiquity, still require you to master the basics of photography—exposure, composition, and so forth—to get a good result. Even an expensive professional-grade digital SLR will not make you a better photographer. If you are barely able to take a decent picture with a point-and-shoot digital camera, a D-SLR will only allow you to take the same bad picture with higher resolution, better color fidelity, and perhaps in a shorter time. There is some art to digital photography, especially digital fashion photography.

The Sigma sd9 and sd10

In addition to being among the least-known digital cameras, the Sigma sd9 and sd10 cameras are also unsung heroes. Incredibly, although these cameras have been around for a couple of years without an update (an update is scheduled for Fall 2005), they are still 10.9-megapixel cameras. These cameras use a Foveon x3 CMOS sensor, which captures color data much differently from a standard mosaic CCD sensor. CCDs capture one of three colors per pixel—red, green, or blue—and then uses software to combine the pixels to create one full-color pixel. Although this works, the interpolation algorithms used to perform this operation create two problems: a softer image and moiré, which is very difficult to remove.

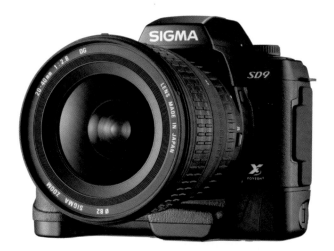

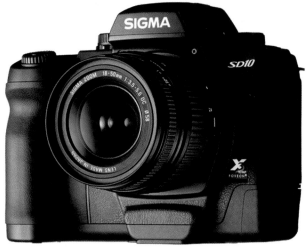

The Sigma sd9 and sd10

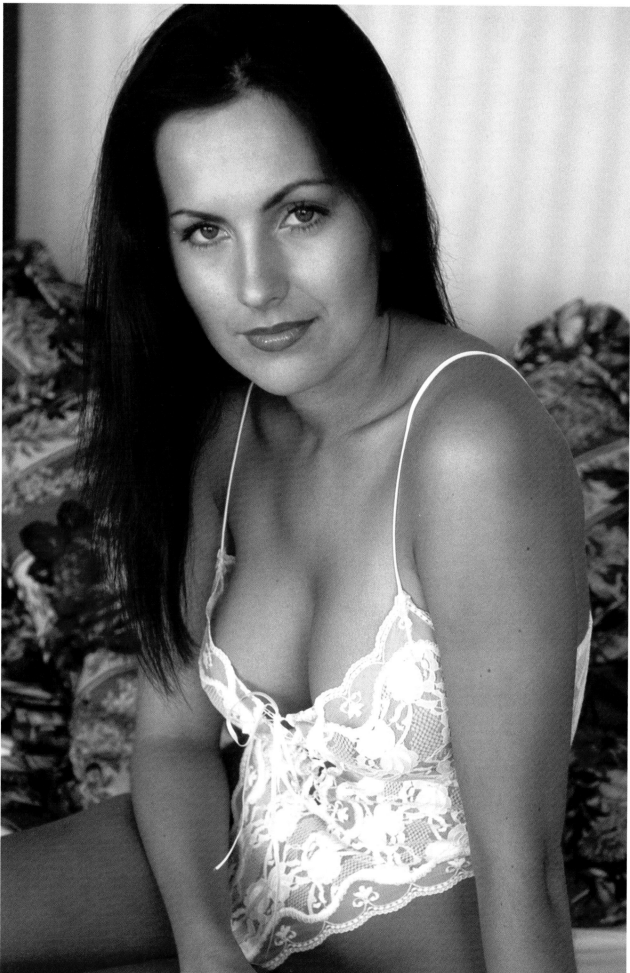

The Foveon technology solves both problems by capturing all the colors to one pixel, eliminating any need for software to combine them. The result is an image that is at least twice as sharp as a conventional digital camera's, allowing for much more detail, with no moiré. The Sigma cameras also have the distinction of shooting only in RAW mode, with three settings available: High, Medium, and Low, with the High producing a file that is only 8MB. Although this is a small file, it can be enlarged extremely nicely due to the lack of noise as compared to a similar-sized capture from another manufacturer's camera.

The Nikon D2x

> **note**
>
> A moiré is an undesirable pattern that occurs when a uniform pattern is captured, usually resembling a gas spill in a puddle or the old wavy lines found on TV sets years ago. Pixels are set to reproduce color at different angles to prevent a moiré from happening, but sometimes a pattern on fabric conflicts with the set angles of the pixels.

Nikon

Nikon has been on a roll with its cameras. With the release of the Nikon D2x, the company has climbed back into the fight with Canon for the best hand-held professional digital SLR. The D2x, a 12.4-megapixel camera, employs a CMOS DX-format sensor that allows high-speed shooting—5fps at full-size RAW, slightly lower than the 8fps on the D2H. The camera also offers a unique Cropped Sensor mode, which takes shots at 8fps at a size of approximately 6.5 megapixels. To really make this speed work, Nikon has added an incredible buffer to the camera that is capable of holding 15 RAW files at full resolution or 21 JPEGs. Perhaps the best feature of the Nikon D2x is its built-in wireless capabilities, which can be used to transfer files from the camera to an FTP server within 100 feet with the supplied antenna, or within 500 feet if the optional extended range antenna is used. (For fastest transfer speeds, a router, as opposed to a direct link to your laptop or desktop, should be used.)

Also added to the Nikon D2x's feature list is automatic control of the sharpening applied to your images. This feature automatically takes into account what lens you are using and sharpens it with the capabilities of the camera's sensor in mind, enabling you to maximize the capabilities of the lens and the sensor. A new RGB histogram, which is a vast improvement over Nikon's earlier green channel–only histograms, has also been added; it also provides individual red, green, and blue histograms.

> **note**
>
> Nikon has chosen to encrypt the white balance of the files created by this camera. That means you will get optimal results if you use Nikon's own imaging software to process your RAW NEF files. All other RAW developers on the market, with the exception of dsRAW and Bibble, cannot decode this encryption. Using software like Adobe's Camera Raw will give you what the program *thinks* is the best conversion, but chances are the white balance will be off.

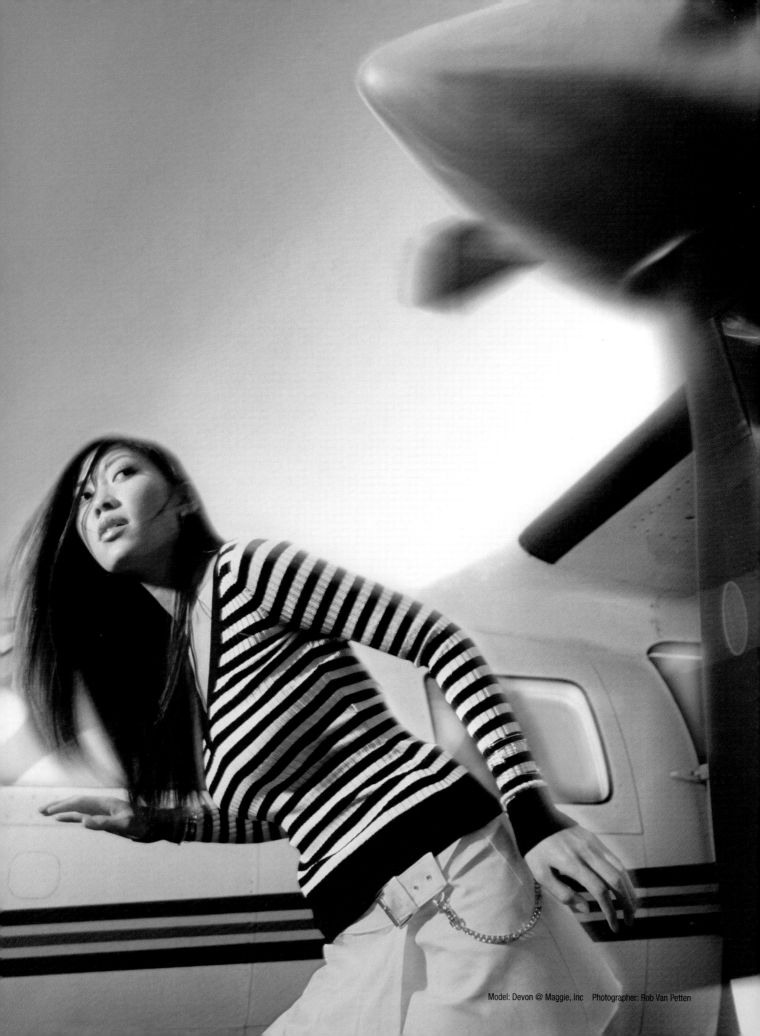

Model: Devon @ Maggie, Inc Photographer: Rob Van Petten

Canon

Like Nikon, Canon has long enjoyed a reputation for quality and excellence. But unlike Nikon, Canon has managed to keep innovating with each camera it releases, further tightening the company's grip on the professional D-SLR market; with the release of the Canon 1DS-MarkII, the company has kept this tradition alive. Very widely used by professionals in the beauty and fashion world, the MarkII offers exceptional quality at a very affordable price. Featuring a full-sized 35mm sensor, this 16.7-megapixel camera is the highest resolution digital SLR on the market, and makes use of the entire range of view of all of Canon's EF lenses. Although the speed of the Nikon is impressive, the Canon 1DS-MarkII, set at its highest JPEG mode, can reach 4fps for up to 32 consecutive shots (JPEG) or 11 shots in RAW format. This is possible because of the camera's accelerated capability to write to card media.

Canon 1DS-MarkII

The MarkII can simultaneously write to both a compact flash card and an SD card, providing photographers with an automatic backup. The camera also offers maximum shutter speeds of 1/8000 second; great dust and water protection, enabling its use in some pretty grueling conditions; an auto-focus that encompasses a 45-point area, allowing for easier compositions; and a custom control feature, allowing photographers to set up their own set of preferences. Canon's MarkII also offers wireless-transmission capabilities, involving a separate antenna that has both 802.11/b and 802.11/g capabilities as well as its own battery pack. This antenna is backward-compatible with older Canon D-SLRs with a FireWire interface.

There is a clear rivalry between Nikon and Canon, with both manufacturers engaged in a one-upmanship contest. This has resulted in the creation of two digital SLRs that rival camera backs like those made by Hasselblad and Leaf for outstanding color and reproduction. This rivalry can only benefit consumers as these cameras push technology to the limit while lowering the price point considerably in comparison to that of a comparable digital back.

Kodak

Kodak has had an interesting time with the professional-level digital cameras over the past few years. After being a strong contender, they kind of fell by the wayside in 2003 with the Kodak 14n, due to high noise at higher than 80 ISO and also for chromatic aberrations. This was not great news for anyone looking to stay with a Kodak camera. Fortunately Kodak came back into style with a wonderful medium-sized format back, the Kodak DCS Pro Back 645.

Kodak's latest foray into professional digital cameras is its 35mm offerings, the Kodak DCS Pro/n and /c. The cameras are once again being offered for Nikon and Canon lens mounts, hence the /n and the /c; except for that distinction, both cameras are identical. They are 14-megapixel cameras with ISO selectives from 6 to 1000. The cameras use a CMOS sensor and are capable of capturing 1.5 frames per second. Perhaps the biggest breakthrough with these digital cameras is the ERI-JPEG technology that Kodak has developed. ERI stands for Extended Range Imaging. Essentially what Kodak has done is to save ERI metadata with the JPEGs, which allows them to be reprocessed as RAW files. This makes for great image protection if the original RAW file is lost or damaged.

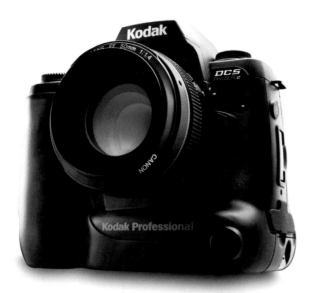

The Kodak DCS Pro digital camera

Unfortunately, Kodak announced in May 2005 that it is discontinuing the DCS Pro/n and /c cameras. The company will, however, continue to support these models until 2008 with firmware and Photodesk upgrades as warranted. As a result, these great cameras can now be found at exceptional bargains, and with the use of Adobe DNG format, can be used for a lot longer than the next three years.

Hasselblad

One of the heavyweights in the digital camera back world is Hasselblad. Hasselblad has made quality cameras for nearly 50 years, and has garnered a strong following of photographers who feel that Hasselblads are the best cameras there ever were. These days, you can purchase either a Hasselblad digital camera or a Hasselblad digital camera back for the camera you already own.

The Hasselblad H1D is a 22-megapixel medium-format camera offering a beautiful capture that is nearly unrivaled. The camera comes with a cooling system that is about twice as effective as in other leading cameras, allowing for a cooler sensor, and thus less noise in the image. The lack of heat also prolongs the camera's battery life, enabling nearly eight hours of continuous shooting. A single file in 16-bit color mode is a whopping 132MB, yielding enough image resolution to take a shot that can be repurposed in any form you wish. To house these images, the H1D comes equipped

with an external image bank hard drive of 40GB. This drive is specially formatted and sectored to speedily move such large files when shooting, and can store as many as 850 full-resolution shots. With the FireWire connection, when hooked up to a computer, the transfer rate is approximately 100 images in three seconds.

The H1D offers interchangeable viewfinders and lenses. And although Hasselblad has parted with the Zeiss lenses of the past, their replacements, the Hasselblad HCs with integrated shutters, are more than equal to the task. ISO ranges from 50 to 400, with the longest shutter speed being 30 seconds.

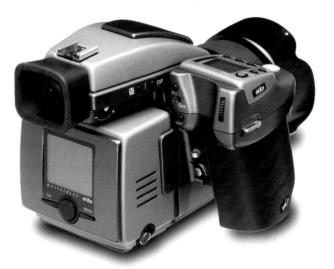

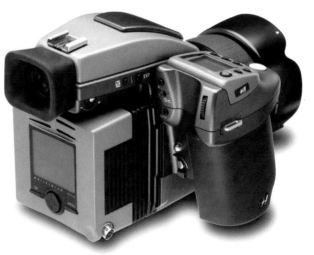

Hasselblad H1D and Hasselblad H1

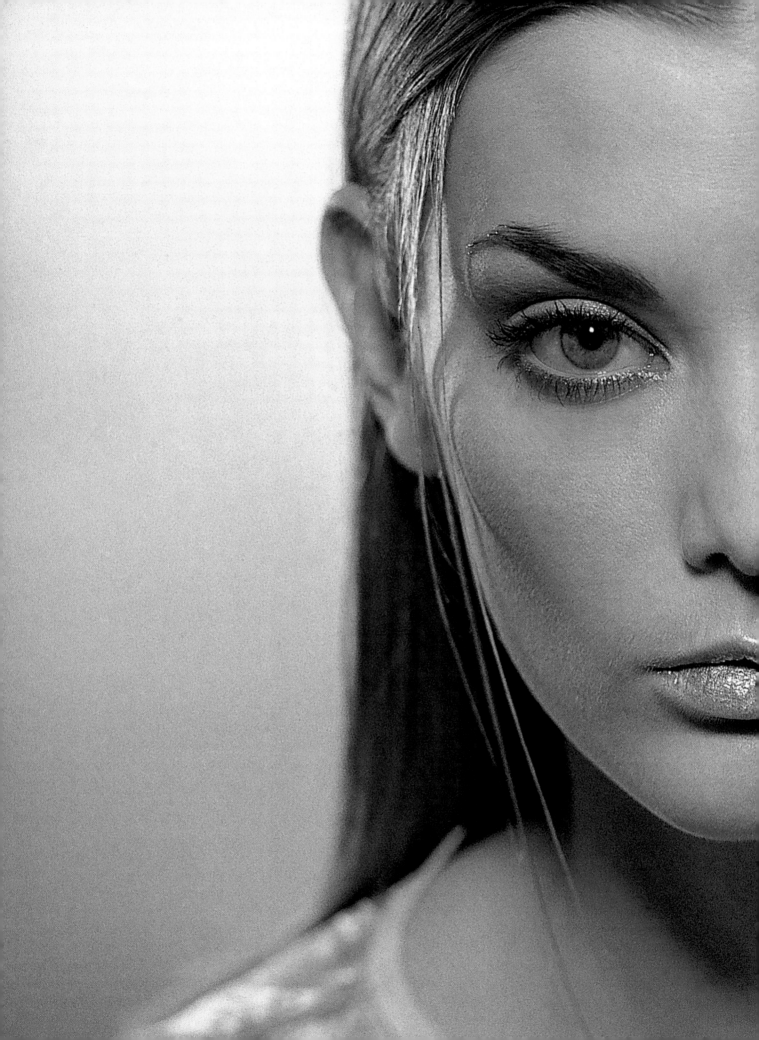

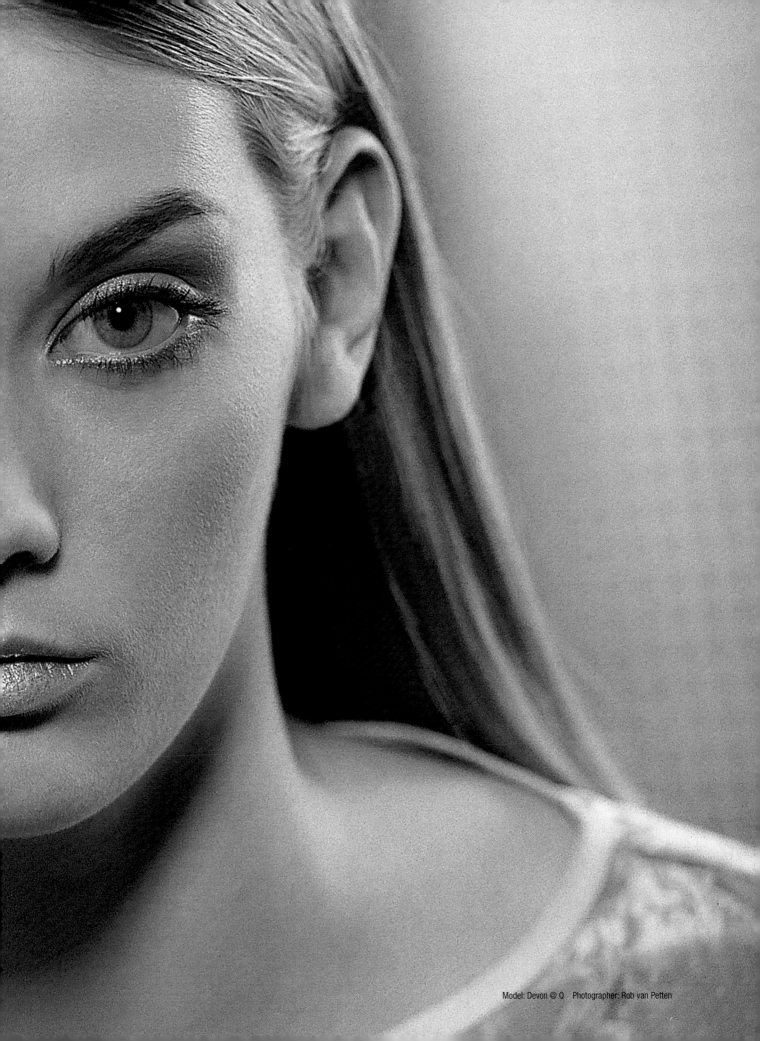

Model: Devon @ Q Photographer: Rob van Petten

Hasselblad also offers two digital camera backs: the Ixpress 96C/384C, a 16-megapixel camera back; and the Ixpress 123C/528C, a 22-megapixel camera back. These backs can be fitted to the following types of cameras:

- Hasselblad H system and V system
- Rollei 600X and AF
- Contax 645AF
- Mamiya 645 Pro, 645 AFD, RB, and RZ67
- Fuji GX680I/II/III via Hasselblad adapter
- Horeseman DigiFlex II and PrecisionWide 35 via Hasselblad adapter

Leaf

If you are ready to mortgage your house, then the Leaf Valeo is the way to go. Released in September of 2003, this wonderful piece of workmanship sells for nearly $30,000! But if cost is no object, run out and get one of these remarkable camera backs. The Leaf Valeo is a true 16-bit back with the largest sensor out there—a chip just short of a full 645 frame. This yields a wider shot than most digital camera backs, and slightly more resolution. Also, because it is a true 16-bit chip, it can render shadows at least a half stop more than others quite nicely.

A second camera back by Leaf is the Leaf Aptus, released in September of 2004. This camera back is offered in two variations—a 17-megapixel version and a 22-megapixel version—with both sharing the same 645-sized CCD as the Leaf Valeo. Additionally, these cameras take advantage of a new compression scheme called *RAW HDR* (CHDR), which compresses the RAW files in a 100-percent lossless compression, thereby reducing file size by 50 percent. This helps with file-transfer rates and archiving.

Both Leaf models offer wireless transmission as well as an option to add a 20GB magazine to the camera back to facilitate the storage of nearly 2,000 images as well as four hours of continuous shooting, depending on camera configuration.

Phase One

Phase One has two excellent offerings, the P20 and the P25, which are both exceptional camera backs. Unlike the backs made by many of Phase One's competitors, however, these camera backs are not one-fits-all. Instead, each back is made specifically for a certain camera. If you ever wish to use the back with a different camera, however, a mounting adaptor is available. The P25, at $30,000, is perhaps the finest back out there. It's a 22-megapixel camera that shoots in RAW format only with no in-camera JPEGing. File sizes once opened are approximately 125MB—good for any print destination and ideal for cropping. The default ISO is 50, but it can range up to 800. Noise at ISO 50 is a non-issue, and believe it or not, the higher the ISO the better the noise compression. The backs can be used tethered to a computer, but are designed to be used untethered, giving mobility for a fashion shoot. And with an outstanding dynamic range, there is no better camera back on the market. It is the best medium-format camera out there.

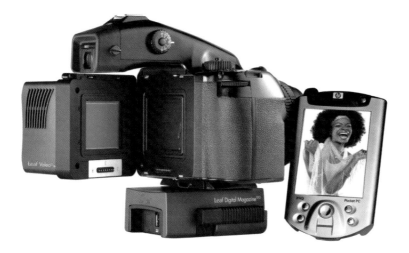

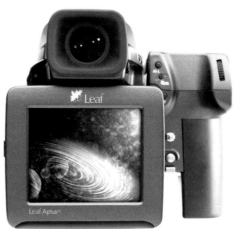

Leaf Valeo and Leaf Aptus

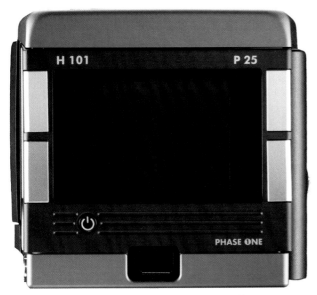

The Phase One P20 and P25 camera backs

note

Digital photography allows fashion photographers more flexibility than ever in creating amazing and memorable images, and more control over all aspects of how those images come out. At the end of the day, however, digital cameras are simply the next stage in the evolution of image capture, mere tools of the trade. As important as the equipment may appear, your ability to realize your vision and aspirations is more about you and your team than what is in your camera bag.

Image-Processing Software

Nearly every camera manufacturer offers its own software for processing RAW files or performing tonal and color adjustments to JPEGs shot with its cameras. These programs are usually optimized somewhat for each camera's specifications and will, for the most part, do the job. All of these programs enable you to adjust tone through either a levels mechanism or a curves mechanism, with some of the more advanced programs adding in exposure and temperature. Some offer you the ability to batch-process and create contact sheets from JPEGs shot in tandem with the RAW files. That said, you may need to purchase a third-party program to process your images. Following is a list of image-editing software packages you might consider:

- **Adobe Photoshop.** Of all the third-party applications out there, Adobe Photoshop offers the most functionality. With sophisticated color controls, retouching, spot removal, and RAW image processing, it is also the most popular. This software is offered for both Apple Macintosh and Windows platforms.

- **Binuscan's PhotoRetouch Pro.** Binuscan offers very powerful profile-editing and -creation software built into its image-processing package, PhotoRetouch Pro, available for Macintosh only. This software includes intuitive, easy-to-use color-correction tools that, in some cases, rival Photoshop's. The retouching and warping tools are also exceptional. Binuscan distributes a free, pared-down version of this software called PhotoRetouch Digicam; try it before you shell out for the higher-end software.

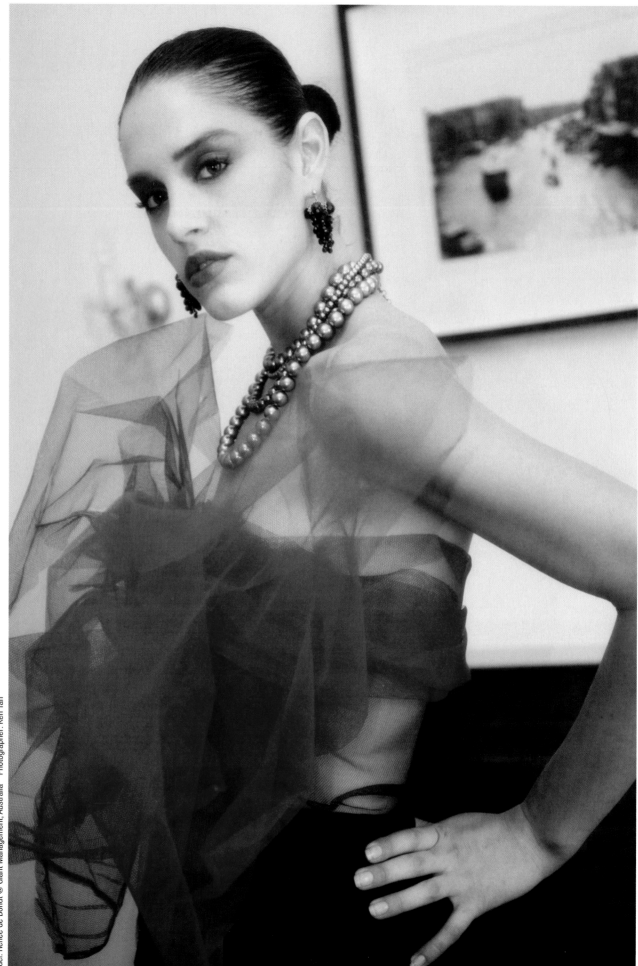

Model: Renee de Bondt @ Giant Management, Australia Photographer: Ken Tan

note

Digital cameras have a tendency to add noise to a capture due to many variables such as ISO setting, how hot the camera's sensor is, and how overexposed your image might be. Several software packages out there will happily tackle this problem with varying success.

- **Visual Infinity's Grain Surgery.** Highly popular, but a little on the slow side depending on your computer configuration and the size of your image files, Grain Surgery by Visual Infinity has a multitude of options. These include remove grain; sample grain, which allows you to extract grain from an image to use at a later time in another image; add grain, which enables you to mimic the grain structure of various films; and match grain, which enables you to match the grain from one image to another image. All achieve great results in making an image look more like a conventional print.

- **PictureCode's Noise Ninja.** Another popular choice, this easy-to-use software, which is sold as a standalone program and as a Photoshop plug-in, tackles digital film grain based on a camera profile. Using a profile informs the program what to expect with regard to noise structure from a particular camera at a particular ISO. You can create a profile based on your camera to make the software even more accurate.

- **Imagenomic's Noiseware.** Another program that gets high points for ease of use, intuitiveness, and excellent results is Noiseware by Imagenomic. Imagenomic has gone the extra mile to make noise removal as simple as possible while achieving the highest-quality results. Offering noise removal based on frequency, the program gives you the option of removing noise based on color, tone, and luminosity. It also includes a preview pane that gives you multiple-choice options based on the current settings, all with near–real- time updating. This software is available as a standalone application or as a Photoshop-compatible plug-in.

Model: Monica Leone Photographer: Chris Tarantino

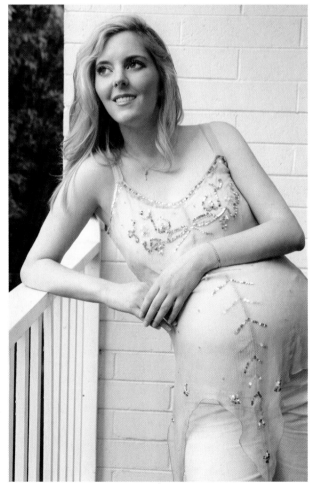

Model: Rachel Tan Photographer: Ken Tan

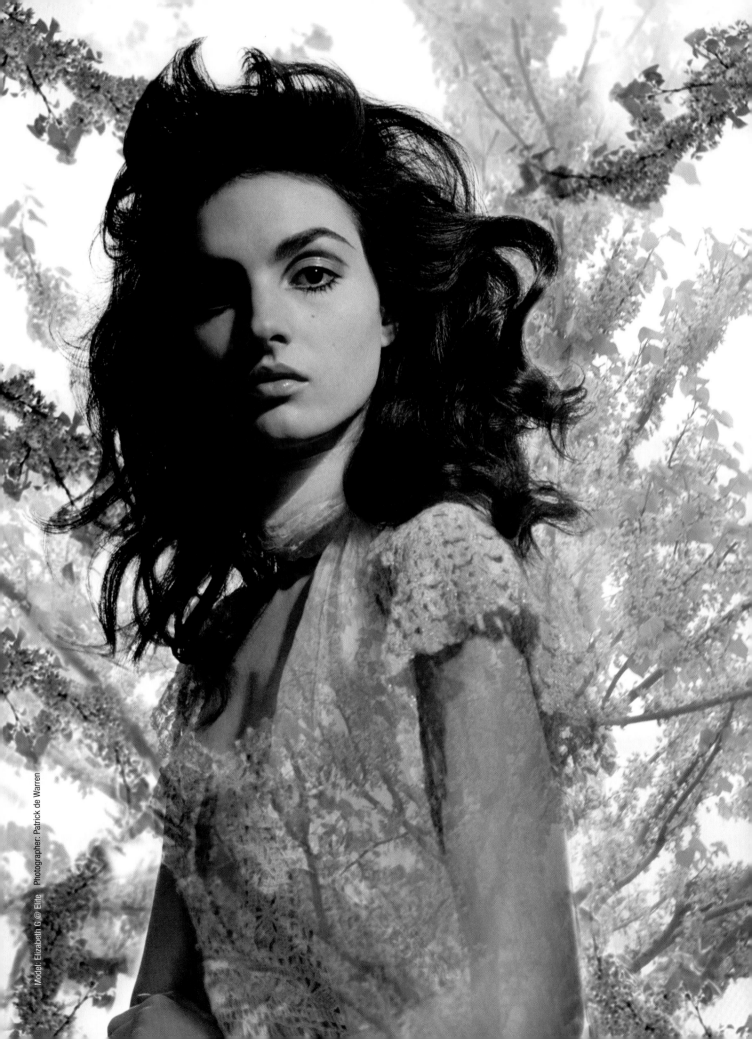

CHAPTER 2

Working with Agents and Clients

As with any business, photography or otherwise, repeat patronage from clients and lasting relationships with partners are the keys to success. In the case of photography, key partners include modeling agencies and creatives such as make-up artists and stylists.

Modeling Agencies

When you work with a group of agencies, you have ready access to a good supply of fresh model and creative talent, which means you don't have to spend too much time in the model-discovery process.

Assembling Samples of Your Work

If you're first starting out as a fashion photographer, whether you work digitally or on film, you must introduce yourself to agencies in order to find work. Before you do, however, you need to have a few pictures on hand that demonstrate what you can do. This is generally referred to as your *book* or *folio*. All photographers have some sort of book, as do models and creatives such as stylists and makeup artists. It's like carrying around your CV in image form; the more "tear sheets" and the higher quality the client logos in your book, the more credible you will appear to prospective clients and agents.

Key Partnerships

This business is too difficult and competitive to make it alone, no matter how talented you are. In our experience, teams that stick together—stylists, agents, makeup artists, producers, and so on—have the best track record for longevity in the business. Of particular interest is the producer, who is also often the agent for the photographer. Under the umbrella of the producer is a select crew of stylists, makeup artists, set builders, retouchers, and so on, all of a like-minded sensibility. The ability to work with the same crew again and again is a real advantage for a photographer, and the chemistry and efficiency of such a crew cannot fail to impress a client. Ideally you're looking for a career-long relationship with your team.

While the power of working with a great team cannot be overemphasized, as a new photographer, you may find it very difficult to break in to such a team because long-lived, successful ones generally don't welcome new photographers into the group. Fortunately, although production companies are gaining power, there are still opportunities for new photographers and creatives because much of the industry continues to do things the old way, via agencies.

That being said, you don't need to have a book full of shots—three or four good ones will suffice—although you should still invest in a nicely bound book (the kind with transparent sleeves) to display your photographs, even if you use only the first few pages. Your book should include at least one 3/4 shot against a plain background, a simple full-page beauty shot, and one shot of a person engaging in some sort of activity to depict motion of some kind—often termed a "lifestyle" shot. You need not use a professional model for any of these images.

Putting Yourself Out There: Mastering the Cold Call

Once you've assembled a book of your best shots, it's time to begin approaching modeling agencies in the hopes of finding work. The standard way to do so is to cold-call an agency to set up a time when you can come in and show them your book. If you're feeling bashful about cold-calling, get over it. Agents are unlikely to learn of your existence otherwise. Besides, although cold-calling an agency may be difficult the first few times you do it, it will become second nature over time.

The simplest way to ensure that you succinctly introduce yourself is to write yourself a little script and practice your pitch before picking up the phone. Your script should include at least the following:

> Hello, my name is [insert name] and I am a photographer. I have worked with [insert relevant experience with clients or notable models] and specialize in [insert specialty, if applicable]. I would like to come in to show you my book, and to take a look at some cards because I am in the process of updating my book. Would you be available sometime this week?

note

Compilation cards, or "cards" for short, are simply cards with pictures of a model and his or her measurements. They're like large business cards with pictures from a model's book. Agents and models give these cards to photographers and clients.

This *pro forma* covers the key points you need to raise when introducing yourself to agencies—who you are, what your background is, and what you want. Of course, you will need to personalize it and to practice saying it many times so you don't sound like you are reading from a script. This initial call is also a good time to point the agent to your Web site if you have one; that way, agents can see some of your work before you arrive—perhaps even while you are still on the phone. As noted in Chapter 3, "Working with Models," having a Web site also enables agents to show your work to models you want to test with.

[caution]

If you are just starting out, you may not have enough images to create a decent Web site, and simply posting every picture you have in your book online obviates the need for you to go into the agency except to look at model cards. For this reason, directing agents to your Web site is appropriate only after you have a few tests under your belt. That said, once you have a strong Web site, don't be shy about sending bookers and their models online to see it.

In most cases, the agency will ask you to come by on a day that they have open calls for models. Be aware, however, that agents often cancel open calls when castings arise unexpectedly; for this reason, it is a good idea to call on the morning you intend to go in to confirm that the meeting is still on. If an agency cancels meetings with you several times, be patient. Don't get frustrated. Simply turn your attention to building a relationship with another agency.

note

If you are a newcomer, your ultimate goal is to arrange some tests with the agency. That said, you should refrain from noting this over the phone; wait until the agency has had a chance to see your work first. If you already have a solid online book, however, you may be able to refer the agent to your Web site, perhaps even while you're on the phone with him or her, in order to get tests.

Test Shots

Test shots are often done with models who are just starting out, and who are eager to get their faces known. Volunteering to take test shots is not only a great way to begin developing your own photographic style, it's also a good opportunity to familiarize yourself with new equipment, such as a new camera. Doing test shots is also helpful for building a team of people to work with—makeup artists, stylists, models, and what have you—hopefully for the long term. Building up a good portfolio of test shots is especially important when you are starting out, as these are the shots you'll show agents and clients in your efforts to get work.

Regardless of your reasons for engaging in a test shoot, it is imperative that you treat these shoots as if they are the real thing. Make the model and lighting the best it can be. Consider hiring a stylist for the shoot to ensure best results; as photographer Schecter Lee notes, "Great styling can carry a shot without substance (styling is often *the* substance). It's hard for even terrific photography to make up for poor styling, clothes, makeup, and so on. If you are trying for the beauty market, your makeup and retouching just has to be first rate." Lee goes on to say that "If you can't afford a stylist, then you really can't afford to do the test, as you will be doomed to failure."

Note that generally speaking, for basic tests, agencies normally instruct models to bring their own clothes or to source specific pieces. Sometimes photographers may provide some of the clothing and accessories, but they tend not to because the pieces are generally not reusable and, if they're worth photographing, are usually expensive.

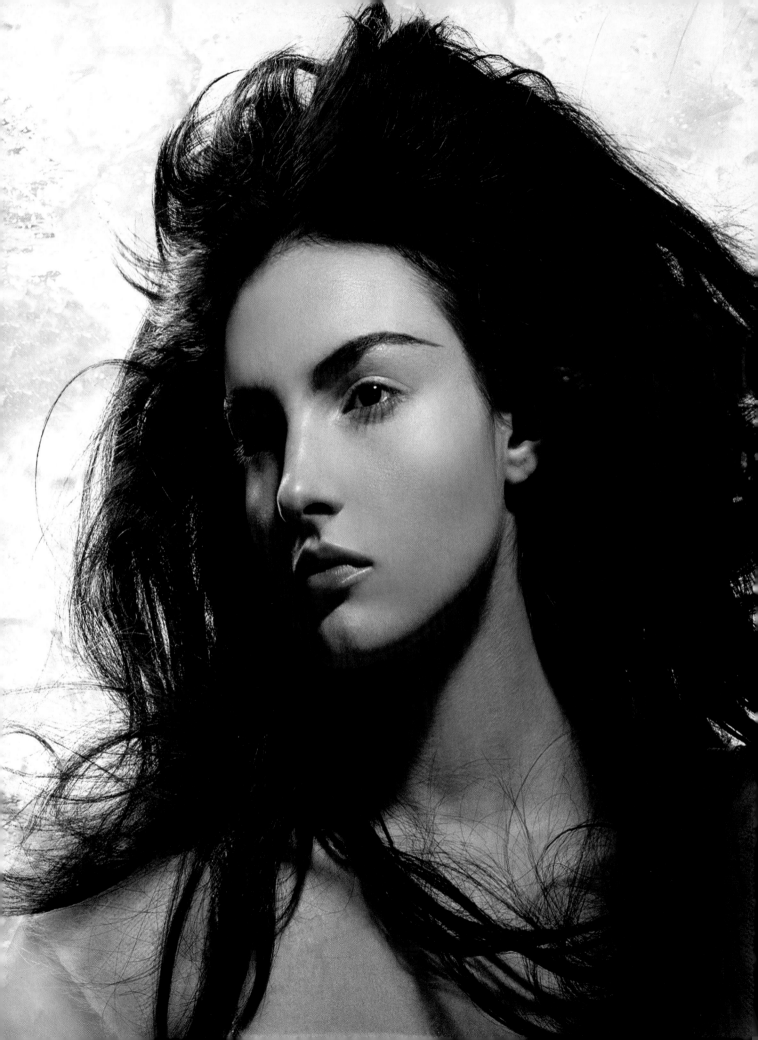

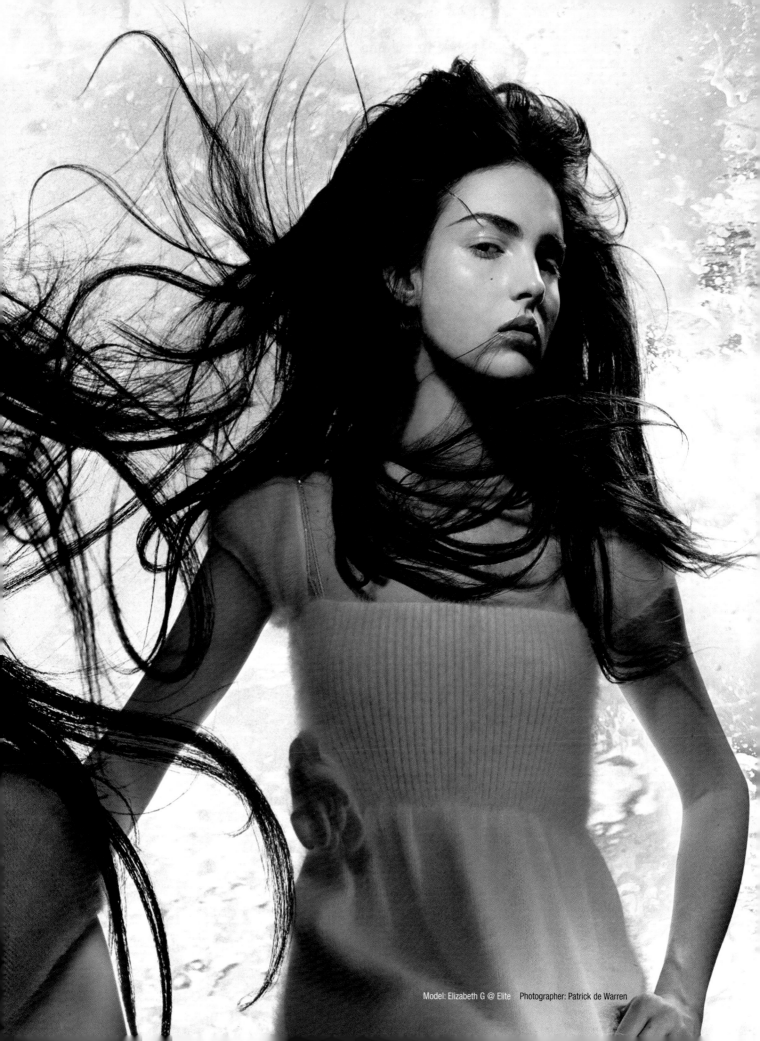

Model: Elizabeth G @ Elite Photographer: Patrick de Warren

Maintaining Your Relationship with an Agency

Over time, you will find that retaining a client requires far less expense and effort than finding a new one. This is also true for agents, because continually having to prove yourself and your capabilities is very time-consuming. Of course, as with any business relationship, you must invest time and effort into your relationship with an agent to ensure that it continues to be mutually beneficial. After all, any relationship that becomes one-sided is unlikely to last.

[caution]

On the subject of one-sided relationships, be warned that you may encounter agents who exploit photographers. In particular, these agents persuade a photographer to shoot several tests, but do not provide the photographer with models when asked and do not recommend the photographer to potential clients. If this happens to you, resist the urge to burn bridges with the agent, even if you would be entirely justified in doing so; you'll find that the industry is quite close-knit, and word does tend to get around.

As a general rule, you should touch base with all the agencies you work with at least once a month. Simply drop in with your book to show your most recent work, and to take a look at the cards or books of any new faces. In addition to providing you with an opportunity to catch up with the bookers, these visits can also provide a heads-up on industry gossip. Once in a blue moon, you may even hear of an upcoming job—although you should not rely on agency visits to prospect for clients.

[tip]

If you see some new faces that you want to test, this monthly visit is a good time to ask. Doing so enables you to photograph the model when she is starting out, and hence start building a working relationship with her before her career takes off. As the model becomes more successful, more high-profile, more "hot," she will be booked by more and more well-known clients; in parallel, you, the photographer, can use your photos of that high-profile model to obtain more and more work. If properly managed, this can be a virtuous cycle—something that all photographers should actively seek out. Indeed, this is generally how photographers ultimately end up working with top models on a regular basis.

As you build a relationship with an agent, and as the agent learns to trust in your ability to deliver, that agent will tend to be more generous when it comes to letting you shoot tests for models he or she represents in order to develop your book—often in exchange for prints for a model's and/or a creative's own book. In the days of film photography, unpaid tests were a net cash drain because you had to pay for film, processing, and prints for both you *and* the model, creative, or agency. These days, with the advent of digital photography, the film and processing costs have been eliminated. And if you shoot enough tests, the amortized value of the up-front investment in the digital gear is not significant over time.

note

In fashion capitals, such as New York City, the talent-management business is of a sufficient scale that there is room for a dedicated test business, where a photographer does nothing *but* shoot tests for agencies. For the average freelancer, however, while the stable cash flow associated with test shots can underpin your photography business, enabling you to focus on more experimental work or on acquiring more commercial clients, you are unlikely to earn enough to sustain your business—let alone retire in your old age.

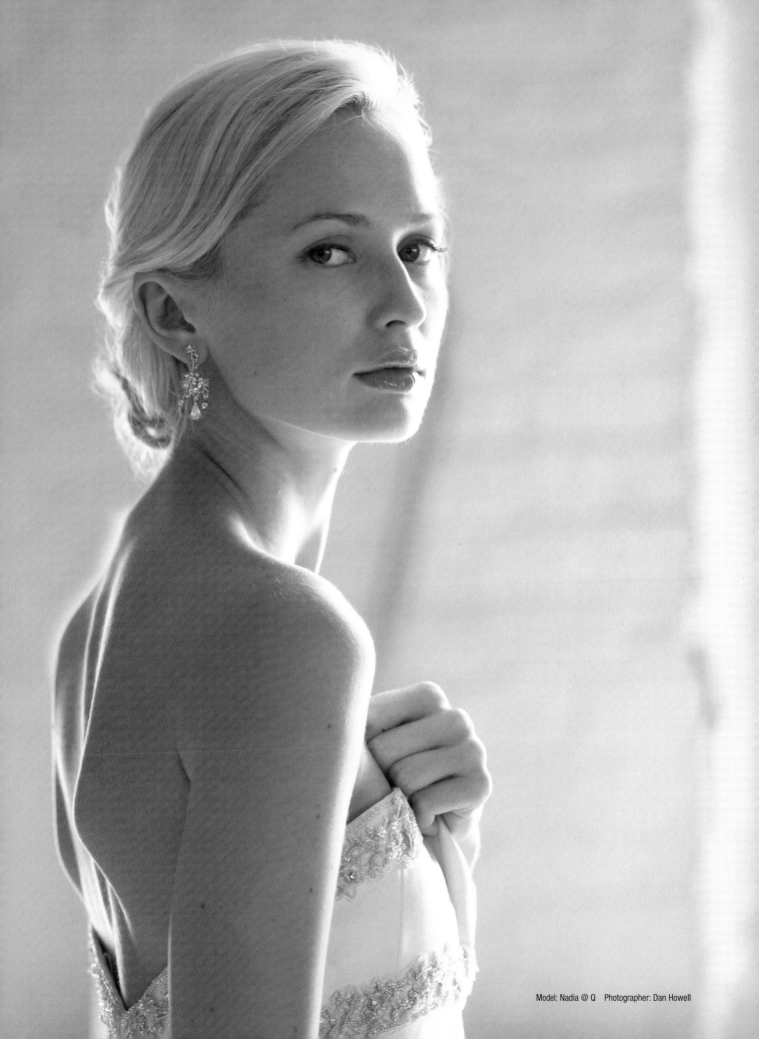

Model: Nadia @ Q Photographer: Dan Howell

Prospecting for Clients

Although you might be inclined to "pound the pavement," book in hand, in an effort to land clients, you're better off applying the tried-and-tested sales processes of a number of other industries, such as investment banking and management consulting. Both these industries rely on successful account and relationship management to identify opportunities to assist their clients and to generate repeat business. Here's how they do it, and how you should, too:

1. Identify a list of target clients—that is, companies you'd like to establish as clients.

2. Research each company you're interested in working with. As you learn more about a company, determine whether you might be an appropriate match. If so, add the company to your short list of target clients.

3. Develop an account plan for each candidate on your short list. This account plan should outline how you intend to establish a working relationship with the potential client.

4. After preparing a script that covers what you want to say, cold-call or e-mail each company on your short list.

Identifying Target Clients

Your first step is to identify a list of target clients with whom you are interested in working. For the fashion photographer, prospective clients are readily identifiable; they are splashed across billboards, magazines, and television. Not surprisingly, every photographer and his dog will want to work for the top brands, companies, and magazines—Prada, LVMH, *Vogue*. Unfortunately, however, the vast majority of photographers are unlikely to *ever* land such high-profile clients, especially when they are new to the business. Why? Because these companies have large marketing units, creative agencies on tap, and defined processes for securing the services of photographers (read: they hire photographers who are represented by agents). If a new photographer does manage to nab such a gig, it's usually the result of serendipity—that is, the photographer was good *and* lucky—not because he or she actively engaged landing the account. The bottom line? Companies such as these should not be your top priority targets early in your career. Your target list must be *realistic*.

The secret to developing a realistic list is to segment the list by client type, size, and a description of their overall style (for example, whether their advertisements tend toward simple, edgy, or what have you). At least initially, you also should limit your list to companies that are geographically close to you. Within each of these categories, try to include 10–15 candidates, prioritized from highest to lowest importance.

Researching Target Clients

Once you've generated a list of target clients, your next step is to research each company on the list in order to develop a solid understanding of the company's work, background, inspiration, and style. First, start a folder for each company. In the folder, place any of the company's press clippings or magazine tear sheets that you manage to find. If the target client is a designer, look for interviews with him or her, and add those to the folder as well. To further familiarize yourself with the prospective client, visit its company Web site (assuming it has one); this will reinforce your sense of the company's product, style, and campaigns. Finally, find out each company's address, contact numbers, and contact e-mail addresses; you'll need these when the time comes to make first contact.

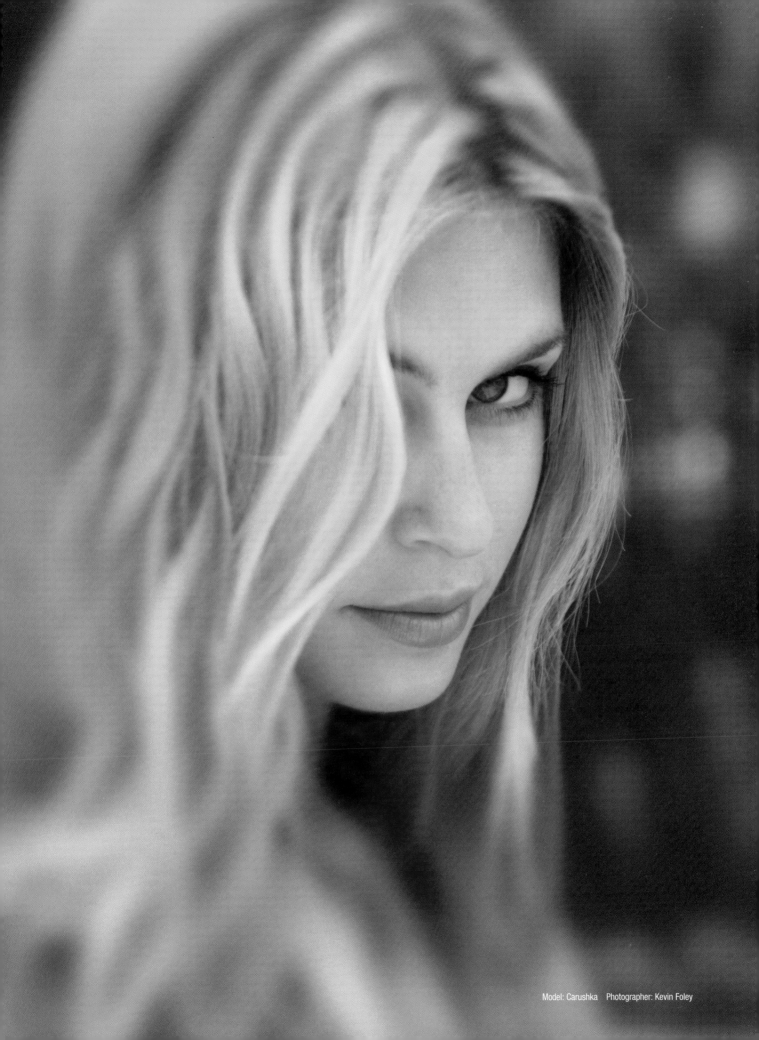

Model: Carushka Photographer: Kevin Foley

Developing an Account Plan

After you've conducted your research, it's time to develop and document an account plan for each of your short-listed candidates. As noted previously, this account plan should outline how you intend to establish a working relationship with the potential client. If you are starting from scratch, your account plan for the first six months may be simply to visit the prospective client a few times to show him or her your most recent work, just as you do when you're trying to cultivate a relationship with an agency. If your target is a designer, your account plan might include volunteering to do some runway shots during his or her next show in order to garner an invitation. Unless you are a very well-known photographer, you will likely have to invest some time and effort to kick-start and to maintain a relationship with a client; your account plan should reflect this.

> note
>
> Your account plans for the companies on your list will likely start out looking fairly similar. As you interact directly with each prospective client, however, your account plan for that client will evolve as you add more client-specific information to become more tailored to a given client.

Contacting Target Clients

Once you've developed an account plan for each company on your short list, it's time to make first contact with your prospective clients. Generally, cold-calls are the way to go. As when cold-calling an agent, you should develop and rehearse a script before cold-calling prospective clients. The script you use will be quite similar to the one used on agents, but should include a bit of additional information in the form of comments that illustrate your understanding of the client's work and needs.

For example, you might say something along the lines of "I saw [Joe Celebrity] wearing your design in [*Fashion Tabloid Magazine*], and I really liked the [fabric/cut/stitching] you used." (As you might have guessed, this is where the research you conducted on the company—reading magazine tear sheets, news clippings, or interviews with the designer—will pay huge dividends!) This part of the script serves the dual purpose of complimenting the prospective client and demonstrating that you have not only seen but actually have some insight into their work. Of course, you should tailor your approach on a client-by-client basis; a comment designed to pique the interest of a cutting-edge designer will likely be completely lost on a multinational corporation's marketing department.

Once you have your script ready, it is time to cold-call the client to try to schedule a meeting. Ideally, this meeting should occur sooner rather than later so that the substance of your initial conversation is still fresh in the client's mind. Be mindful, however, that there are certain times of the year (prior to release of the next collection, for example) when a pushy attitude is likely to permanently damage your chances of ever working with that client. Indeed, you may have to schedule the meeting a few months out, and that meeting may be with someone *other* than the designer. If you wind up talking with the marketing manager or the sales manager, that's just fine; those people are often in need of good product shots and usually play a significant role in designing and executing advertising and marketing campaigns.

If you are unable to secure a meeting time with a prospective client, don't lose hope. The key is to start off slowly so the client doesn't immediately fob you off. Then, continue to put yourself in front of the client and to show what you can do. Point your contact to your Web site to show off your work. Don't give up after the first (likely) rejection! Modify your account plan to roll with whatever your potential client throws you.

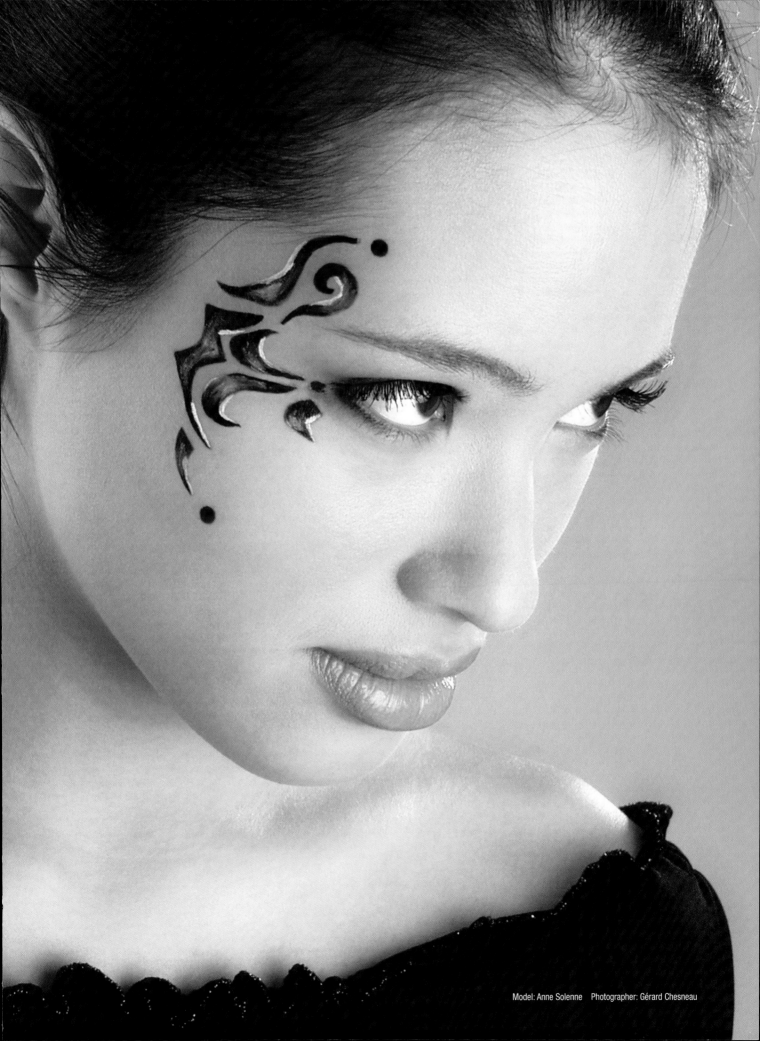

Model: Anne Solenne Photographer: Gérard Chesneau

Managing Your Client Relationships

When you consider the amount of effort required to identify, cultivate, and establish a relationship with a client, you will find that it's far simpler to keep an existing client happy, ensuring he comes to you again and again for his photography needs, than to continuously shake out new clients. Of course, that's not to say you shouldn't continue to add new clients to your stable; indeed a solid base of loyal clients can be the very thing that provides you with the cash flow you need to expand your client base.

All this begs the question: How does one keep one's clients happy, thereby ensuring their repeat business? Ongoing investment in client management is the key. This involves tracking your relationship with your client and developing an account plan similar to the one you used when prospecting for new clients. Your ability to track your relationship with a client is tied to your diligence in documenting your interactions with him or her. This documentation should be placed in the client's file and should include anything that will remind you of how previous interactions with a client went—their likes and dislikes about certain looks, which models they preferred, the lighting setups used. It should also contain anything to do with what specs were used on their jobs, as these will most likely remain the same.

Particularly if you have a large client base, you must regularly—say, every six months or, at the very least, once a year—update you account plan for each client. In addition, you should make it a point to continue researching your clients, even after they've signed on with you. That means updating your client's file to include any relevant press clippings, interviews, or magazine tear sheets. That way, you'll have information about what each client has been up to right at your fingertips. In addition, at least once a year, you should make it a point to show something totally fresh or innovative to a client to show him or her that you are continuing to develop your technique and style; by demonstrating that your work is not stagnating, you solidify your reputation in the client's mind. Although it might require a bit of discipline to keep this up, you'll find yourself getting better at it over time.

As you get to know your clients, decide whether it's appropriate to send them holiday cards, and perhaps even birthday greetings. You may also decide to send other correspondence throughout the year to thank them for their continued patronage. And of course, if your client is featured in a particularly noteworthy forum—say, *Vogue* or *W*—make it a point to offer your congratulations! Inevitably, your professional relationship may become more personal and friendly in nature; if that's the case, make it a point to arrange the odd dinner or coffee together. The idea is to keep yourself visible in the client's sphere, to ingratiate yourself to them, to build some history together, and to keep track of where the client's own style is going.

[tip]

In some instances, you may not have the opportunity to interact directly with the actual client, and instead work with an art director from an advertising agency. This is common with larger clients who can afford to hire external PR and advertising support. If you find yourself in this situation, it's imperative that you treat the art director—or whomever you're working with—as a client, and manage that relationship accordingly. Individuals who work in advertising and PR generally have a portfolio of clients themselves; if they are pleased with your work, they may open other doors for you.

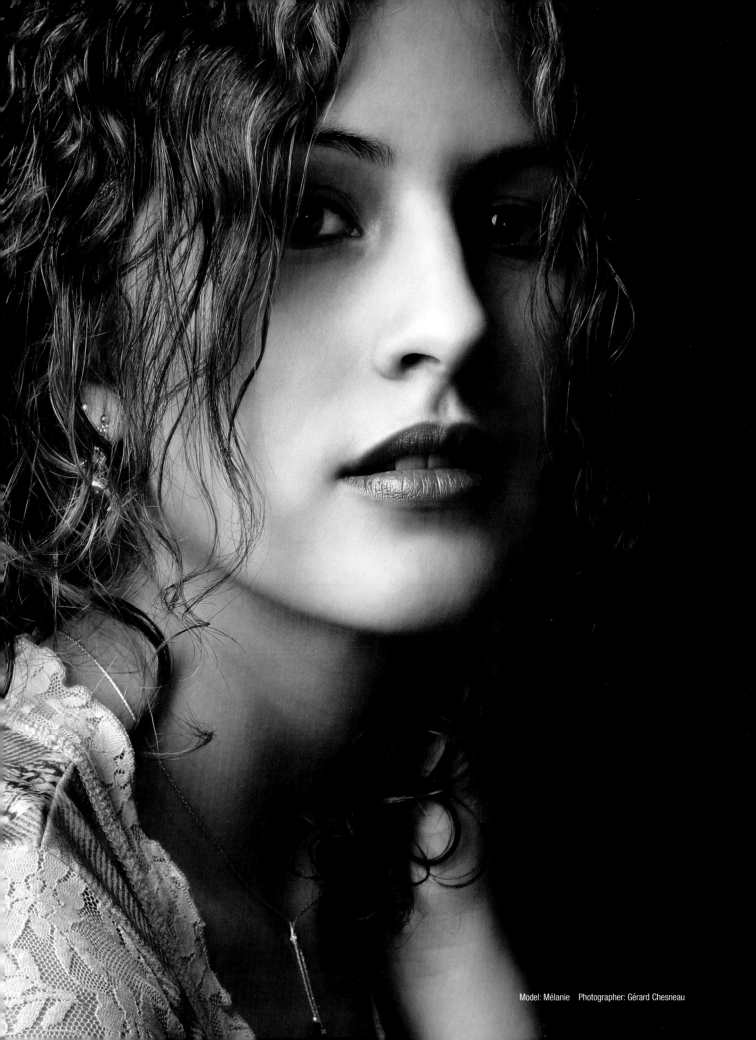

Model: Mélanie Photographer: Gérard Chesneau

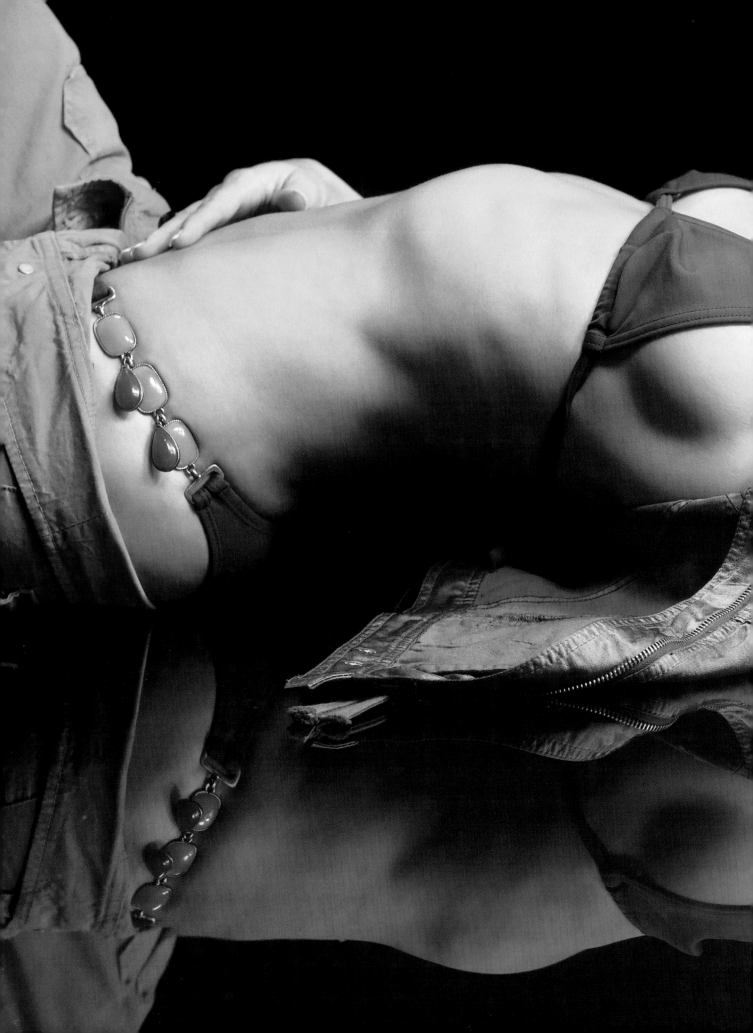

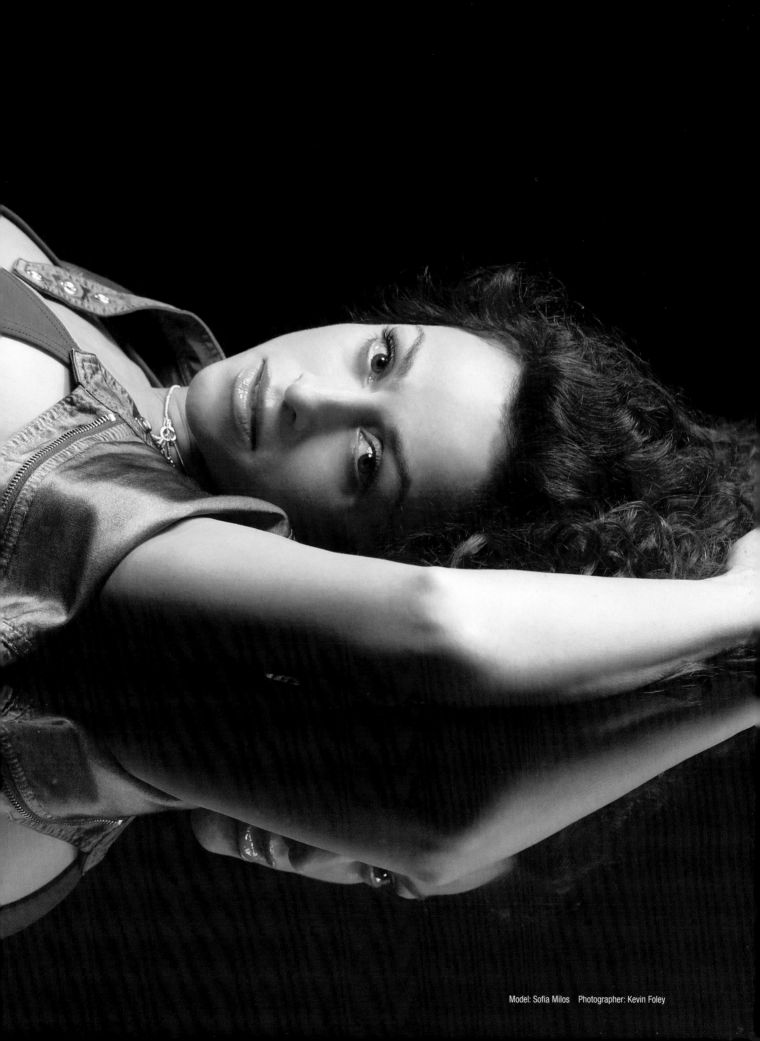

Model: Sofia Milos Photographer: Kevin Foley

Tips from Agent Greg Tyshing from Giant Management, Melbourne

When you start out, you may need to offer to test models free of charge, as well as pick up some expenses for styling and props. This is necessary to demonstrate your abilities to an agency. Something that really makes a photographer stand out in an agent's mind is consistency in the photographer's work. An agent is more likely to trust you with tests if you have demonstrated that you can repeatedly produce great images. If you have successfully demonstrated your abilities (assuming you have abilities to demonstrate), then agencies will likely start to call you. If you find yourself constantly chasing agencies for tests, you have not successfully established a good relationship. On the flip side, if you have established a good relationship, but don't have the required abilities to deliver a good product, you are unlikely to enjoy success.

The top five things a new photographer should keep in mind when trying to establish a relationship with an agency or a client are as follows:

- When you are starting out, don't approach an agency until you have a strong book. The principle of "less is more" applies here. Three fantastic shots are better than a book full of mediocre shots.

- To help defray the costs of acquiring clothes and accessories for tests, don't be afraid to approach shops and designers (start with the lesser-known ones first) to source the items you need, offering prints in return or a small rental fee. When you are starting out, you will likely have to invest (money or in kind) in establishing your book.

- If you can afford a stylist, get one. Hiring a stylist for half a day will put you back a few hundred dollars, but apart from your camera, it's one of the best investments you can make. The difference between a styled shot and an unstyled shot is reasonably evident to agents and clients in most cases.

- The city where you are working likely has many established photographers whom the agencies already know. For this reason, you may initially need to discount (or, put another way, invest in relationship building) just to be considered. Don't price yourself out of the market, but by all means try to earn an adequate return on your time and try to cover out-of-pocket expenses.

- Do your homework on potential clients. The worst thing you can do is cold-call a designer without understanding what sort of clothes he or she makes and knowing a bit about his or her history. Doing your research enables you to better target your sales pitch to the potential client, demonstrates to the potential client that you have an understanding of his or her business and direction, and allows you to build some empathy with the potential client during your initial conversations.

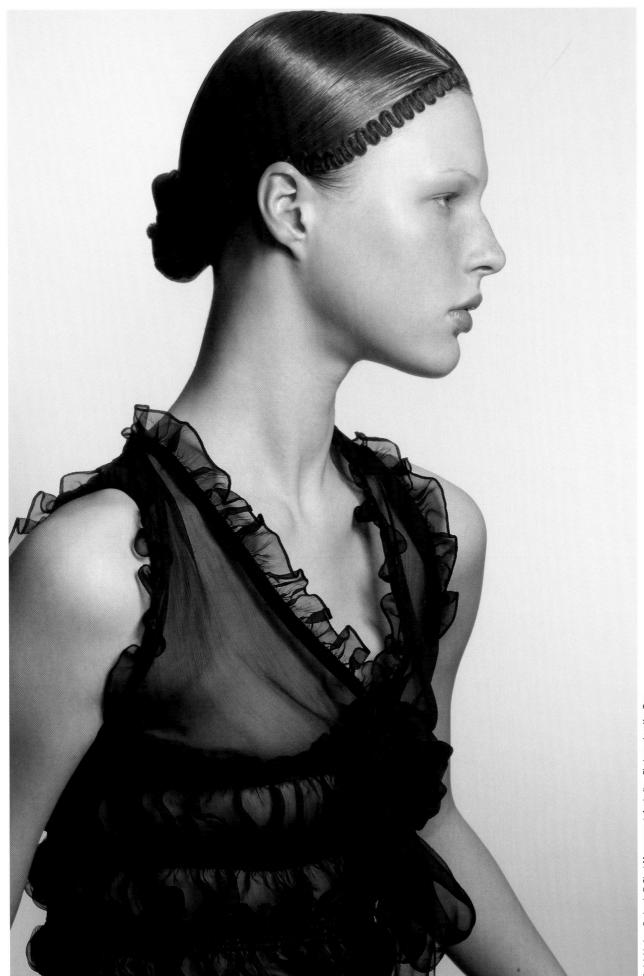

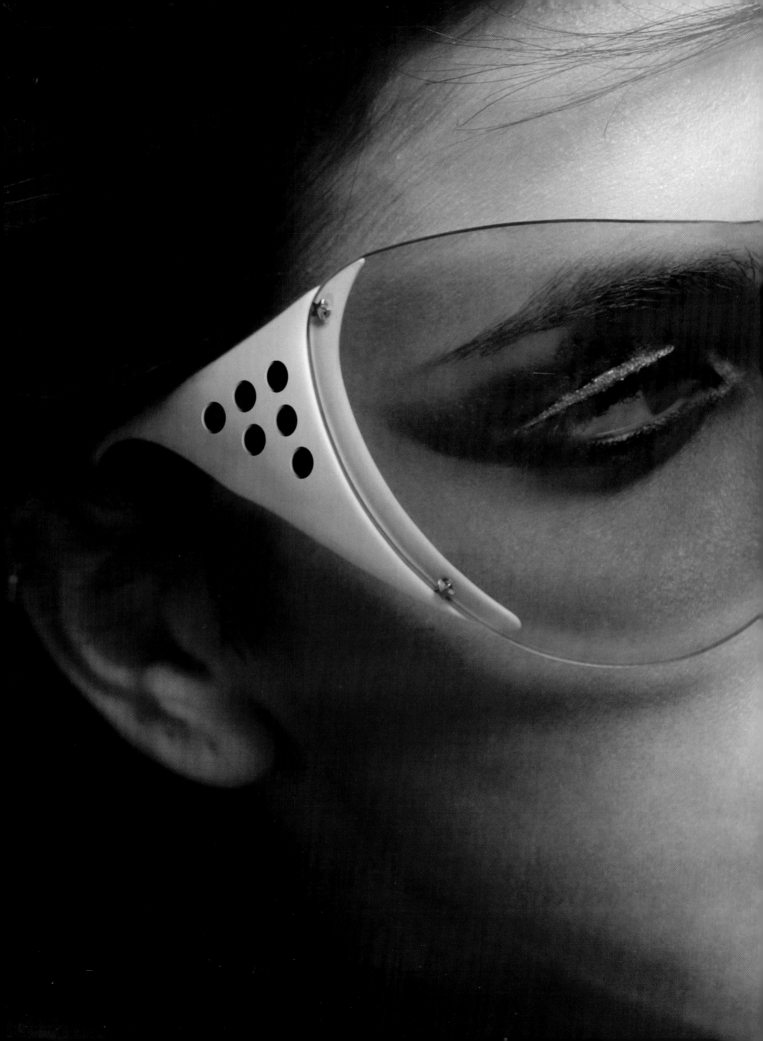

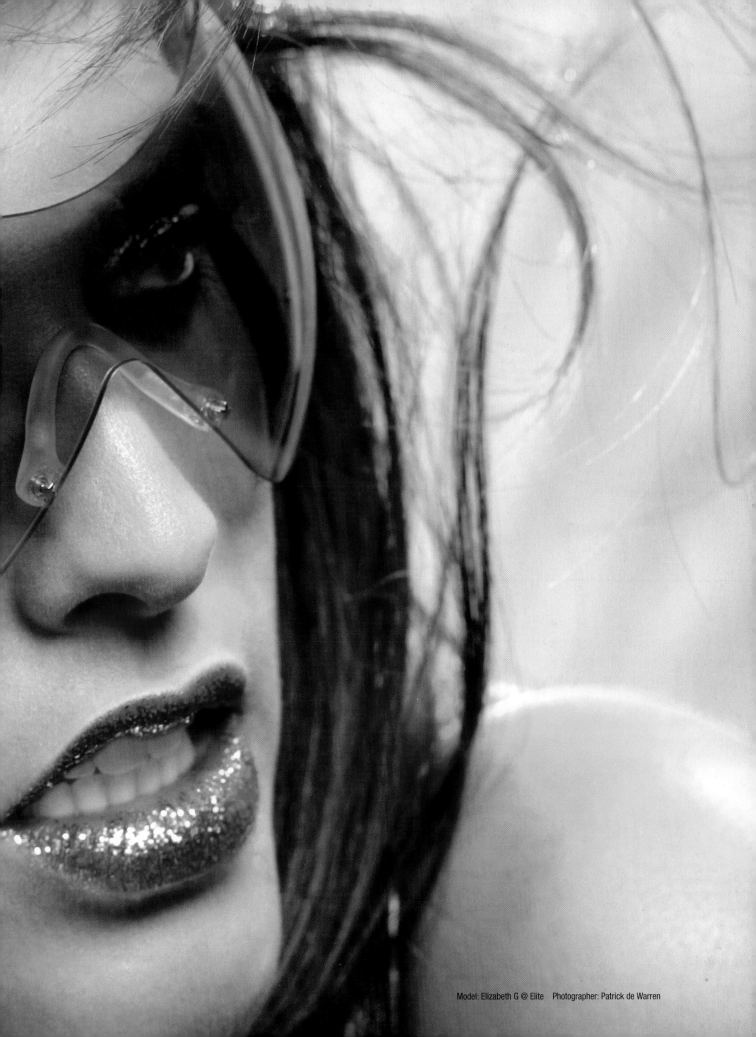

Model: Elizabeth G @ Elite Photographer: Patrick de Warren

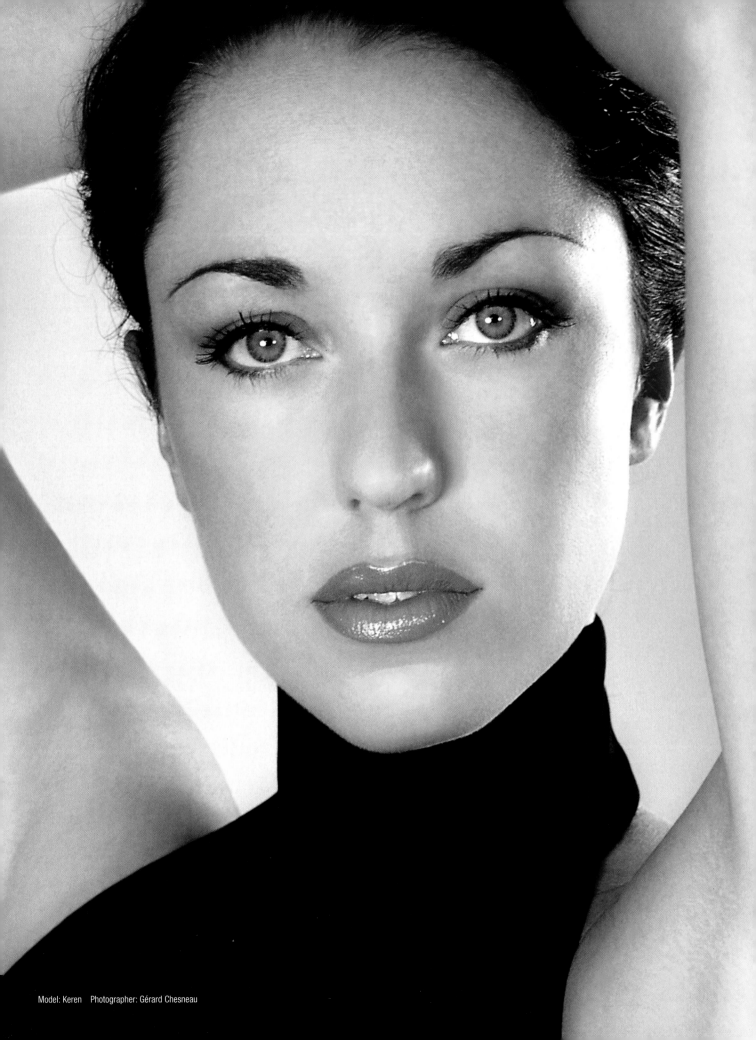

Model: Keren Photographer: Gérard Chesneau

3

Working with Models

Developing a Shared Vision with Your Model

In order to get that coveted cover shot or a widely acclaimed editorial spread, you will need to develop a comfortable working relationship with your model. No matter how experienced the model, any form of unease or lack of clarity with respect to what you are trying to achieve is likely to show up in a model's expression, and can dramatically affect the

> Chances are, you will get better shots with a model after you've worked with him or her several times. Likewise, you'll obtain better shots from a model with more experience. That said, more often than not, you'll find yourself working with fresh-faced models who are new to you. For this reason, it's imperative that you clearly outline your expectations to your models before the shoot.

outcome of a shoot. The first step in cultivating a good working relationship with any model is developing a shared vision with him or her. The best way to achieve this is to convey your ideas about the shoot to the model long before the shoot begins.

Most agencies do not release model contact details, even if you have worked with them for some time. Most agencies will, however, pass on messages to a model to call you prior to a shoot to discuss logistics and to set expectations. Take advantage of this to organize a pre-shoot call with the model as your first step toward establishing a good working relationship with him or her. Doing so enables you to convey your vision for the shoot. For larger-budget and more-complex shoots, possibly involving multiple models, you might even go so far as to organize a pre-shoot meeting for all the crew and talent (you'll need to enlist the agency's help to accomplish this). This is far more efficient and effective than briefing your team one-on-one, and enables all team members to hear the input and questions from their colleagues.

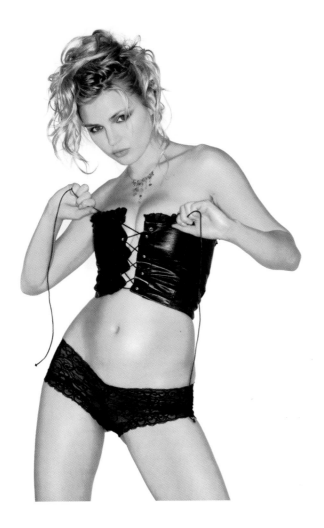

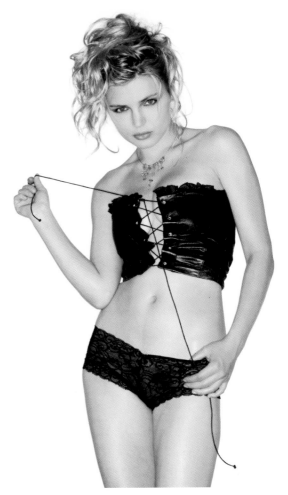

Model: Irina Novic @ C.E.D. NYC Photographer: Dan Howell Agency C.E.D. NYC

note

You may come across a fresh, undiscovered face on your own. Indeed, many successful photographers engage in a significant amount of talent discovery. If you find yourself spending too much time scouting, however, then you begin to cross the line between agent and photographer. If you do discover a model on your own, make it a point to introduce that model to an agent to make sure his or her best interests are looked after.

When discussing your vision for a shoot with a model, consider covering at least the following topics:

- **Who you are.** If you've never worked with the model, briefly introduce yourself and outline your experience. Consider maintaining a modest but broad online portfolio; that way, you can point your model to it to give him or her a sense of your style and recent projects.

- **What the shoot is for.** Tell the model whether the shoot is meant to provide a photograph for a magazine (and if so, which one), a billboard for a company, for the development of your book, or what have you.

- **Where and when the shoot is planned.** Odds are, the agent has already discussed tentative dates and other logistics with a model, but it is always good to confirm these details with the model yourself. At the same time, outline your expectations with regard to how early the model needs to get to the location (factoring in travel time), and the likely duration of the shoot.

- **What the shoot will entail.** Clearly outlining to the model your expectations with regard to what the shoot will entail is probably the most important part of the preliminary discussion; doing so increases your chances of having things run smoothly on the day of the shoot. I usually tell the model how many *stories*, or looks, will be involved in the shoot, talk a little about the makeup and hair requirements, and discuss the clothes that will be featured.

- **How the model currently looks, and how he or she should look upon arriving at the shoot.** Usually, you select your model using printed model comp cards or online portfolios. Unfortunately, these shots can be misleading. For example, they may mask less-than-perfect skin through overexposure or touching up, or inappropriate proportions, may fudge the model's true measurements, or may be a little out of date. (Indeed, many models who are well into their 30s keep photos that were shot in their late teens on their comp cards.) For this reason, you should ask some basic questions about the model's appearance. For example, you might ask how long the model's hair is, what color is it, how the model's skin looks, and whether the model has any tattoos or piercings. The answers to these questions may affect not only the styling of the shoot, but also—especially if the model is experiencing an acne breakout—the amount of post-production touching up that may be required.

- **Your excitement about the project.** If you aren't enthusiastic about a shoot, you can't expect the model or the broader team to be excited on your behalf.

On the day of the shoot, start with a brief team meeting, including the models and the crew. This will serve to remind everyone of what you are trying to achieve. I also like to have a one-on-one with each model in the shoot, picking up where our preliminary discussion left off. This helps build on the nascent working relationship.

A Word on Nudity

If the shoot will involve nudity of any kind, you should mention this to the model when you outline what the shoot will entail—even if you discussed this requirement with the agency before choosing your model. Many models, even experienced ones, are uncomfortable with nudity, even if it's only implied. Before proceeding with the shoot, it's imperative that you make absolutely certain that the model is comfortable with posing nude. If not, and if the nudity is a critical element of the desired shot, you should thank the model for his or her time, but let him or her know that you will need to select someone else.

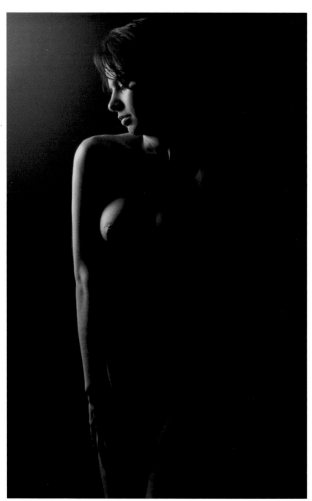

Model: Roxanne Photographer: Dan Howell

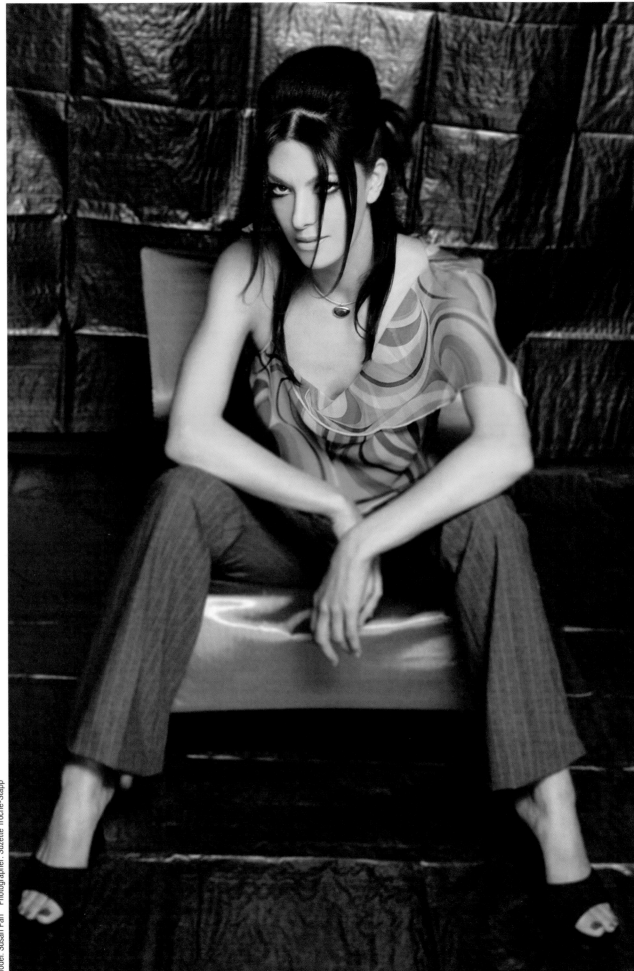

Photographing the Model

When the time comes to photograph the model, there are a few key points to keep in mind:

- Make sure the model feels comfortable at all times.
- Provide visual feedback to the model.
- Respect the model's personal space.
- Respect the model's privacy.

A Word on Posing

Most models have (or soon develop) a programmed sequence of basic poses that they can reel off as quickly as you can release the shutter. These generic poses are appropriate for catalog or test work, where the emphasis is on the clothes or on highlighting a model's versatility. If you're looking for something a bit edgier, however, you'll need to find a way to help the model break free of his or her programmed poses. The challenge is to help the model to pose in a way that he or she is not used to, but to do so without the final image looking forced. (This is one reason why it is good to work with relatively fresh talent; they haven't yet settled into using a series of clichéd poses. They require a lot of coaching, but they're generally worth the time investment.)

Making the Model Feel Comfortable

As mentioned previously, the lack of shared vision and clarity in expectations can show up in an undesired manner in a model's expression. Similarly, any discomfort in what you are asking the model to do can also show up in their expression and ruin an otherwise well-planned and executed shoot.

The absolute best way to make a model as comfortable as possible during a shoot is to strike up an easy (read: not forced) conversation with him or her, much the way a good hairdresser does during a cut. Keep the topic neutral, however. Even if you have worked with the model before and you know a bit about his or her personal circumstances, avoid asking too many personal questions. If the model wants to discuss something personal, that's fine, but you should not pry. Ask about recent jobs and castings, or talk about recent fashion shows you've attended or even some upcoming projects in the pipeline. As you chat, keep your finger on the shutter release. Often, you will get exactly the facial expression you envisioned as the model talks or pauses to listen. Of course, you will need to give the model and your crew instructions during the shoot, or to change camera settings and compact flash cards; try to do this quickly, and then get right back to the conversation, so that you don't interrupt the flow of the shoot.

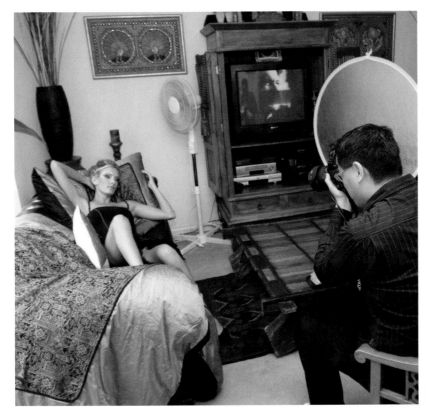

> ### note
>
> While assisting other photographers on shoots, I've heard them use the archetypical patter, "Beautiful, fabulous, gorgeous!" I find this to be a bit '80s, and choose not to say such things—partly because I would burst out laughing if I did. But this is a case of horses for courses, so do what feels natural to you!

Model: Kathy Lloyd @ Giant Management, Australia
Photographer: Ken Tan

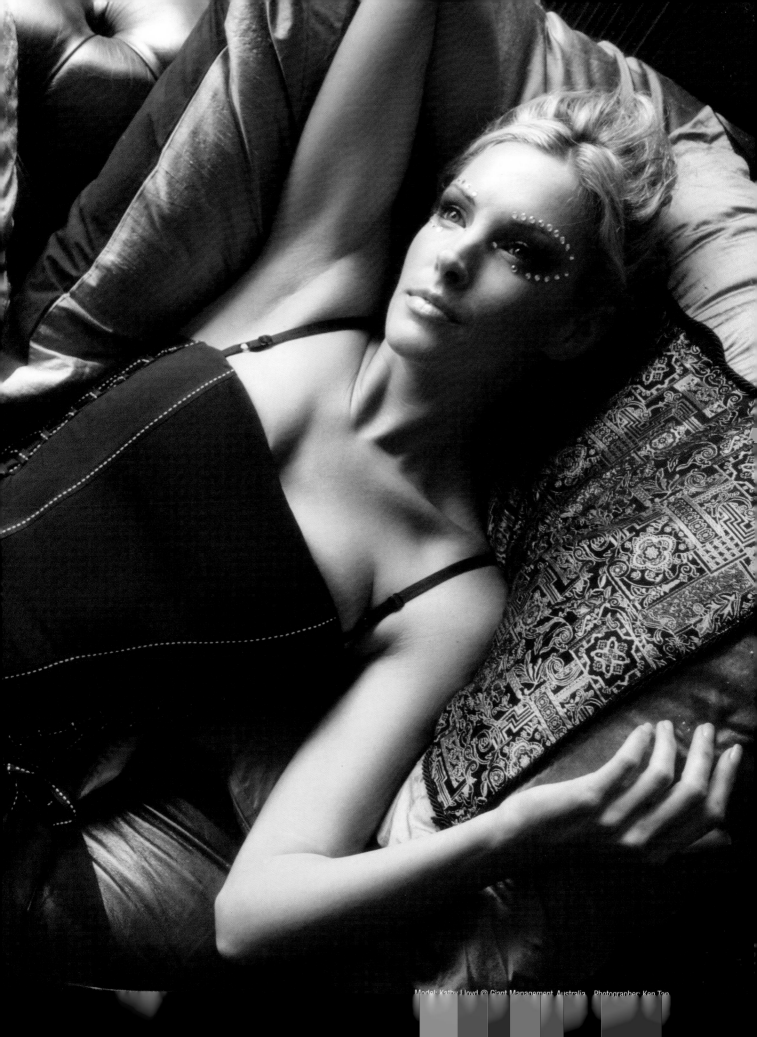

Providing Visual Feedback to the Model

Providing the model with visual feedback as you shoot is a good way to help him or her achieve your vision for the shoot. In the days of film, visual feedback was limited to the use of Polaroids. These days, with the advent of digital photography, and with all digital SLRs incorporating rear LCD panels, you can now provide as much visual feedback to the model as you like. Indeed, because most of today's models have had experience working with digital cameras, they usually ask to see some shots as the shoot progresses. The key is to make sure you don't swing to the opposite extreme, stopping the shoot to show the model every shot. Not only does this practice interrupt the flow of the shoot, it also leads to time over-runs, which are particularly detrimental if your shoot involves a significant number of looks and/or models. To ensure that you provide regular feedback to models but don't allow this feedback process to delay or derail your shoots, do the following:

- Before you begin shooting, explain to the model that you will aim to provide feedback at least twice during a single look or pose: after you shoot the first couple of frames of a new look, and after you finish shooting the look. In addition, note that you'll provide mid-set feedback in the event you need to correct something that the model is repeatedly doing.

- If you are working in a studio, consider setting up a monitor so both you and the model can see the results of each shot. This monitor can be placed either to the side of the set or directly in front of the model; the latter setup may be preferable because the model can see each shot without having to significantly divert his or her gaze. If you like, you can even use a splitter box to provide multiple monitors—one for the model, and a second one for the art director. This second monitor can be placed in the editing or green room, which enables you to keep the set relatively free of people. Wherever you decide to place the monitor(s), you will need to shoot with the camera tethered to your capture computer.

Respecting the Model's Personal Space

Particularly with new models, or with models with whom you have not worked before, you should try to keep well outside his or her personal space during the shoot to ensure that he or she remains relaxed and comfortable; otherwise, the model's discomfort will likely show up in his or her expression (particularly in the eyes). This is particularly important if the shoot involves skimpy clothing or nudity.

Although many models would be comfortable with your doing so, it is generally not a good idea for you to approach or touch the model, even if you've worked with him or her before, and even if the adjustment is relatively minor (such as pushing the model's hair behind his or her ear). If you need the model's hair to be fixed or to move one of his or her limbs while keeping the rest of the pose intact, take the professional high ground by asking for assistance from the stylist or makeup artist, or as a second choice, from one of your assistants. That way, there is no chance that the model will accuse you of inappropriate behavior. Besides, being viewed as strictly professional—not to mention a nice person to work with—can only be positive for your working relationship with your model and his or her agency.

Respecting the Model's Privacy

As an extension of this "keep it professional" mantra, resist the temptation to ask a model for his or her contact details. Likewise, even if a model offers to give you his or her e-mail address or cell phone number to arrange a time to see proofs or prints of the shots, it is generally not a good idea to accept unless you have worked with the model a few times. If you find yourself in this situation, suggest that the model call *you*, or suggest arranging a meeting on the spot—possibly a joint meeting with the model's agent, just to err on the side of caution. Opting for a joint meeting with the model and his or her agent also eliminates the need to conduct two separate meetings with these parties, which saves you time.

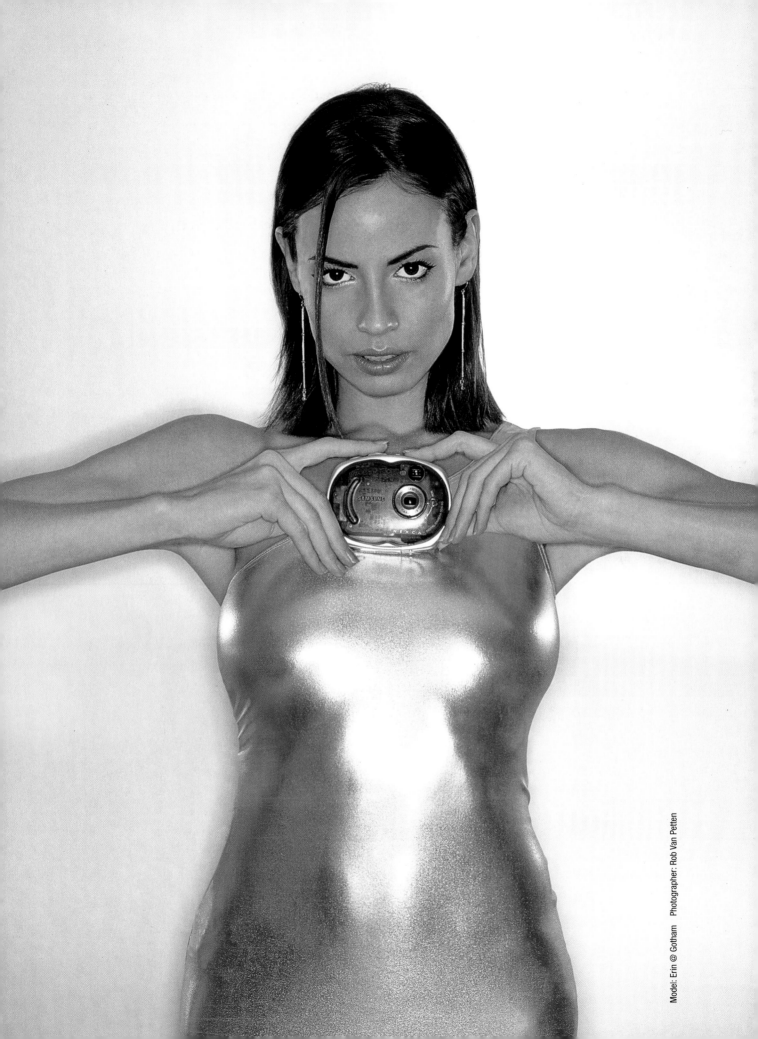

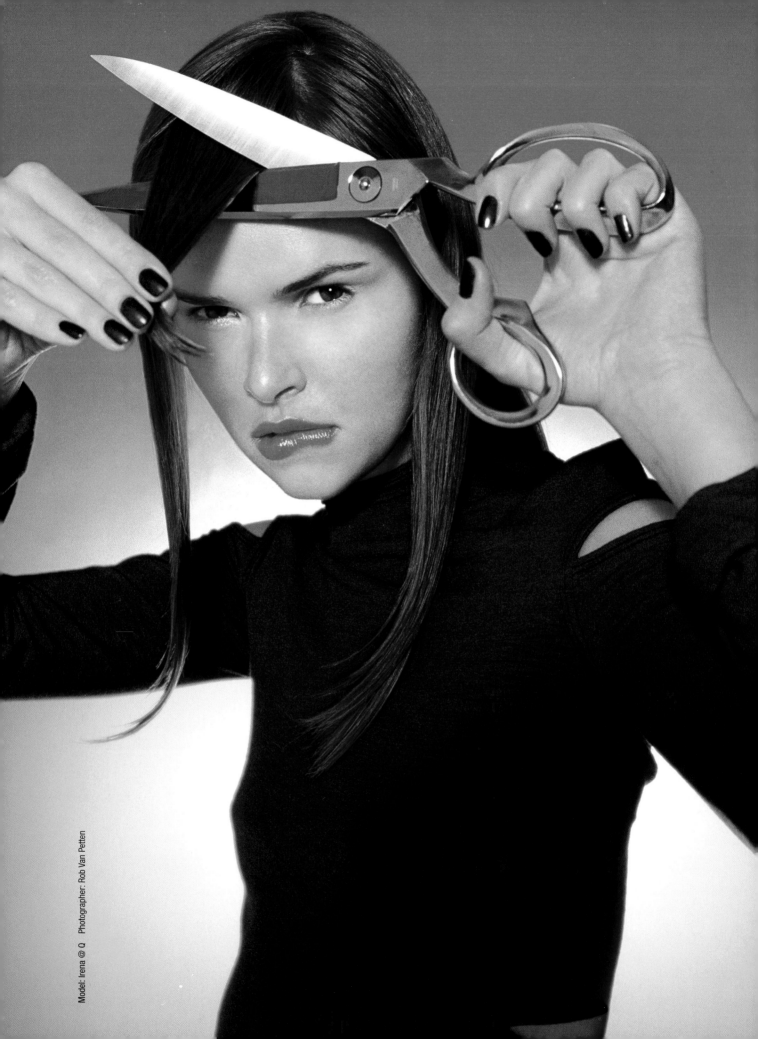

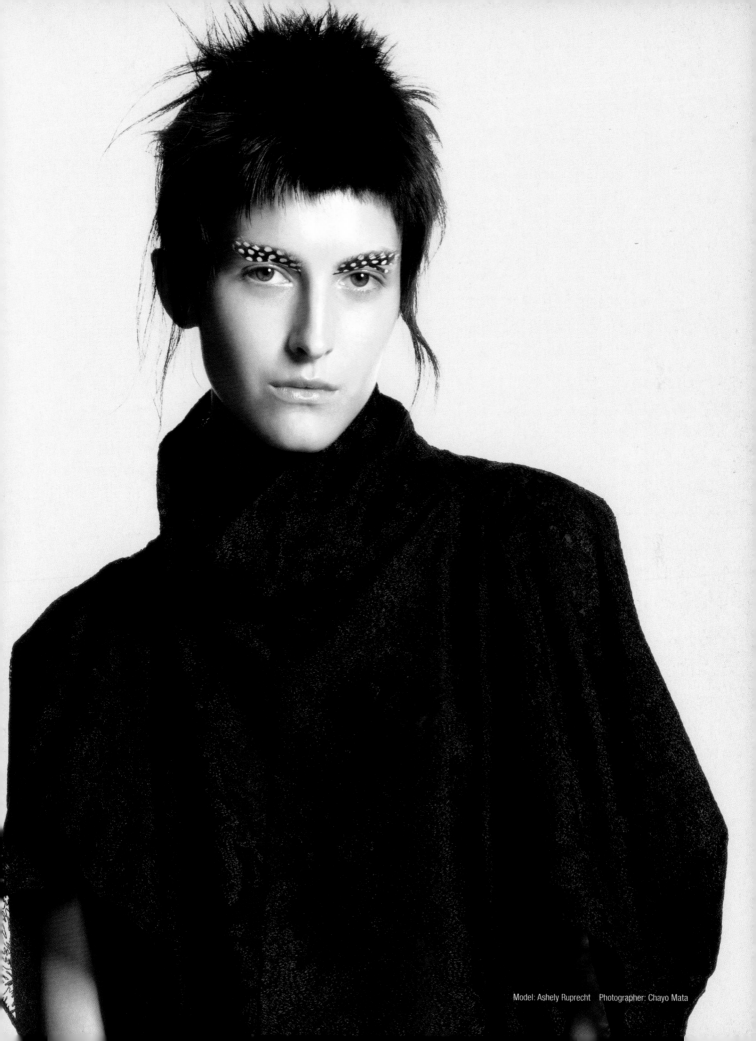

Model: Ashely Ruprecht Photographer: Chayo Mata

In the old days, when photographers used film, everyone understood that it took time to process the film and to create contact sheets. With digital photography, however, people often expect to be able to see contact sheets and even prints almost immediately; they fail to consider that you must transfer the images from your camera to your computer, sort the images, color-correct raw shots, and create and print contact sheets, let alone perform the necessary touch-ups. That means it's imperative that you manage the expectations of anyone who needs to see proofs, be they the model, agent, art director, or what have you. A good guideline is to give yourself a week; not only does this enable you to complete all these tasks, it also allows you to continue shooting additional jobs in the interim, if necessary.

Don't Forget to Get the Release!

A release allows for the legal usage of any images generated from a shoot. It is a legal document that binds the photographer, agency, and model into an agreement as to how the images can be used. Although there are no rules as to who prepares the release, the wording is generally agreed upon by all before any kind of signature is applied. Even though the photographer may have his own release, depending on the type of shoot or who is being shot, there can be separate release forms by agencies or managers involved. In all cases, the intent of and specific wording in a release is usually subject to negotiation; you'll likely often find yourself starting with a fairly standard release and agreeing on ancillary terms specific to the circumstances of the shoot.

In general, if you're working with a model who is represented by an agency, the agency will usually sign the release on the model's behalf. This can happen either before or after the shoot. The type of release used depends on what type of shoot you're doing. If the shoot is a test, you will likely receive a limited release that allows both you and the model to use the images royalty-free for your respective books, and on self-promotion materials such as Web sites. For commercial shoots, both you and the model will sign releases supplied by the client which gives the client license to use the images in their marketing materials. In this situation, you should also sign a release with the agency so you can use the images for your book and Web site.

These releases are an important piece of intellectual property protection, which you should carefully and securely file. (Over time, you will inevitably wind up with a large number of these releases, so purchasing a dedicated filing cabinet is a good idea.) That way, if you choose to use an image for your book or other self-promotional materials long after the shoot is over and perhaps even after the model has retired from the business, you can act with the assurance that you have the necessary permission (subject, of course, to the limitations defined in the release). If at a later date you choose to use an image for a commercial project, even if you are not being financially compensated for the image, you should contact the agency as a starting point to negotiate an additional release, usually to be accompanied by some additional payment to the agency and model. When an agency is involved, you will find that you generally need not discuss the issue of releases with the model.

On the other hand, glamour models are generally not represented by agencies (other than a small percentage associated with magazines such as *Playboy*, and those of sufficient celebrity to have a manager). If you are working with an unrepresented model, make sure that you agree on the terms of your own release before booking the shoot, and that the model signs the release before the shoot begins. In other words, all paperwork should be complete before you start taking photos. In many cases, glamour models operate extensive personal Web sites with associated subscription businesses. If your model operates such a site, he or she will likely require that the release allows them to publish your images on their sites for commercial purposes. Unless you also have a for-profit Web site, the default is that the release will not mention anything about commercial use of the images for you. If you also intend to use the images for commercial purposes, you will need to discuss the exact terms of the arrangement (just as with any binding contract) and ensure that this is properly documented in the release.

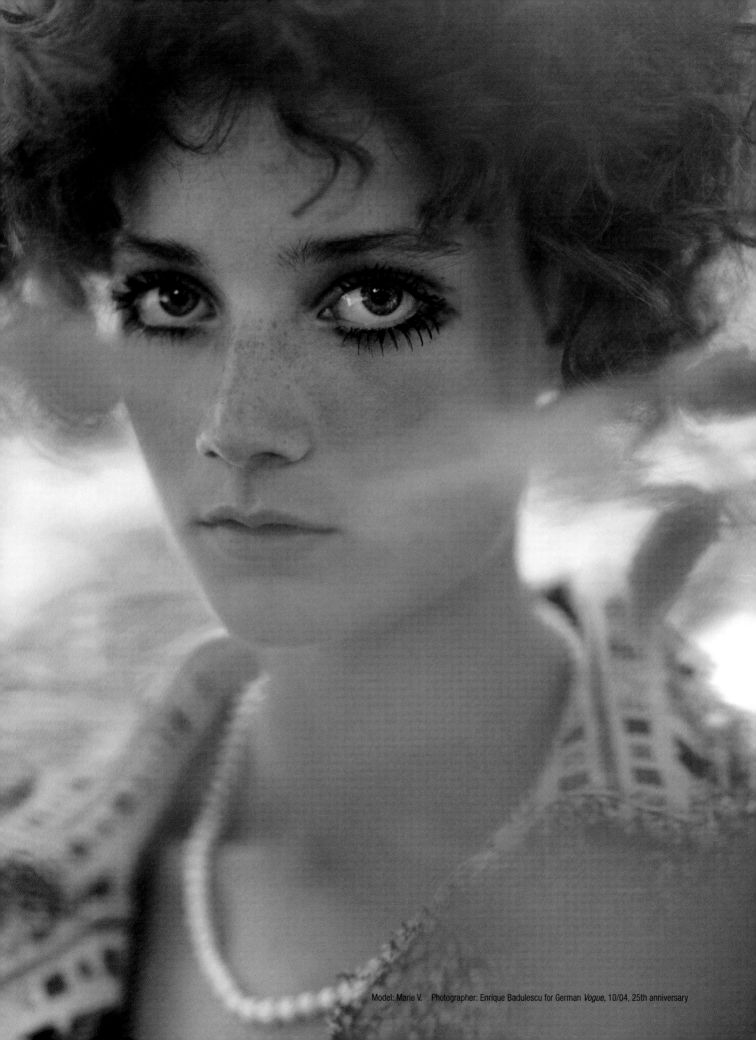

Model: Marie V. Photographer: Enrique Badulescu for German *Vogue*, 10/04, 25th anniversary

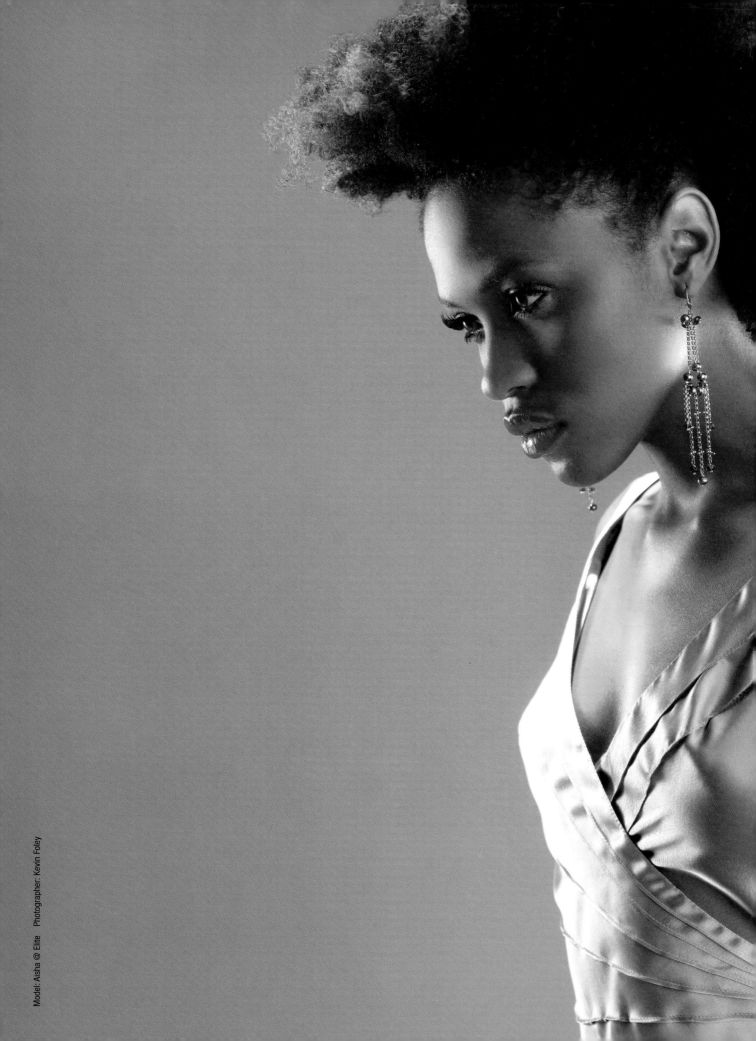

CHAPTER 4

Studio Work

Studio work represents about half the fashion photography in which I engage. This bread-and-butter work is comprised of tests for agencies, commercial shoots, and a significant portion of my personal photographic pursuits. This chapter discusses the major aspects of studio work—in particular, what you need with regard to a location and equipment, lighting (including some of the most common and versatile lighting setups), planning, and some relevant aspects of my studio workflow. The discussion focuses on basic tips and techniques that should come in useful on a shoot-by-shoot basis. You can combine them and add your own ideas; I encourage you to experiment.

To Do Studio Work, You Need a Studio!

Photographers have a wide range of definitions for the word "studio." To me, the word generally refers to a location—designed for photographic use or otherwise—that is (typically) enclosed by at least some walls and where you have access to a power supply. Note that this definition does not preclude outdoor studios. Indeed, there are some really

wonderful roof-top studios where photographers have set up white fabric paneling (basically fixed scrims) to enclose an open area on the roof of their building. I've also seen some great warehouse studios where three sides of the space consist of floor-to-ceiling windows.

Many photographers—especially those first starting out—are unable to afford a studio for their own exclusive use. Fortunately, in many larger cities, such as New York, photography studios can be rented on a shoot-by-shoot basis for a reasonable price. Indeed, studios for hire are generally designed specifically for this purpose; they are generally painted white and provide generous access to power sockets. In addition to featuring a main studio area, where the actual photography occurs, these facilities typically provide a green room for the model's entourage as well as an area designated for changing clothes and applying make-up. Most studios for hire also enable photographers to rent cameras and lighting equipment at relatively inexpensive rate. For the budding photographer, it often makes sense to rent items that are essential but not regularly required—for example, a high-power ring flash and power pack (Profoto, Elincrom, Broncolor, and Hensel Porty come to mind).

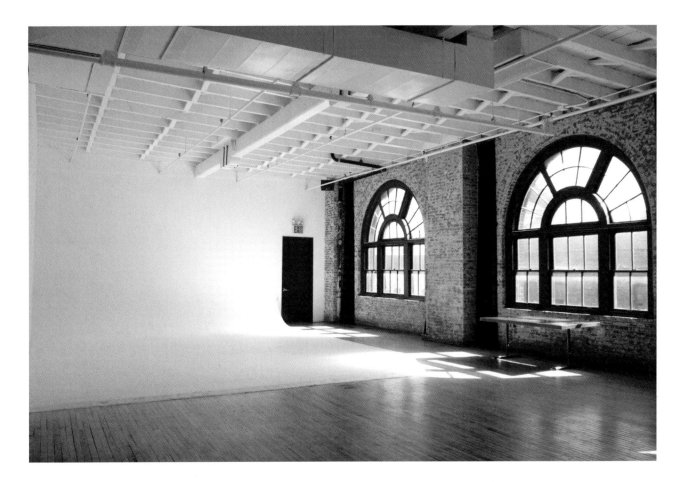

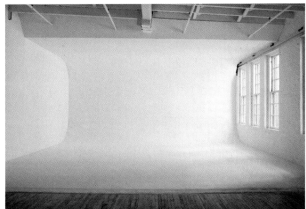
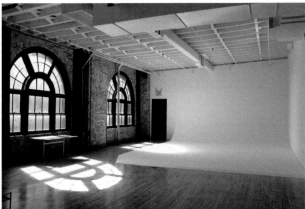

Courtesy d•Space Studios

Studio Specs

When shopping for a studio, be it for your exclusive use or a for-hire in a foreign city, you should seek out candidates with a minimum set of dimensions and working space—its width, height, and length—as well as other facilities such as a green room and a make-up and changing area. You'll also want to make sure the space has adequate power supply for your needs.

Studio Width

Specifically, the main working area should be at least twice as wide as the widest backdrop or set element that you will need. This provides plenty of room for and easy access to lighting equipment, which ensures that models and assistants don't trip over equipment as they move around the set.

A typical setup uses a 9-foot (3-meter) roll of white background paper on a mounting system, such as a collapsible background roll holder or a more permanent multi-roll holder, both of which may extend as much as 3 feet or so in each direction. This adds up to around 15 feet (5 meters) of background; if you apply the previously described rule of thumb, you should have a further 7 feet or so (around 2.5 meters) of space on either side, for a total width requirement of around 30 feet (roughly 10meters). An alternative to roll-paper is to use a cyclorama ("cyc" for short) as the background. A cyclorama comprises a number of flat and curved panels (the curved panels are know as *coves*) joined together to create a background with no perceptible beginning or end. This is also referred as an *infinity background* (one where you can't see any discernible edges or seams), but they tend to take more space (particularly depth) as the panels curve out toward the photographer's position from below. Cycs are generally more appropriate for larger studio areas, take longer to set up and tear down, and are far more expensive than background paper—but if you have the space and the budget, they are very useful.

> ## note
>
> You could use shorter background rolls (5 feet, or 2.5 meters), but you will likely find them less useful because they are too narrow except for close-up work. Attempts at three-quarters or full-length shots will result in the edges of the paper being visible, which requires more post-production work to clone them out.

Studio Height

In terms of the room's height, look for a space that is at least twice as high as the model in heels so that the ceiling is not visible in your shot. When you consider that most fashion models are roughly 5'10" and that they often wear heels that are on average 3 inches high, you're looking at a ceiling that is at least 12 feet in height to ensure that the ceiling is not in the field of view. (Of course, you can also remove the possibility of seeing the ceiling with appropriate cropping and choice of focal length.) For maximum flexibility, shoot for 12–15 feet (3–5 meters). If you plan to install a rail system on the ceiling that enables you to suspend lights, light control equipment, or fog generators from the ceiling—a great way to avoid having copious power cables and trigger cables gaffer-taped to the floor—you will need to budget at least another meter in studio height, particularly if you install some of the accordion-like monoblock fittings. Likewise, if you ever plan to shoot models on a platform, thereby improving the perspective of the image, you'll need to factor that into the height requirement.

Studio Length

The room's length is less important than its width and height because you can somewhat compensate for it with the appropriate selection of lenses. A 24–70mm lens or equivalent is a useful focal range to work with for a typical fashion shoot, so to get the model full length in the sweet spot typically between 50–70mm, the model should be 21–30 feet (7–10 meters) from you. If you're looking for a three-quarters length shot, you'll need to be a little closer at the same focal length (12–15 feet or 4–5 meters away).

You should also aim to have at least a meter—preferably two, especially if you're looking for a three-quarters length shot—between the model and the backdrop, especially if you want a high-key shot (such as a shot of the model against a bright white background, where you can't see where the floor stops and the background starts). This ensures that any shadow caused by the flash does not fall visibly within the image. With this distance between the model and the background or greater, you have the added flexibility to modify the color of the background from pure white, through gray and nearly black simply by modifying how much light hits the background. Given the dimensions of the studio described above, you can get an out-of-focus background in post-production with selective masking and

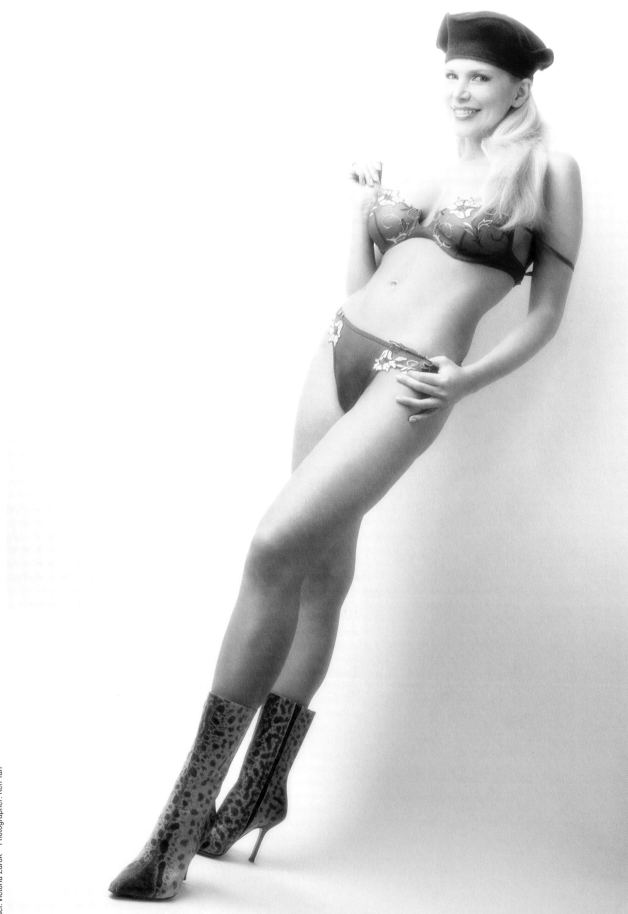

blurring, or you can use a longer focal range lens such as the well-respected Canon 70–200 2.8L IS (image stabilized) lens.

This is all a long way of saying that to get a basic test shot done, and depending on your lens, the length of the main studio area (excluding the green room, change areas, and other facilities) needs to be at least 21 feet (7 meters) long, with a preference for at least 36 feet (12 meters), and around 30 feet (10 meters) wide, with the height depending on how you intend to compose the shot (at least 12 feet is a good rule of thumb).

You Can Never Have Too Much Power!

When it comes to the power supply in a photography studio, the old adage applies: More is better. Indeed, if you're looking to establish your own studio space, it is generally a good idea to have triple phase coming in—in part to power a reasonably substantial (preferably industrial) air conditioner unit and in part to provide plenty of current to your raft of equipment. When setting up your studio, you should also make sure that double power sockets are positioned around the main shooting area to provide maximum flexibility. On average, they should be spaced 6 feet (2 meters)

apart and allow for as many as 10 lights to be on simultaneously, although most of your shoots will typically only use two or three. You should also mount light sockets near or on the ceiling to power hair lights and background lights, and be able to support the use of fans and other less frequently employed equipment like smoke generators. And of course, no studio is complete without an entire crate of high-current extension cords of various lengths, powerboards, and double adapters. You can never have too many of these.

You will also need to dedicate a couple sockets to powering your capture support equipment, including a laptop or desktop capture machine, portable drives, and possibly a TV monitor for the model and crew to see the shots as they are taken. Your computer area should include a generous supply of additional power outlets for your editing machines, servers, scanners, and printers. Finally, you'll need to route adequate power to the makeup and changing area. For each makeup station, you should provide at least two power sockets—one for the indispensable hair dryer and another for other makeup artist essentials like hot curlers and hair straighteners.

Makeup area

Garment area

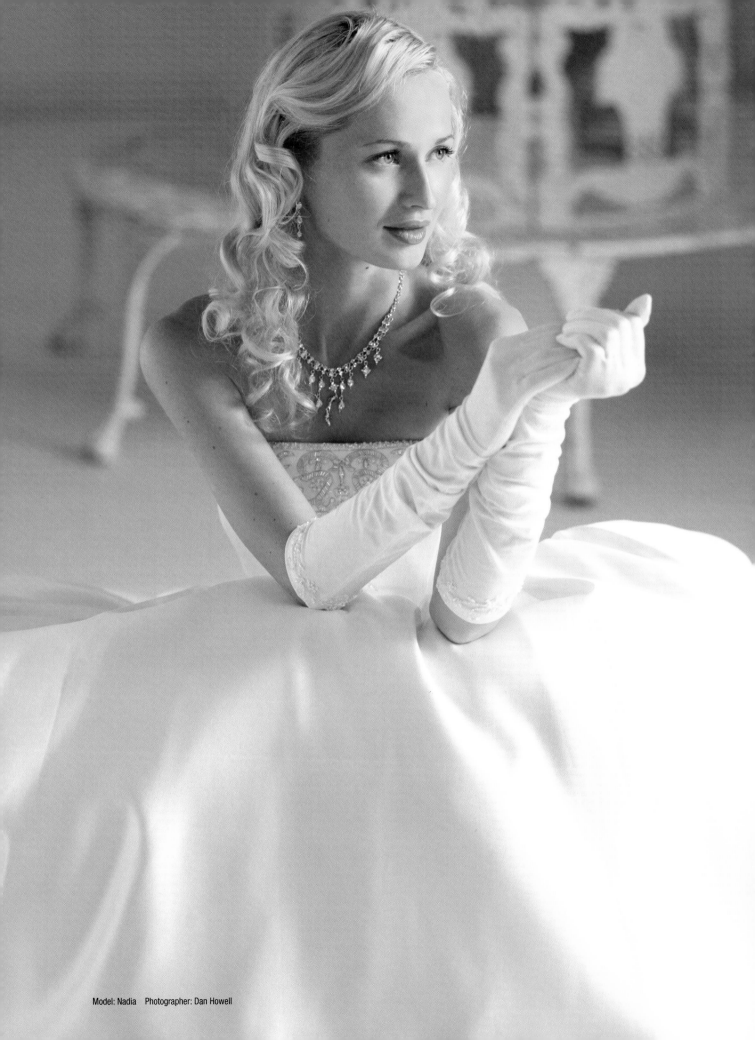

Model: Nadia Photographer: Dan Howell

Equipping Your Studio

Once you've found just the right space for your studio and made the necessary arrangements to call it your own, you'll need to equip it. At the very least, you'll need the following:

- A tripod
- Lighting
- Backdrops
- Props
- Storage equipment

Tripod

You can hand-hold the camera for entire shoots, but you are likely to end up with a sore wrist the day after—and more serious damage over time. Unless you want one arm to be more muscle-y than the other, you'll want to use a solid tripod, particularly if you have a heavy camera like a Canon 1Ds (Mark I or Mark II—I refer to them in this chapter without the version number). Indeed, all basic studio setups involve at least one solid and dependable tripod—usually of the Manfrotto/Bogen variety—preferably a few. In addition to ensuring your symmetrical physique, using a tripod enables you to control camera shake, making your photos as sharp as possible while still offering you the flexibility to use slower ISO ratings (this yields images that are generally less noisy), slower shutter speeds, or both. This is especially critical for lower-light, moody shots typical of some fragrance and fashion advertisements.

At a bare minimum, you should have one tripod with a standard three-axis head, although ball heads and trigger/grip heads also come in very handy. Having one of each provides a good deal of flexibility. Ball heads and grip heads are more useful for fast-paced shoots where the model is moving around a bit and you want to be able to quickly adjust the camera's orientation without fiddling with multiple knobs. For more structured shots, however—the kind where the stylist and art director spend a significant amount of time on the set positioning the model—standard heads are better because they allow more precise single axis control.

Rather than getting hung up on brands, just select tripods that feel solid, have a solid locking mechanism on each leg, and allow for retightening over time. For a studio tripod, or one that is moved only infrequently, go for the heaviest in your budget.

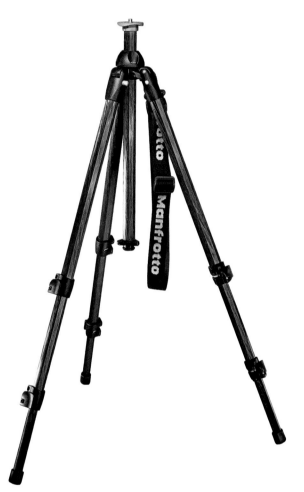

This is an example of a light but stable tripod (Manfrotto ProMag 3 Section Tripod).

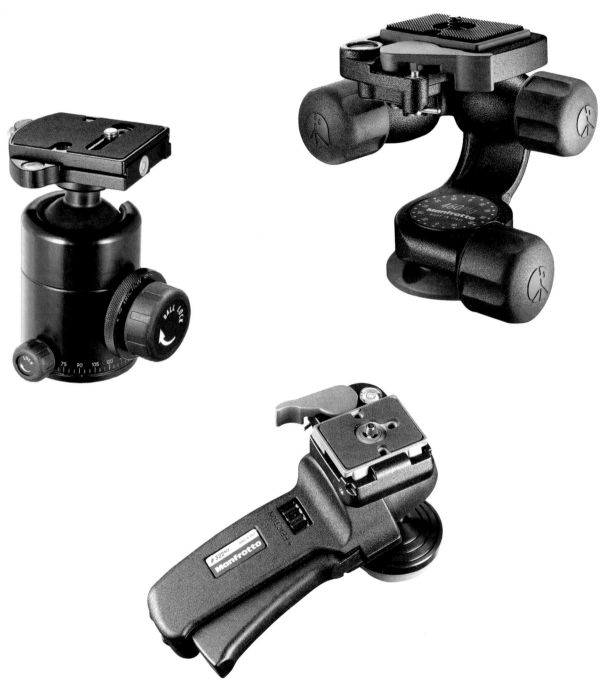

These are examples of typical tripod heads for use in studios—Manfrotto Deluxe 3-Way Head, Pro Ball Head, and trigger (grip) head.

Lighting Equipment

There's no doubt about it: Lighting control is one of the most important aspects of successful studio photography. Lighting design and execution is the key to a successful studio shoot. In this section, you'll learn about the lighting equipment every photography studio requires, as well as explore a few common studio lighting setups.

Lights

In general, if you are shooting in a studio, you will need some lighting equipment. The list of various lighting types is long, however, and beyond the scope of this book. Suffice to say, you can get the majority of your work done with three types of lights: monoblock flashes ("monoblock" simply means that the power unit is in the same box as the flash tube), flashes requiring external power units (usually referred to as *powerpacks*), and incandescent lights. Of course, you can use other type of lights such as fluorescents, but the basic principles are the same (although in the case of fluorescents, they tend to generate a green cast, which you need to compensate with the appropriate white balancing).

> ### note
>
> Studio flash units come in a range of power outputs, but a minimum of 300Watt Seconds (preferably 600Watt Seconds) per unit is required to give you a reasonable amount of light and flexibility in ratios.

[tip]

You should try to use monoblocks that have continuous output selection (sliders or digital) so after the initial metering, you can manually adjust the light output based on the rear LCD of your camera and/or an external monitor.

Some photographers especially like using incandescent lights—that is, those generated by a glowing electric filament (such as a simple household light bulb). You can use incandescent lights exclusively or mix them with flash. Just bear in mind that incandescent lights typically provide a warmer light output. (Physics aside, that just means that if you shoot with an incandescent light source and have your white balance set to flash, the image will come out very yellow.)

In addition to the lights themselves, every manufacturer provides a wide range of light modification accessories. For example, most flashes ship with a standard reflector, which generally focuses the flash light into a 30–60 beam. There are also wide-angle reflectors, which spread the light over greater than 100 degrees; frenels and grids, which soften the light; and beauty dishes, which produce very soft and flattering light by double-reflecting the flash output. (They contain a small inner reflector directly in front of the flash tube, which bounces the light back to a larger, concentric outer reflector.) Also, a snoot is sometimes useful to focus light down to a small area for highlighting, such as with a model's face.

In addition to these light-modification tools, one of the most important and frequently used pieces of equipment for "softening" raw flash light is a *softbox*. These come in all shapes and sizes—squares, rectangles, and in the last few years, octagons—and are made by a number of well-known manufacturers, including Chimera and Photoflex. Essentially, a softbox is, as its name suggests, a box comprised of an opaque fabric stretched over a metal frame. This box is attached over the front of a flash unit and is typically lined with white, silver, and sometimes gold fabric to increase internal reflections and, in the case of softboxes with gold lining, to warm the raw flash light. Most modern softboxes also come with an internal baffle of white translucent fabric to further diffuse and soften the raw flash light, as well as a front diffuser of similar white translucent fabric. Using both the internal baffle and the outside diffuser yields the softest (often referred to as *shadowless*) light output. Although these diffusers are removable, I almost always have them installed when I use softboxes.

[tip]

If you are just starting out and find the softboxes are a little expensive, you can achieve almost the same results by bouncing the monoblock light off of a large white reflector. This also diffuses the light. Although you lose a stop or so doing this, most monoblocks have plenty in reserve.

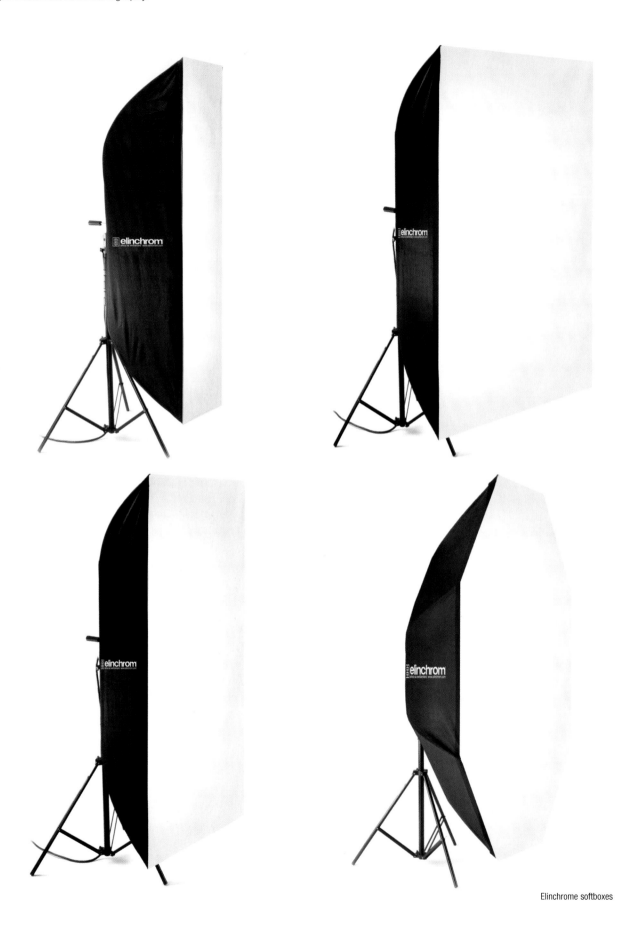

Elinchrome softboxes

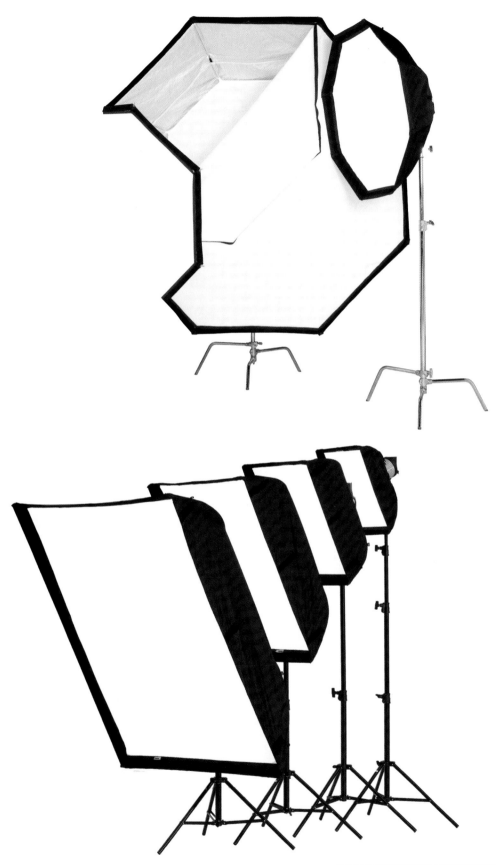

Chimera Lighting Octa Group and SuperProShallow, respectively

Reflectors

Reflectors come in two basic flavors: fixed and collapsible. They also come in a range of sizes and of colors—usually white on one side and silver or half-gold on the other). The collapsible reflectors are generally round in shape and fold down with a simple twist of your wrists. Fixed reflectors come in all shapes and sizes (typically rectangular), and larger fixed reflectors sometimes come with their own stands.

Reflectors are used primarily for filling in shadows. When using them, just remember the old rule, "the angle of incidence equals the angle of reflection." That's about all you need to know—aside, of course, from trying to avoid blinding models by reflecting bright light directly into their eyes.

[tip]

If you find the collapsible round reflectors a little expensive, you can get the same effect with a piece of white polystyrene either on its own or mounted on a piece of MDF to give it rigidity. You will likely lose up to two stops of light output using a polystyrene reflector, but this is a cheap alternative. You can also increase the reflected light by gluing domestic aluminum foil to the front of the polystyrene, and can increase the diffusion by placing some cheap tulle from a fabric store in front of the reflector. I made one of these when I first started out for around $20, and I still have many of them lying around—mostly for light control on the edge of my sets.

Light Meter

Metering is one of the most important skills that underpin a successful studio shoot. While all digital SLRs have built-in exposure meters, as do all medium format systems (albeit often as an added-cost option), as a working photographer you would be under-equipped without a hand-held "reflective" meter. My personal favorite is the Minolta IVF (now replaced by the VF). It provides ambient, corded, and cordless metering over a broad range of f-stops, ISOs, and shutter speeds, as well as a useful averaging function. If you already know how to use a hand meter, feel free to skip this section. If not, read on.

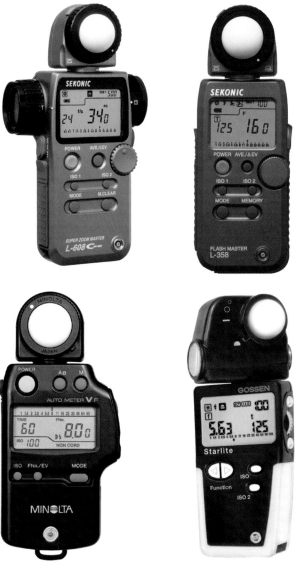

Hand meters L-608 and L-358 by Sekonic and Minolta and Gossen

Hand metering plays a far more significant role when you are shooting on location because you are less in control of the light. For a studio shoot, you will generally only need to meter at the beginning of the shoot, although it is not a bad idea to re-check the meter periodically. After you set up your lighting equipment, ask one of your assistants to stand in place of the model. Then take a reading off of the assistant's face—one parallel to each cheek. This gives you a general idea of the lighting level; you should try to achieve at least f8 at ISO 100. When the model is on set, take another set of readings in case the makeup the model is wearing has a different reflectance from your assistant's skin.

Most light meters come with a half-spherical plastic cover for the light sensor. I find that this tends to pick up too much scattered light from directions parallel to the plane of the sensor, and often results in a little underexposure. Hence, you should try to use a (typically optional) flat sensor cover so that only light perpendicular to the direction of the sensor influences the meter reading. Of course, this observation is based on one meter—my own—and may not apply to yours. You might want to conduct some tests with your own meter to see if you have the same issue.

Backdrops

Thus far, I have limited mentions of backdrops to rolled paper. Many alternatives are available, however, including muslin, painted canvas, and so on; most photography stores will be able to provide you with numerous options. In addition to these, I also frequently use bare or painted brick walls in my shoots, depending on what effect I am trying to achieve. I know other photographers who use large framed backdrops on rollers, which are moved around during shoots and placed in storage when not in use. These backdrops can include anything from fabric, sheet and pressed metal, and mirrors, to faux brick walls, faux windows and balconies (complete with controllable simulated ambient light), and even faux walls designed to resemble those of a 16th-century chateau. Unfortunately, I don't have the space in my studio to take this modular approach, but I would if I had the room.

A flat diffuser and spherical diffuser

Cool studio sets aside, the key issue to consider when selecting an appropriate backdrop for an image is whether you want to emphasize or to de-emphasize the model. A busy backdrop can distract the person viewing the final image from the model or from the clothes that the advertisement is meant to sell. Likewise, a backdrop that is too close in color to the clothes worn by the model may make it difficult for the viewer to distinguish the model's clothes from the background. On the other hand, this may be exactly what the photographer intends to achieve. Just be aware that this should a conscious decision by the photographer (and, usually, the art director and stylist).

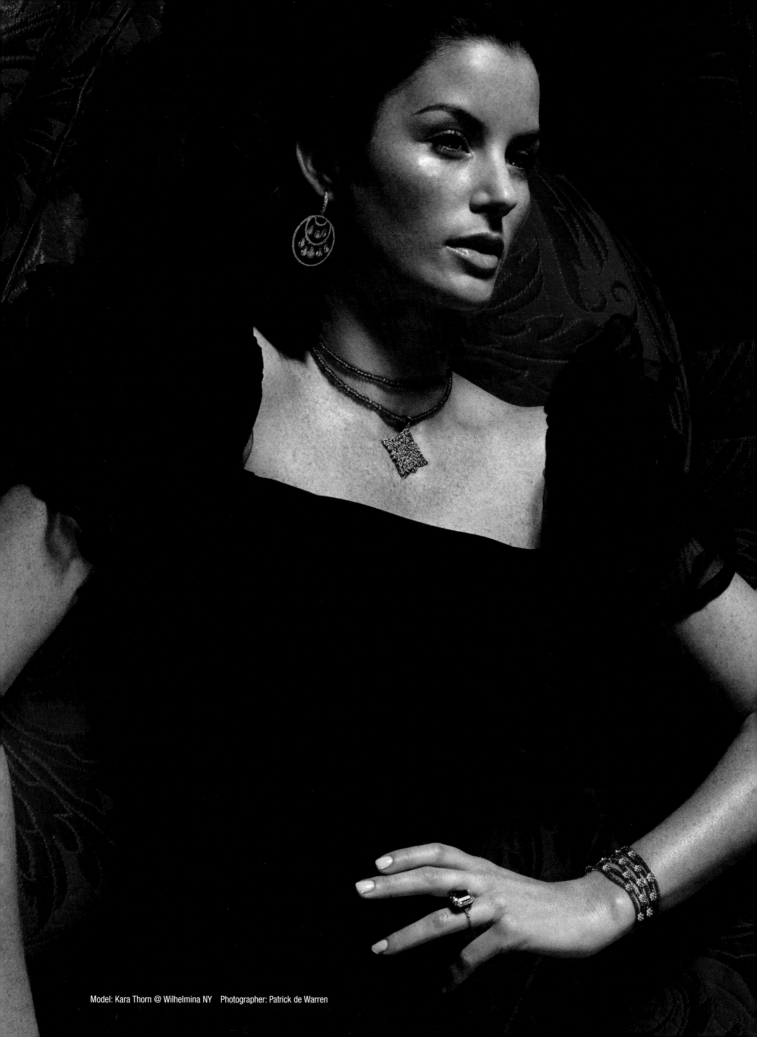

Model: Kara Thorn @ Wilhelmina NY Photographer: Patrick de Warren

Props

Props can be somewhat a double-edged sword. When used properly, they can add drama, context, and structural support to a picture; if misused, however, props can clutter an image and distract the eye. For this reason, props should be used selectively, and only as appropriate.

note

Props can be a significant slab of any commercial shoot budget. A nice chair or other piece of furniture can be quite expensive; unless you intend to keep the piece after the shoot, it is difficult to justify purchasing large prop elements on a personal budget. Fortunately, significant props required for commercial shoots are usually discussed during preplanning and are budgeted for accordingly. In cases like these, props such as furniture are usually rented, typically at a cost of 20 percent of the piece's purchase price. Fortunately, I am not required to pick up the tab too often. As an added bonus, because my wife, Rachel, is an avid collector of reproduction antique furniture (British Victorian, French provincial, and so on), we have a reasonable collection of nice pieces that I sometimes use in shoots. (Once you use a piece in a photo, however, it is difficult to use it again—particularly if the images are for commercial purposes or for your book.)

That being said, there are some essential items that I believe every studio needs:

- **A set of wooden boxes or pillars, painted bright white.** These often appear in "high fashion" editorial shots, where models are propped up, sitting on or lying over one or more of these boxes. These boxes can also be covered in material to provide different looks and also to adjust reflectivity (for example, covering one of these boxes with black velvet will absorb light and darken the edge of the model against the box).

- **A collection of stools.** Procure at least one basic wooden stool with a single foot rail and a round seat, commonly used for tests. In addition, you'll want some metallic stools for a more industrial look.

- **A fan.** It may be a stretch to call these items "props," but a fashion studio would be underequipped without at least one adjustable fan—in part to generate movement in the model's hair and clothing, and in part to keep the set cool on warm days and/or during long shoots under incandescent (hot) lights.

You should also draw heavily on your set stylist and art director when it comes to props; that is what they do. I usually do venture my opinion about props during planning meetings, particularly if the choice of props will have a material impact on my lighting design or my ability to get the shot they seek, but I am generally happy to defer to them.

note

Over time, as you get to know the stylists and art directors in your area and you've established a good working relationship with them, you'll feel more comfortable voicing your opinion on matters such as these. Indeed, I find that the most creative shoots arise from the collaboration of a team that has worked together many times, and that has experimented and grown as a result of a range of different projects.

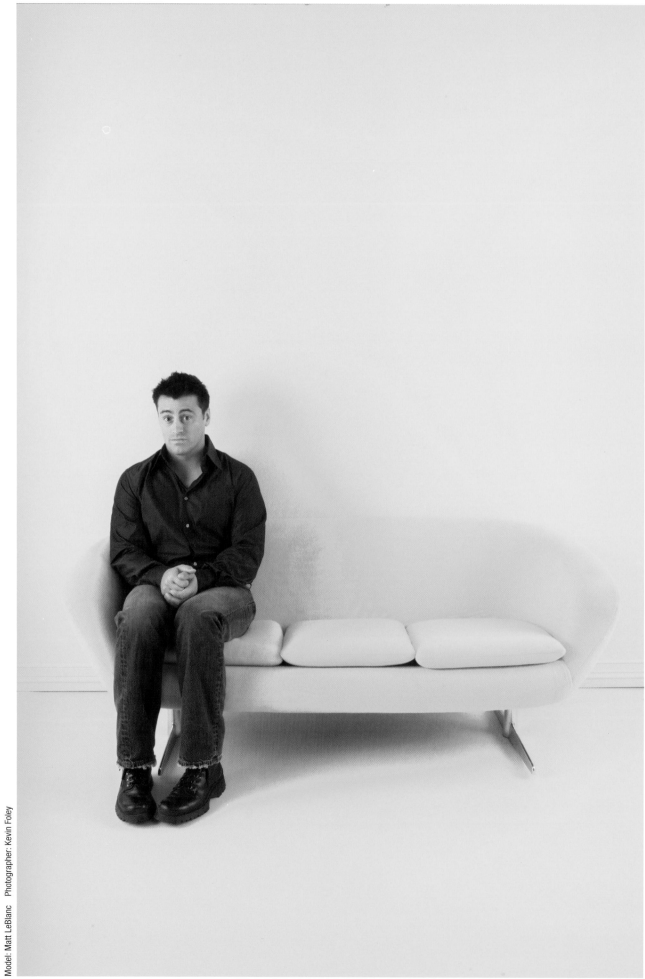

Storage

In part to keep your studio neat, and in part due to the fact that you need ready access to a semi-trailer load of equipment, you may want to develop your own equipment filing system. A good way to organize your equipment is to group similar equipment together, such as power cords, clamps, chargers, batteries, and so forth. Alternatively, you can organize your equipment into sets by usage, such as a box that contains two monoblocks and their associated cords, labeled "basic test."

As a starting point, you can never have too many basic plastic storage boxes, which you can purchase inexpensively from any number of houseware stores. In addition, you will need some sort of stand to store your rolled paper backgrounds and other longer items such as folded-up softboxes, booms, and so forth. For my light stands, tripods, and reflector holders, I have found the Tenba PAT50 hexagonal cases to be a great solution. These unzip flat and can rest against a wall in the studio; when closed up, however, they are self-standing, robust for air transport, and generally an easy way to carry a large number of stands. For more delicate equipment, you may want to consider Pelican cases, which feature a lifetime guarantee and are nearly indestructible. You can buy them with padded dividers or pick-and-pluck foam. The dividers are a little more expensive, but provide more flexibility for reconfiguring how you pack your equipment. One way to pack these cases is to have one bag per camera set, (a 1Ds, a few lenses, a flash, and so forth). You may also want to dedicate some of these cases to storing your lenses.

Storage cases. Photo courtesy Tenba

Selecting the Appropriate Equipment

You should select your camera based on the projected size of the final image. Typically, for A3 full bleed (that is, an edge-to-edge image with no blank borders), I shoot with a Canon 1Ds as my primary camera with a Canon D60 as backup—although I rarely unpack the Canon D60 because the 1Ds performs flawlessly. (I intend to replace the D60 with another 1Ds or the 1Ds Mark II in the near future.)

A few years ago, when I made the switch from film to digital, my primary camera was either a Pentax 645N or a Canon EOS 1V, depending on how large the final output print needed to be. I skipped the D30 after a short trial and waited for the D60 before taking the leap into digital. The D60 was fine for 8×10-inch prints, but for dual-page magazine work, it was just a little too low in resolution and no match for my medium-format gear. A year or so later, I purchased the 1Ds and made the decision to go totally digital. For my first few shoots, I kept the 1V as a backup, but pretty soon, I realized I didn't need it. I switched fully to digital and haven't looked back.

With regard to other equipment, I have a full studio at my disposal, as well as a full location setup that I have built over the years. I usually unpack the relevant setup based on the nature of the shoot.

Seeing the Light: Lighting Design

A fantastic wedding photographer once told me that to take my photography to the next level, I would need to learn to see light. I thought the comment odd at the time; indeed, I did not understand until many years—and thousands of photos—later. What this talented gentleman was trying to tell me was that I needed to learn to visualize the effects of individual lights on a set, as well as the effect of the lighting setup in its entirety. That way, with sufficient thought, I would be able to visualize what the final shot would look like and make adjustments as needed long before I set up the equipment and the model showed up.

Although Polaroids—and now, LCD screens on digital cameras—provide a significant level of immediate feedback, as well as the ability to make adjustments to exposure, lighting, and so forth, being able to mentally plan the set remains a valuable skill. Using it, you can avoid making time-consuming errors in set design. (For instance, being able to make minor exposure adjustments will not fix the problem if, say, your flash units cast ugly shadows on the props).

Some simple lighting principles that are particularly applicable are as follows:

- If the light source is small compared to the object it is illuminating, the shadow cast will have strong edges. For example, a bare light bulb just off-camera to a model will cast a fairly defined shadow behind the model, an effect that is commonly used in high-fashion editorial photos.

- If the light source is large compared to the object it is illuminating, the shadow cast will have soft edges. For example, a 5-foot Photoflex Octodome softbox will cast soft, less-noticeable shadows behind the model. This effect is often used in beauty and cosmetic campaigns.

- More diffuse light yields a light that is lower in intensity and softer. This effect is commonly used for beauty shots to achieve that "flawless skin" look.

I encourage you to experiment with various lighting setups to get a feel for what small changes in parameters can do to an overall scene. I am a firm believer that lighting control is key to differentiating a moderately talented photographer from a great one, and has a lot to do with the artistic aspect of photography.

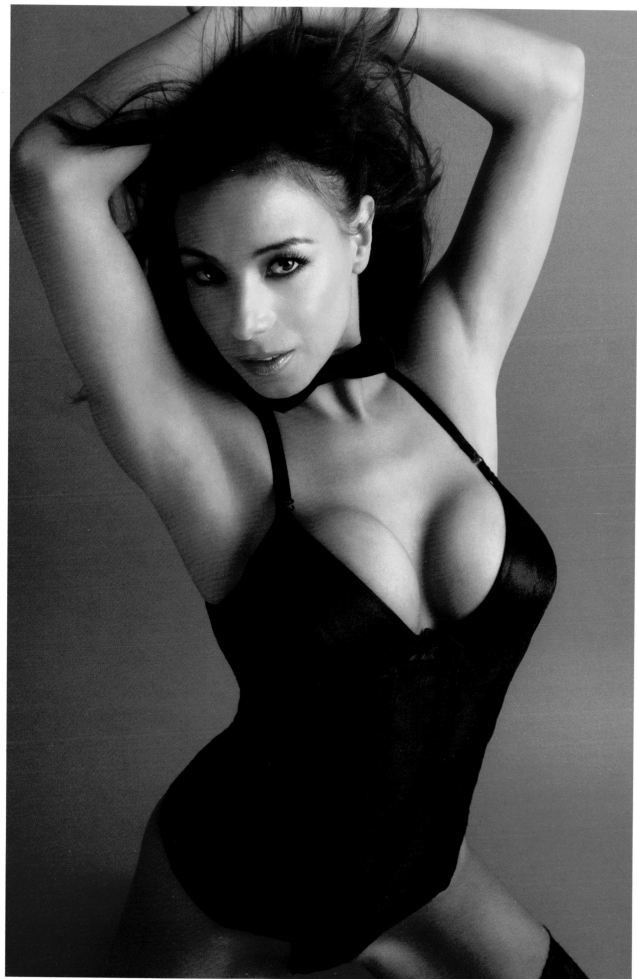

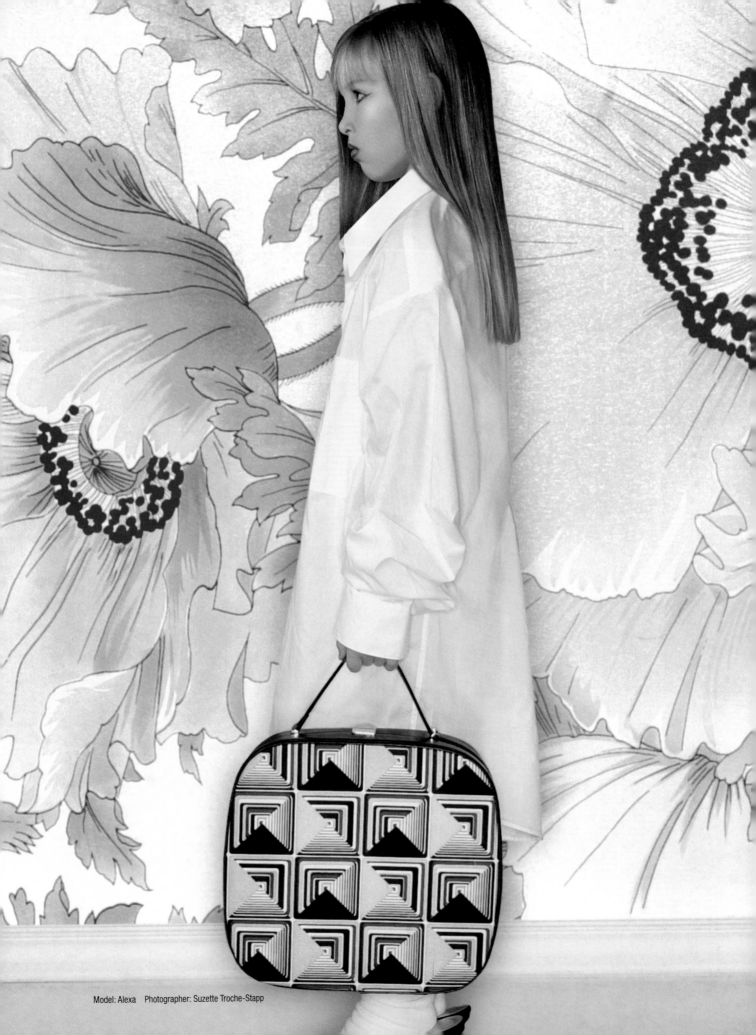

Model: Alexa Photographer: Suzette Troche-Stapp

Lighting Design

When designing the lighting for your photograph, you should try to adhere to a few basic rules:

- **Use only as many lights as you need.** Although this sounds like common sense, I have often seen photographers set up multiple lights just because they have them.

- **Make sure there is sufficient light such that the average exposure is f8.** This results in the lens being set to its sweet spot in terms of sharpness, and also allows you more flexibility to control depth of field. That is, if you have enough light for f8, you can then open the aperture to 5.6 or even 2.8 to make the depth of field shallower.

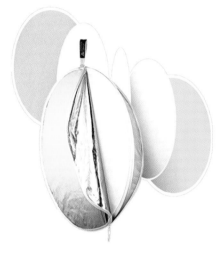

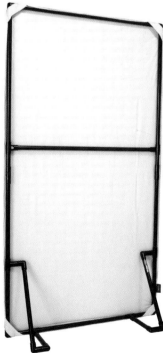

- **Identify which aspects of the photograph you want to emphasize and which aspects you want to de-emphasize, and select your lights accordingly.** For example, do you want the model to stand out from the background? Do you want a high-key image, such as one where the entire background is white? Do you want the entire image to be dark except for the model's face? Do you want to add drama to the image with strong shadows behind the model, or with shadows from something off-camera? Do you want to add a soft golden glow by mixing flash with tungsten and incandescent lighting? Do you want to blend natural light from a large window with studio flash? The list goes on.

- **Lighting can be both additive and subtractive.** By this, I mean that you can add and subtract lights from a scene, but you shouldn't forget the numerous lighting control products that help modify the quality and nature of the light in the image after you have chosen the number and location of your lights. Such light modifiers include scrims (large panels of material, some opaque and some translucent, to either block light or to soften or filter it) and reflectors (panels of cloth or some other material, such as polystyrene, that reflect light and/or modify the color cast of the light). These enable you to control how much ambient light appears in the picture, or how much main flash will fall on the background.

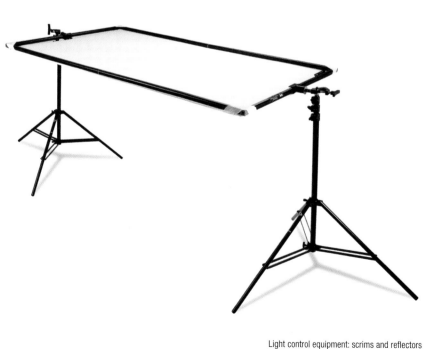

Light control equipment: scrims and reflectors

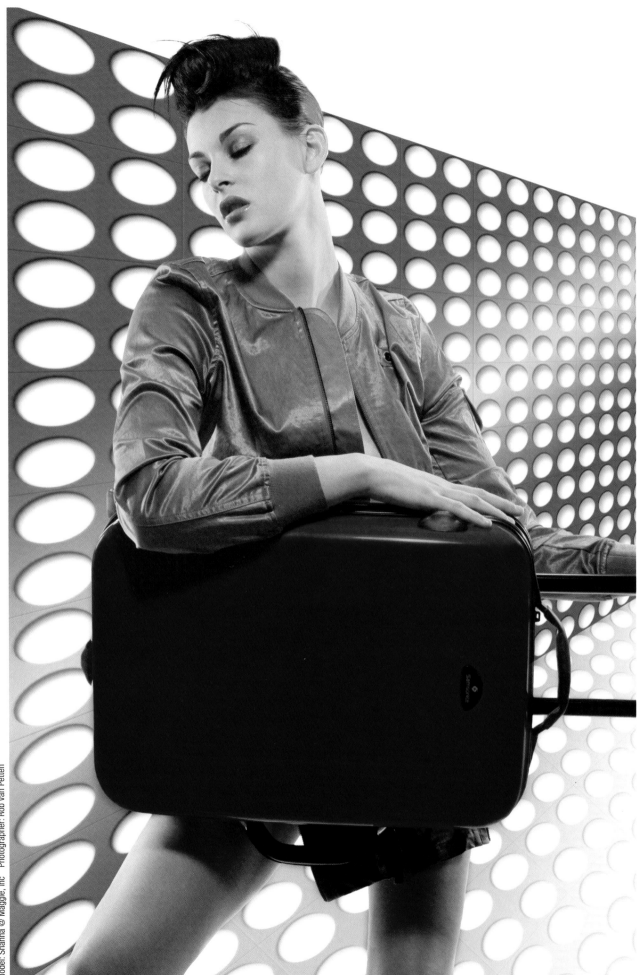

[tip]

It's a good idea to install opaque scrims or panels along each side of the main shooting area to prevent light from background lights falling back on the camera position or to reflect some additional light on the model.

As a final thought, most basic lighting setups include PC cords to trigger the primary light (or lights), and use on-board slaves on the other secondary monoblocks to trigger the rest of the lighting setup. These days, however, wireless triggers are relatively inexpensive. I used the Quantum FreeXwire, which is affordable and error-free, to wireless-enable my entire lighting kit. This has enabled me to remove a whole lot of wires from my studio, thereby eliminating the potential occupational safety hazard of tripping over cords.

MultiMax by PocketWizard

Lighting for Test Shots: A Basic Setup

A basic lighting setup is generally the way to go if you're shooting a test of a model for an agency—especially for the full-body or three-quarter shot the agency will inevitably require. The difference between the full-body and three-quarter shot is, funnily enough, a matter of cropping rather than lighting design. (You'll also likely be asked to shoot a close-up beauty shot and what I call a "wild card shot"—a photo that shows the model doing something, such as walking, interacting with an object, or what have you.) Specifically, a basic lighting setup should consist of the following:

- A paper background on a crossbar held by two clamps (such as Manfrotto SuperClamps), with each clamp mounted on top of a lighting stand

[tip]

Although most major manufacturers offer air-cushioned light stands, they are more expensive. With appropriate care when setting up and tearing down the set, you can probably save your money and go with the uncushioned stands.

- At least two monoblock lights with softboxes attached. Your primary light should be fitted with as large a softbox as you can afford—for example, a 5- or 7-foot Photoflex Octodome.

note

Modern softboxes generally have removable internal translucent baffles to increase the level of diffusion. You should keep these installed unless you have a good reason not to.

Background stand and SuperClamps

■ A white or silver reflector just out of the shot, low down in front of the model, if you need to add a bit of fill in the neck area. Photoflex produces a solid and inexpensive reflector holder, which you can attach to a low light stand. This will pick up sufficient reflected light from the background and the monoblocks to add anywhere from a half stop to a full stop to the neck area.

A reflector holder

In addition, you may want to use a hair light to generate a glow around the model's hair. (Be warned: This sort of lighting can unnecessarily complicate things, and may look a little dated if not done properly.) Also, depending on what the model is wearing and the shot you are going for, you might opt to place a small fan on the ground immediately in front of the model, blowing diagonally upward to generate some subtle movement in the hair. These additional elements should be used carefully so that the images don't look too corny. In a test situation, think editorial *Vogue* or *Harper's* rather than *FHM* or *Maxim* (more on those in the next section).

Position the model 3 to 4 meters away from the rolled paper background, curving the paper as it hits the ground so there is no discernible line where the wall meets the floor. Depending on the composition, you might also have the model lean on a white pillar (refer to the section "Props" earlier in this chapter). The lights should be positioned about 2 meters to the left and right of where the model will stand. Although most formal texts on portraiture suggest a fill ratio of 1:2 for the primary to fill lights, you will generally set the lights to produce approximately the same light output for most test work. You should also raise the lights so the center of each softbox is around 1.5 times the height of the model in heels, and aim the heads slightly downward. This further shortens the already practically non-existent shadows, allowing a (almost) perfectly white backdrop. You can then meter the shot with your hand-held meter (you may have to average between the model's cheek and clothes), targeting at least f8 at 1/125. The final level of fine-tuning can be done using exposure compensation on your camera, but it is generally preferable to adjust the lights themselves because they generally allow finer (continuous) adjustments, while the on-camera controls are either in 1/3- or 1/2-stop discrete steps.

note

Before shooting, you should turn off all lights in the room except the modeling lights on the monoblocks to control extraneous lighting. (That said, at 1/125 or faster, you'll find that no noticeable ambient light is captured anyway.)

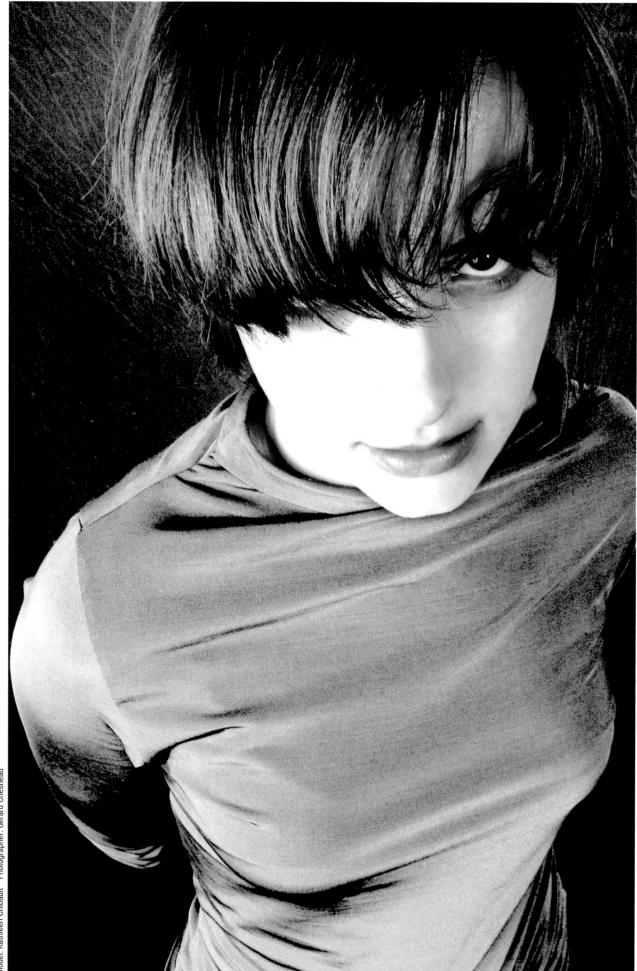

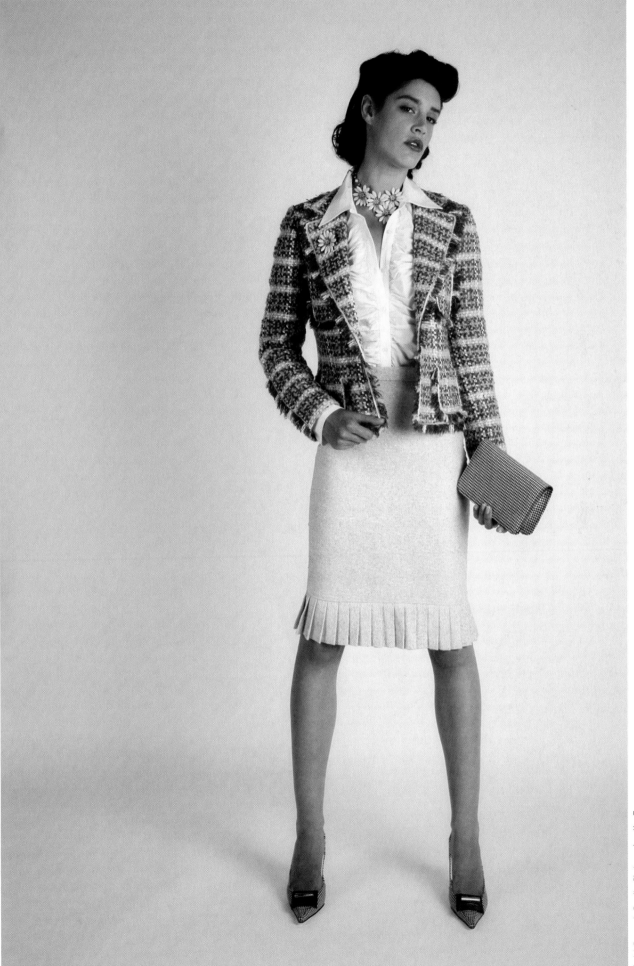

Lighting Glamour Photography

Glamour photos, *Maxim*-style, are similar to those shot for agency tests, but usually involve far less clothing and models who are more voluptuous—and generally shorter—than their fashion counterparts, bigger hair, and sprayed-on water. If the picture is against a plain background, you'll start with the same setup as for the test shoot. In most cases, however, you will need to warm up the image to provide a more tanned appearance. There are several ways to do this (you might decide to use these in combination with each other):

■ You can add a fill reflector similarly positioned as in the test shoot—low and in front of the model. Instead of using a white or silver reflector, however, you should use a gold or half-gold one. Many collapsible reflectors are double-sided, with one white side and one half-gold side; if you plan to buy only one reflector, this type is the way to go. There are also purpose-made beauty fill reflectors, such as those produced by Westscott.

■ Instead of or in addition to a gold reflector, a simple way to warm up an image is to place a simple 60- to 100-watt domestic light bulb in a floor lamp and remove the shade. The bare light bulb will add warmth to the image, assuming you don't use such a fast shutter speed that ambient light is excluded from the shot.

note

You will likely find that the full gold reflectors warm up the image too much; for this reason, you may find it easier to warm up the image during post-production instead of during the shoot.

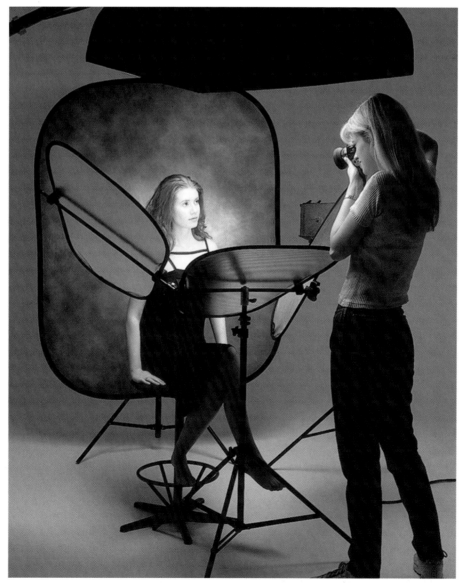

A tri-reflector

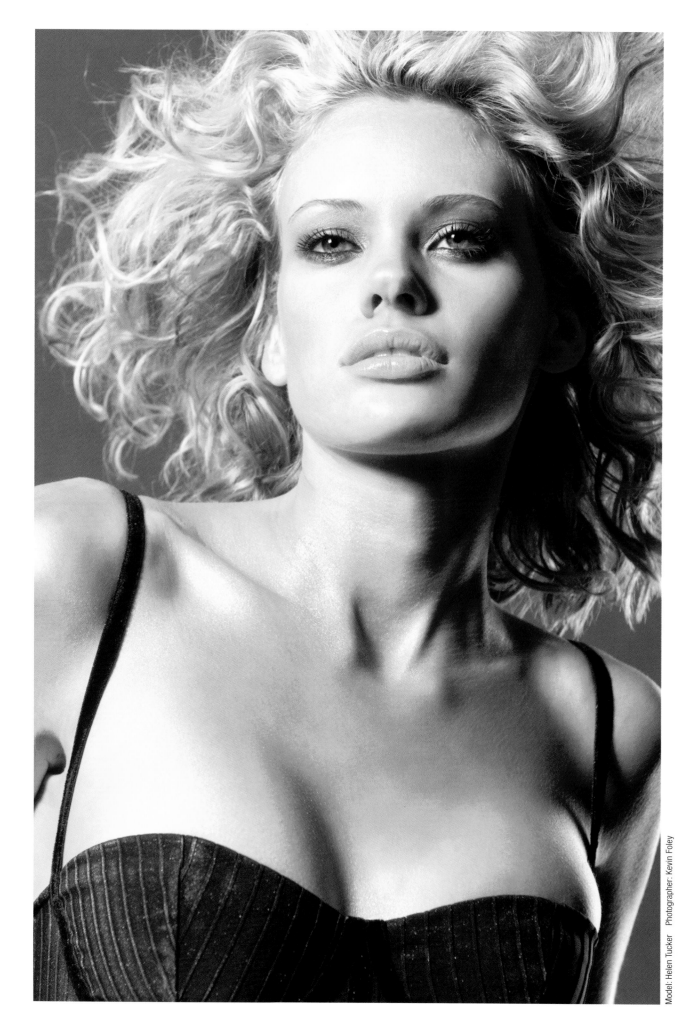

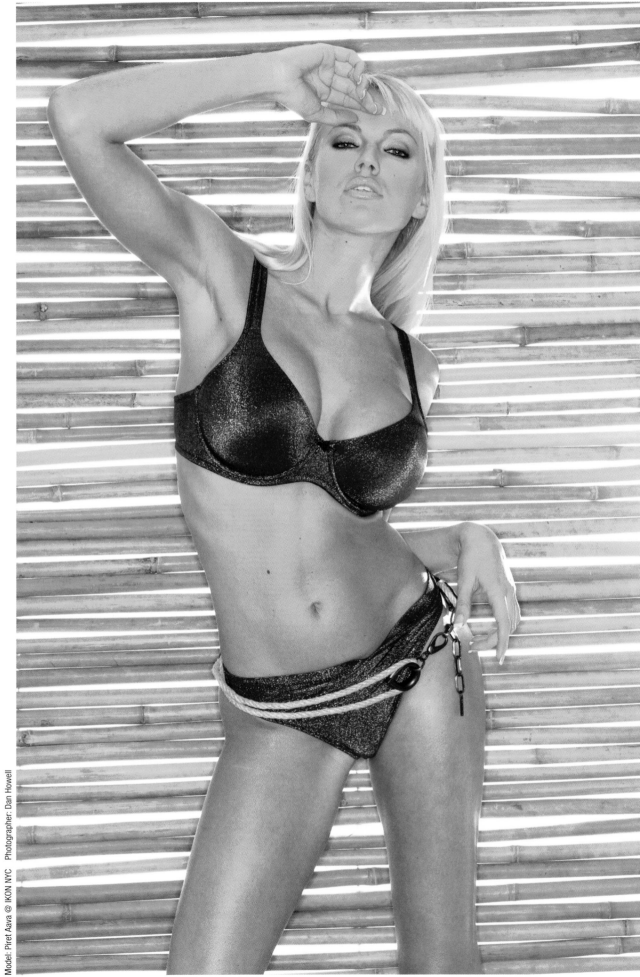

Most digital SLRs have an aperture priority setting, which automatically balances flash and ambient light. That said, you may want to do this manually, a task made easy by the fact that you can get immediate feedback from the camera's LCD.

In addition to taking special steps to warm up the image, you'll need to consider the following when shooting glamour photography:

- You will probably need an additional hair light, located on the ceiling, about 45 degrees above the back of the model's head. This will provide some good definition for the model's hair.

- It is common to use additional monolights to illuminate the background, especially if the scene contains props or furniture. Indeed, I've used as many as six background lights—some with barn doors to control spill, and others diffused through material or softboxes. The diffusion, and in some cases double diffusion, was necessary to ensure that shiny objects in the background were illuminated but did not create a distracting specular highlight. This case was probably extreme but does sometimes arise.

- In many glamour magazines, such as *Playboy*, models often have an ethereal glow on their faces. Although this can be achieved in post-production, which is how most people think the shot is done, it is actually easier to create this effect at the time of capture by using an additional continuous light source, set at about 1/2 to 3/4 of the f-stop on my primary monoblocks and fitted with a snoot pointing at the model's face, just off to the side of my camera. I usually position this light to my left, but it is up to you; either way, the point is to avoid shining the light straight into the model's face. This is where an assistant comes in handy, but a foot switch will work in a pinch. Just before you take each picture, you or your assistant can turn on this additional light, which provides just a little more light and glow to the model's face. You should have this light on a dimmer so you can adjust the intensity using the rear LCD on your camera for feedback.

- On occasion, you might have more than one model on set at the same time. Depending on the shoot, you may want to illuminate each model separately, or you might opt to use the same light for both—it's horses for courses. Be aware, however, that if the two models are positioned close together such that they may each cast a shadow on each other, you may need an additional moonlight in front, more fill reflectors, or an additional ring flash to make sure you remove unnecessary shadows. (Then again, if you *want* a dark, ominous shot, then shadows may be what you're going for.)

Lighting Beauty Photography

Beauty photography is deceptively simple in output, but generally the most complex during setup, often requiring significantly more equipment than test and glamour shots. For beauty shots, you generally want to have very diffuse light to smooth out minor skin imperfections. (Of course, again you can touch up spots, moles, and the like—most models have them—during post-production, but I generally prefer to make as many adjustments as practical at the time of capture.)

In what follows, I describe a technique for beauty photography that results in a shot that looks something like a L'Oreal or Max Factor cosmetics advertising campaign that involves an extreme face close-up—very soft and flattering lighting, also particularly good for older models. The starting point for this beauty setup is a stool for the model to sit on and a table on which she can rest her elbows, and on which you can place a large white reflector for neck fill. (You could also use a reflector on its own, without the table, if you prefer; a purpose-built front-fill reflector such as the Westscott Tri-reflector would do the trick.)

To achieve a perfectly white background in the final photo, place a white paper background a few meters behind the model, lit by two diffused monoblocks. Optionally, to further soften the backdrop, hang a large piece of tulle a meter or so in front of the background.

Then, install wooden baffles on each side of the model (and table). These baffles should either be painted white or faced with white polystyrene or foil. You will also need a third baffle, which can be a large piece of wood with a hole cut into the middle, through which you will insert the camera lens. As with the other two baffles, this third baffle should be painted gloss white or covered in white polystyrene or foil. In this way, the model is enclosed on each side, in front, and from underneath (using the reflector on the table).

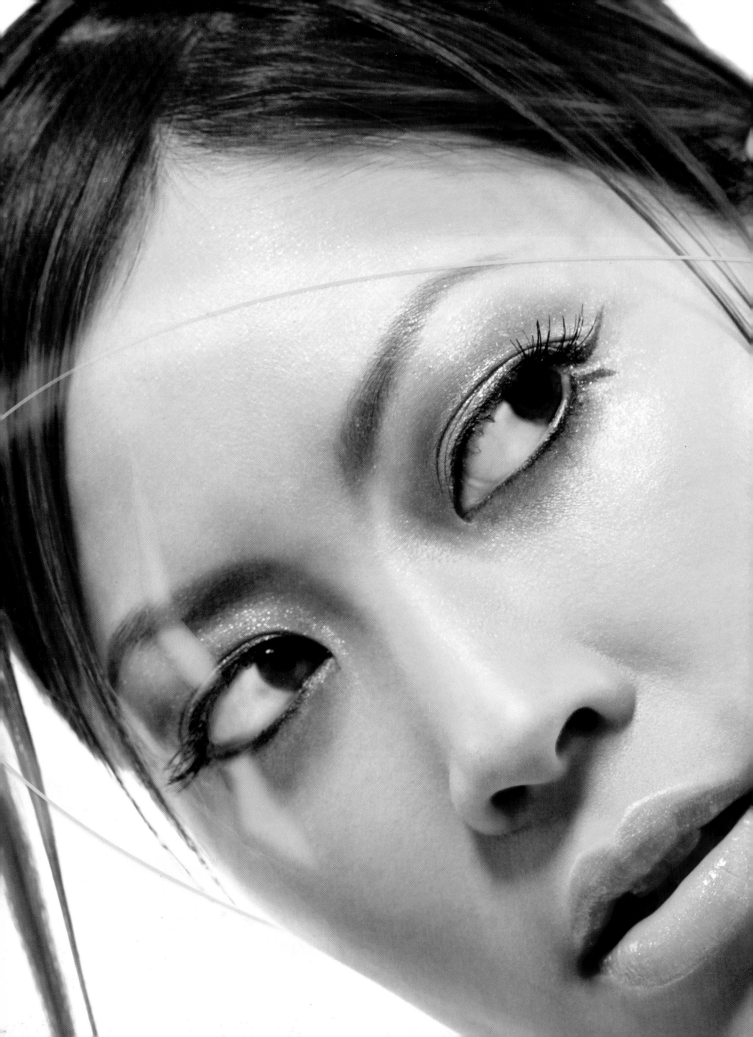

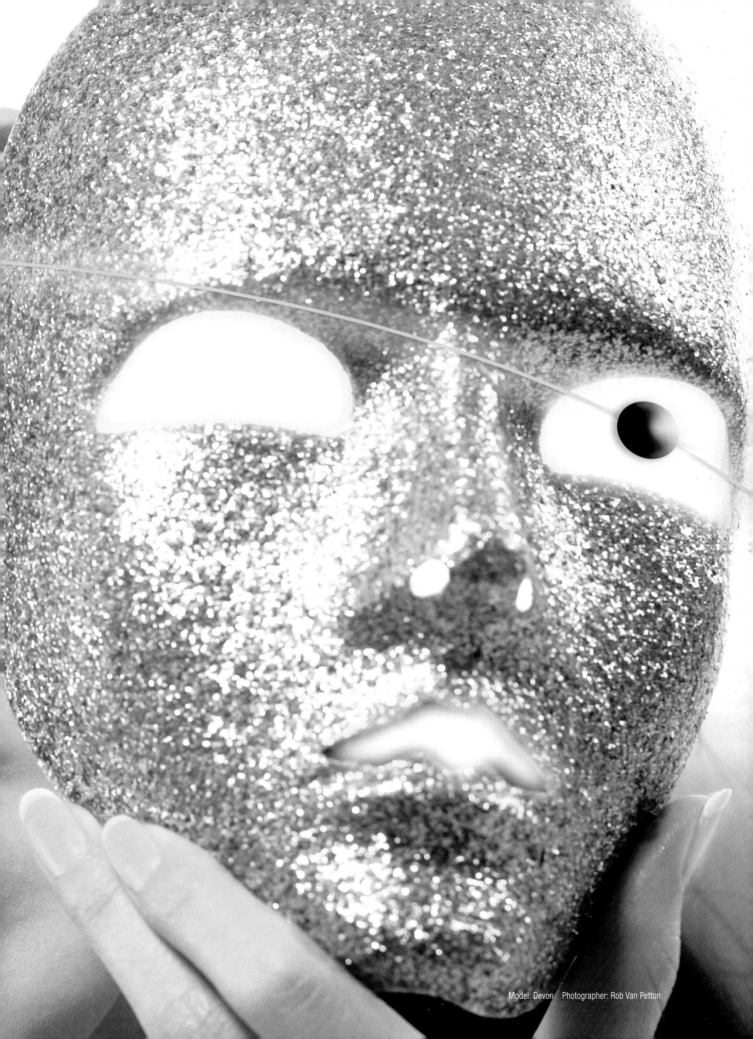

Model: Devon Photographer: Rob Van Petton

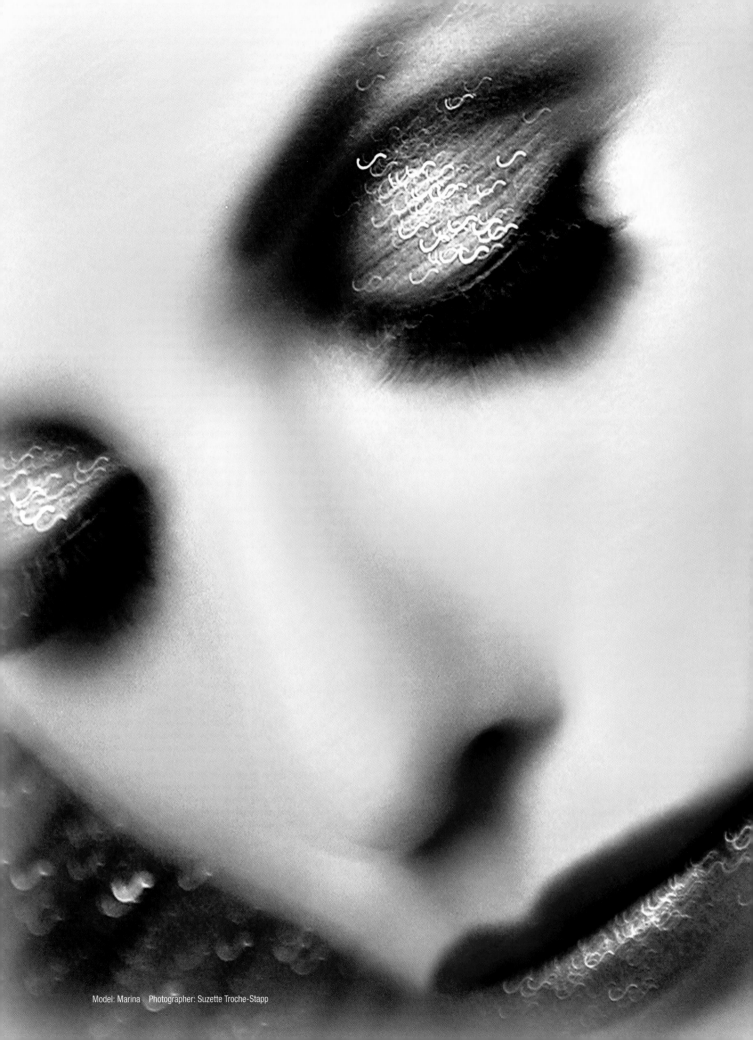

Model: Marina Photographer: Suzette Troche-Stapp

note

When I started out, a rig like this cost me roughly $50 and a few hours of gluing. I also built little stands for the baffles, but you might prefer to use some sort of SuperClamp plus C-stand combination to achieve the same result.

Next, add your primary lighting, which in this case involves either one or two monoblocks; with so many reflectors, you can get away with one softbox in a pinch, depending on how tightly you intend to crop. Because the model is more or less surrounded by baffles, you must place the monoblock and softbox on a boom attachment that is positioned above the baffles, pointing diagonally down. If you're using two monoblocks, you'll need two booms, which you can position on each side of the model, slightly in front. You might also use some beauty-specific attachments for your monoblocks, such as a beauty dish. You can purchase similar attachments for portable flash units and ring flashes. These provide similar functionality to a softbox, but are generally more compact; that said, they do not fold up, and can take up a lot of room in storage.

Last, mount the camera on a tripod (or, in my case, a custom fixture I have built into my front baffle), push the lens through the hole in the front baffle, and shoot. It is a good idea to warn the model before you shoot to ensure that she is prepared for a significant flash of light.

Lighting High-Fashion Photography

Whether a photograph is deemed "high fashion" is often very subjective; there are as many definitions of the phrase as there are photographers. For the purposes of this discussion, however, high-fashion photography involves the following:

- The model's styling is a little more extreme, involving, for example, heavy eye makeup, body paint, airbrushed colors, crystals or glitter, no eyebrows… the list goes on.

note

As you may have guessed, high fashion is one type of photography that requires you to rely heavily on your makeup and stylist team.

- The model is clothed in pieces that clearly will not be seen on the street—a lavish gown, luxurious furs, jewels, copious use of accessories, and so forth, all clearly expensive and exclusive. Of course, this is a generalization, but you will find it difficult to convince a broad audience that a photograph of a model wearing Wal-Mart *prét-a-porter* is "high fashion."

- The lighting is more textured. That is, a deliberate attempt is made to avoid the use of diffused light as a primary light source. In high-fashion photography, you will find strong shadows cast by the model onto the background or by an object onto the model. You will also see the use of colored gels over the flash or of incandescent bulbs to alter the cast—and hence the mood—of the image. You may also see deliberate attempts to eschew the usual rules of the 2:1 fill ratio, with higher ratios chosen to increase contrast on the model's face, even to the extent that one side of the model is in total darkness.

- The sets will be more extreme—either the ultimate in minimalist (for example, a shot of a model in a completely white room sitting on a white block) or extremely lavish (such as the use of the inside of a French château, with its rich wall textures and copious artwork in the background).

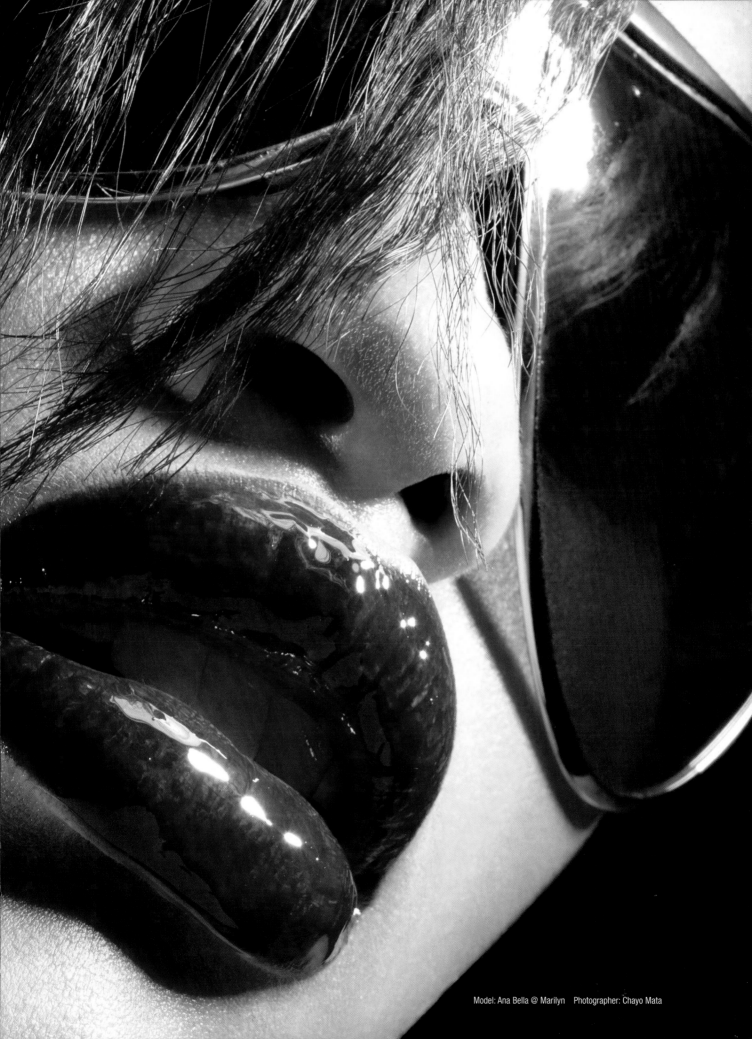

Model: Ana Bella @ Marilyn Photographer: Chayo Mata

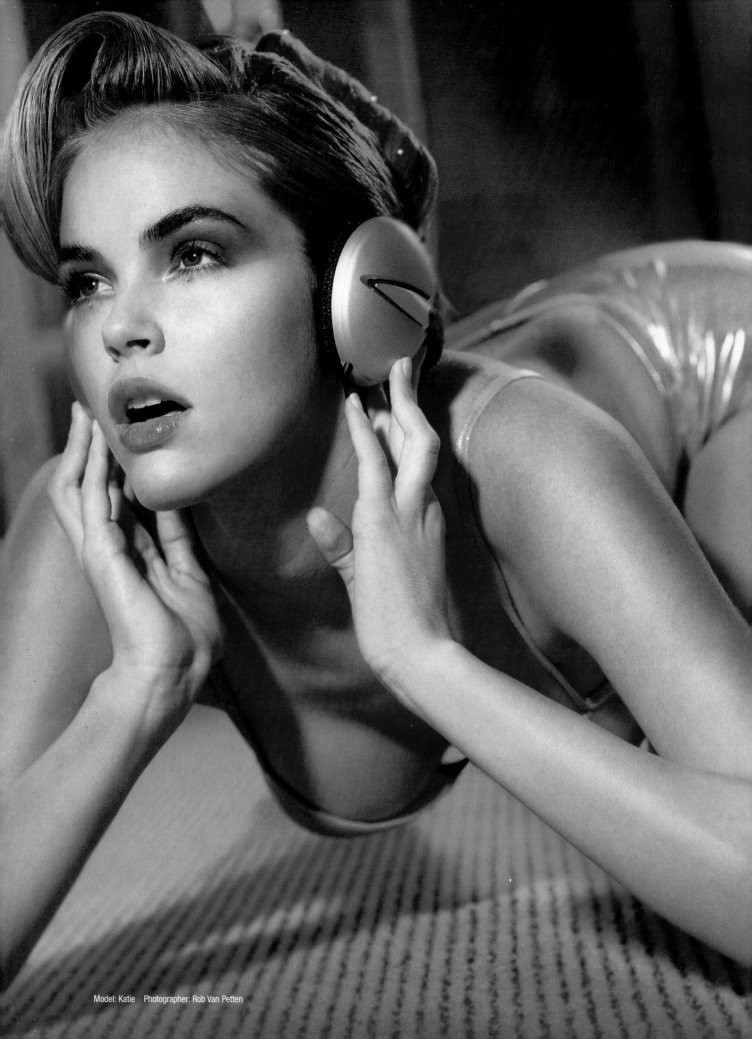

Model: Katie Photographer: Rob Van Petten

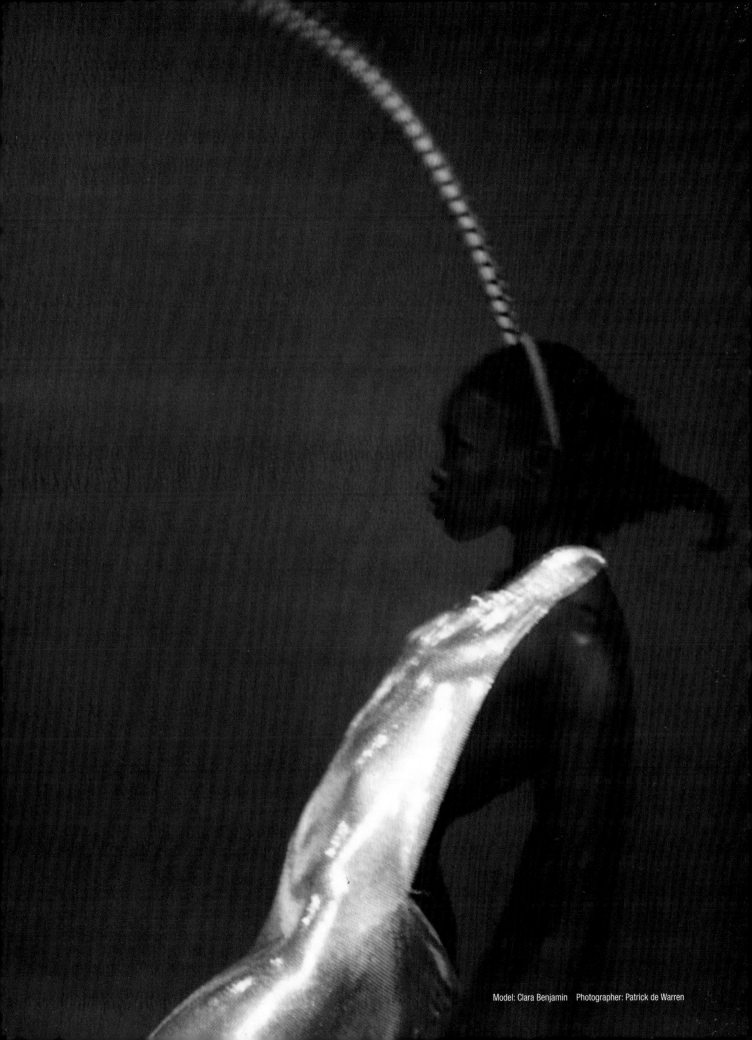

Model: Clara Benjamin Photographer: Patrick de Warren

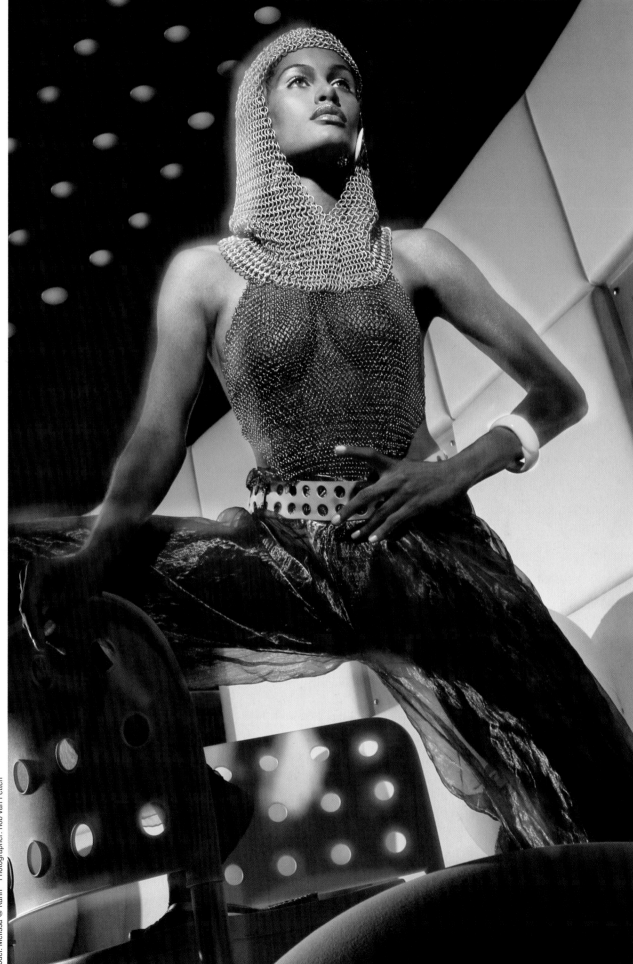

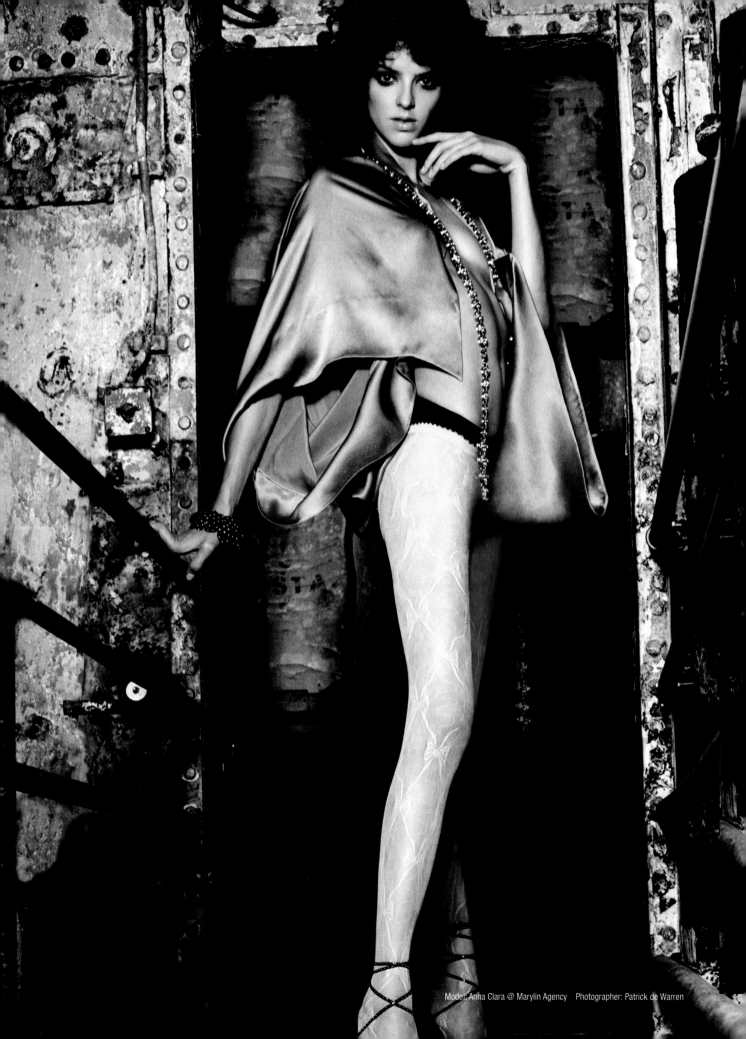

Model: Anna Clara @ Marylin Agency Photographer: Patrick de Warren

It is difficult to describe a single lighting setup that will result in an image being deemed "high fashion." As mentioned previously, however, you'll need to devise a lighting scheme that is more textured than the setups involved in test, glamour, and beauty photography. Indeed, it could be said that you will need to do the *opposite* of what I have described in the preceding sections. Your best bet is to experiment to see what results you can generate. Here are a few points to consider:

- Remove the softboxes from your monoblocks and install the basic reflectors that the manufacturer provided. This will result in harsher shadows being cast by the model and by elements of the set.

- Experiment with the position of your lights. For example, position the lights to either side of the model while maintaining a 2:1 ratio. Or, try turning one of the lights off and using a single side light. Alternatively, position the light immediately in front of the model, but placed low and pointing diagonally upward.

- Move the model closer to the background so that shadows become more visible.

Incorporating Natural Light in Your Studio

Natural light is very often already diffused (and hence flattering), and at certain times of day, is far more abundant than light generated by an electronic flash. When possible, you should try to incorporate some sort of natural light into your studio photography, especially in the following situations:

- A large window bank that illuminates the scene from behind the camera position can generate enough ambient natural light to illuminate your shoot, enabling you to eschew the use of the usual two or more monoblocks. You may need to add some reflectors to correctly illuminate the background. The color of the light—and hence the cast on the photo—will be influenced by the sky; if the sky is blue, you may need to place some diffusion material, such as white tulle or chiffon, in front of the window to further soften the light and to color-correct it. If the sky is cloudy, the light is already more or less white and diffuse, so the diffusion material is probably not necessary.

- If there is a large window that illuminates the scene or model from the side, you can prop the model against the window or sill. You see a lot of these types of shots in *Vogue* and *Harper's*. In this case, you will find that unless there is a significant amount of ambient light inside the room, that the sidelight on the model will cast strong shadows on the side of the model opposite the window. Although in some cases, you may *want* such a high contrast (often 3:1 or more), more often than not you will need to provide some fill on the interior-facing side of the model. To do so, use a simple reflector (white or silver for fashion, or half-gold for glamour) held by a reflector holder or, preferably, by an assistant who can adjust the reflector as the ambient light levels change. Alternatively, you can fill with an electronic flash; simply meter off the window facing side of the model and set the fill flash to the desired (typically 1:2) ratio on the opposite side.

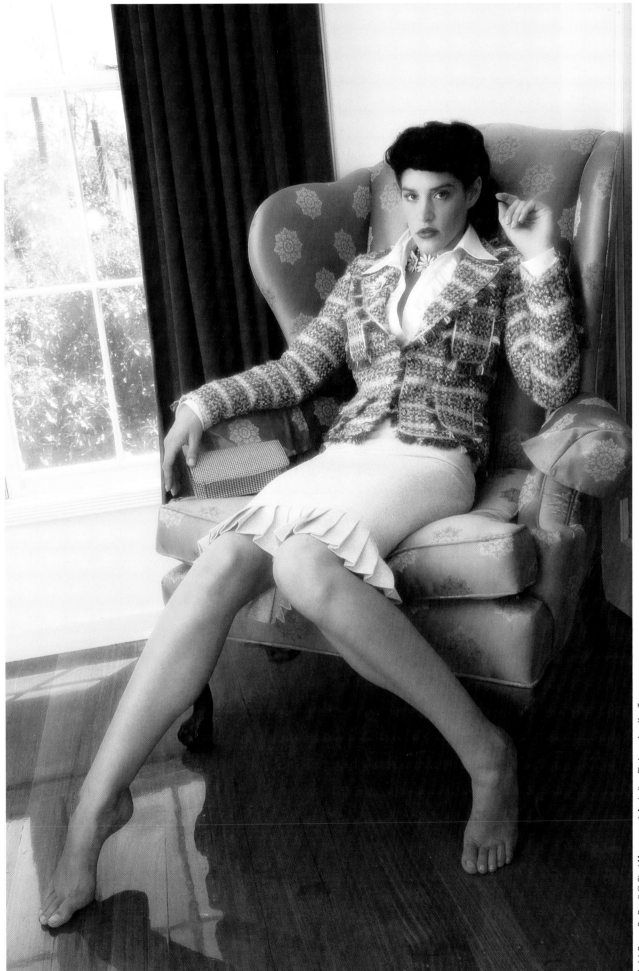

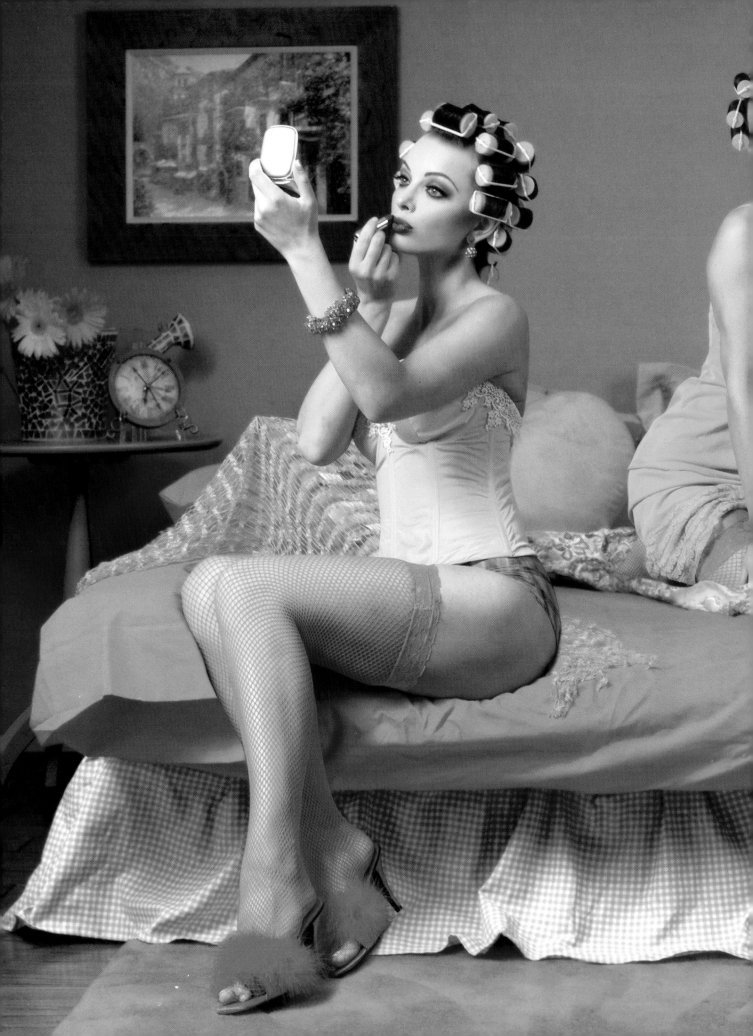

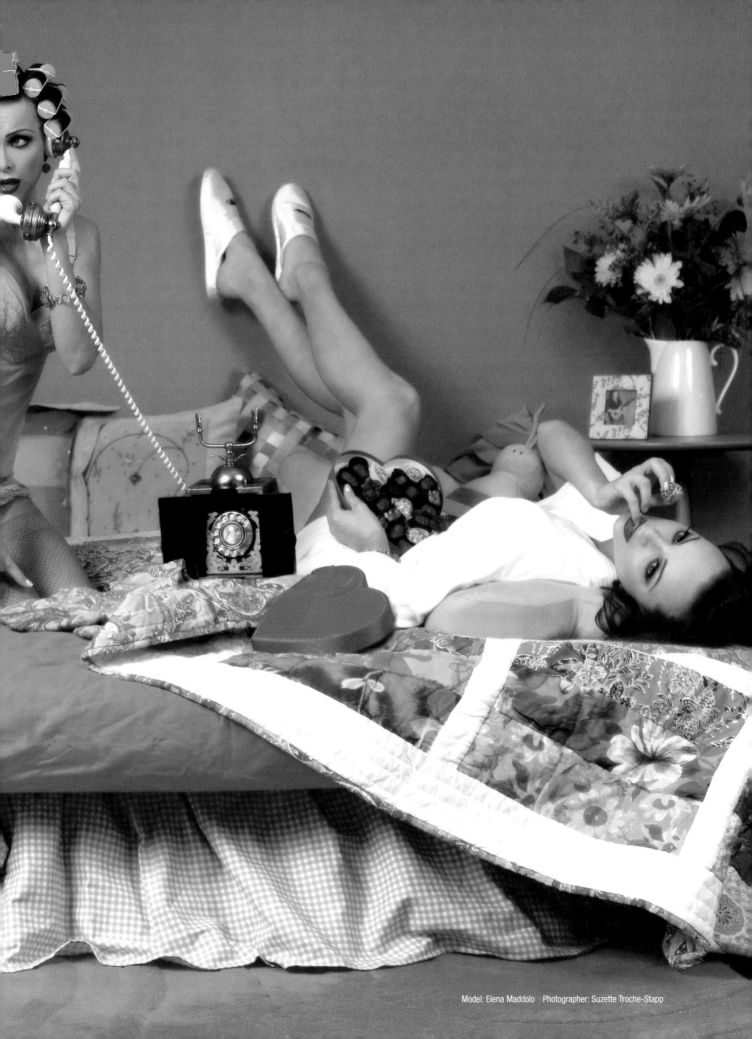

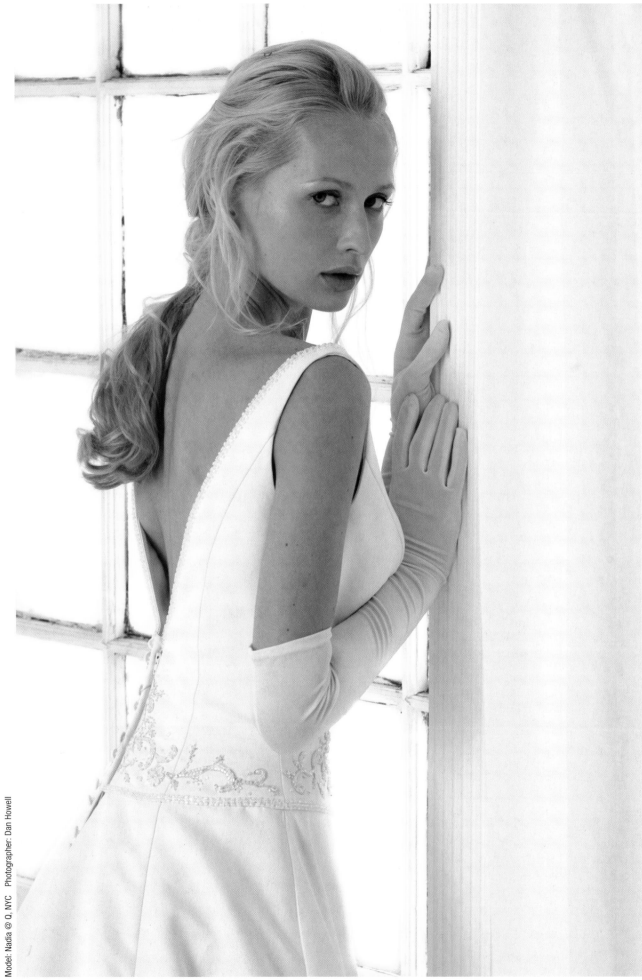

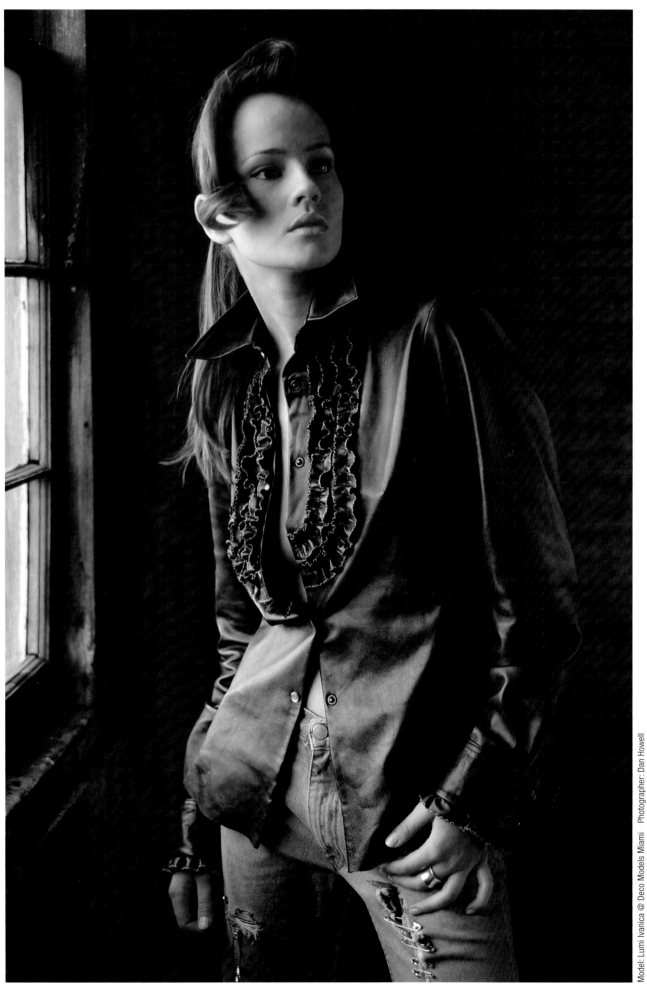

Shoot as Close to the Final Version as Possible

Just because you can effect significant changes to your image during post-production doesn't mean you should not attempt to shoot your photograph as close to its final version as possible. Why? If you take shots that need fundamental editing, such as lighting adjustments and so forth—which result in added costs, not to mention slowing down the pre-press process—you won't be too popular with your clients. It's far better to get things right the first time around. To ensure you get the best possible results, ask yourself the following questions before you release the shutter:

- Is the model in the right position?
- Is the crop correct? Although some photographers prefer to shoot a little wider to give them latitude in Photoshop, I try to crop the photo as near to the final image as I go.
- Are there any stray hairs or fluff on the model's clothing?
- Are the model's eyes in focus?
- Will the selected aperture provide the correct depth of field? This is where you will need to be able to imagine what the final image will look like based on aperture and the lens focal length.
- Is the model's shadow correct?
- Is the background appropriately lit?
- Will the shadows from set elements fall correctly?

[caution]

Unless the model is blinking, or if she is unintentionally out of focus or bleached out, you should not delete images as you go.

Although this may seem like a long list, with practice, this loop will occur in mere seconds. Once you're satisfied that the setup is correct as is, press the button to take the picture, simple as that.

With compact flash prices continuing to plummet, shooting RAW or Fine JPEG is not a significant financial burden. There are numerous online theses on why RAW is better, and I don't intend to debate this point here. I simply like being able to adjust white balance and such after the shoot, and prefer to do any image manipulation in Photoshop rather than rely on the in-camera processing.

The JPEGs are for quick review, either as you go or later for speedy contact-sheet creation. Art directors use these JPEGs to create short lists and to suggest adjustments to individual setups. They are also useful for creating contact lists and for the crew to watch between touch-ups. During more intimate shoots—for example, when it's just you and the model—you may want to review images with the model on the rear LCD of your camera. This review process is also useful for suggesting changes in poses and expressions.

note

You may sometimes shoot with the camera tethered to laptop (my preference is a 15- or 17-inch Apple PowerBook) both in the studio and on location depending on how your clients want to participate in the shoot. Most art directors like to be hands-on, so tethering is useful for these situations.

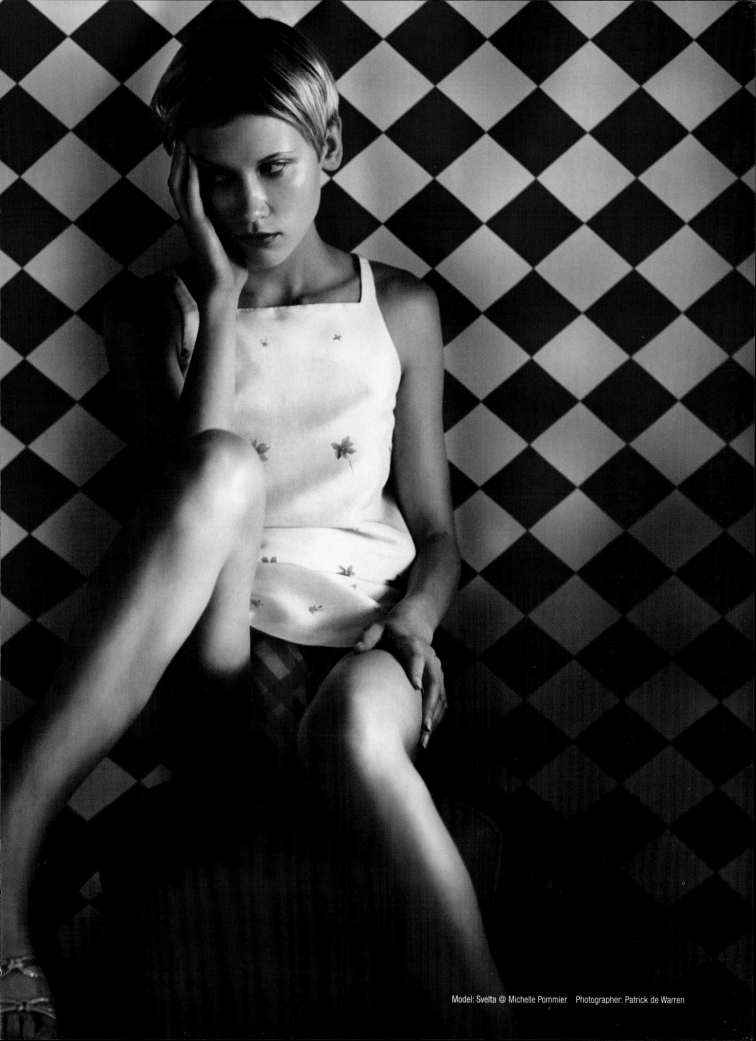

Model: Svelta @ Michelle Pommier Photographer: Patrick de Warren

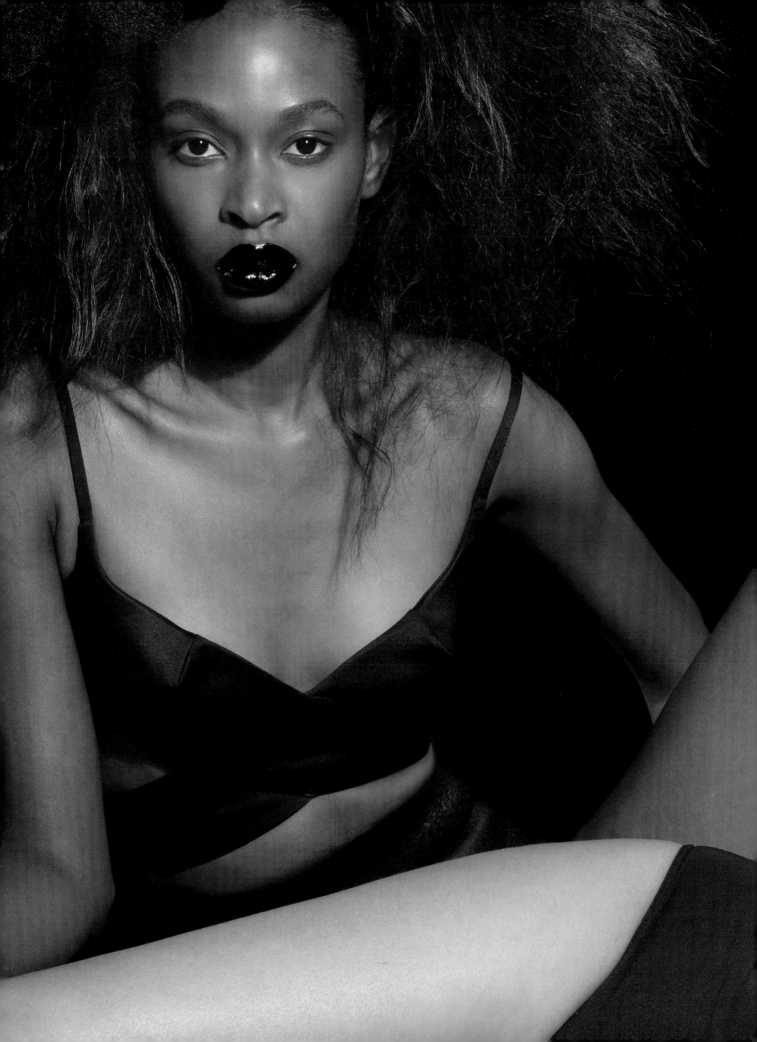

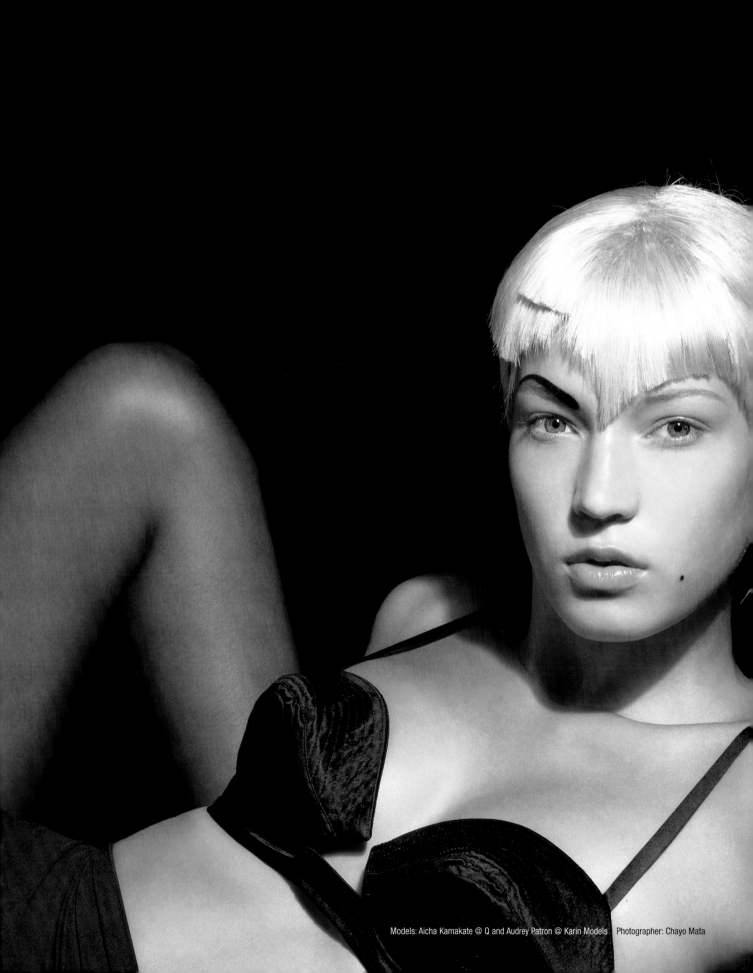

Models: Aicha Kamakate @ Q and Audrey Patron @ Karin Models Photographer: Chayo Mata

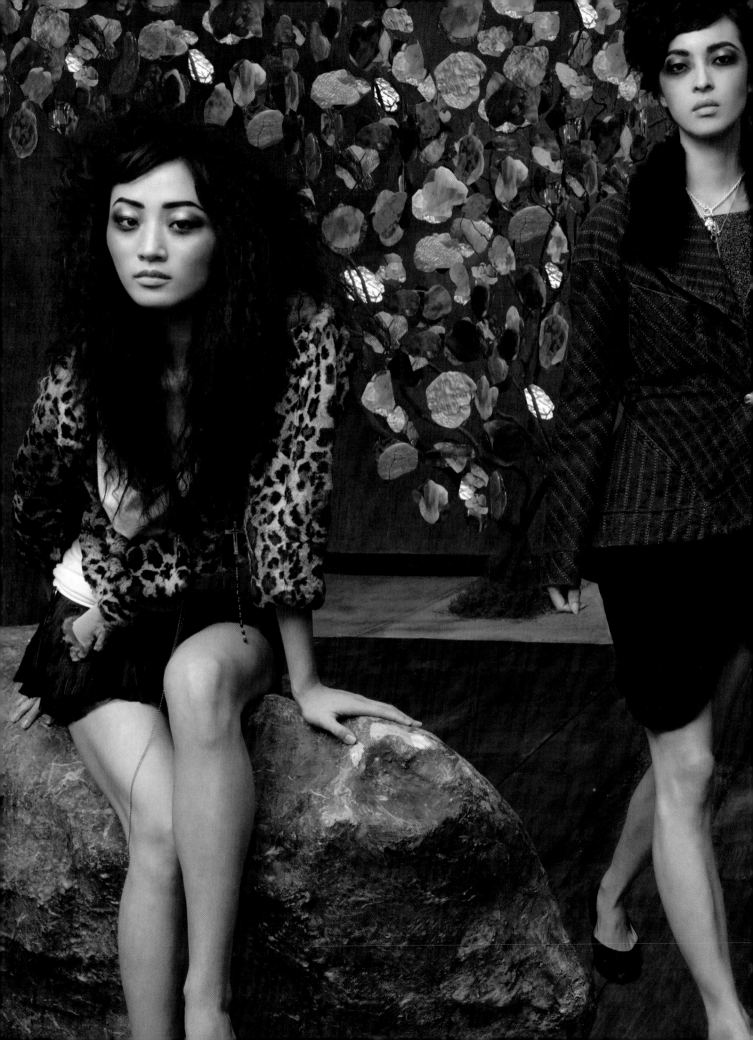

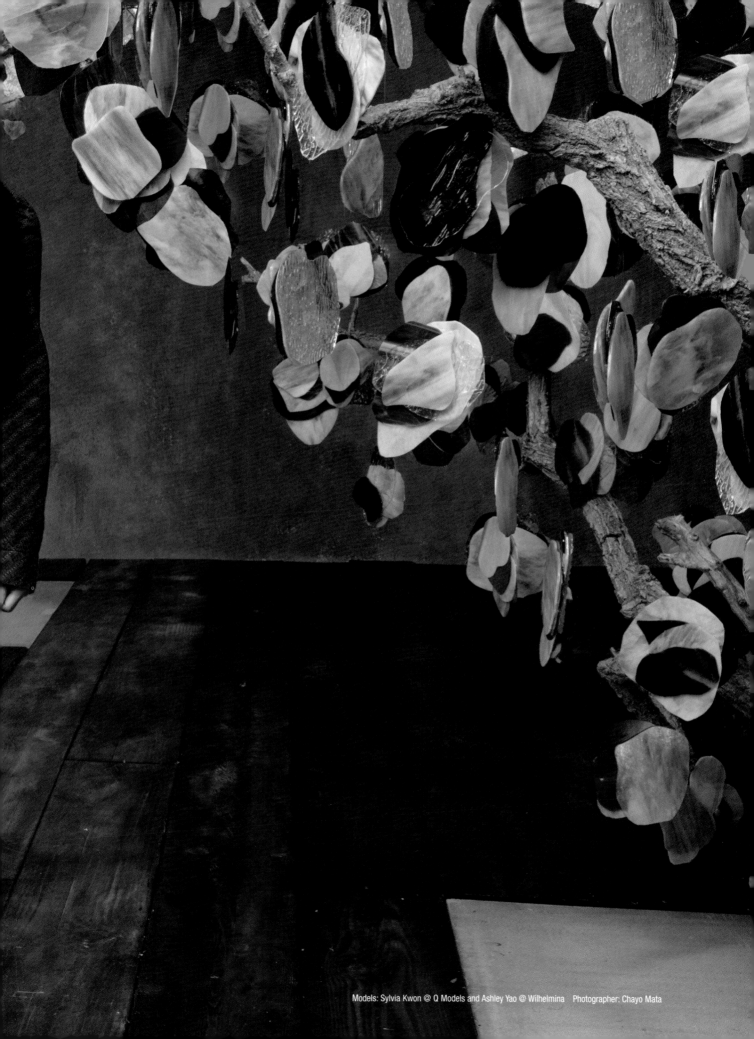

Models: Sylvia Kwon @ Q Models and Ashley Yao @ Wilhelmina Photographer: Chayo Mata

After the Shoot: Cleaning Up

Although some might say I exhibit a touch of obsessive-compulsive behavior, I always clean as much of my equipment as I can after a shoot. In my view, diligently cleaning up is a good way to maximize the life of my expensive toys. At the very least, you should wipe down your camera and the outside of the lens with an absorbing cleaning cloth (the kind you get from optometrists for cleaning spectacles)—particularly the rear LCD, the shutter release, and the front and rear control dials. This prevents the camera from taking on that shiny, worn-in look that occurs when plastic is over-handled. You should also use a blower brush on the lens, as well as blow any residual dust from the body of the camera. You should also wipe down all the power cords before winding them up and putting them away, and discard any background paper used in the shoot. (Some photographers reuse background paper to save a few dollars, but I find that having to Photoshop out the scuff marks, creases, and such that inevitably appear on reused paper is far too time-consuming—or, put another way, *expensive*.)

note

I generally do not clean the sensor until just before the next shoot because I find that dust often manages to gather on the sensor (most likely from the crevices around the sensor) when the camera is in storage.

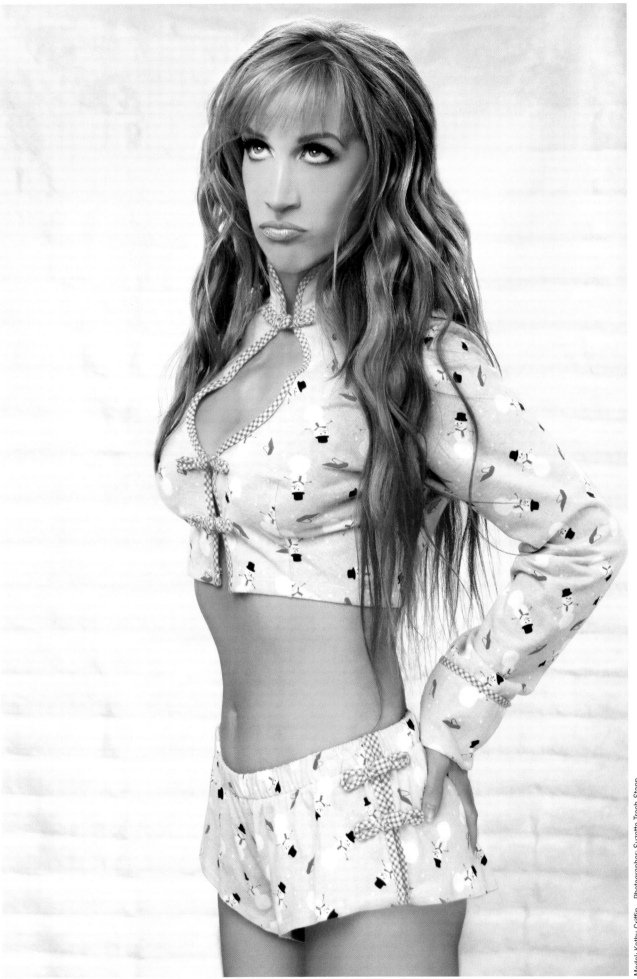

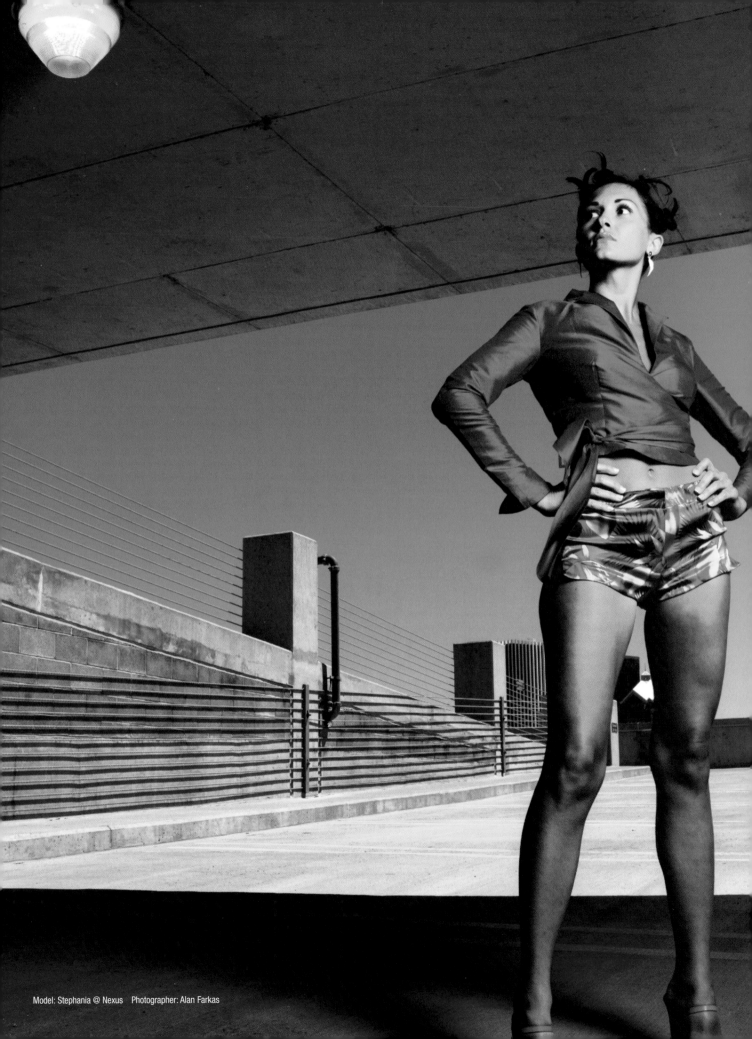

Model: Stephania @ Nexus Photographer: Alan Farkas

CHAPTER 5

Location Work

Location shoots are far more complicated than studio shoots for a number of reasons. First, especially if you are shooting outdoors, you are at the mercy of the elements. Second, when shooting on location—be it in a field, on a beach, in the street, or inside a house or public building—you may or may not have access to power. Third, there may be times when you do not have total control over all aspects of the set. For example, if you are shooting in one of the grand stairwells in the Palace of Versailles, you can't simply move a sculpture because it is in your way!

Now the good news: Properly selected locations can add a level of depth and texture to an image that is not possible even in the most elaborate of studio sets. In addition, most outdoor locations are also solar-powered, enabling you to easily harness the ambient light to provide diffuse and flattering light for your model and set, all while minimizing your equipment load. This chapter is loaded with tips and tricks to help you keep your location shots running smoothly.

Scouting Locations

As a fashion photographer, you should make it a habit to continuously scout for locations as you go about your daily life. For this, you might want to keep a point-and-shoot digital camera handy; I usually carry a Canon Powershot 4 Megapixel camera in my car's glove compartment or in my wife's purse. That way, you can take a quick snap of a great location. I keep a database of these locations on my laptop and can recall them during pre-planning sessions with clients or agents, and I urge you to do the same. You should also keep notes on each location, including such information as whether you need permits to shoot there.

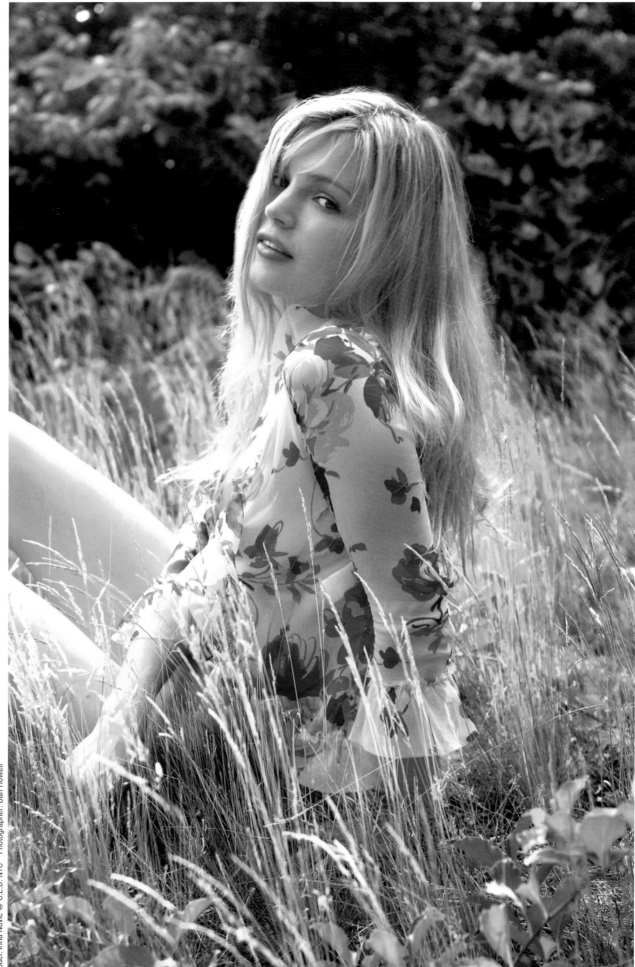

When selecting a suitable location for a specific shoot, you need to keep in mind how you want the final image to look. Ask yourself the following:

- What is the image meant to convey? An urban or provincial feel? Simplicity or complexity? Brightness or darkness?

- What will the model be wearing?

- Will the model be standing, walking, or interacting with an image element or with other models?

- What will be in the background?

- Should the model stand out from the scene or blend into it?

- Do you want the colors found at the location to be of a similar palette to the model's makeup or clothes, or to stand in stark contrast to them?

Hopefully, asking these questions will help you develop a short list of potential locations. To make your final selection, you'll need to visit each location—ideally, accompanied by the art director, stylist, and makeup artists. Each member of your team will have unique requirements for the day—power for a hair dryer, a place to set up the touch-up table, the ability to match the color of the foliage to the rest of the spread in the magazine—and will be able to provide their perspective on the site's suitability.

Before you visit a prospective site, however, take the time to study a map of the area. Doing so can help determine whether the site is suitable, and thereby help you avoid unnecessary travel. For example, if from the map you can determine that one beach location runs north-south, thereby allowing three hours of golden light at dusk, while another runs east-west, which means the sun will always be perpendicular to the water line resulting in a side-lit model, you may want to choose the former. You may also select a more secluded beach over a public thoroughfare beach so you don't have to deal with the added complexity of managing on-lookers. After you have ruled out all other candidates, you should visit the chosen site or sites and establish exactly where you will set up for the shoot, where the support areas will be, and what equipment you will need to bring.

[tip]

It is quite common, particularly in the Los Angeles glamour industry, for photographers to rent Hollywood Hills or Santa X (where X stands for Monica, Barbara, and so forth) mansions for a few days for their shoots. If you decide to do the same, you have the added benefit of being able to look at online sites and to work with real estate agents to shortlist candidates, allowing further culling before having to actually get into the car.

note

Commercial clients generally do not tolerate pre-press delays due to weather. If you are planning to shoot in a location that is subject to rain or excessive wind, establish at least one backup location within a short distance (that way, you avoid wasting significant time traveling from one site to the other). Alternatively, consider ways to modify your shoot in order to make use of the inclement weather. I was once caught unprepared by a rainshower when shooting at a historic house in the countryside; we moved the shoot to the house's veranda and created some wonderful images of the model with the rain clearly visible in the background.

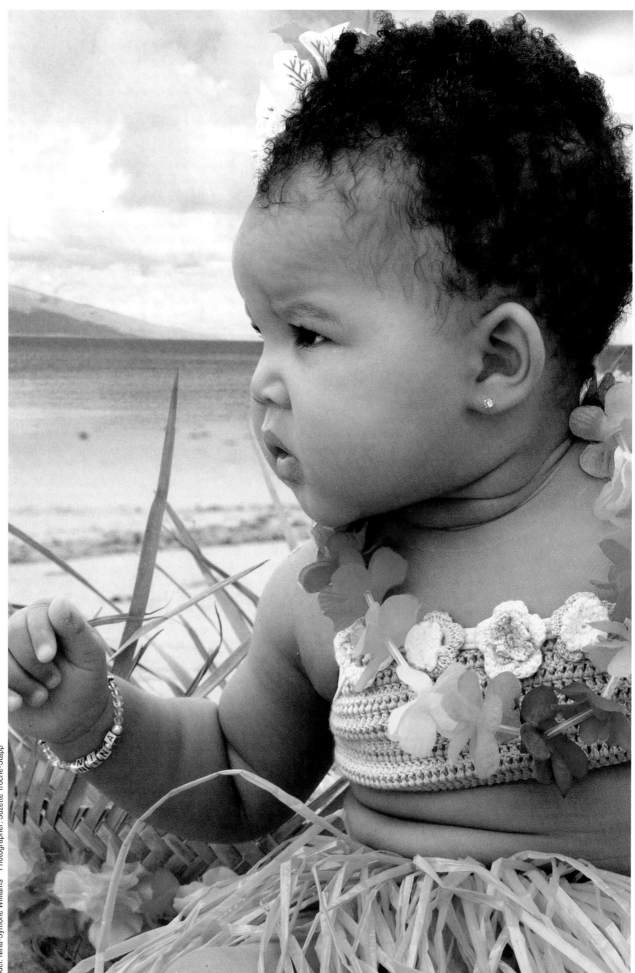

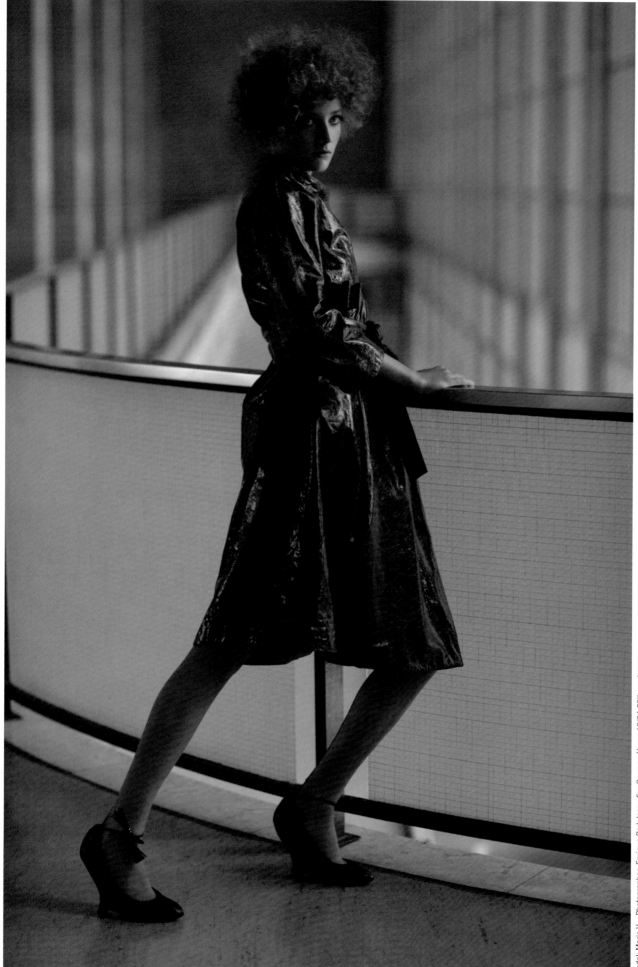

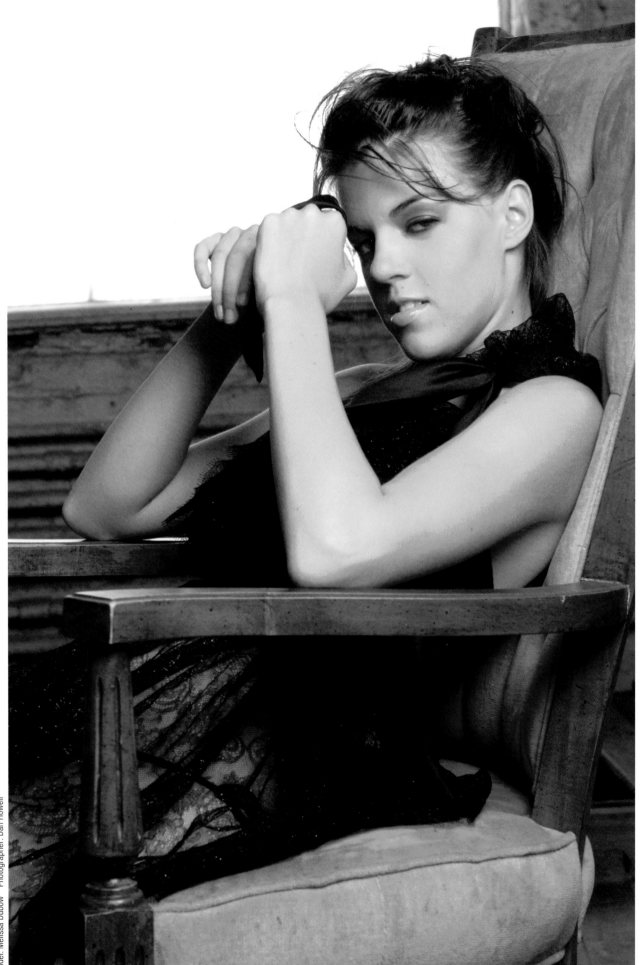

Bring Your Own Power

If you are on location at a facility that offers mains power, then you can tap into that power to use the same equipment and lighting setups as described in Chapter 4, "Studio Work." In the vast majority of location shoots, however, you will need to bring your own power sources for your lights and equipment. For the average shoot, you will need adequate power to supply juice to a few monoblocks, to your camera, and to one or more laptops. In some cases, you may also need to power wind machines and other lighting equipment such as flood lamps to illuminate the set or to provide working lights for the crew. There are many ways to provide power on location:

- Self-powered equipment
- Automotive battery
- Generators

Self-Powered Equipment

Self-powered equipment is the most fundamental of all location equipment. This category of equipment includes camera-mounted flashes (I have a whole bag of Canon 550EX, which are set up for wireless TTL), cameras (you should always bring sufficient batteries for the entire shoot, and then a couple more spare), and of course laptops. Also in this category is the broad range of high-powered portable flash units and battery packs, such as the Elinchrom Ranger RX, Profoto Pro-7b 1200, Hensel Porty Premium, Quantum Q-Flash, and Lumedyne Signature Series. These are usually more expensive and heavy but provide significantly more light than their camera-mounted equivalents.

For my location work, assuming no mains power is available, I have multiple sets of equipment, depending on the nature of the shoot. Most frequently, I use a Quantum rig, which I assembled from various off-the-shelf components. This rig is comprised of two Quantum Q-Flashes (one a T2 and one a T4D) mounted on a Manfrotto four-point T-bar and a self-standing Manfrotto monopod. Each flash is attached to the T-bar with a basic hexagonal Manfrotto mounting plate, which allows each flash to be removed for storage. Underneath the T4D is a Quantum Turbo Battery Compact, which powers this flash, and the Quantum

FreeXwire wireless transceiver, which is attached to the T4D using a Quantum L bracket. The T2 is powered by an older standard Quantum Turbo battery, which sits below the rig and provides additional stability (this acts like a small sandbag on the monopod legs). In the long term, I will likely replace this battery with another Turbo Compact, in part to improve the weight balance of the rig. For the time being, however, I figure if it ain't broke, I'm not going to fix it. Each flash is also fitted with a Quantum mini softbox, and each provides more than 100 watts of diffused light.

> **note**
>
> I chose to describe this particular location lighting rig in part because I wanted to demonstrate that it is relatively easy to design and build your own lighting equipment from off-the-shelf components, and in part because I don't believe anyone else has built this exact rig, which meets some of the most common location-photography needs, even though the components are readily available.

This dual flash rig is adequate for the vast majority of my outdoor shoots, where I don't need a lot of light. The flash heads can be individually pointed subject to their own degrees of freedom, but you can get extra degrees of freedom from the additional controls on the T-bar. Using these controls, you can move the flashes closer together, rotate each flash in the vertical plane far more than within the constraints of each individual flash's degrees of freedom, and even fully invert each flash to make the rig more compact to fit in a tight spot. Plus, in case you want to add yet more flashes, there are two more mounting points on the T-bar—one on each end. To mount the additional flashes vertically on these points, simply add standard tripod heads (set to 90-degree rotation). Although this rig is fully self-standing, I usually get one of my assistants to hold the monopod, with the Quantum Turbo battery slung over one shoulder. This allows more dynamic positioning of the light.

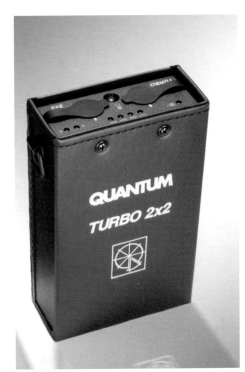

Hensel Porty by Hensel

Quantum Turbo 2×2

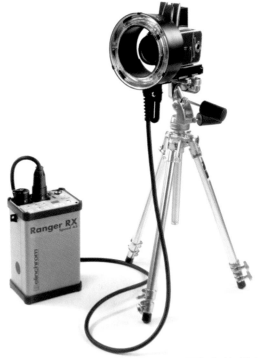

Ranger RX Ringflash by Elinchrom

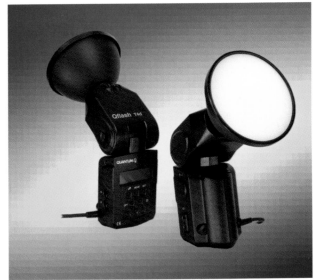

Quantum T4D flash

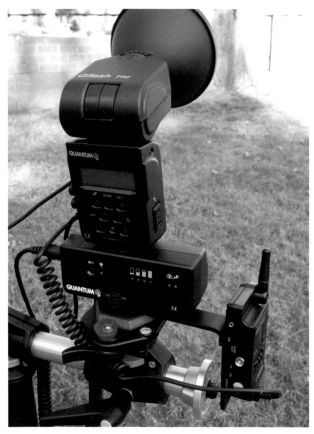

Ken's Quantum rig

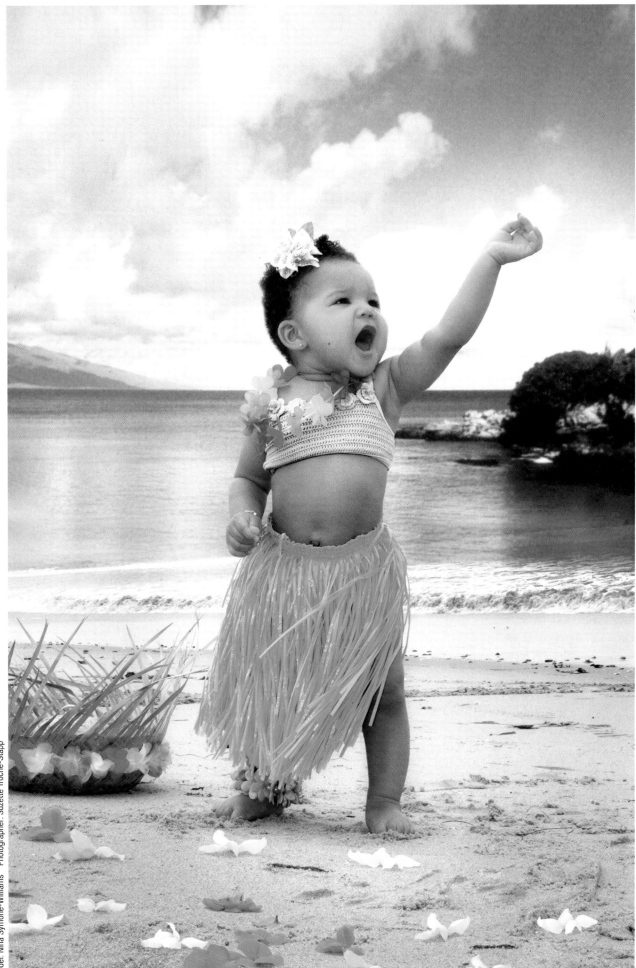

This light rig is triggered by a Quantum FreeXWire transceiver on my camera, mounted via Quantum's TTL adapter dedicated to my camera. There are a number of ways to set up the two flashes, but for most of my shoots, I have the T2 as the slave of the T4D, which is subsequently triggered from my camera. As such, when I press the shutter release, both flashes fire, and with the TTL adapter, I get wireless TTL similar to what I can get with my 550EXs— but with a lot more light output. That said, very often, I also use this rig in full manual mode. In that case, I use the wireless metering mode on my hand-held meter and manually set the output levels on each flash. Alternatively, you can keep the flash units at, say, f8 or f11, and move the rig back and forth to achieve the desired light output at the model's position.

Quantum Turbo battery compact

note

There is no reason why you could not have multiple sets of this rig. The FreeXWire can trigger multiple units, so it is conceivable that you could have a number of assistants positioned strategically around an outdoor scene (for example, a large group photo at sunset), each with one of these rigs to provide additional illumination to your camera-mounted or to some other front-on primary flash.

When you need more power, you may have to use a different set of self-powered equipment. A typical battery-powered location lighting setup may involve equipment such as a Hensel Porty Premium 1200-watt battery pack and flash heads. The powerpack in this system provides two sockets with asymmetrical power output, a built-in radio slave, and the ability to attach a high-power ring flash. The unit's battery is removable, so you can have a few of them charged and ready to go for extended shooting. The powerpack's charger also works from a full range of input voltages and frequencies, making this a great unit for traveling.

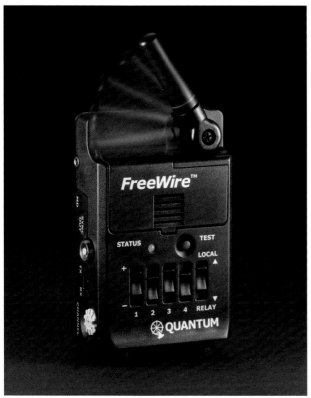

FreeXWire by Quantum

[tip]

If you use such equipment infrequently and cannot justify the high price tag associated with this gear, consider renting this equipment as needed.

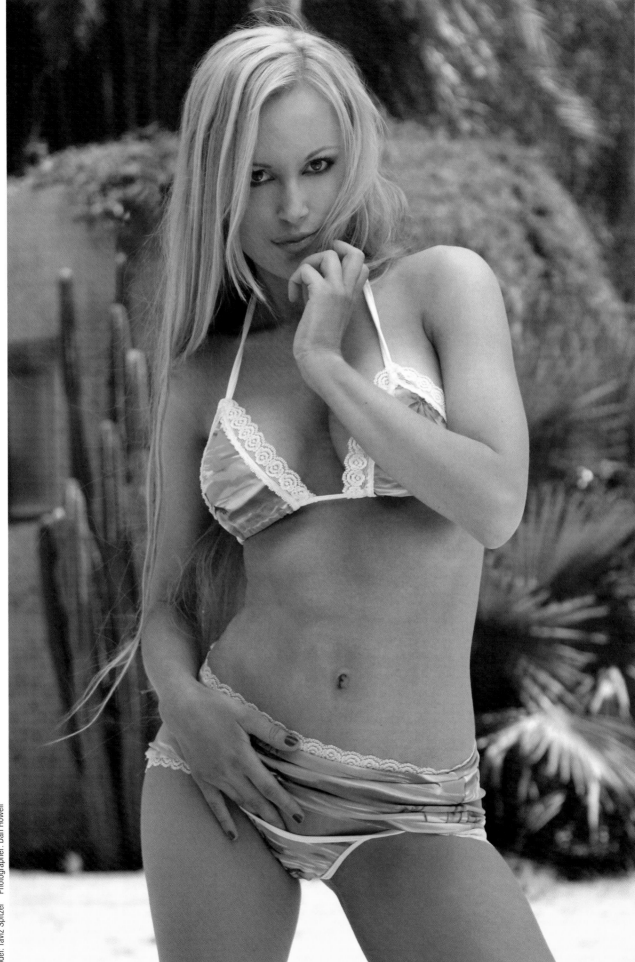

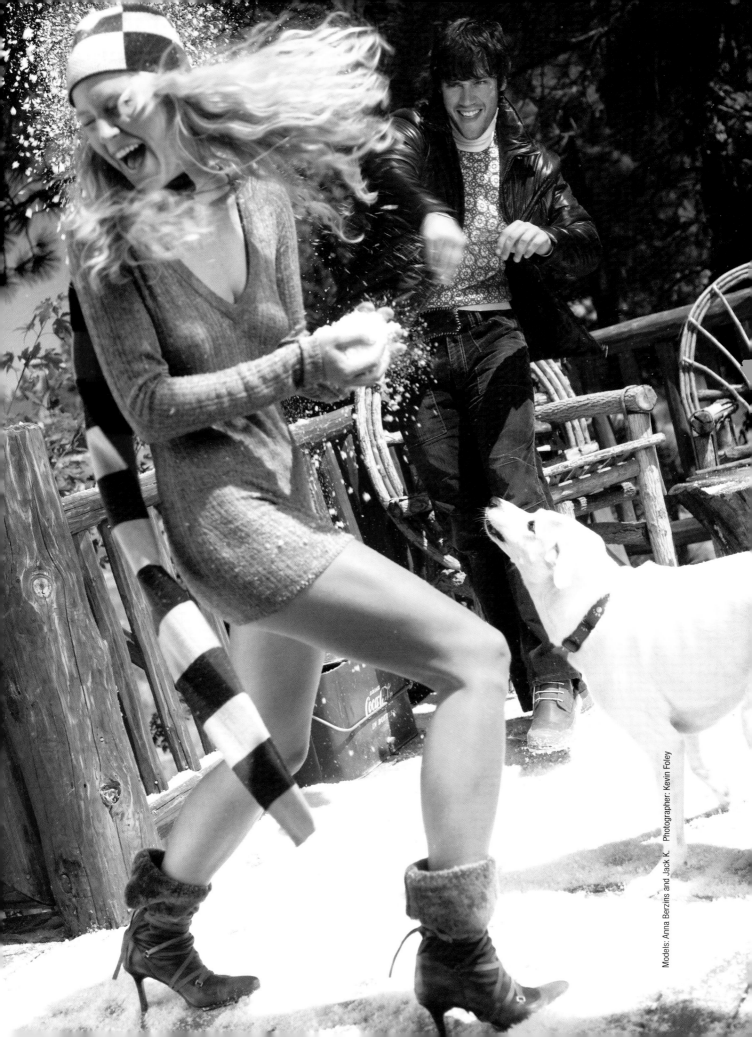

Automotive Power

When possible, you can use the lighter socket in your car to power some of your equipment. To achieve this, you should have several automotive inverters as part of your location kit. Although these units are not up to the task of powering a mains-powered monoblock, they are perfectly adequate for powering a laptop or charging smaller battery-operated equipment such as cameras. (Note: Having the review laptop attached to the car socket enables you to provide a relatively quiet area for reviewing images, away from the bustle of the main set.)

[tip]

If you use these automotive chargers, you must remember to start the car every so often in order to keep the car's battery charged. The number of times someone has forgotten to do this and nearly flattened the car battery defies reason!

Generators

For larger shoots that require numerous lights and other equipment, and for extended shooting, consider using a petrol- or diesel-powered generator. These are commonly used as backup generators at holiday houses and provide near–mains quality power. Generators can be rented from local suppliers and usually last a few hours before having to be refueled. When using a generator, it is critical to keep it as far from the set as possible, due to the associated noise and fumes. That means you'll need long extension cords to get the power to the set; these cords must be securely fastened down to avoid injury.

Powering Overseas Shoots

Photo shoots often occur in overseas locations—often in locations without good-quality mains power. Depending on the size and budget of your shoot, you can either carry all the equipment you need with you or arrange to rent larger equipment from local suppliers. Although it is risky to rely heavily on rental equipment sight unseen, these days, most major destinations do have reliable rental facilities of some sort. Renting equipment also offers the benefit of helping you avoid high transport costs, particularly if your travel involves flying.

The larger issue is that in many locations, the quality of the mains supply is sufficiently poor that powerpacks, chargers, and even laptops and cameras may not charge or function appropriately. This is mainly a problem in developing countries. If you know the approximate duration of your shoot, pack sufficient pre-charged batteries to make it through. For example, a Quantum Turbo battery compact will provide at least a few hours of shooting, so for a two-day shoot, packing 4–6 of these small units in your hand luggage will do the trick.

You will also find that in these types of locations, more modern, digitally controlled lighting gear (for example, equipment with LED readouts) is more prone to malfunction in these situations. If you know you will be shooting in one of these locations, you might want to pack older, analog powerpacks, which have been tried and tested to work despite significant mains frequencies variations (like what I once experienced in Southeast Asia, from 20–75Hz, all within a few minutes).

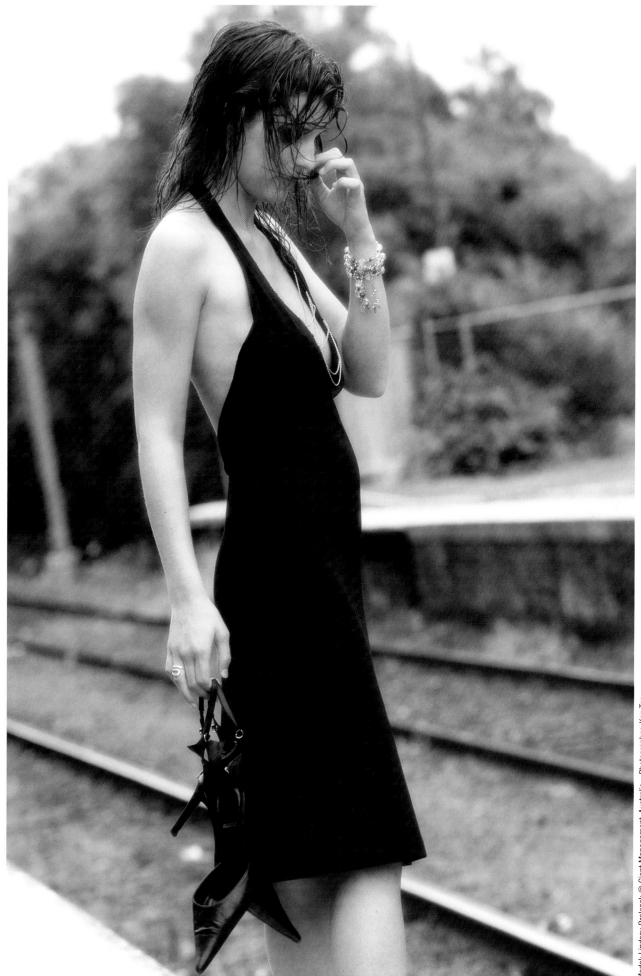

Shooting on Location

As with a studio shoot, shooting on location involves good planning. In this section, I discuss the ins and outs of shooting at these common types of locations:

- On the beach
- In the water
- In public buildings, in parks, or on city streets

Shooting on the Beach

In order to shoot on the beach, you'll need two key pieces of equipment:

- Scrims
- A flash setup

Scrims

Conventional wisdom dictates that the best times to shoot are from around sunrise to about 10 a.m., and from about an hour before sunset until just after sunset. But if you are shooting, say, a swimwear catalog with 50 pieces, even with a pipeline of multiple models and an army of stylists and makeup artists, you simply cannot fit that many shots into the hours when the natural light has the necessary soft, golden quality.

This is where scrims come in. Scrims are very useful for controlling extraneous light, but more importantly, for filtering and diffusing light to provide flattering illumination for the model. A *scrim* is comprised of a large piece of opaque or translucent material stretched across a large, collapsible frame—a good size is 72 inches (180 cm) square. For simplicity, I have taken some poetic license in this section, and have referred to the large range of light control panels generically as *scrims*. Like reflectors, these light control panels come in a range of shapes and sizes. Round ones are called *dots*, long, skinny ones are called *fingers*, and so forth. Scrim Jim (a Westcott brand) produces a range of light-modification materials and frames that are perfectly suited for location and studio shoots. Using scrims, you should be able to shoot more or less from dawn to dusk with a significant supply of diffused, flattering light.

[tip]

This equipment can be a bit expensive for those starting out. If you find it's outside your price range, it is usually possible to hire scrims or to even make them yourself by stretching cheap white sheets across thin PVC tubing from a plumbing-supply store.

Of course, a scrim is comprised of 36 square feet (over 3 square meters) of material, which in other circumstances would be considered a reasonable sail. As such, with typical sea breezes, it is not uncommon for scrims to simply blow away. Fortunately, many larger scrims today contain small slits in the material to allow some wind to pass through, which interferes with the aerodynamics of the sail and reduces the chances of the scrim blowing away. Beyond that, to hold a scrim in place, use C-stands with Super Clamps, and in turn use a number of sandbags or what have you to hold the C-stands in place.

Flexdrop for Location by Photoflex

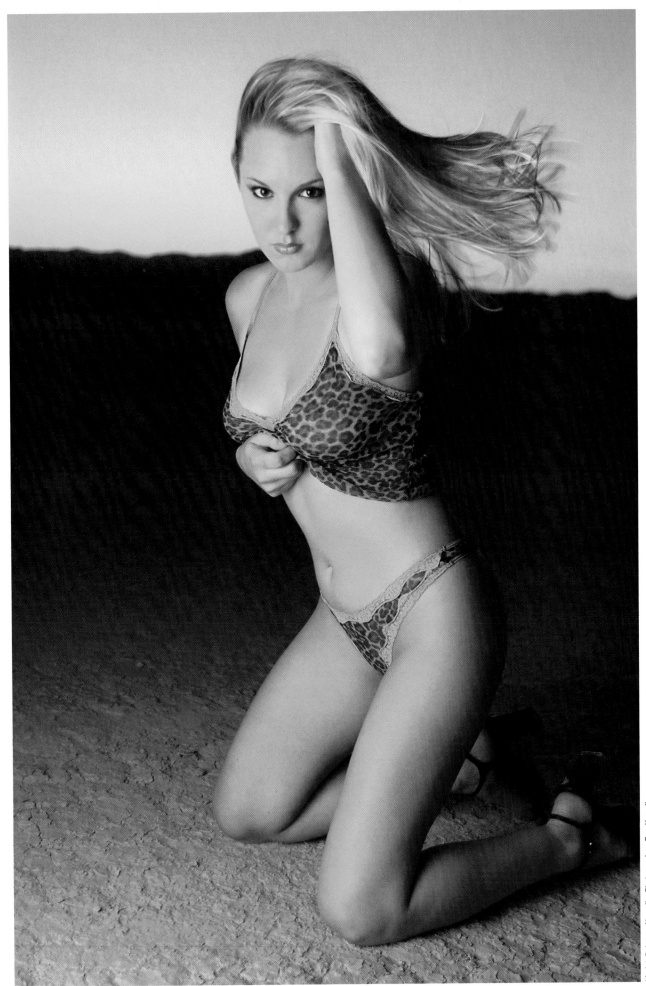

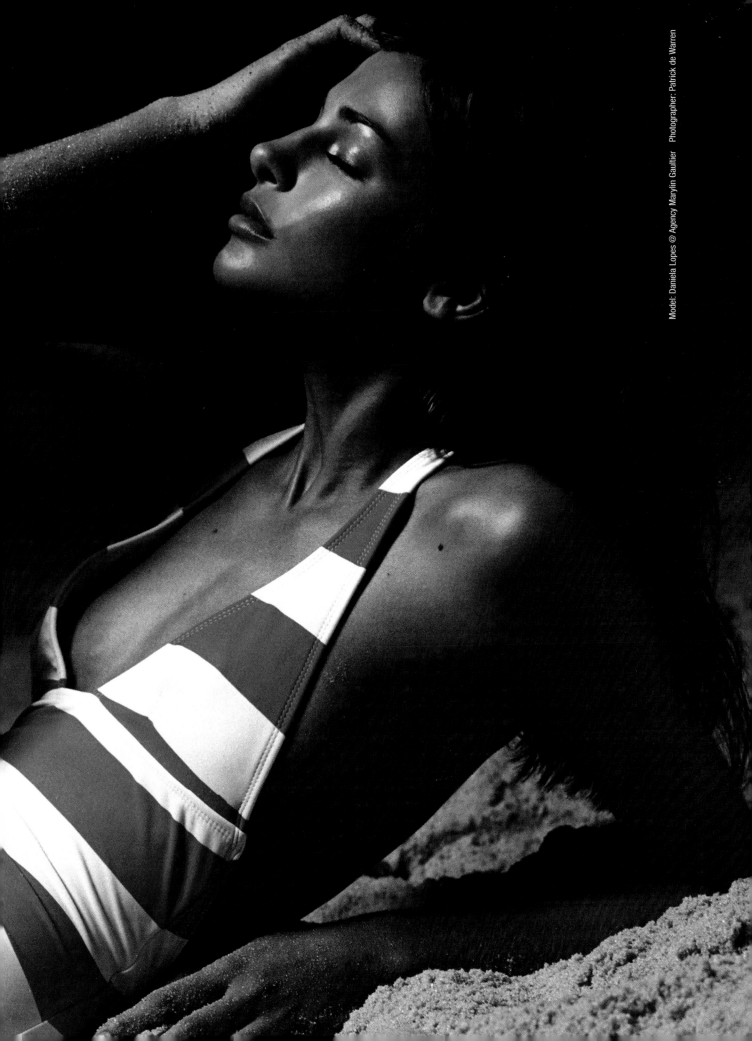

For most beach shoots—that is, shots on the beach with the sea behind the model—you will need three scrims: one above and one on each side of the model. The top scrim does most of the work, filtering and diffusing the light as well as providing shade to the model between shots. The side scrims filter scattered light from the side, as well as provide a modicum of privacy to the model, who may often be in various stages of undress. Scrims can employ a range of materials, from opaque black to a 1/2-stop translucent to even chroma key green; for a typical beach setup, you should use 1-stop or 3/4-stop translucent material on all three scrims.

[tip]

When you read the labels on the scrim material, the "f-stop" rating refers to how much light the material will block. (Opaque material blocks all light, and as such will not have a rating.)

I usually set the scrims up above the high-tide line, at least 30 feet (around 10 meters) from the water. This ensures that you don't have to move the scrims as the tides change. Growing up in Australia, you spend a lot of time at the beach and you quickly learn not to place your towels too close to the water. The same principle applies to your far more expensive and fragile photographic and lighting equipment.

[tip]

In addition to the scrims, a relatively inexpensive way to provide a shady place for models to change or for you to review your shots is to purchase a "sun-smart" tent, available at beach recreation stores. These collapse to a small bag and are also handy for storing items that are heat-sensitive, such as your lunch.

Flash Setup

After you have set up your scrims, you can turn your attention to your flash setup. My standard beach rig comprises some combination of on-camera flash (remember, with the scrims in place, the model will already be illuminated, so the role of the flash is principally to provide fill or highlights) and a ringflash with a shoulder-mounted battery pack or my trusty Quantum wireless rig.

note

This discussion assumes you have ready access to light-control equipment, such as scrims. If you don't, look for a shady spot near the water, such as under a jetty, in the shade of a beach bathing box, or the like. Although this is not ideal, it will provide you with shade during the middle of the day, and you can apply the flash techniques described in this section.

Although you can always rely on TTL metering, I find that the camera's on-board metering sometimes gets confused by light reflected from the water and ends up slightly underexposing, even if you use spot-metering mode. As such, it is a good idea to use your hand-held meter to manually set your flashes' light output. For such shots, you should shoot with a longer focal-length lens (for example, my trusty Canon 70-200 2.8L IS) to shallow up the depth of field. You will still meter off the model's face, targeting f8 with the flash; due to the longer focal length, you will find that the model will be in sharp focus while the background is pleasantly blurred. If you want the background more in focus, you should use a shorter lens. This allows more depth of field at a given focal length and ensures that you don't have to shoot at f11, f16, or even f32, which then means that the background will become increasingly dark as more ambient light is blocked.

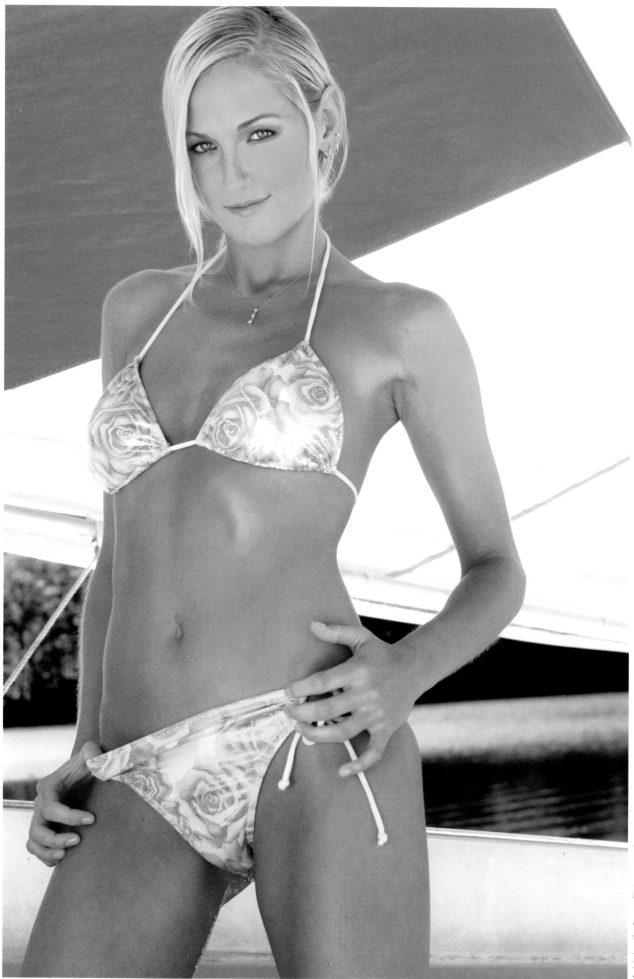

Model: Jennifer Doan Photographer: Dan Howell

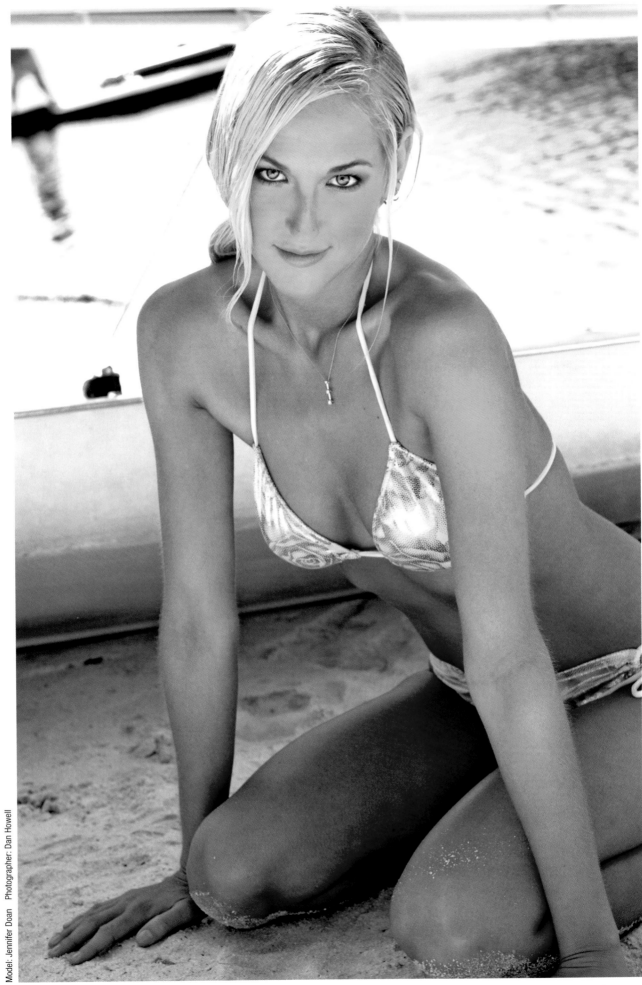

The image stabilization provided on many modern lenses generally works very well; I would have no hesitation hand-holding even as light levels drop off toward the end of the day. That said, if possible, you should mount the lens on a tripod, simply because it can get heavy after a while.

In addition, you may need to measure the ambient light with your hand-held meter and to make minor adjustments to the traditional f8, 1/125 setup to ensure the relative brightness of the background and the model. To compensate for a particularly bright day, you might have to increase the fill flash output. (This is the other reason I use the 3/4-stop scrim fabric. Although higher-stop fabrics provide even softer lighting, they also increase the relative lighting differential between the model and the background, hence requiring larger apertures—which, at long focal lengths, may result in less latitude to get the model perfectly in focus—and/or the use of higher flash outputs, which drain your battery packs at an accelerated rate.) You may also need to add a circular polarizer to the front of the lens to improve contrast and to avoid having reflected light from the water bleach out the image. Using these polarizers generally results in the loss of one or two stops of light, so you will need to dial in some compensation on your camera.

Shooting in the Water

Shooting in the water—where the model rolls around just where the tide ends, kneels in the surf, or is immersed to the knee or waist—is extremely common. Not surprisingly, these types of shoots involve a few special considerations. In particular, you'll need to take precautions with your equipment and to control the light.

Taking Precautions with Your Equipment

Photographing a model in the water will undoubtedly involve getting both you and your assistant wet, and significantly increases the chances that you may fatally drown your equipment. To avoid this, I usually take a few precautions with my gear. In particular, I cover my camera body and lens with a plastic bag, which I secure to the front of the lens with a UV filter or polarizer. In addition, especially when working in waist-high water, I typically use a trolley or even a small inflatable raft, tethered to an assistant, to hold some of my equipment (such as my light meter and filters).

note

Although the Canon 1Ds is water resistant, as are my lenses, tripping over a rock and falling into the water while holding a camera is likely to cause some damage to both me and my gear. This is one case where it doesn't hurt to be a little over-careful!

If you wish to use a C-stand–mounted light, you can, but you will need to heavily sandbag the stand in the water to prevent it from being buffeted by waves. Your best bet, however, is to opt for an on-camera flash, be it a 550EX or a ring flash, over standalone lighting. If you use a ring flash, you might need another assistant to hold the battery pack over his or her shoulder; alternatively, you can place the battery pack in your floating trolley or raft.

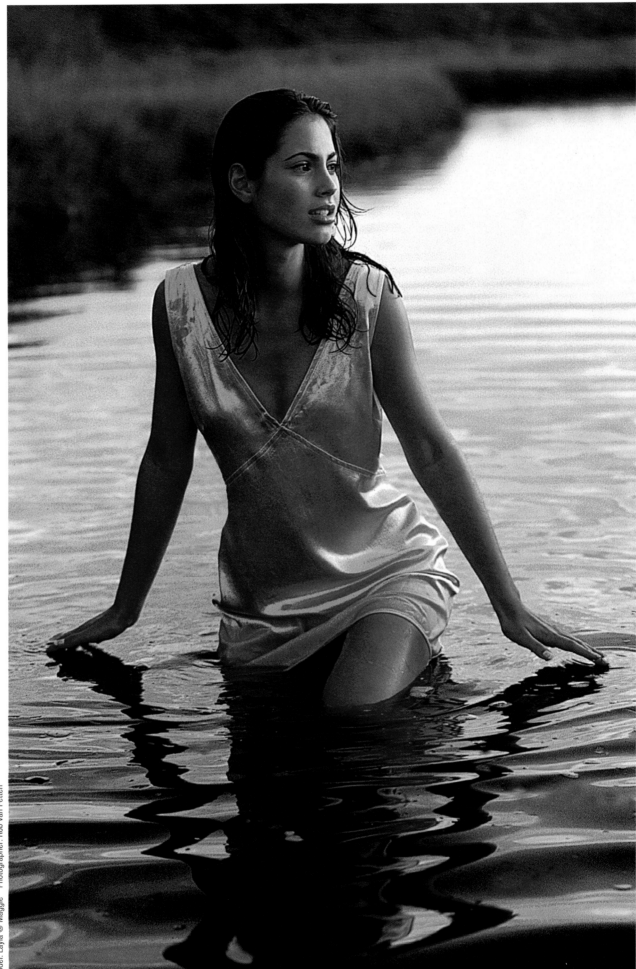

Controlling the Light

When working in the water, it may not be easy—or even possible—to set up scrims and other light-control equipment, and you are usually far from any natural shade. To achieve a diffused light effect, and to enable yourself to shoot through the middle of the day, a small investment in a large umbrella (the kind you use to shade outdoor tables or to provide shade at the beach for you and a few friends) and an extra assistant is a must-have. Simply ask the assistant to stand off to the side of the model and hold the umbrella in such a way that the shadow cast by the umbrella fully covers the model. This takes the overhead sun out of direct play, leaving you to deal with scattered side lighting. For this reason, you will likely need to shoot with a polarizer, which takes care of much of the scattered light for a one- to two-stop penalty. You can provide additional fill by way of another assistant holding a large half-gold reflector.

[tip]

This umbrella approach can also be used on the beach and in other location shoots, such as fields, where you don't have scrims or access to natural shade.

Shooting in the Water

Other than the additional precautions and increased use of sandbags, shooting in the water is technically identical to shooting on land—although you may need additional assistance to hold the various pieces of equipment. I generally use my favorite 24–70m lens because I need to be relatively close to the model in order to use an on-camera flash. Alternatively, you may want to shoot from shore with the 70–200m lens and have your assistants hold the previously described Quantum rig just off-camera next to the model.

Here are a few more pieces of advice for working in the water, gleaned from valuable experience growing up on Australian beaches:

- Avoid shooting tethered when in the water for obvious reasons.
- Try to shoot with larger Compact Flash cards so you don't have to fiddle about changing cards mid-shoot, thereby increasing your chances of dropping something in the water.
- If possible, work with two cameras so that an assistant can change the Compact Flash on the shore while you continue shooting in the water.
- Someone should always keep an eye out for you and the crew. A freak wave or a wake from a Jet Ski can cause damage to equipment and ruin a perfectly good shoot.
- Invest in a pair of rubber beach shoes to wear in the water—the kind that you use to walk around on rocks and that go inside swim fins. They provide good grip and also protect your feet from marine nasties such as jellyfish, which always tend to drop on in to oversee my beach shoots.

Shooting on City Streets, in Parks, and in Public Buildings

I once watched a photographer, his assistant, and a model work on the corner of 3rd Avenue and 60th Street in Manhattan—which is, as you may have guessed, the site of Bloomingdales. It was mid-morning, pre-Christmas, and as such, a huge mob of people naturally flowed in and out of the department store. In addition to buffeting the photographer and his assistant, some members of this horde decided to stop to sticky-beak at the shoot. It was very difficult to work at such close quarters with the crowd. Worse, I don't doubt that the photographer had a slew of well-intentioned onlookers in the background of his shots.

Shooting in the street, in parks, and in public buildings is not significantly different from shooting on the beach. The added complexity arises—you guessed it—from controlling people on the street, as well as from obtaining the necessary permits. Once you have the required permits, you can establish crowd control points, with assistants directing the crowd, and even some ropes to keep the set free of onlookers. This allows you to focus on the shoot and not on the onlookers.

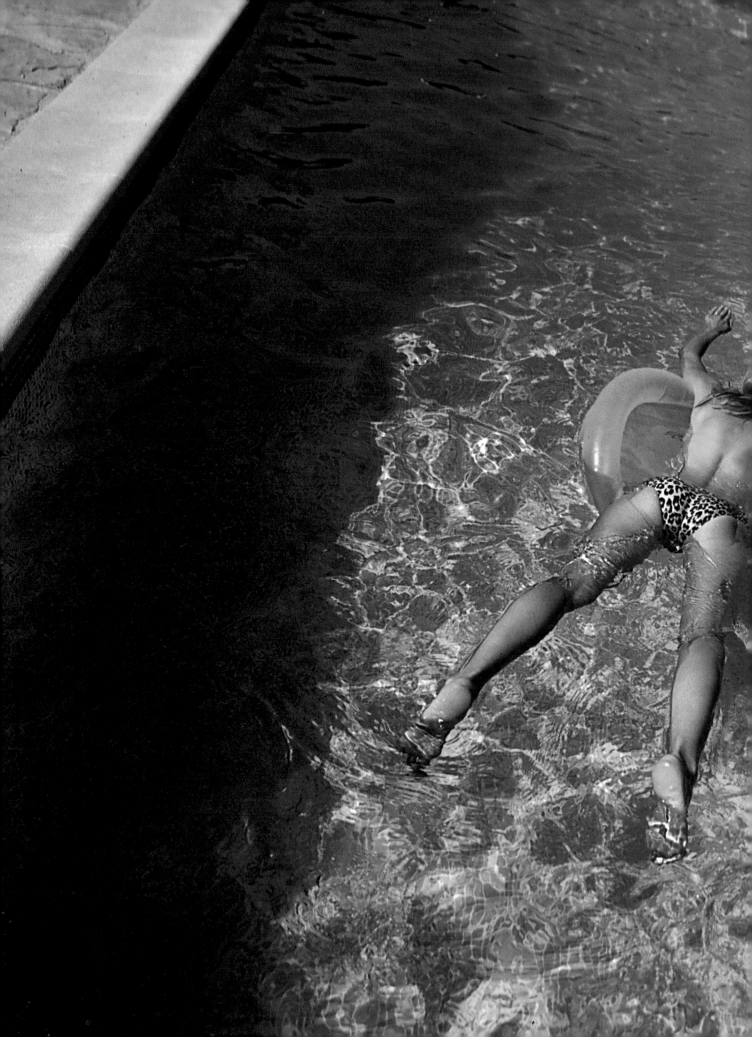

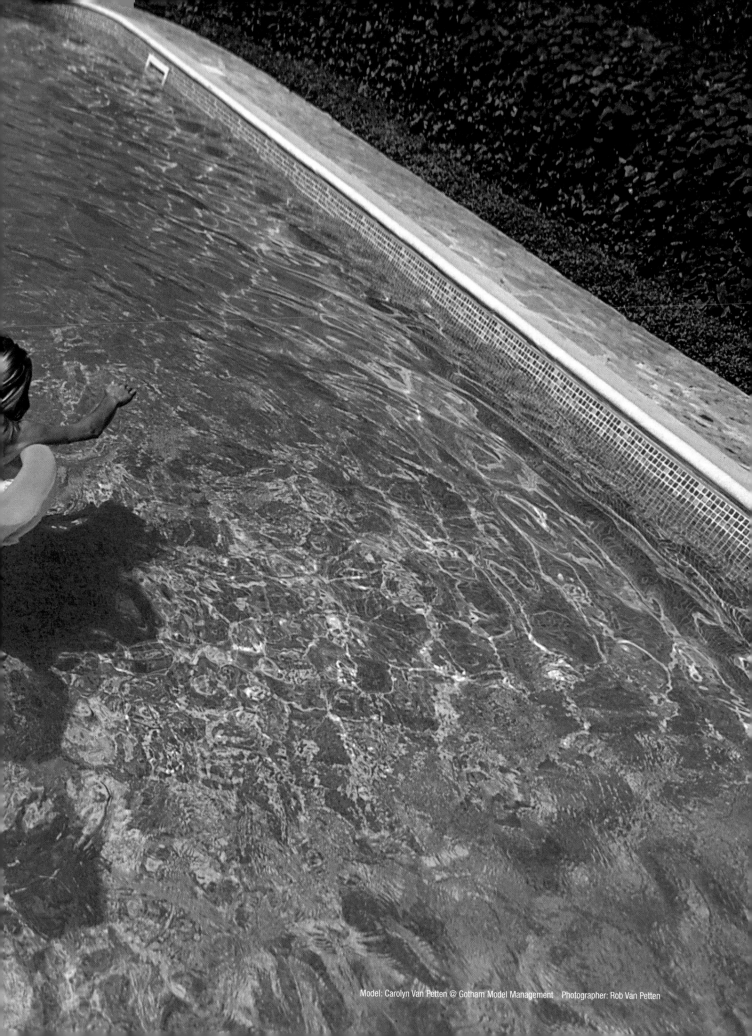

Model: Carolyn Van Petten @ Gotham Model Management Photographer: Rob Van Petten

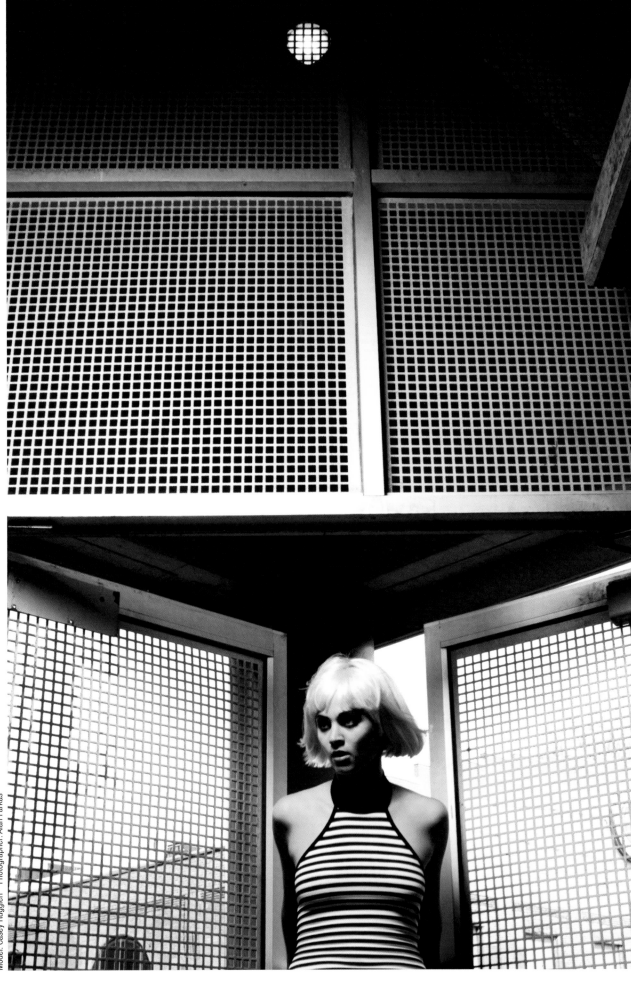

When shooting in any public place, particularly one with many onlookers, it is always a good idea to keep a watchful eye on all the equipment. Although most onlookers are well-intentioned, I have had some equipment stolen on location before.

Obtaining the necessary permits is particularly important in cities such as New York. I once had to obtain five different permits from five different authorities to take some photos using a tripod on and around Brooklyn Bridge—one from the MTA for setting up on the pedestrian path on the bridge itself, and one for each of the parks on the Brooklyn side. Although this was an added bureaucratic burden during the planning process, it did allow my assistant to legally manage the tourists who constantly walk across the bridge. Likewise, in Melbourne, Australia, taking pictures of Federation Square requires a permit—particularly if the images are to appear in any commercial platform. Once you have the necessary paperwork (I usually have each of my assistants carry copies of these in folders in case they are challenged), you can plan your shoot in the same way you plan any location shoot.

One particularly wonderful building to shoot in is the Empire State Building in Manhattan. Although you are forbidden to take even a tripod up to the observation deck during normal hours, you can call building management and arrange for off-hours entry—for example, between 3 a.m. and 6 a.m. This enables you to obtain some fantastic night or dawn shots with the New York City lights as backdrop. Even more wonderful is the fact that the night crew often pipes jazz music through the PA system; the entire building becomes alive with the sounds of Ella Fitzgerald.

In large cities, there is often sufficient diffuse light and shadows from skyscrapers to enable you to eschew the use of large scrims. My street kit usually includes a few collapsible reflectors and possibly a hand-held scrim, my Quantum portable rig, and possibly a couple 550EXs as backup. I usually transport the equipment to the site in plastic storage boxes; when I have unpacked the equipment for use, I then stack the boxes on top of each other for use as a table for the review laptop or as a touch-up station for the model's makeup.

Cleaning Up After Yourself

Most city streets are quite dirty, with rubbish and contributions from people's pets. For this reason, it is always a good idea to bring along a few large brooms, a brush, and pan. These come in handy for a quick set cleanup before the shoot—which helps you avoid additional touch-ups in post-production—and also allows you to clean up after the shoot. You should always do your best to leave the set in good shape after you finish up.

Most city permits contain clauses requiring you to repair any damage you may cause to the location, such as replacing grass in a park if you have built a dolly track through a lawn.

In addition to cleaning up the area where the shoot has occurred, you should also clean your equipment before packing it up. This entails shaking or blowing off dirt, sand, and so forth from your equipment prior to packing it into your car. When you get back home or to your studio, unpack all the gear, placing it on a large mat. Then, systematically clean the equipment. Use compressed air or blower brushes to remove as much sand and dirt as you can. Then wipe down all the equipment—lights, stands, tripods, power cords, the works—with a damp sponge. You can then repack each piece of equipment into its case, ready for the next shoot. Doing this requires a little discipline, but the extent to which sand can impair the longevity of equipment with moving parts should motivate you to properly care for your pricey equipment! With just a little effort, you can keep your equipment relatively serviceable for many years.

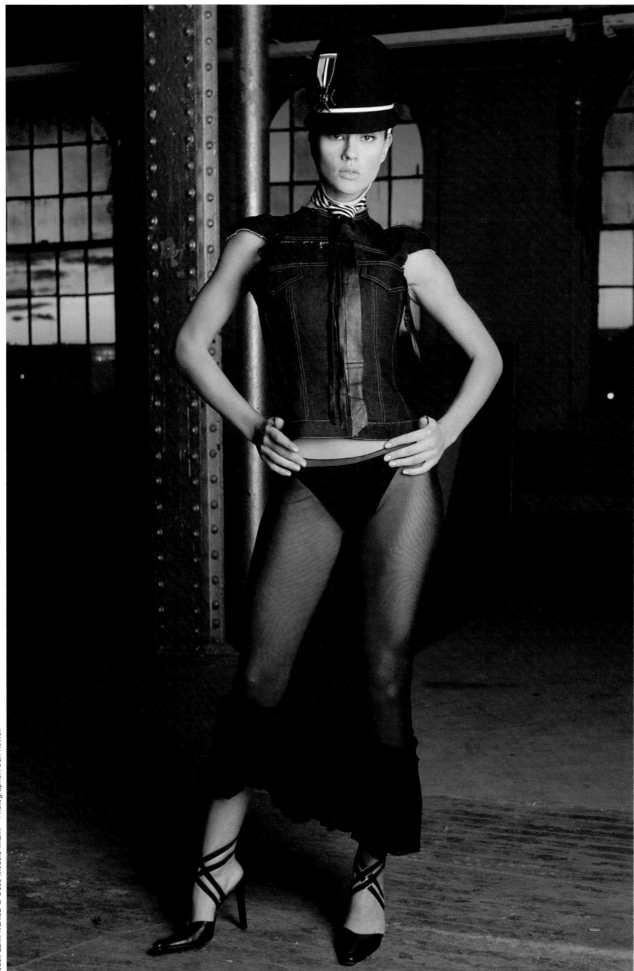

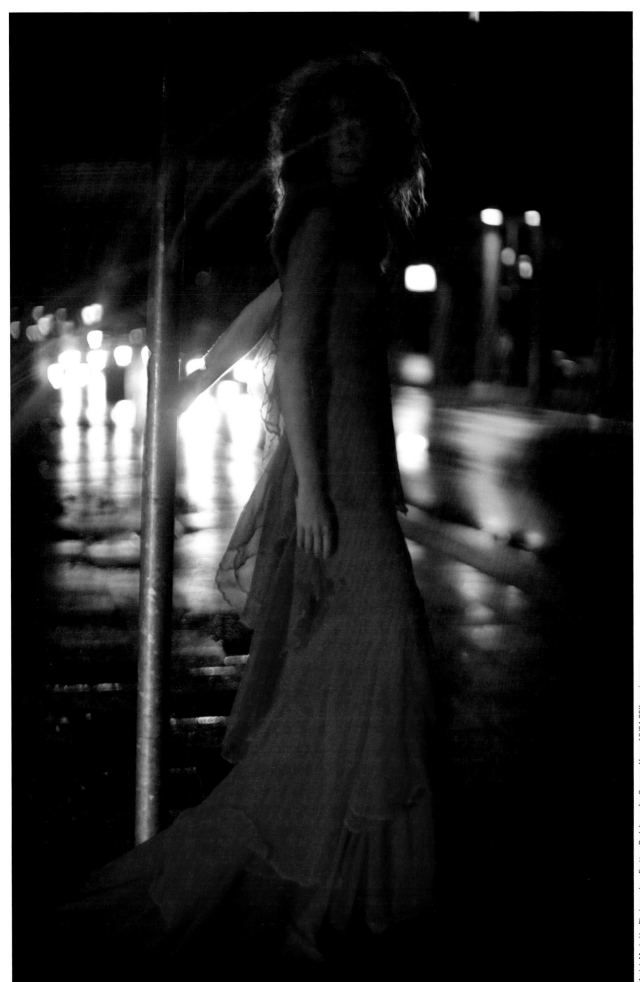

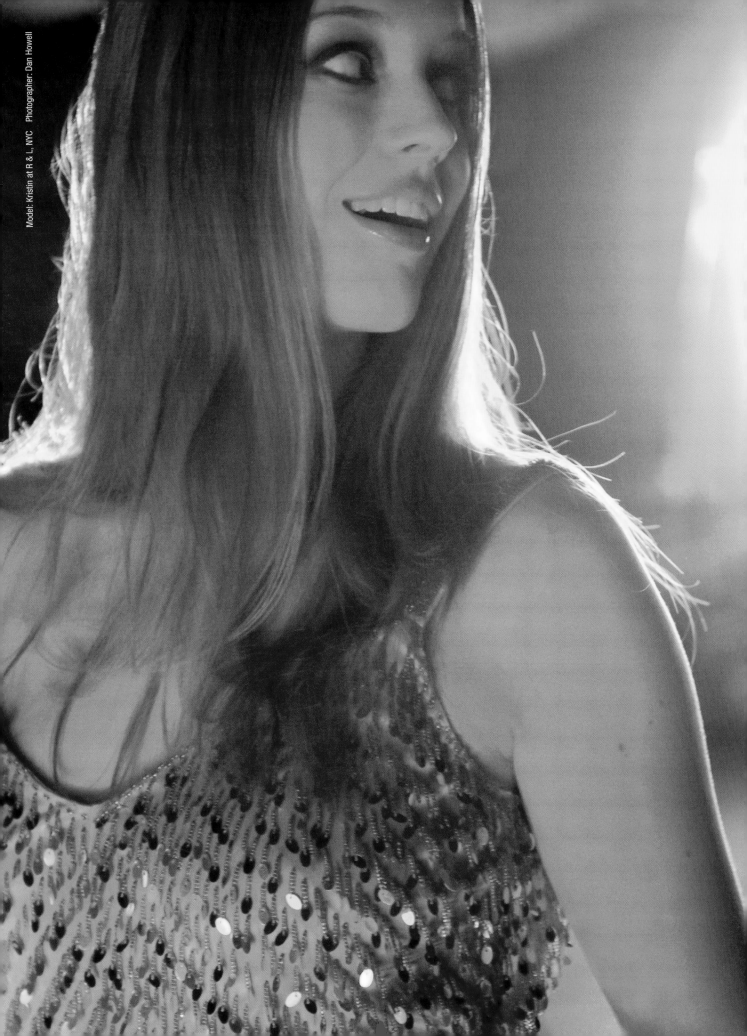

6

Post-Shoot Image Selection, Transfer, and Storage

After a solid day or night of shooting, you may be tempted to call it quits. If you consider the images from your shoot as valuable assets, however, then you will understand the importance of developing a post-shoot workflow to ensure that you protect these assets, and to ensure that you have them readily available for your clients. By turning your attention to sorting, filing, and archiving your digital images immediately after shooting, you will ensure that you do not generate a backlog of work over time.

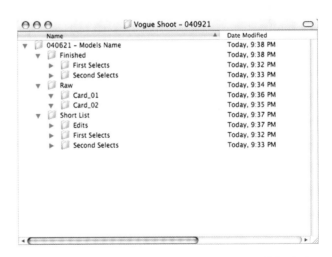

Folder structure

Filing Your Images

Having a good filing system is essential both to ensure that you can retrieve images easily, even years after a shoot, and to ensure that your valuable images are preserved for as long as you want them. This is especially so if you are a prolific photographer. Filing your images simply and consistently over time is key to easy retrieval. There are many ways to organize images after a shoot; it's incumbent upon you to find a method that works, adopt it, and use it consistently over time.

Creating a Master Folder

A good starting point is to create a "master" folder on your computer for each shoot. The folder's name should contain the date in reverse (for example, "040921" for September 21, 2004), followed by the model's name. That way, if you place many folders in the same directory, the folders will be sorted in chronological order. While it is a good idea to

have this structured folder setup before the shoot, it is not always possible. That said, considering how much needs to get done during a shoot, make an effort to set it up ahead of time if possible.

[caution]

Avoid relying on the date-stamping function built into operating-system filing systems, because the date and time stamps are typically updated by default if you alter any of the files contained in a given directory. Although most operating systems allow you to disable this automatic update, doing so is fiddly; it is far easier to adopt a simple naming convention such as the one described here.

Storing Your Raw Images

In this master folder, you should create a subfolder to contain the "raw" images that will be downloaded from your camera during and after the shoot. Note that the use of "raw" here is not meant to imply that the images stored here should be in the RAW file format; you might choose to shoot in RAW format, JPEG format, or both. The point is that the folder should contain images that have come straight from your camera and that have not been manipulated in any editing program; think of these images as your digital negatives.

note

If you are shooting tethered, you should set up the capture program—whether it's the one that came bundled with your camera or a third-party program such as Phase One's Capture One software—to point to this directory.

Most digital SLR cameras reset their file-naming counters each time you insert a new media card (you can of course change the settings for these functions, but again, they tend to be fiddly and are just an extra thing that you can forget to do before a critical shoot). If you use many cards in a single shoot, you could very well wind up with multiple

files that have the same name. The problem? If you attempt to download a file into a folder that already contains a file with the same name, the existing file will be overwritten— deleted—by the new one. For this reason, it's imperative that you create subfolders within your "raw" folder for each compact flash card to be used during the shoot—named, for example, "Card 1," "Card 2," and so on. As your media cards fill up during the shoot, you or your assistant can download their contents into the appropriate folder; a good time to do so is during touchups or set changes. Of course, you can rename and renumber your images later, but it is a good idea to keep at least one copy of each original file (filename included) intact. If you reuse a card during a shoot, label the relevant subfolder as you would a new card—that is, if you have three cards and you reuse the first, then the second time around, the associated folder should be labeled "Card 4."

note

You might also want to use the folder-creation functions built into your camera to further refine your filing. That said, it is much easier to simply copy the entire contents of a card into its corresponding subfolder in the "raw" folder.

Creating a Short List

After you have stored your raw images, you'll need to create some mechanism for selecting your favorite images. In some cases, you will do this on your own, or possibly with the model after the shoot; more often, however, you will engage in on-the-fly selection with the art director or other creatives during or after the shoot. For more information on deciding which images make the cut, see the section "Selecting Images" later in this chapter.

Regardless of how the selection process occurs, you should create a temporary "short list" folder directly under the "master" folder to contain these images. As you make your selections, simply copy the relevant raw images to the short list folder. This preserves the original versions in the raw folder while enabling you to narrow down your choices of images. Note that you might have to rename some files if you select images from different cards to avoid overwriting.

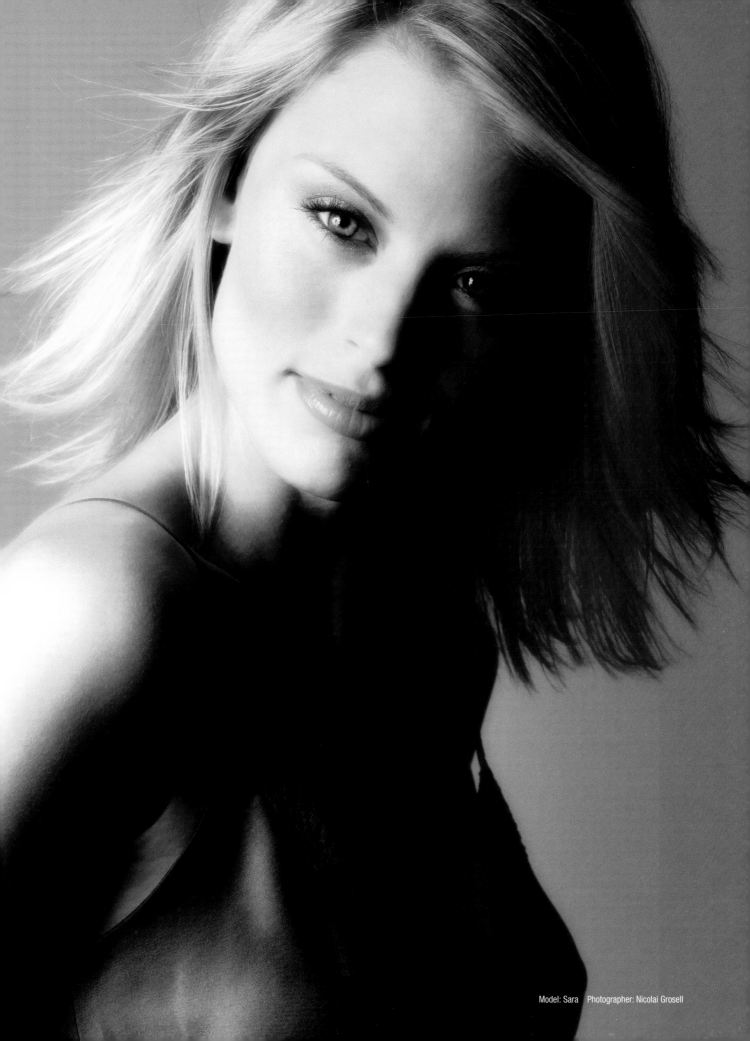

Model: Sara Photographer: Nicolai Grosell

Storing Your Finished Images

As a final step, create a "finished" folder directly under the "master" folder for the shoot. As you edit the raw images in the "short list" folder, you can then move them to the "finished" folder; when you've finished editing your images, the "short list" folder should be empty, and the "finished" directory should contain edited versions of each image on your short list.

note

For more information about editing your images, see Chapter 7, "Post-Production, Retouching, and Printing."

Selecting Images

At the end of a typical all-day shoot, you may find yourself with a couple hundred images to sift through. The easiest way to do so is to use a thumbnail browser, such as the one included with Adobe Photoshop CS2 or a separate freeware viewer like Irfanview for the PC (http://www.irfanview.com). Another excellent choice for both computing platforms is Photomechanics by Camera Bits. This program offers much of the same functionality of Adobe Photoshop CS2 if you do not own Photoshop. Look at your images two at a time; when you see an image you like, move it to the "short list" folder discussed previously. Although you may be tempted to make only one pass through your images in order to create your short list, you should resist doing so; at least two passes through the "raw" folder are in order.

[tip]

It is sometimes necessary to composite two or three images together to create the perfect final photograph. In such situations, it is always easier to pull portions from other images than it is to create new portions from scratch. For this reason, after your images have been selected, it is a good idea to have handy a secondary set of images that did not make the first cut; you may be able to use portions of these images to create your final photograph.

Don't be afraid to select for your shot list multiple shots that appear similar during your first pass. You can compare these side-by-side during your second pass to decide which ones make the final cut. When doing so, ask yourself the following questions to identify the image that will be generally accepted as "more pleasing":

- Which image has a more natural-looking head and neck position? Does the model's head look twisted relative to his or her neck?

- In which image does the model's hair look better? Which one is neater? Which one is messier? Are there any straggly hairs? (This is not fatal in the days of Photoshop, but may be a consideration in some cases.)

- In which image do the model's clothes and shoes look better? Are there any unsightly wrinkles in the model's top? Is the model's foot sitting properly in her pumps?

- Which image has better cropping? If an image is not perfectly cropped, can it be fixed in Photoshop? (This is easy if you are cropping down, but far more difficult if the starting image is already cropped too tightly.)

- In which image does the background support the desired final image? Does the background in one image distract you more than in the other? Is this intentional?

Of course, much of this lies in the eye of the beholder. Also, in many cases, you may be looking for something specific in an image, and this may not necessarily follow a set of rules. As an example, however, consider the two images on this page. In the image on the left, the model has a slightly unnatural neck position, while in the image on the right, the neck position is much more natural. Note, too, in the left image how the model's front hand sort of hangs there. In contrast, the hands are more symmetrical in the right image, conveying a more confident air.

[tip]

It sometimes helps to break similar images into quarters or ninths, and to analyze the differences between them in a systematic fashion.

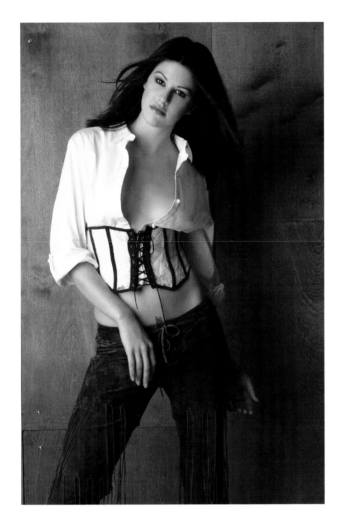

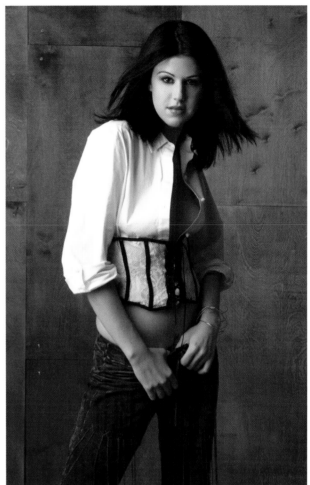

Model: Jessica Hillman Photographer: Dan Howell

After you have made a second pass through your "short list" folder, deleting from that folder any images that don't make the final cut, it is a good idea to make a final pass through the remaining images to ensure that you have a reasonable selection. Sometimes, despite your best efforts, the culling process eliminates too many shots. In this case, you may want to take another pass through the raw images. As you can see, this is an iterative process; very often, you may end up with a set of short-listed images that are quite different from your initial selection. These short-listed images will then undergo post-production, as discussed in Chapter 7.

note

Although it is super convenient to view images on the computer screen, it can be slow looking for the one you want if you don't have a large monitor. This is where old-style paper contact sheets come in handy. Once you have found the image you want on the paper sheet, it is a much easier task to locate it on the computer. I only bring this up because as a photographer, you will inevitably take hundreds of shots per session. Even if the images are organized in an image database, they are still going to be a mess for your service bureau to sort through after a shoot. You will also find that most agents still like paper contact sheets because they are used to marking them up with stick dots and felt-tip markers.

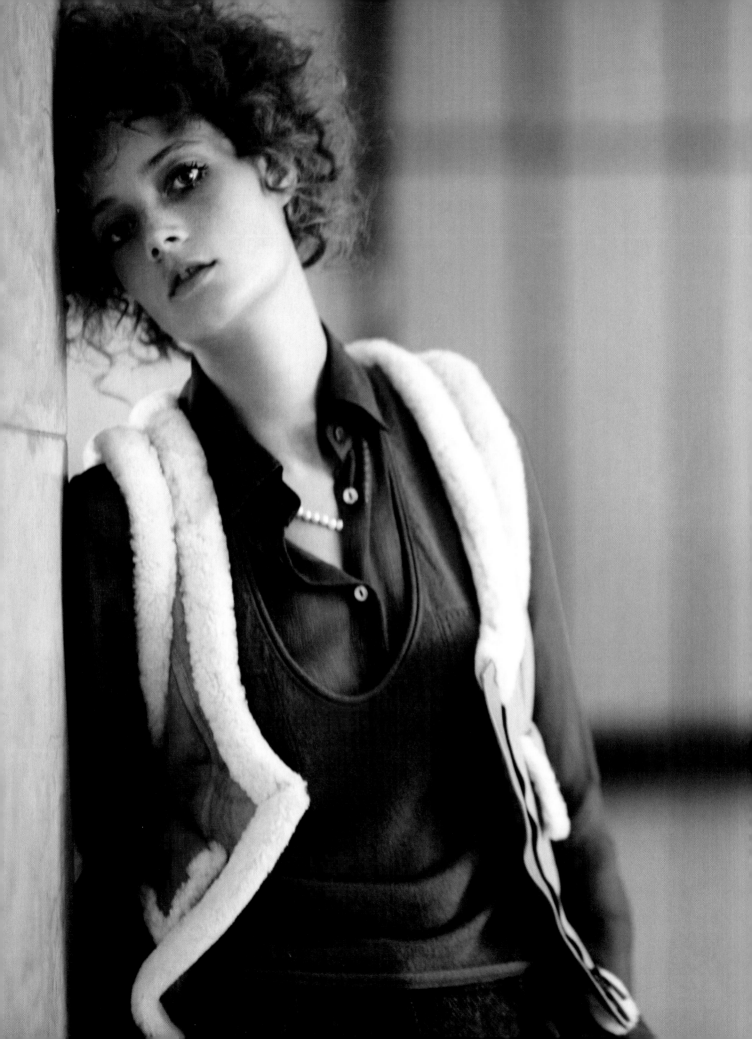

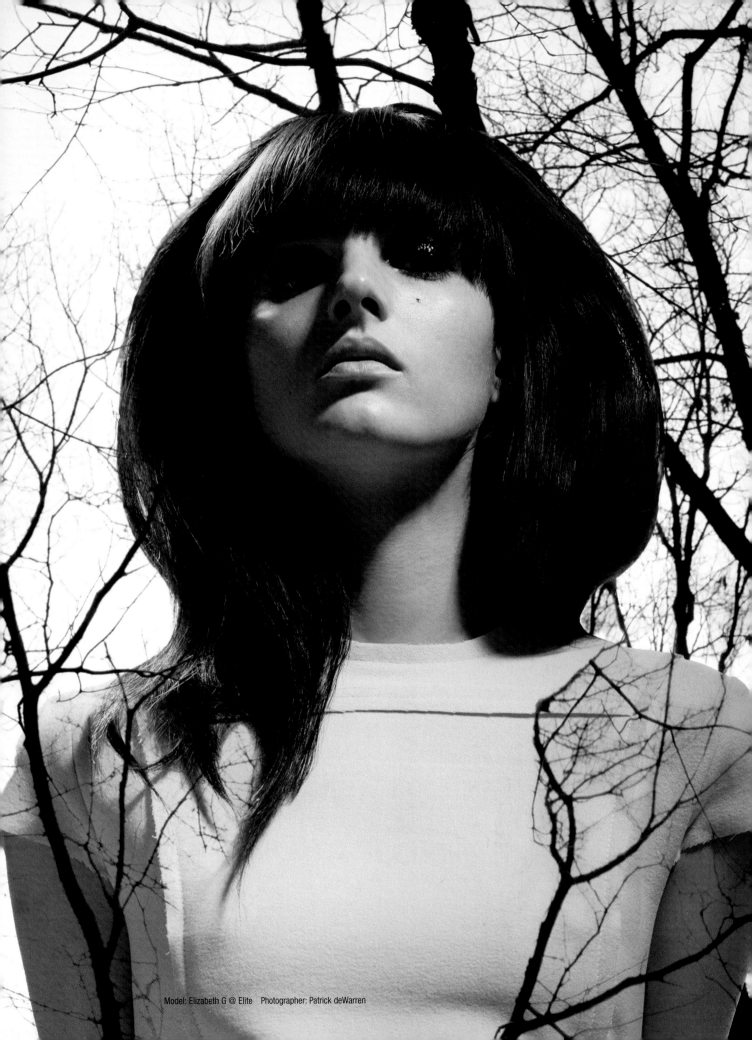

Model: Elizabeth G @ Elite Photographer: Patrick deWarren

Transferring Images to the Client

There are many ways to get your image files to where they need to be; the method you use is based entirely on how quickly they need to get where they're going, and how far away that location is from you:

- **"SneakerNet."** The most reliable way to get a file somewhere is through what I call "SneakerNet." Essentially, you burn the file to disc, put on your sneakers, and hand-deliver it. This eliminates the need to use third-party delivery services, which, though seldom, have been known to be late or to misplace packages. Of course, this delivery method is viable only if your client is located nearby.

- **Third-party delivery services.** If your file needs to travel farther than you're willing to walk or drive yourself, you can burn it to disc and trust it to a third-party delivery company, be it local, national, or international. FedEx and its friendly competitors do get the job done when files need to be sent cross-country or even around the world.

- **FTP.** One primary advantage of digital photography over film is that with digital, you can transfer your image files to clients via the Web—specifically, using File Transfer Protocol (FTP). This saves both time and money. One way to do this is to set up your own FTP server for your clients to access your images; alternatively, your clients themselves may have an FTP server, which you can use to upload your images for their review. To use FTP, first prepare your files for transfer by compressing them to a Zip or Stuffit file to make them smaller (the smaller the file, the less waiting time you are going to have). Then, with an easy-to-use program such as Transmit or Fetch for the Mac or LeechFTP or Xerver Free Web Server for Windows, you upload your images to an FTP server (note that if you are uploading to a client's FTP site, a user name and password will likely be required; you'll obtain that from your contact at the client company). When choosing your FTP software, look for a program that will automatically resume in the event your upload or download is interrupted.

note

If you plan to use FTP to transfer your images, it is best to have a broadband Internet connection on both ends for fast copying. If you or your client operates on dial-up, odds are the image files will be too large for transferring.

This shows the Fetch interface; the left side represents the user's hard drive, and the right side the FTP site. Drag files from one side to the other to upload or download them.

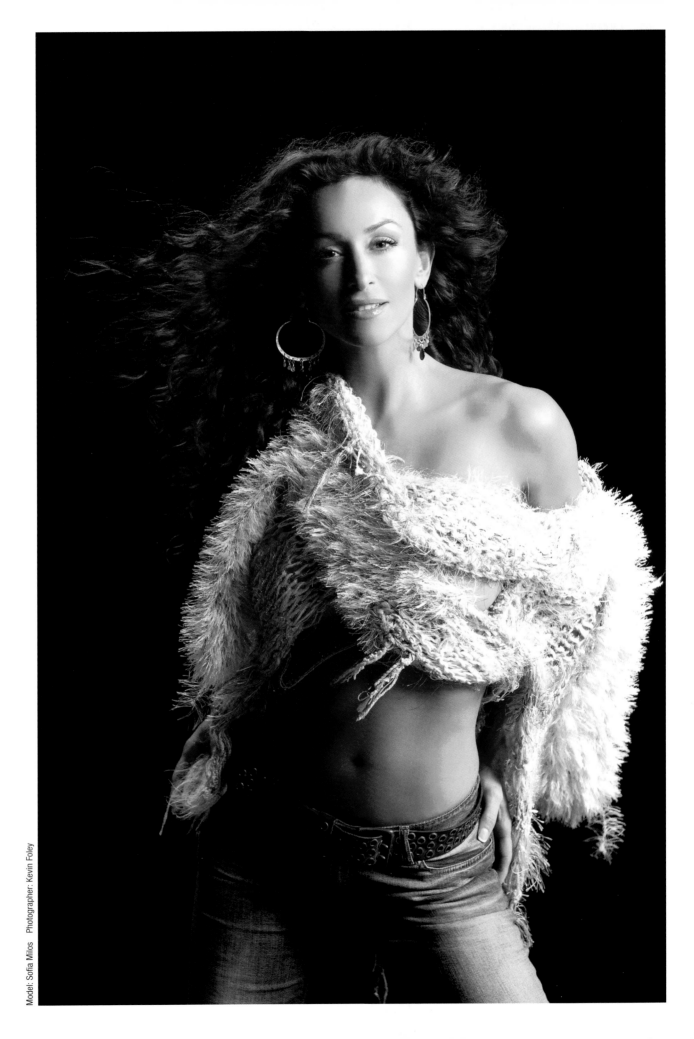

Archiving Your Images

Back in the days of film, when you wanted to archive your negatives, you stored them in archival sleeves and used drying packs and so forth. In some cases, you might even have gone so far as to make duplicates of your negatives and stored them in different locations, just in case. With digital photography, the approach is essentially the same. Having a tiered—and slightly over-cautious—file-storage system is a good way to preserve your images. Instead of archival sleeves full of negatives, however, raw files are stored on CDs or DVDs. As a starting point, it is generally a good idea to take the extra time immediately after your shoot to burn two DVD-R backups of your raw files and store them in two locations. With a dual-layer DVD+R burner like the Pioneer 109, you can fit the entire set of raw files from a typical full-day shoot—just over 8GB—on one disc. Then, simply keep your most recent images—say, from the last year or so—on your hard drive for quick access. When the files are more than a year old, you can delete them, knowing they've already been burnt to multiple discs.

That said, when designing your storage and backup approach, you should realize that despite manufacturer claims, the life of recordable CDs and DVDs is not indefinite. One of the main reasons that CDs and DVDs may not last as long as the promised 100–200 years is that the dye within the disc that holds the recorded information can fade over time. Do yourself a favor and keep the discs hidden away in a dark, dry spot; your best bet is a fireproof safe. Also, rewritable discs should be avoided; they do not last as long as plain-old recordable discs do.

[caution]

A CD or DVD may degrade without you noticing it because of the disc drive's error-correcting capabilities. This can become a problem if the CD/DVD is read on a different drive in the future; it may even become unreadable.

If you need ready access to your images, and your collection of CD/DVD backups is getting a little large, you may want to set up a server (any reasonably recent PC or Mac will do, and the machine doesn't have to be dedicated just to image storage) with a lot of internal disk space or with a large FireWire or USB2 external hard drive, such as one made by LaCie. Several manufacturers offer hard drives that hold as much as 1.5 terabytes, and that offer RAID capabilities for added redundancy. (Usually, these larger drives are a single enclosure, but contain multiple drives.) If the necessary RAID redundancy level is present—for example, RAID1 (mirroring)—a second drive that contains a mirror image kicks in when the main drive fails. (Note that many of the "consumer" type drives like the Lacie actually do *not* provide redundancy; they tend to stripe the drives [RAID0] to increase throughput.) These same manufacturers also offer *network drives*, which have similar capacity to larger hard drives, but plug in to your Ethernet network. These network drives automatically configure themselves, assigning an address for you to access it from anywhere in the world. This is great if you have high-speed access; you can upload your images right from the shoot, wherever it occurs, to the network. This is also a good way to transfer files to a retoucher or post-production house via network access or FTP.

note

While at the moment it is not as prevalent, images are sometimes accepted right from the shoot. To accommodate this, some photographers have a retoucher on-site who does minor work on the image—mostly tonal adjustments and so on. Then the photographer FTPs the image right to the post-production shop for preparation to print.

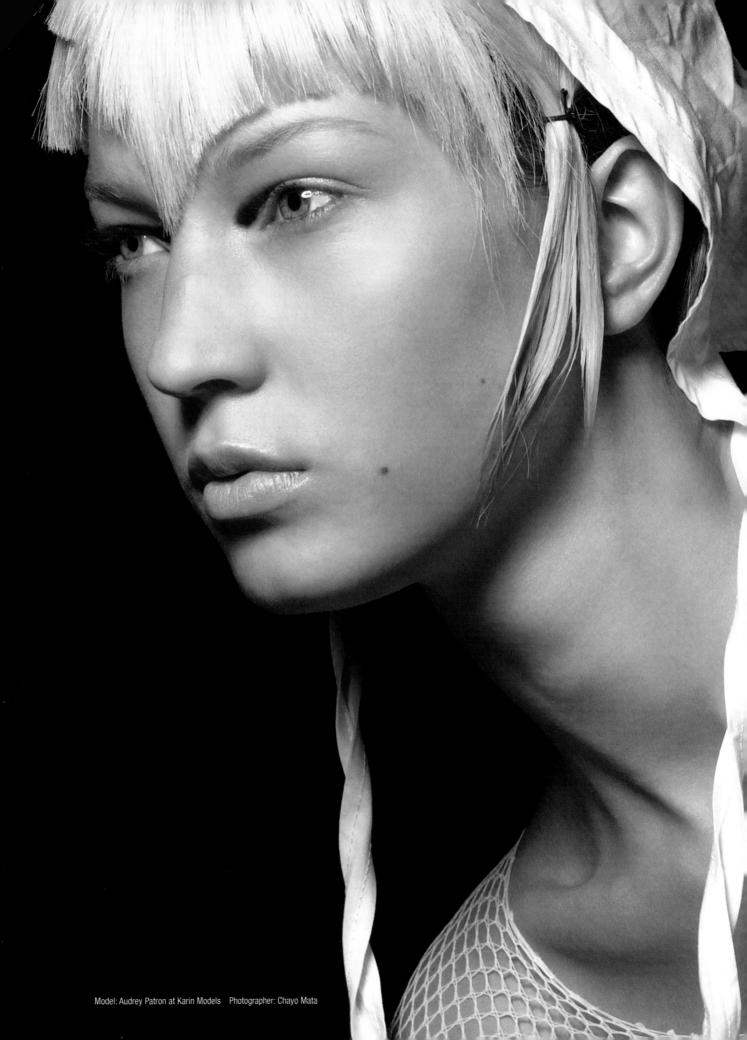

Model: Audrey Patron at Karin Models Photographer: Chayo Mata

[tip]

Although broadband has certainly made transferring files a lot faster, it is generally a good idea to do this in pieces—say, per compact card as each one is filled up.

One last point about archiving your images: There is growing concern over the life expectancy of raw file formats. Suppose, for example, that sometime in the future, the company that makes your computer's operating system opts against supporting your camera manufacturer's software—or that the camera manufacturer itself stops supporting it. What do you do? To address this problem, Adobe has devel-

oped a system called DNG, short for Digital Negative, which is available free of charge. Essentially, DNG converts raw file into a universal format that can be read by any program that supports it—without changing the metadata of your raw file. You can even embed your raw file in DNG and extract it at a later date, if needed. DNG, which is growing in acceptance among camera manufacturers, is an open format, which means that camera manufacturers can freely include support for it in their own software. As a result, chances are that DNG will be supported for a long time to come. I can't stress the importance of this format enough; do yourself a favor and look into adopting it for your own peace of mind.

The LaCie Biggest F800 and the ReadyNAS 600, respectively

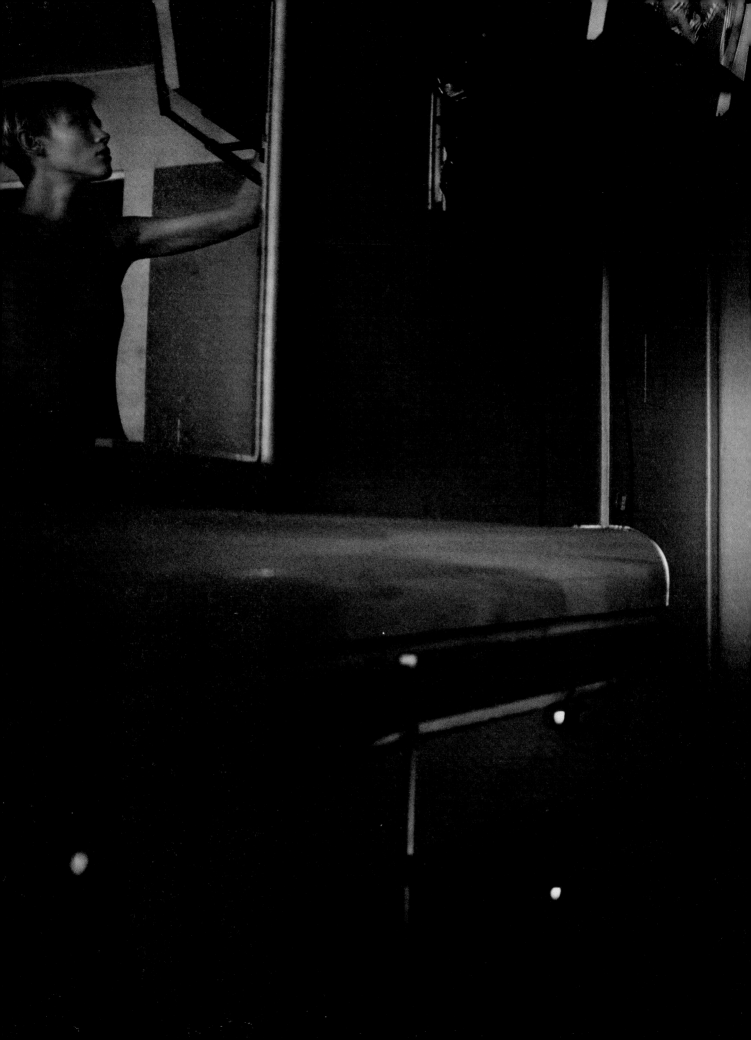

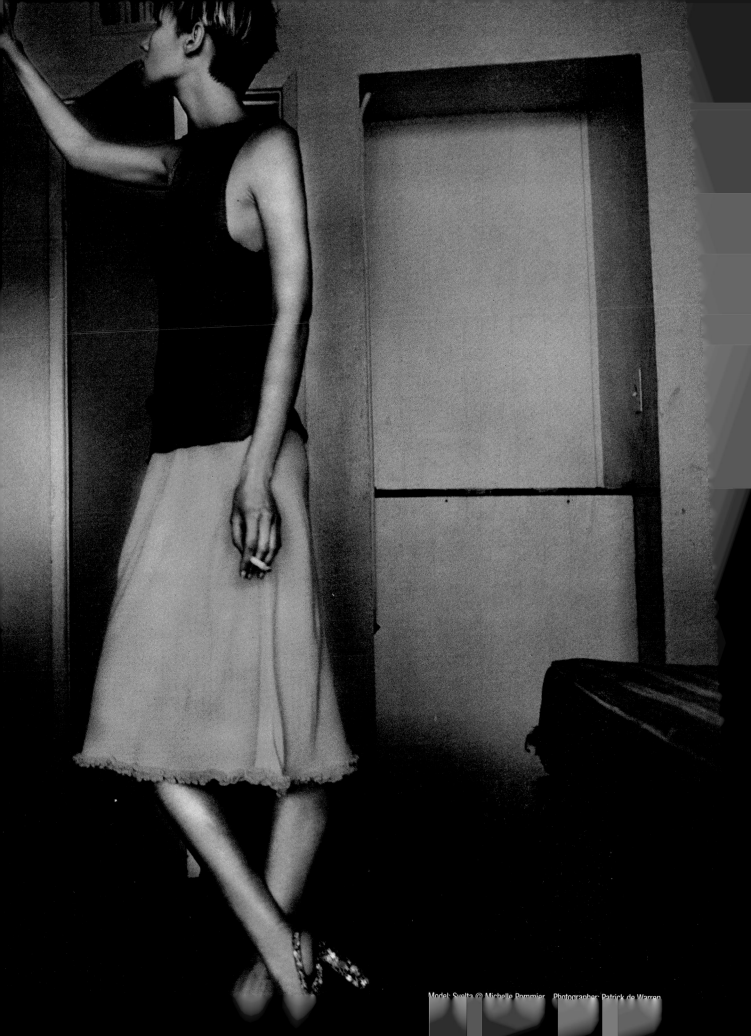

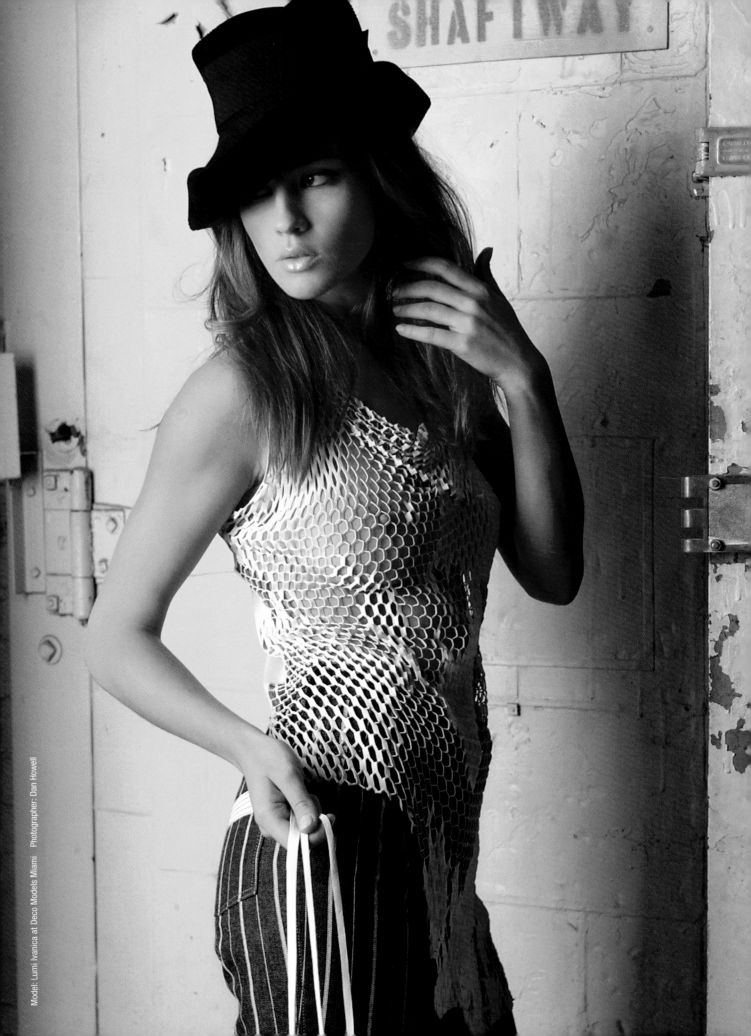

SHAF T WAY.

CHAPTER 7

Post-Production and Adobe Photoshop

Often, the mistaken belief is that because a photograph was shot digitally and will be processed digitally, very little time and effort will be needed to create a beautiful final image. To some degree they are right. Photoshop and other image-editing software do simplify and expedite much of what happens in a darkroom. But it still takes a good eye, good direction, and patience to get an image just right.

This "good eye" belongs as much to the post-processor as it does to the photographer. If a photographer has set up a shot correctly and taken the time to ensure that the necessary manipulation is possible, then his or her instructions to the retoucher, color specialist, and other post-production experts will be a breeze to complete. There are instances, however, when an image is not under the complete control of the photographer—think inclement weather or an acne outbreak on the model. In such cases, the post-production specialist will need some time to realize the photographer's and client's vision.

Markup

One of the benefits of digital photography is that it gives you, the photographer, a choice with regard to markup. You can do it the old-fashioned way, printing out a copy of the image and doing markups with a grease pencil. This is excellent for quick reference on the table. Another way of doing markup is in Photoshop, with annotations to be attached to the image file either in written form or by voice. Opting for this markup route offers a few advantages. For one, attached annotations remain with the image file until they are deleted. In addition, attaching annotations eliminates the problems associated with bad handwriting. It also gives the photographer a good chance to see what is wrong with the image. A variation is to add a transparent layer to the file; then, using a paintbrush in Photoshop, you can

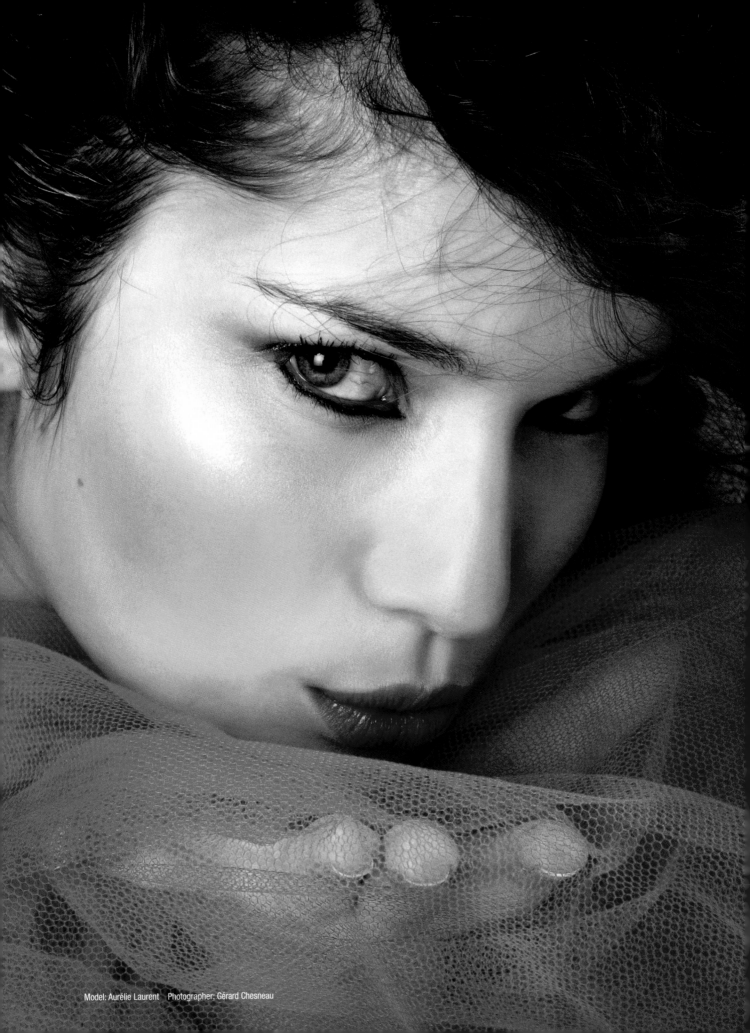

Model: Aurélie Laurent Photographer: Gérard Chesneau

write and draw what you want done to the image. A third option is to actually do the work you want done yourself using a lo-res version of the file. This file can then be passed to a post-production specialist, who repeats the work on a hi-res version of the image.

As mentioned in Chapter 6, "Post-Shoot Image Selection, Transfer, and Storage," it is very convenient to view images on the computer screen. That said, it can be slow-going looking for the one you want if you don't have a large monitor. This is where old-style paper contact sheets come in handy. Once you have found the image you want on the paper sheet, it is then a much easier task to locate it on the computer.

Of course, regardless which way you choose to do your markup, you will find it to your benefit to review everything with your retoucher. Nothing you can write down will ever communicate your vision as well as a good discussion with the post-production artist. Questions will inevitably arise, and the last thing you want to do is to have to talk it out over the phone or via e-mail—especially when the job is halfway done and time is of the essence.

Using Adobe Photoshop

Without a doubt, Adobe Photoshop is the software of choice for image manipulation by photographers. This application is considered the 800-pound gorilla in the digital world, and with good reason: It offers a tremendous amount of power. From having a first-class RAW developer built in to correcting color and compositing, it can do it all.

Adobe has gone through great pains in the last two revisions to make this program more intuitive and accessible to photographers. As but a few example of enhancements, consider the following:

- Adobe Photoshop CS2/Photoshop 9 includes a RAW converter that enables automatic adjustments to be made to the file when the file is opened, as well as adding a Curve capability that can be used to fine-tune the slider adjustments.

- Cropping and rotating can now be done within ACR (Adobe Camera Raw), thereby eliminating at least some double interpolation of pixels.

- The RAW file format gives you the ability to adjust white balance and temperature after the fact—yet another great way to reinvent a picture.

- Also added is the ability to work on high dynamic range (HDR for short) images. These are 32-bit images, which capture more information than 8- or 16-bit images could ever dream of. With this HDR capability comes the power to easily merge two or more images with different exposures and to maximize the dynamic range of the final image by blending pixels from the two images. These images are then converted to 16-bit and then to 8-bit for output.

- A new Smart Sharpen feature can fix lens blur, Gaussian blur, and motion blur. Although this feature has tremendous success with correcting lens blur and Gaussian blur, the motion blur is not quite on par with the other two. You really have to pinpoint the exact angle of the blur to nail it down. Regardless, people will be finding themselves using Smart Sharpen instead of Unsharp Masking; the quality difference is amazing.

- Also added is noise-suppression capability, a new Healing brush, various blur filters—the list goes on.

- Perhaps the best enhancement is the separation of the image browser, now called Adobe Bridge, from Photoshop. A completely separate application, Adobe Bridge gives photographers tremendous flexibility when organizing images. Using Adobe Bridge, you can rank, color-code, rotate, and even view a slide show of images in a folder. Best of all, Adobe Bridge features Adobe Camera Raw built in. As a result, you can open the files from Bridge either in Photoshop's ACR or in Bridge's ACR. You can then batch-process images in Bridge's RAW and continue to edit in Photoshop instead of tying up the program and grinding the process to a halt.

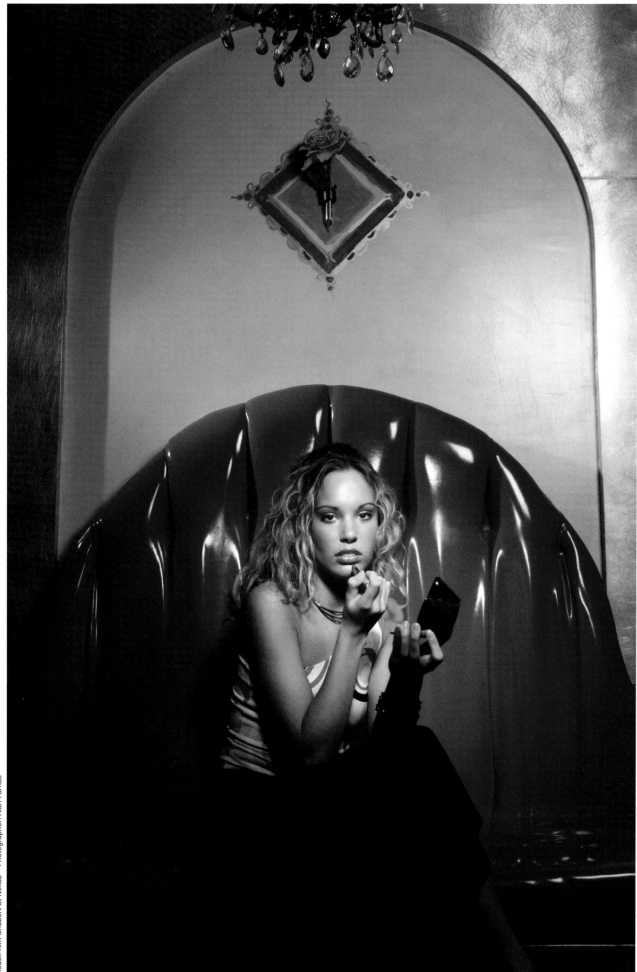

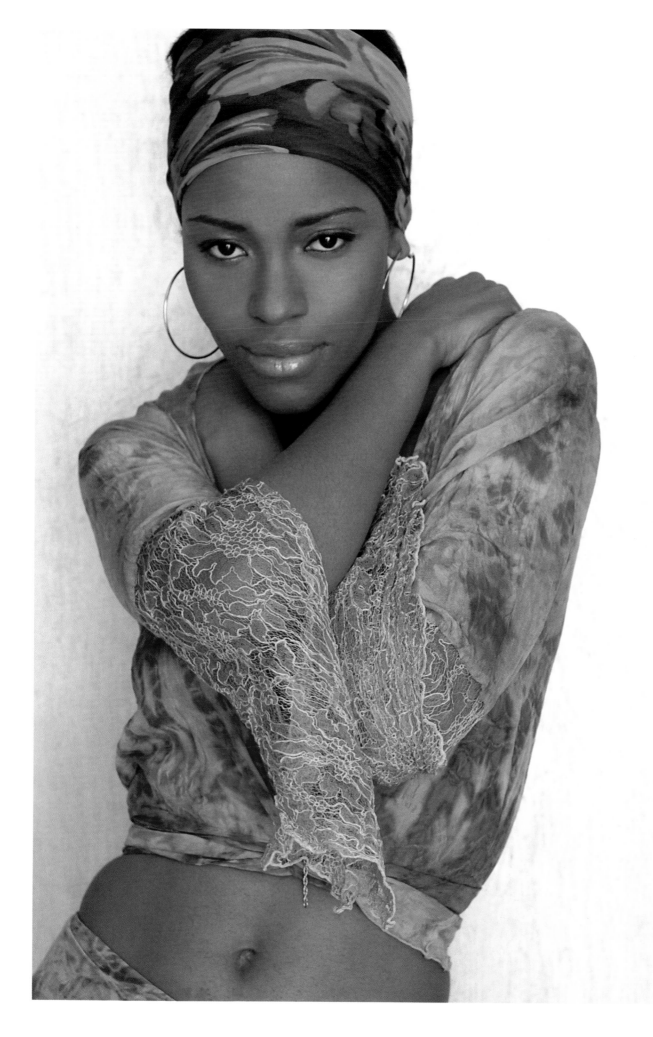

Adjusting Color

Adobe Photoshop offers many ways to adjust color. Tools like Curves, Levels, and a new one called Exposure give you great control when adjusting different zones of an image. Also available is the Shadow/Highlight tool, which greatly enhances your ability to adjust the dynamic range of an image. With this tool, opening shadows for detail is a snap.

[tip]

The Curves tool gives you the most control when isolating areas for correction. Levels are great for adjusting your end points or for making large linear moves, but fine-tuning is best left to Curves.

Using the Layers palette with these and many more tools allows for non-destructive editing of your image. This offers a great way to experiment with an image, print it, and still be able to go back and change what you have done. You can also apply lens filters on a layer just as if you were shooting with a camera lens, enabling you to apply a vast number of color options including polarizing or sepia tones.

The nice part about all these controls is that Adobe has made them very simple and intuitive to use. Although reading the program's manual can't hurt, there is nothing like diving in and pushing around some sliders and buttons to see how things work.

Retouching

Retouching fashion photographs typically involves reshaping clothing or the model's figure in order to improve the featured garment's fit. It could also include removing the wrinkles and folds in an outfit that can occur from normal wear, but would look out of place in an editorial photograph where everything has to look perfect. Alternatively, retouching might involve correcting spots on the model's face or imperfections elsewhere on her body.

[caution]

Although some clients would love to have the garment look as ironed as possible, retouching accordingly can lead to some unrealistic results. Taking wrinkles down too far or removing them completely from a garment can give the clothing a very plastic appearance, almost like a badly rendered 3D image. The wrinkles and crinkles, to a point, are what help give the image life and texture. Selectively changing them too much makes the lighting of the image strange, and worse, discernable to the average viewer.

For retouching, Photoshop provides as many options as for adjusting color. Specifically, there are now four forms of the Healing tool:

- A new Spot Healing tool works great for, well, spots. Just keep the brush size as close to the size of the spot for optimal results.
- The Healing brush works like the Stamp tool, but miraculously blends the texture around the area much better.
- The Patch tool enables you to replace very large areas with another area, blending the edges for a natural appearance.
- The Red Eye tool includes a healing brush that tackles red eye has been added.

People look at faces first, then clothing, then surroundings. This is not to say that at first glance, when flipping through the pages of a magazine, people won't be drawn to a picture for a variety of reasons. Photographer Rob Van Petten's images are a great example of this; composition is a big part, after all. But the beauty is what will keep viewers longer on a given page. That's why, when retouching fashion photographs, even though it is the clothes that are being featured, the flesh is still a big deal. If the flesh looks good, and not over-retouched, then the rest of the image will often fall into place.

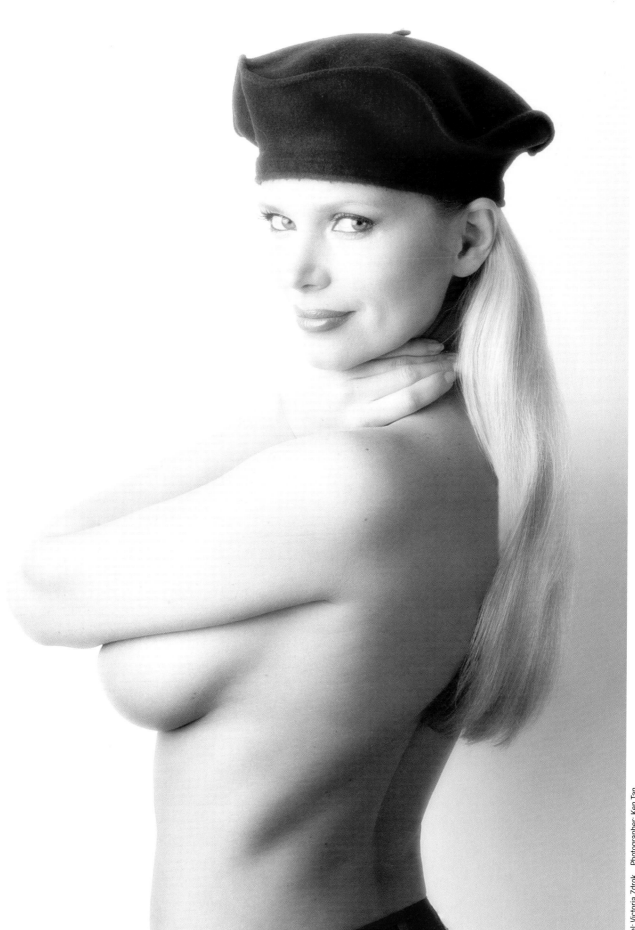

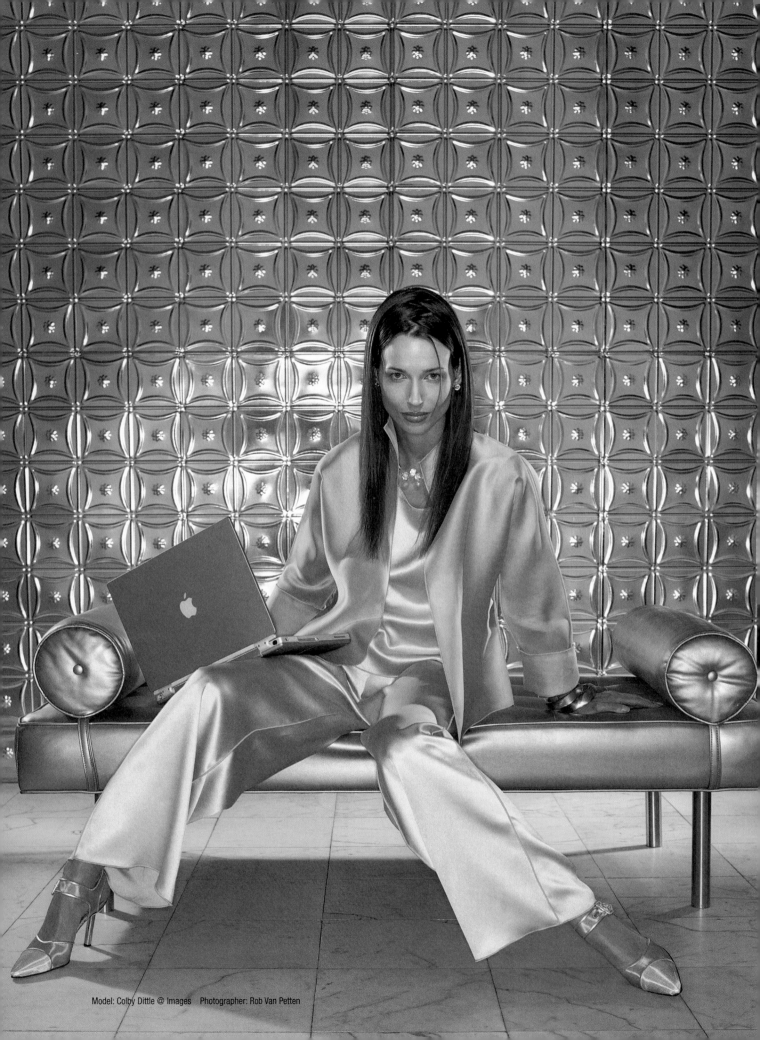

Model: Colby Dittle @ Images Photographer: Rob Van Petten

Resizing

When shooting digitally, you must consider the desired size of the final image. By *size*, we mean both the dimensions of the printed image as well as the number of pixels and bytes in the final image file. A good rule of thumb is to multiply the final image dimensions—say, 10×8 inches—by either 300 dots per inch for a high-quality output or 150 dots per inch for a lower quality (for example, for a newspaper or non-glossy color publication). This results in a 3,000×2,400-pixel image in the high-quality case, or just over 6MB—a perfect match for "prosumer" cameras such as the Canon 20D or the Nikon D70. As such, an 11-megapixel camera (such as the Canon 1Ds) captures sufficient pixels for a two-page spread without leaving too significant a margin for cropping. When using such a camera for a single-page or sub-one-page image, you have the latitude to crop the image by around half the pixels and still maintain sufficient quality for a perceived "high quality" print.

All this is to say that contrary to the popular belief that the more megapixels a camera has, the better off you are, you do not need a 22-megapixel camera if your goal is to create an 8×10-inch image. A 6.3- or 8-megapixel camera is more than capable of achieving optimal results in such a case. Indeed, using the larger megapixel camera will only mean extra work sizing the image down to fit. Sure, changing an image's resolution or dimensions is easy enough, but why do it if it's not needed? Besides, consider this: The images in this book were shot from cameras that varied between 3 and 22 megapixels, but I suspect you would be hard-pressed to see a significant difference in image quality.

Of course, if push comes to shove, you can always use Photoshop to resize an image. Photoshop offers different interpolation methods to enlarge or reduce an image. The best by far are the Bicubic, Bicubic Smoother, and Bicubic Sharper settings found in the Image Resize option of Photoshop. While some will argue that the smoother and sharper settings work best for only going in one direction, up or down but not both, they work best if you like the results. Try them all to find out what gives you the look you are hoping to achieve. While there are many excellent third-party software programs that exist for resizing, rarely do they achieve a noticeable improvement over Photoshop's resizing capabilities.

In general, downsizing an image—specifically, making its dimensions smaller—results in less degradation than upsizing. That said, upsizing images has gotten easier over the last couple of years, with improved results—although it is still not a great idea to do so. Why? Because the results, while improved, still involve some degree of image degradation, making small details diminish to the point of being unrecognizable or even nonexistent. Noise in the shadows can also become more pronounced when images are upsized, which is generally undesirable from a photographer's or client's perspective. When you resize an image, the final version should give you as close a representation to the original image as possible.

Now that we've thoroughly bad-mouthed resizing, it should be said that resizing is usually unavoidable—especially if you happen to be compositing a bunch of images together to achieve that magical look. The image on pages 108–109 is a good example of this. In this example, the photographer shot the model several times and constructed the image from multiple takes to convey the feeling she was after. Thanks to the capabilities offered by digital cameras and Photoshop, this is happening more and more.

note

It is especially important to try to get the figure's proportions correct in the various images when taking the shots themselves. Although you can resize them in Photoshop, altering angles and rotations involves a lot of lighting adjustments on the post-production operator's part, which is very time-consuming and tedious. Photoshop can match the in-camera setup eventually, but it is so time-consuming it's not worth the effort.

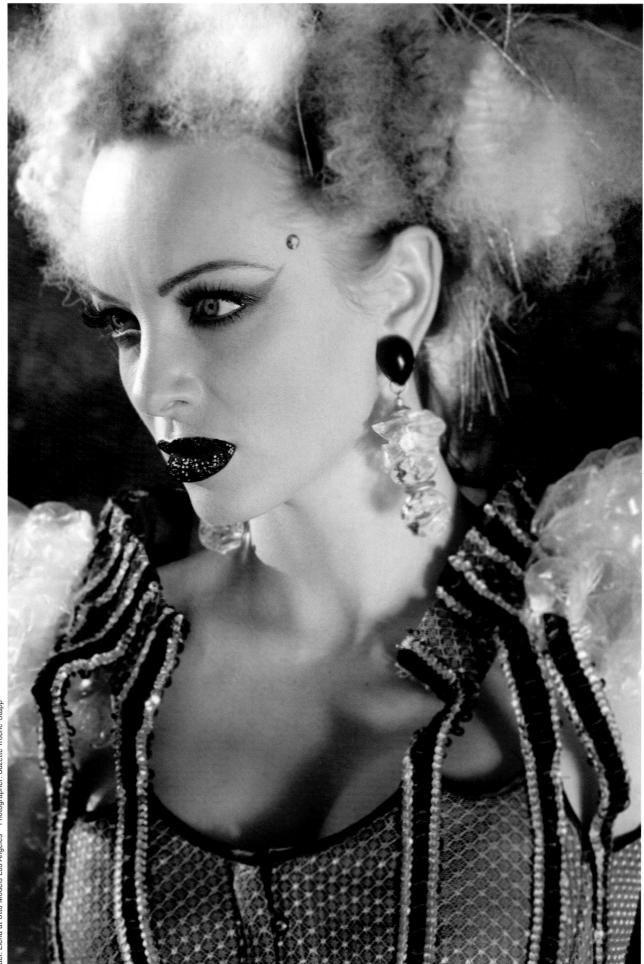

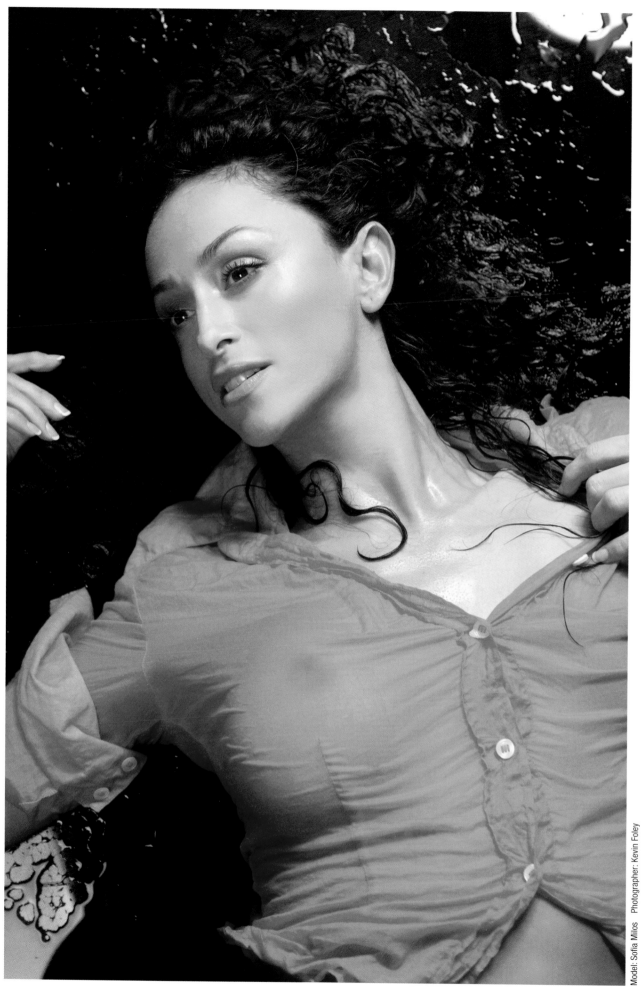

Model: Sofia Milos Photographer: Kevin Foley

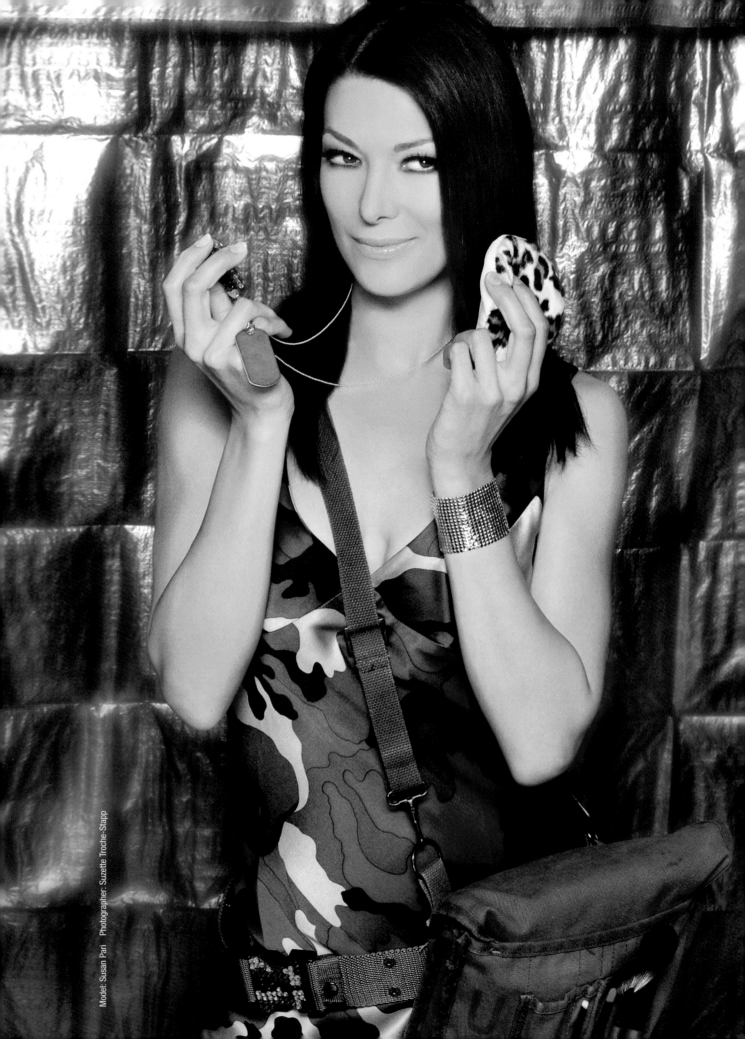

When the game plan involves compositing, a larger-megapixel camera is without question the way to go. A 16- or 22-megapixel camera allows for a blowup of a smaller area to be done to amazing proportions. The quality of this "localized" blowup is very nice; a person's face in an image can be enlarged to 11×14 inches without the noticeable degradation that happens with a smaller camera. The beauty of this is that the original image can be repurposed many times for different crops and enlargements without your having to worry about it looking *crunchy*—that is, containing artifacts from the enlargement or any sharpening that occurred.

Depending on what your final output destination is for the image, a 22-megapixel camera's capture can print as large as 20×24 inches quite comfortably. If the image will be printed from a device such as a Lambda (essentially a huge RGP print device that's great for posters or wallboards and is often used for museum displays), it could easily look great at twice that size. Your ability to generate such a large, high-quality print can open up a whole new world of job possibilities, especially when you consider that a large portion of client requests involve resizing an image or a portion thereof.

That said, when a shot from one of these large-capture cameras is sized down for print and is compared side-by-side with a capture from a smaller-sized camera, the results will be nearly identical. After all, only so much information can be printed; more is not always better. This explains why some of the most successful fashion photographers shooting in the world today use a Canon 10D to great effect. So is it worth having that large-capture capability? It is something to think about, but it's an expensive investment that you might not need to make.

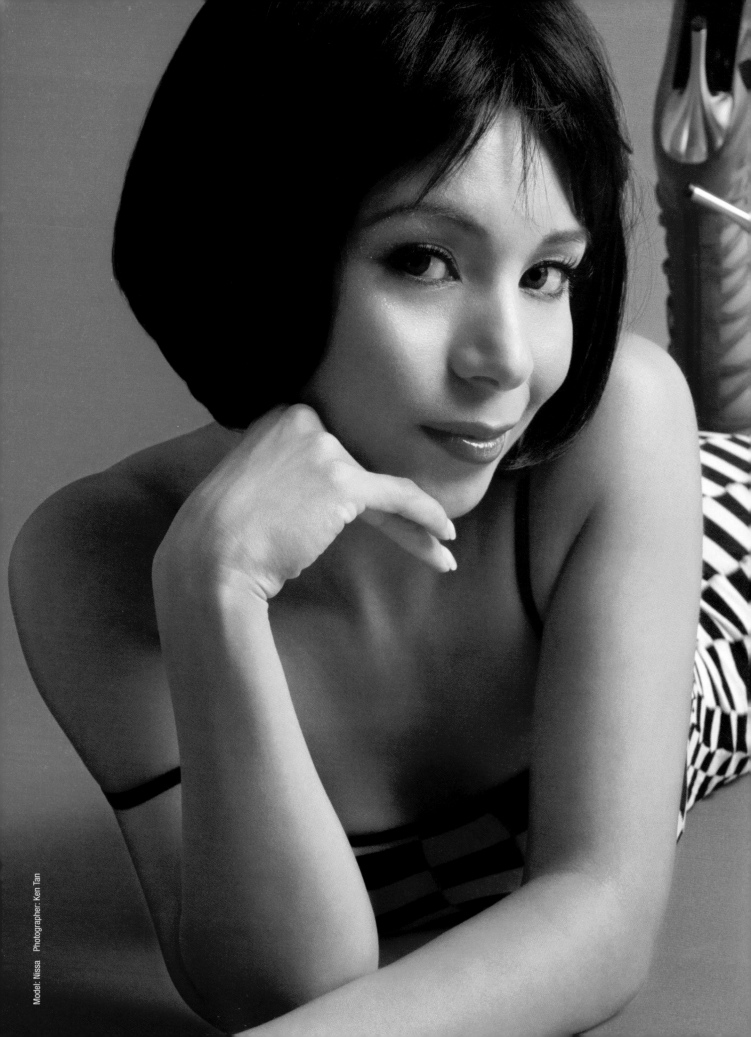

8

The Ins and Outs of Color Management

One of the most essential aspects of digital technology is color management. It's imperative that the digital fashion photographer have a strong grasp of the ins and outs of working with color. It sounds easy, and for the most part, it is. But on occasion, a photographer creates an incredible palette of colors during a shoot that is found to be nearly un-reproducible during post-production.

In this chapter, you will find out how color management can help you control how the colors in your images will be perceived and reproduced. By taking to heart the information found here, you can enjoy a reasonably worry-free and successful attempt at reproducing the images in your camera on a monitor and in print. Fortunately, certain industry guidelines based on protocols set up by the ICC (International Color Consortium) have been established to help you handle color management.

Where to Start: Controlling Your Environment

The one aspect of color management over which you have absolute power is your workspace—both your computer workspace and your viewing workspace. You may be wondering, what does the room where I view my images have to do with color management? Simple. If the room where you view your images contains color, this color will cause a change in the ambient light. This change in the ambient light will be reflected in the images themselves. As a result, your ability to accurately assess the image's color will be reduced.

[tip]

The secret to this is consistency. Avoid introducing new forms of lighting, carpeting, anything at all that would change the neutrality of the room. Even viewing color while wearing a red shirt will dramatically affect how the color is perceived.

Correct color-managed areas, courtesy GTI Graphic Technology, Inc.

There should be no bright colors in the area. Furniture should be neutral; blacks and grays work nicely. Likewise, the walls should be neutral. Although you might be tempted to go with white or black, they are not good choices because white tends to be too reflective and black can create a false sense of depth. Your best bet is to walk into your local paint store and ask for a shade called "Munsell grey." It's as monotonous as it gets, but you are guaranteed a beautiful neutral. Speaking of walls, make sure they are devoid of any brightly lit artwork or any brightly colored prints. It's okay to showcase your work; just do it at a safe distance from where you will be viewing your images.

In addition to controlling the color in the room, you must also control the light. Indeed, it cannot be stressed enough the extent to which ambient and reflective light can affect your viewing experience and how crucial it is to keep both types of light to a minimum. Since it is impossible to eliminate it, then you need to find a way to minimize it.

One way to do this is to keep the room as dark as possible. One benefit of this approach is that your image will seem to have more contrast—although, as with black walls, this can be misleading. Keeping the room dark also means that you'll need some sort of light source by which to see written-word or other organizational material. To manage this, you'll need little lights here and there, which, of course, can be a real shock to the eyes.

The other option is to keep the workspace as evenly lit as possible. This can be much easier to maintain than the sporadic lighting involved with a darker room. Ideally the light should be the industry standard for viewing images, 5,000K. Indeed, this type of light very nearly eliminates the need for a light booth, although it can become prohibitively expensive to constantly change the bulbs. Then again, considering what an image with the wrong color can do to a photographer's career, those 5,000K lights might be worth the money.

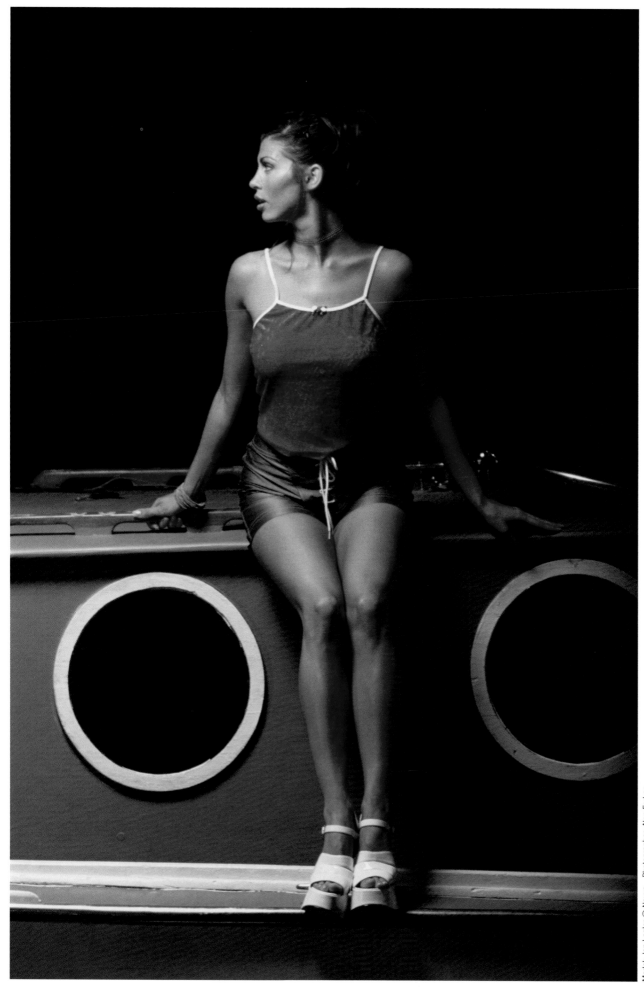

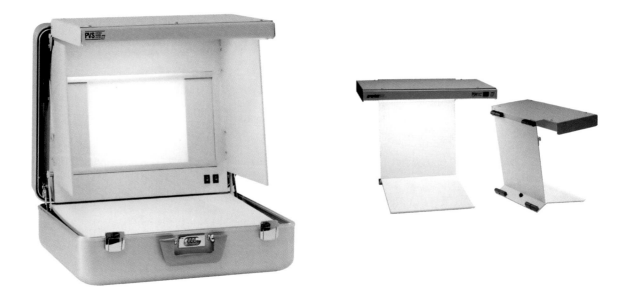

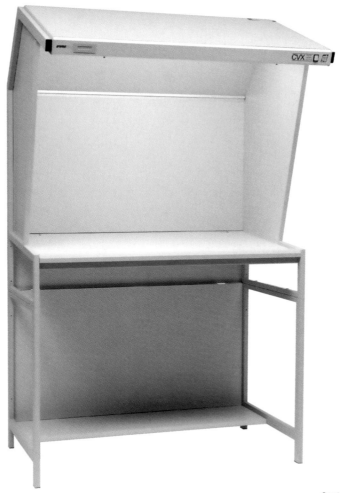

Courtesy GTI Graphic Technology, Inc

When you have your décor and lighting established for prime viewing, the last thing you need to add to your work environment is a viewing booth. These come in varying sizes and offer several shades of portability; the one that's right for you depends on how transient you tend to be. That said, nearly all post-production studios have a permanent viewing booth capable of displaying a 20×24-inch print. These types of studios typically also have some portables around in case they need to be used somewhere that is not a color-managed environment. In addition to these permanent and portable booths, you'll need some sort of viewing booth for transparencies or reflective works, placed next to a computer. This is used to view printed matter or transparencies made from a digital file as you do retouching or color work onscreen. The one common element of all these various types of viewing booths is that they all contain 5,000K bulbs, and therefore—theoretically, anyway—they allow for consistent viewing no matter where you go.

Be aware that the placement of these booths is critical to how accurate they are. You do not want to place one next to a row of windows or a door that is continually in use. Keep it consistent. The 5,000K bulbs are meant to get you as close to a controlled sunlight or natural viewing light as possible, and if you can't regulate that light, then you will be unable to achieve color accuracy.

Monitor Calibration

Now that your workspace is color-managed, it's time to move on to the next most important piece of equipment you need to color-manage: the monitor on your computer workstation. If your monitor displays colors in a way that's completely out of whack, it won't matter how perfectly you've designed your viewing and working areas or how well your printer can reproduce what you see. After all, if what you are seeing is wrong to begin with, then what's the point?

At the moment, computer monitors come in two flavors:

- **Cathode ray tube (CRT).** The tried and true CRT monitors have been the standard for ages. Image quality on most professional CRTs is exceptional. Indeed, when the monitor is properly calibrated, images display very accurately and include details in the shadows that might not be immediately apparent in print or on the camera. When selecting which image to use, gradation and tonal rendition are obviously very important; CRTs answer this need by offering the best available range and require the least amount of follow-up calibration. (They need to be recalibrated on a regular basis, but they do not float nearly as much as they used to.) Thanks to competition from LCD displays, high-end CRT monitors have plummeted in cost of late.

[tip]

If your system supports it, consider setting up two monitors. This can be a great time-saver when working in Photoshop, when viewing before-and-after pictures, or when comparing different selects.

[tip]

If you're considering buying a CRT monitor, consider what kind of front glass it has. A CRT with a flat screen will minimize the distortion that sometimes occurs in the corners.

- **Liquid crystal diode (LCD).** Reasonably new to the market, LCD monitors, commonly called "flat-screens" because of their slender profiles, are great for saving space—because let's face it, CRT monitors are huge. Although price and quality has historically been a complaint, flat-panel LCD monitors have begun to make inroads in both areas. Indeed, LCD screens come in sizes up to 30 inches and are nearly as cheap as slightly smaller CRTs. One problem with using LCDs, however, relates to viewing angles; looking at an LCD screen even slightly off-center may affect how you see the color. Although viewing angles have become much wider in recent years, this remains a valid issue. That said, color accuracy is very good on higher-end LCD monitors.

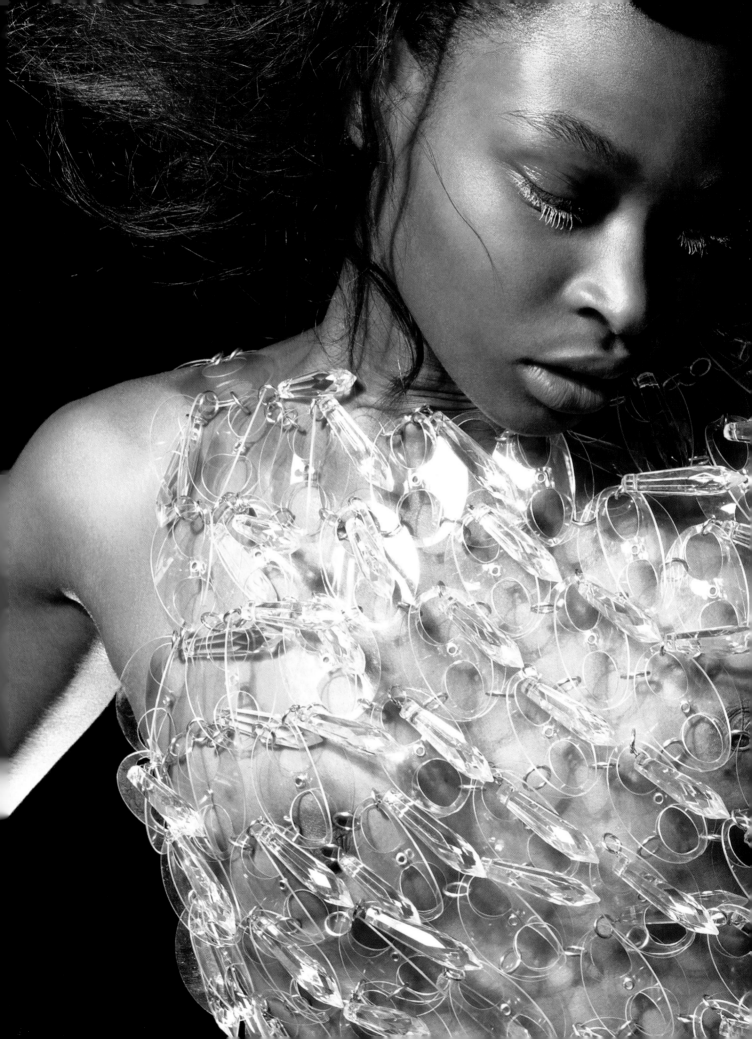

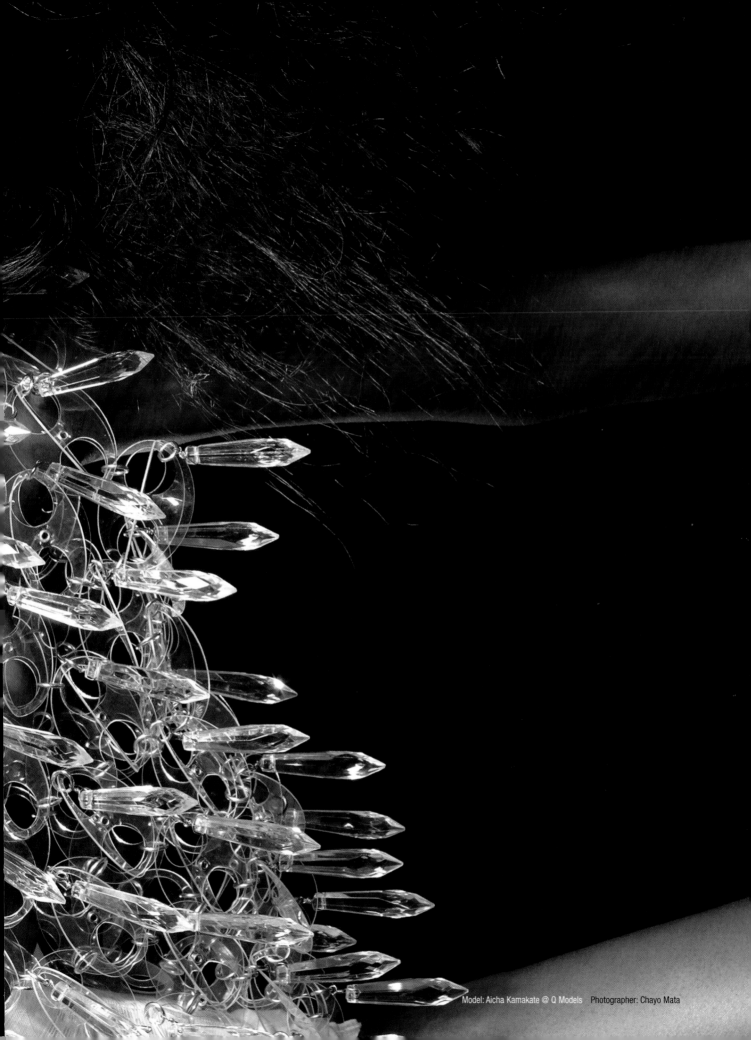

Model: Aicha Kamakate @ Q Models Photographer: Chayo Mata

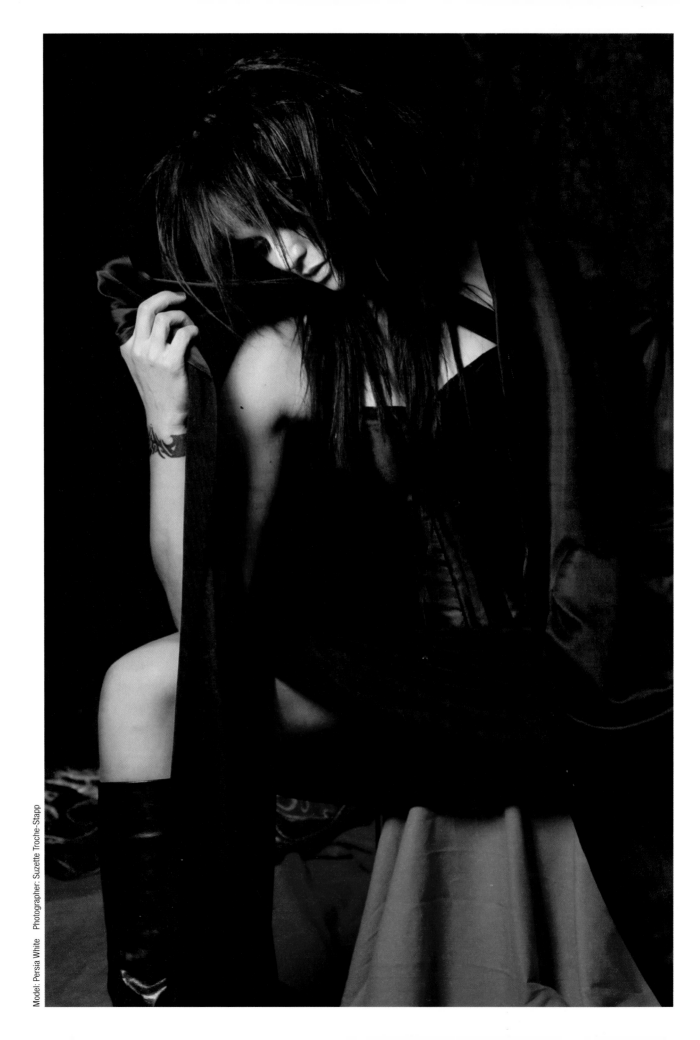

note

Companies like EIZO make LCD monitors that are highly customizable and accurate. They have a small footprint (that is, they take up less table space), and can tilt to be viewed in either portrait or landscape mode. They have very saturated colors, are very sharp, and enjoy long lives. On the EIZO and Apple Cinema Displays, the color is arguably the best out there—including among CRTs.

Whether you have an LCD or a CRT, the process of calibrating your monitor is nearly identical. One difference, however, is that CRT monitors do not support the use of a 10-bit color lookup table (CLUT), while some LCDs do. The benefit of the larger CLUT is that it provides more accurate color rendition for skin tones, gradients, and tonal range. One debatable deficiency with regard to calibrating LCD monitors is that they do not have contrast controls. Only a brightness setting is adjustable.

Regardless of type, calibrating your monitor is best done with software that allows adjusting for the individual red, green, and blue color spaces. On CRTs, this allows software to take into account the aging guns that allow for color fluctuation over time. (CRT screens are made up of rows of red, green, and blue pixels that, when excited by the electron "guns" within the monitor, combine to create any number of colors to make up the image you see.) On some LCDs, such as the EIZO, you can also adjust CMY values. Programs such as Pantone's ColorVision, GretagMacBeth's Eye-One Display, and Monaco EZcolor, and also the Pulse system by X-Rite are all excellent solutions for tackling your calibration challenges. The makers of these programs have gone well above and beyond to make them simple and powerful in order to make color management as painless as possible.

Eye-One Display, Monaco EZcolor, and Pantone ColorVision Spyder.

Setting Up Photoshop's Color Management

You have calibrated your monitors and color-managed your work area. Now you need to set up your work area *inside* the computer to handle color management. In particular, Photoshop needs to be told what color profile should be associated with a particular image and where the image is going to end up.

When shooting from a digital camera, you decide what color profile is identified with each image file; how these files are attached depends on which file format you are using—RAW or JPEG. RAW images are not tagged in the camera. No compression is done to RAW images, nor is sharpening or color management. They are a representation of exactly what the camera saw and captured when the shutter opened and closed. As such, RAW files are very large, and portions of them can be cropped and significantly enlarged. JPEG images, on the other hand, experience all of the above. They are compressed by a value you specify. If you set it to do so, the camera will sharpen a JPEG image automatically. Likewise, JPEG images are tagged with a color space that alters what the camera captures.

Regardless of file type, your color profile options include Adobe RGB, ColorMatch RGB, ProPhoto RGB, and sRGB. Although the Adobe RGB, Colormatch RGB, and ProPhoto RGB spaces are prohibitively large, there is almost nothing wrong with sRGB. Yes, it boasts a much smaller gamut compared to the other spaces, but it is more than suitable for the vast majority of print work. The fact is, large color spaces look great onscreen, but a lot of the time, they offer too much color. Worse, when converting to a printable color space, some of the colors change dramatically.

In a post-production shop, Adobe RGB is the most commonly used because of its suitability for conversion to the much smaller-gamut CMYK printing specs. You will still have some problems with certain vivid colors like bright yellows, bright blues, and bright reds, however. sRGB is used primarily for images that are bound for screen viewing, such as on the Web or in online portfolios, and for home printing. Both are considered safe for conversion to CMYK, and if you have already been using one over the other and are used to it, then stick with it.

To access Photoshop CS1's color-management settings, open the Edit menu and choose Color Settings. If your images are Camera Raw with an Adobe 1998 RGB color space attached, choose the North American Prepress 2 option. If the images are Camera Raw with sRGB, and are to be used for the Web only, then choose North American Web/Internet. To access these settings in Photoshop CS2, open the Photoshop menu and choose Color Settings. In CS2, all the North American settings are grouped at the top of the pull-down for convenience; use the same options as with Photoshop CS.

Photoshop also gives you the ability to preview on-screen how a different profile would look if applied to the image currently on display. So if, for example, your default Photoshop color-management workspaces are Adobe RGB 1998 and US Web Coated (swop)v2, you can temporarily switch viewing to a different profile. To do so, open the View menu, choose Proof Setups, and select a different color space—say, sRGB, or a custom CMYK profile you received from a service bureau—from under the Custom setting. You can even duplicate the image in Photoshop, view a different profile for each copy, and then view them side by side for easy comparison.

North American Prepress2, North American Web/Internet for CS2, North American Prepress2, and North American Web for CS1

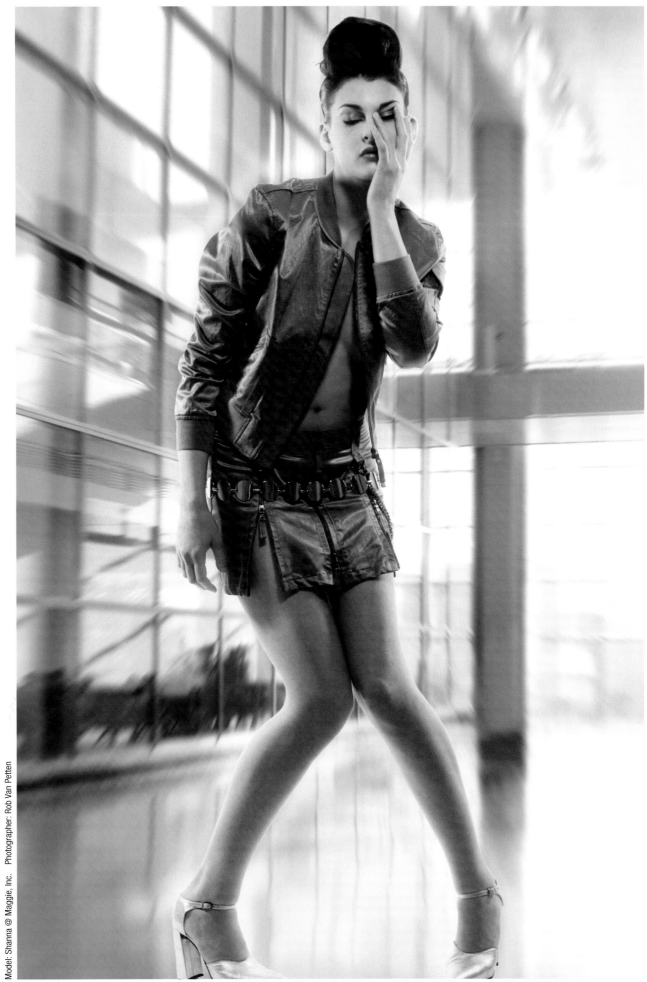

Color management in Photoshop is not complicated. In fact, the easiest way to screw it up is to make it more complicated than it has to be. In simple terms, Photoshop uses an input profile to describe where the image came from, a viewing profile to describe how the image looks on-screen, and an output profile that describes the color space to which the image will end up when printed. Profiles in Photoshop are handled in two different ways:

- **By assigning a profile to a file.** Assigning does not alter the pixel data in a image. In a way, it just soft-proofs onscreen how the color is being manipulated and what it will look like. You can assign as many profiles as you like until you get to the one you want.

- **By converting a file to use a particular profile.** Converting to a profile is exactly like it sounds. Pixel data is physically changed to a different color. Converting is the final step for finalizing the color.

Printing Your Images

Printing technology has come a long way in a very short period of time. Only two years ago, home printing was at best a hit-or-miss endeavor. Epson made some great printers, such as the 2200 and the 2000p, that yielded wonderful color prints, but the black-and-whites needed some beef. Canon, too, had some great printers, which were fast and boasted beautiful color and detail, but they tended to fade a little too quickly. Indeed, this seemed to be a big problem with all the printer manufacturers. Promises of multiple decades of non-fading color and lasting prints rarely came true.

All that has changed—and quite dramatically. These days, it is quite possible to generate prints that are rich in color and offer little to no banding in flesh tones, as well as to create black-and-white prints that easily match the quality offered by many processing shops. These printers have also become so much faster, with an 8×10-inch image printed directly from Photoshop taking an average of 90 seconds! Compared to as much as 10 minutes a year ago, this is remarkable.

Printers now come in several different ink configurations. Some use pigment-based inks, some use ultrachrome, and some even use photographic inks. Each manufacturer has what it believes to be the best solution to address everyone's needs, be they amateur to professional. And for the most

part, they are right. There is really not one printer out there that won't get the job done. So how do you choose? Simple. You need to decide what you want to do with your printer. Are you printing at home for yourself? Are you printing the all-important portfolio to get a job? Or better yet, are you already doing great work for different magazines but need to make that killer portfolio to get a top-notch agent? If it comes down to the last two, then you need to do some serious research about the various printers on the market. Different inks, and perhaps more importantly, different papers react differently to exposure to the elements—not just light and humidity, but also heat, ozone, smoke, and a bunch of others. To really get the lowdown on what to expect from the major manufacturers of paper and printers, check out http://www.wilhelm-research.com. This firm has conducted a lot of research into this topic and has been around for a very long time. They know their stuff.

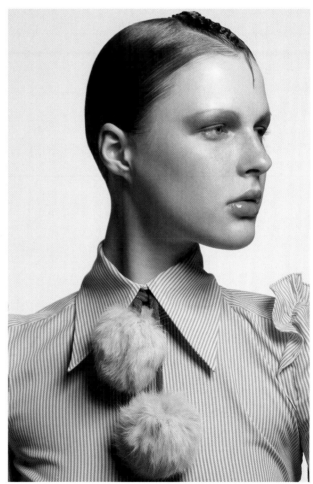

Model: Elena B @ Elite Photographer: Chayo Mata

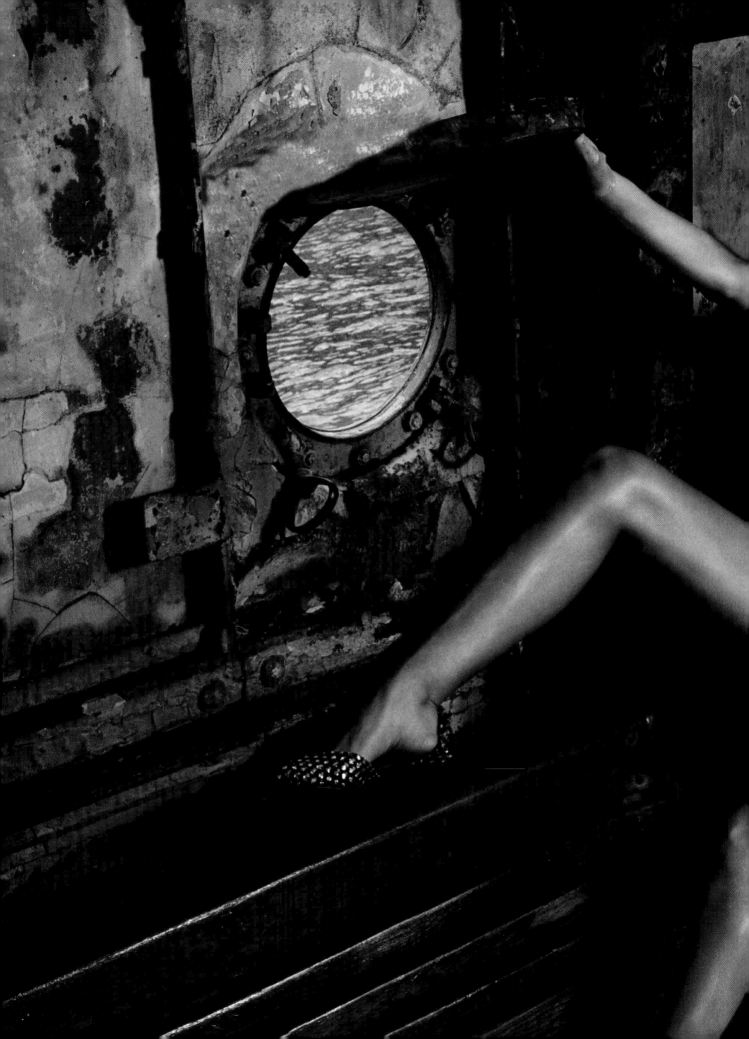

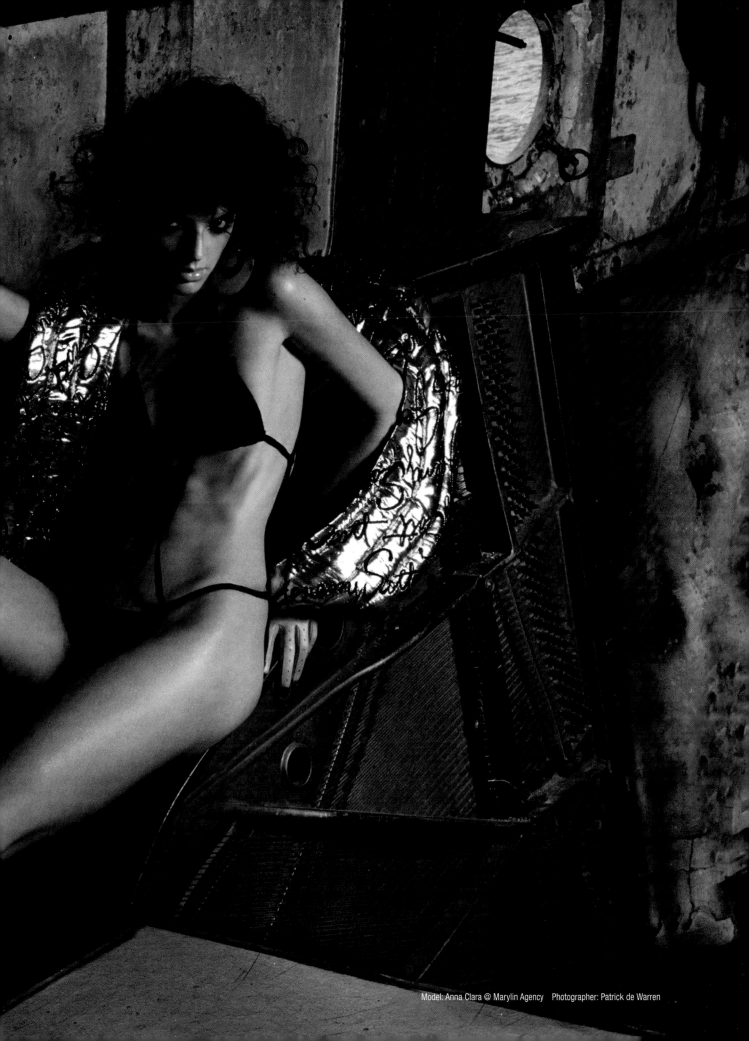

Model: Anna Clara @ Marylin Agency Photographer: Patrick de Warren

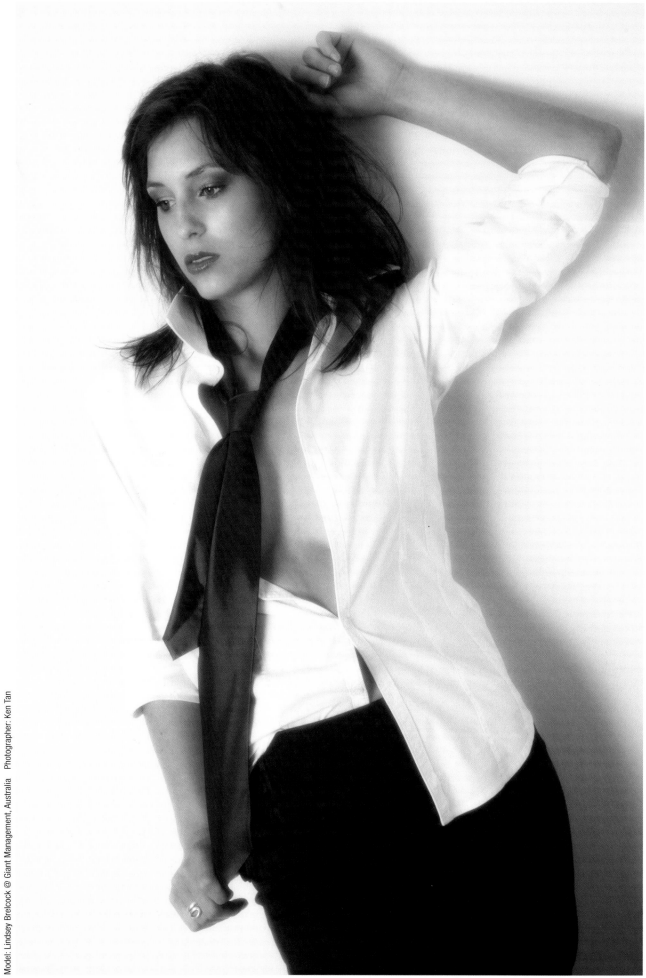

A print can look very different depending on what type of paper is used. Paper stock varies due to bleaching, fluorescents, and thickness, among other variables. Some stocks yield a rich color representation, but the blacks can look gray. Some papers offer the opposite. Some papers will make an image look very yellow, thereby throwing off skin tones. Fortunately, you can rectify many of these problems by making or purchasing a profile for each type of paper you use. These profiles won't make things perfect (keep in mind out-of-gamut colors), but they can get you most of the way there.

Although four-color printers still exist, it is now very common to find six-, seven-, and eight-color printers. Depending on which printer manufacturer you use, these "extra" colors can vary. Some have extra magenta and cyan inks, some utilize green and orange. Some add an extra black or a gray. All the extra inks are there to provide the same end result: prints that are less vulnerable to breaking up in the flesh tones, prints that have better shadow detail (because the new printers use incredibly small drop sizes of ink), and prints that enjoy richer color thanks to the use of a larger print gamut. The printers that provide a second black or a gray ink give the nicest results for black-and-white prints. Indeed, these prints can rival a good c-print, and under the proper conditions, can last a long time. Metamerisms are now a rare thing to see instead of commonplace for these black-and-whites.

Probably the most sought-after printer in the professional arena is the Epson 4000. This is a large print inkjet with a 17-inch-wide page size. It uses seven ultrachrome inks for really nice, continuous-tone (or as close as you can get) images. It includes a level-3 RIP and built-in Apple Bonjour (formerly Apple Rendezvous) networking, making it quick and easy to set up and put into use. The pigmented inks include a matte black along with a standard black and light black. Use of the light black really improves how gray balances are replicated, including eliminating most colorcasts. The printer is fast and accurate with the right profiling, and can be used for acceptable preliminary press proofs. Even better, it is very affordable. Another popular printer is the Canon i9900. This very fast printer is highly accurate, uses eight colors for images that can rival print pho-

tographs, and generates borderless 8×11-inch prints in about 50 seconds. The largest available paper size is 13×19 inches, borderless. This is a great printer for seeing very quickly what your image will be. Most desktop printers like the Epson and Canons are not PostScript printers, so if you wish to print PostScript files to one of these printers, you will need to purchase an application that is capable of doing so. These are called *RIPs* (short for *raster image processors*) and enable vector images and EPS files to be printed at high quality.

In May of 2005, Epson announced the arrival of two new printers that really push the boundaries of desktop printing: the R2400 and Stylus Pro 4800. These printers introduce a nine-ink print system that generates remarkable quality and are capable of reproducing at 10-bit color for unbelievable skin tones and gradations. As great as this sounds, if you do invest in one of these, use it for limited editions and such, as the commercial industry will be unable to match such quality and you might be a little disappointed at their attempts to do so.

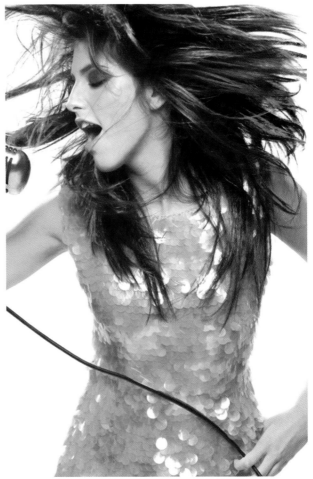

Model: Dina @ Maggie, Inc. Photographer: Rob van Petton

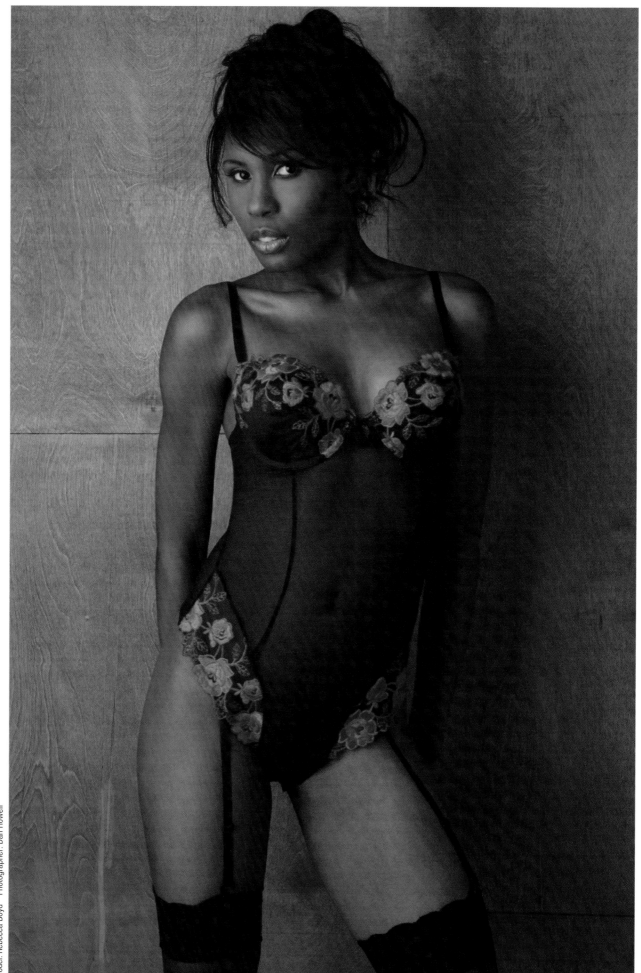

If you are doing your own image preparation but do not want to deal with having your own printing device, there are plenty of shops that offer professional printing services. These shops can generate prints ranging in size from small 4×5-inch to huge 40×60-inch prints. They also offer a variety of materials to print on, from standard c-prints to Duraclear and Duratrans. Duraclear and Duratrans are, in effect, extremely large transparencies that are popular for backlit displays in clothing stores, etc. In fact, some shops can even print on canvas. Pricing may vary depending on quantity, so shop around for the best deal. If you're not sure where to start, try calling the customer service lines for various magazines to ask who they use for their prepress services.

Interestingly, two prints can look identical in one viewing area, yet look totally different in another. This is caused by ink sets being created differently. The inks reflect and absorb light in different amounts, giving a very different look to a print, to a product that was matched on a print, and most especially to prints made by different printers. If you are experiencing this problem, the best thing you can do is bring a print to the post-production house for them to match with the final output. The file you give them will still need to go through the shop's own color-management process, so some tweaking of the file will occur. Even so, it is best that they have an accurate rendition of what you want to achieve in order to make everyone's lives easier.

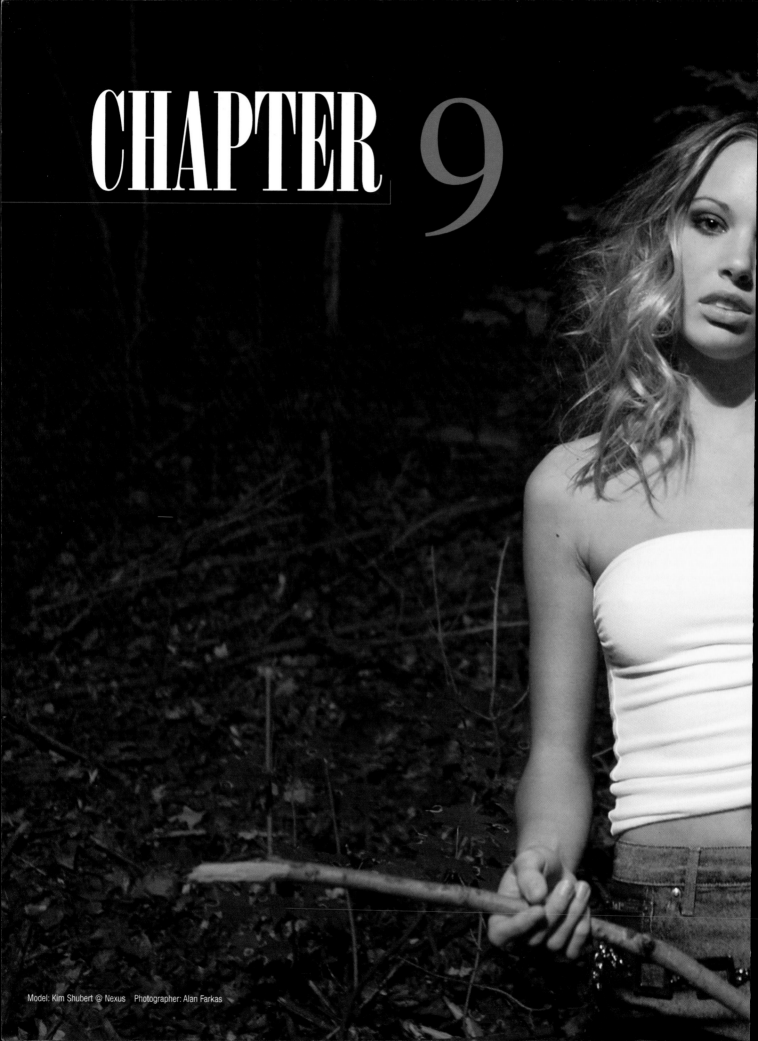

CHAPTER 9

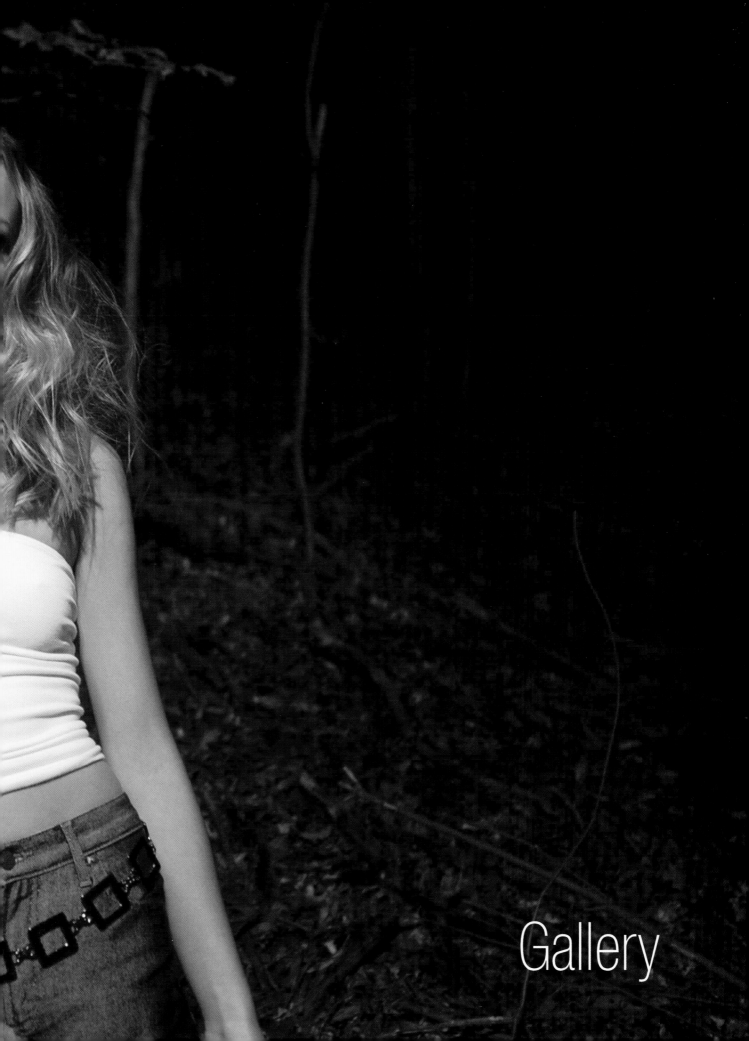

Gallery

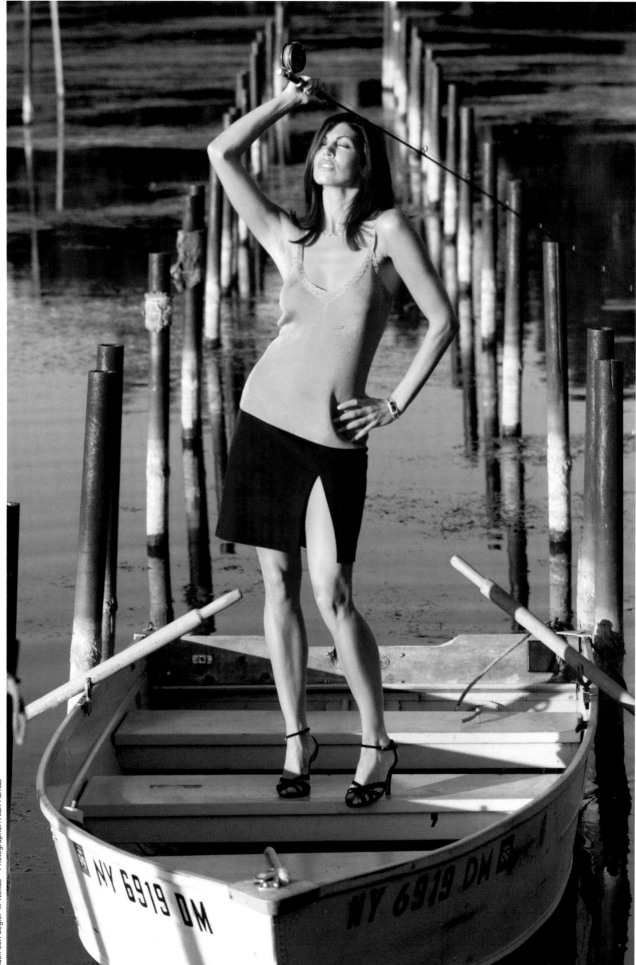

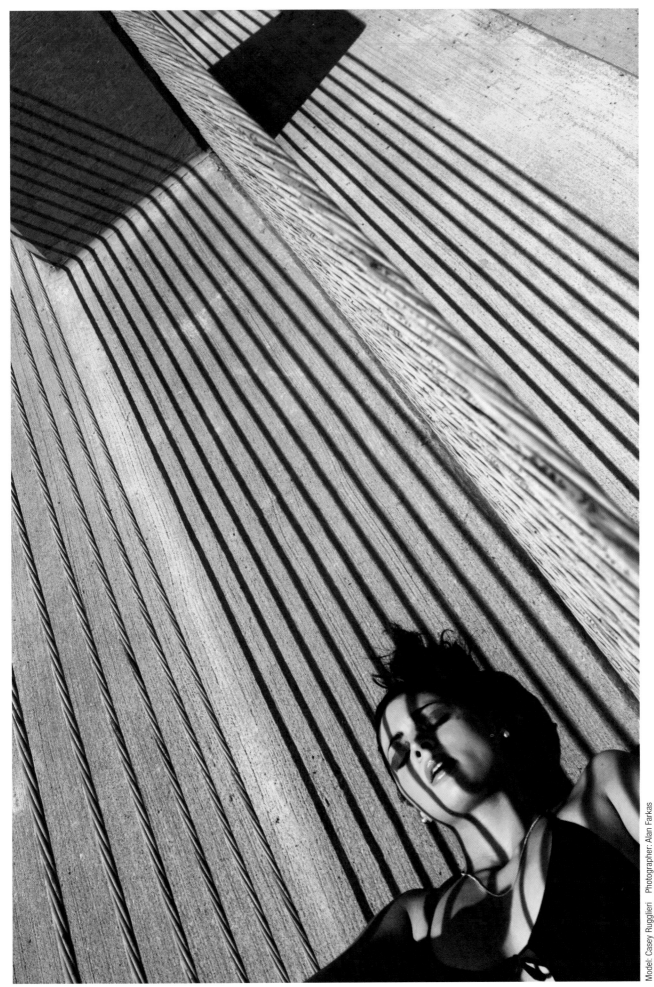

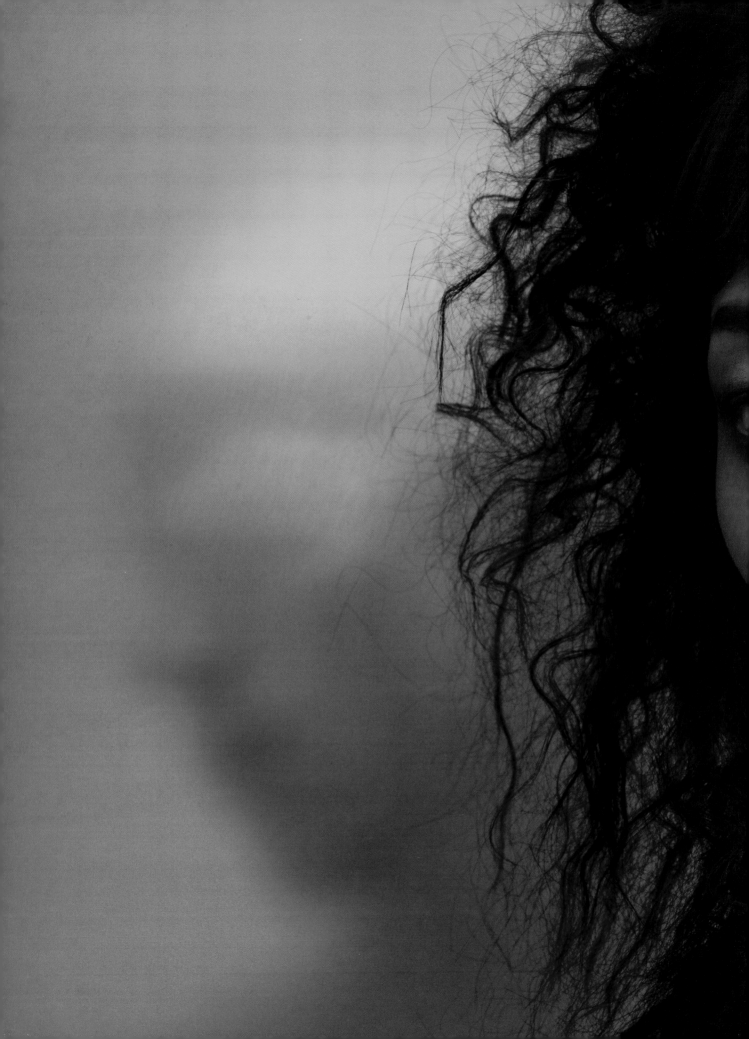

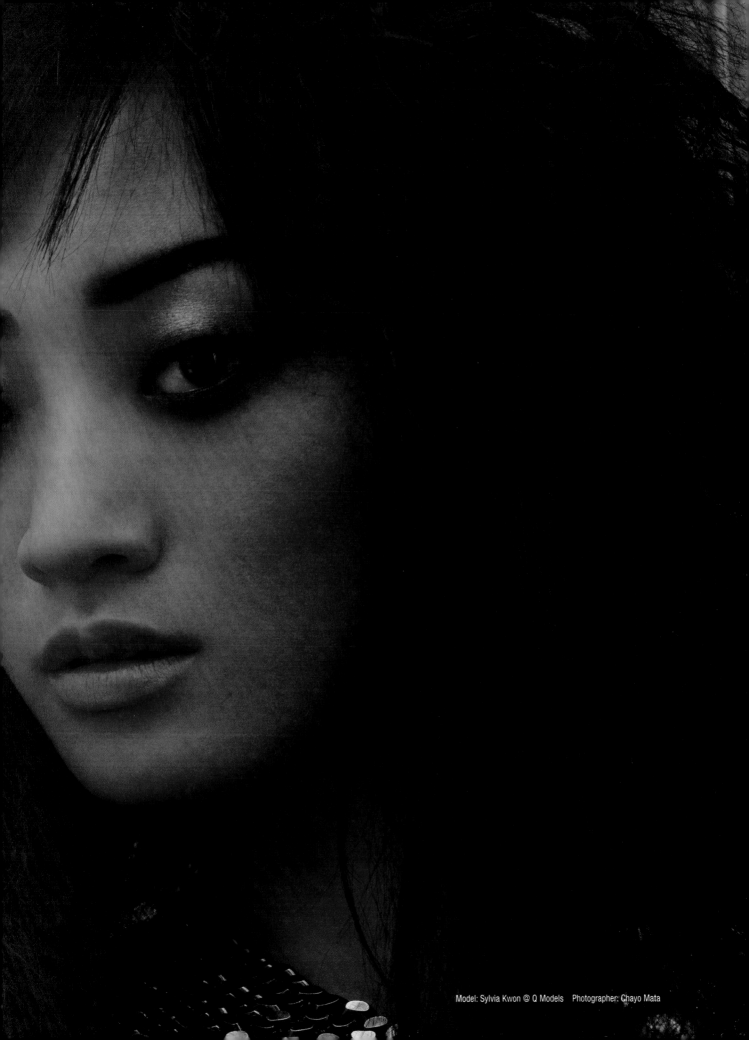

Model: Sylvia Kwon @ Q Models Photographer: Chayo Mata

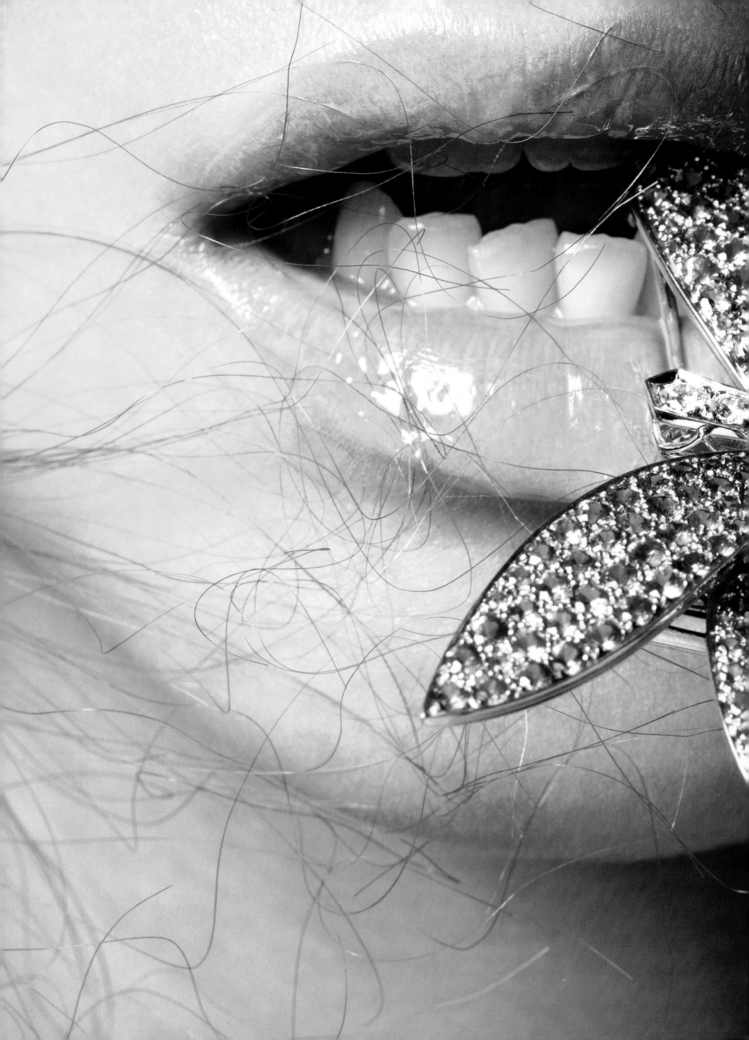

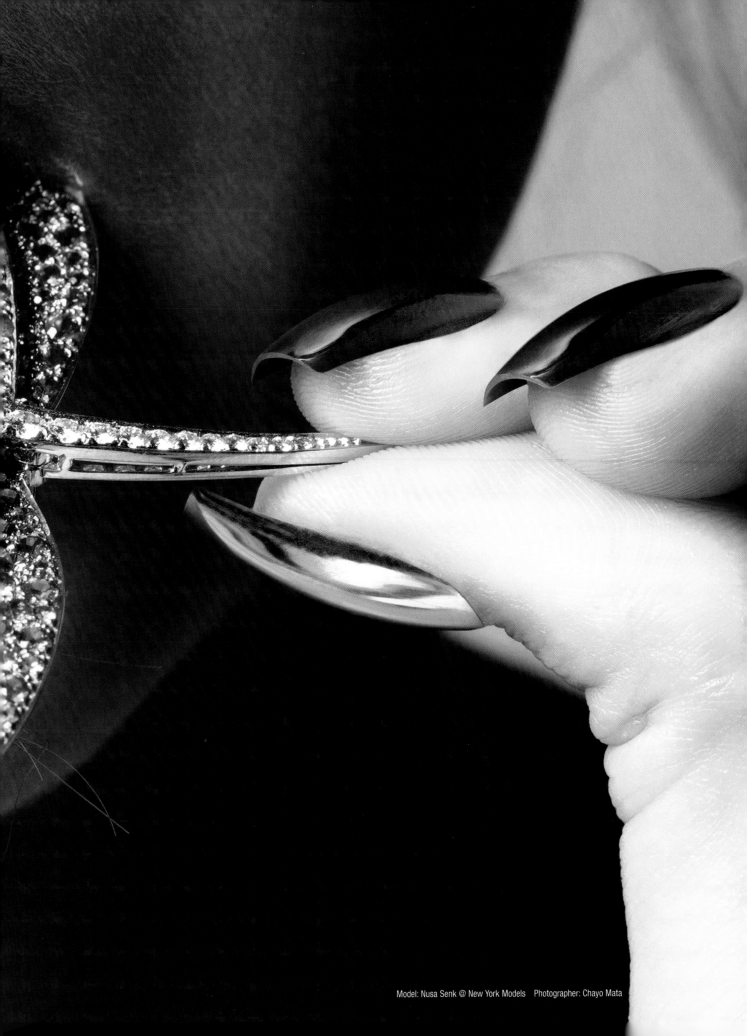

Model: Nusa Senk @ New York Models Photographer: Chayo Mata

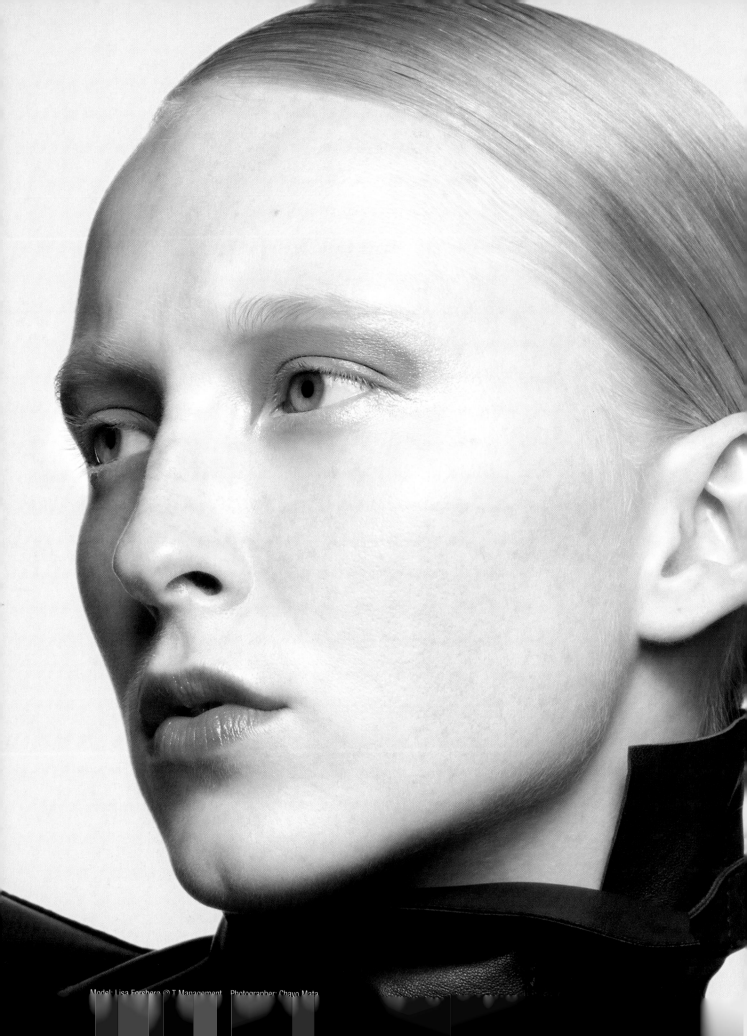

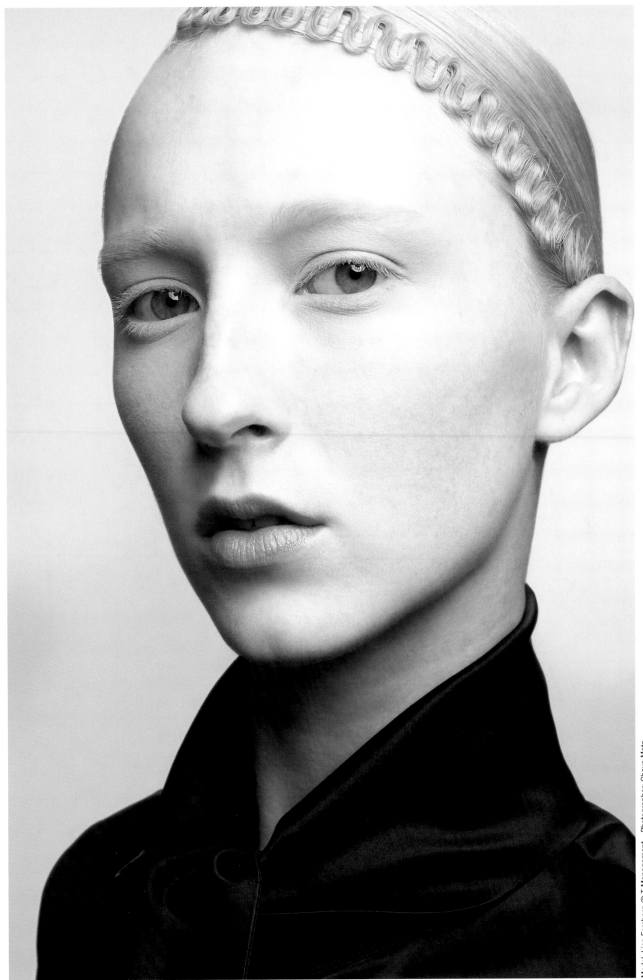

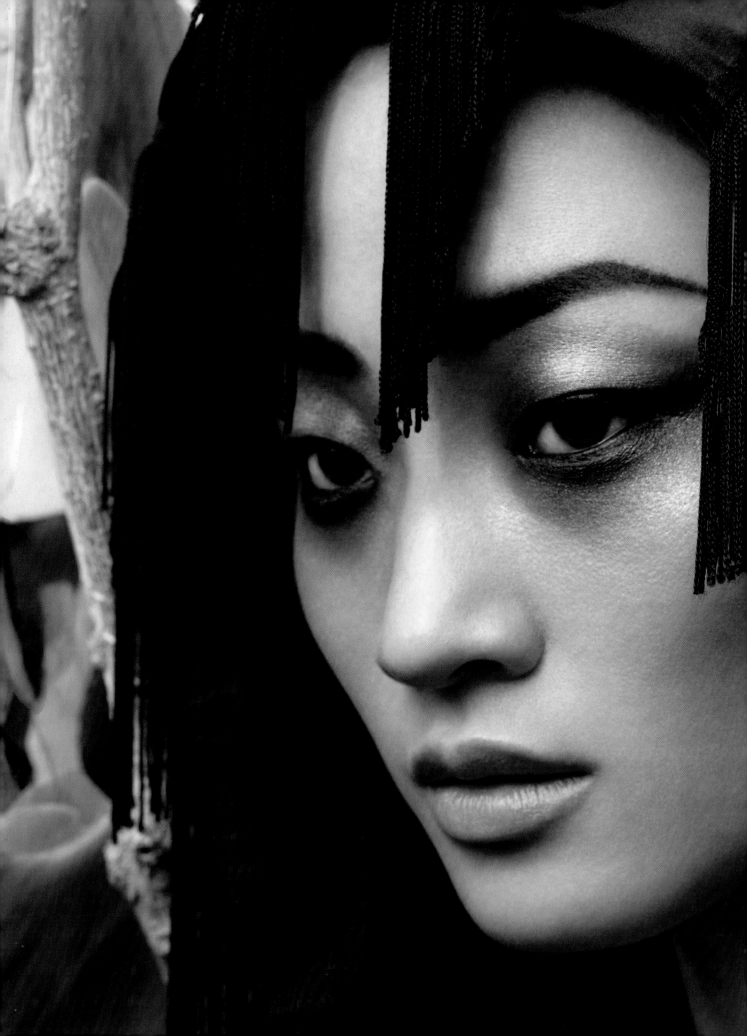

Model: Ashley Yao @ Wilhelmina Photographer: Chayo Mata

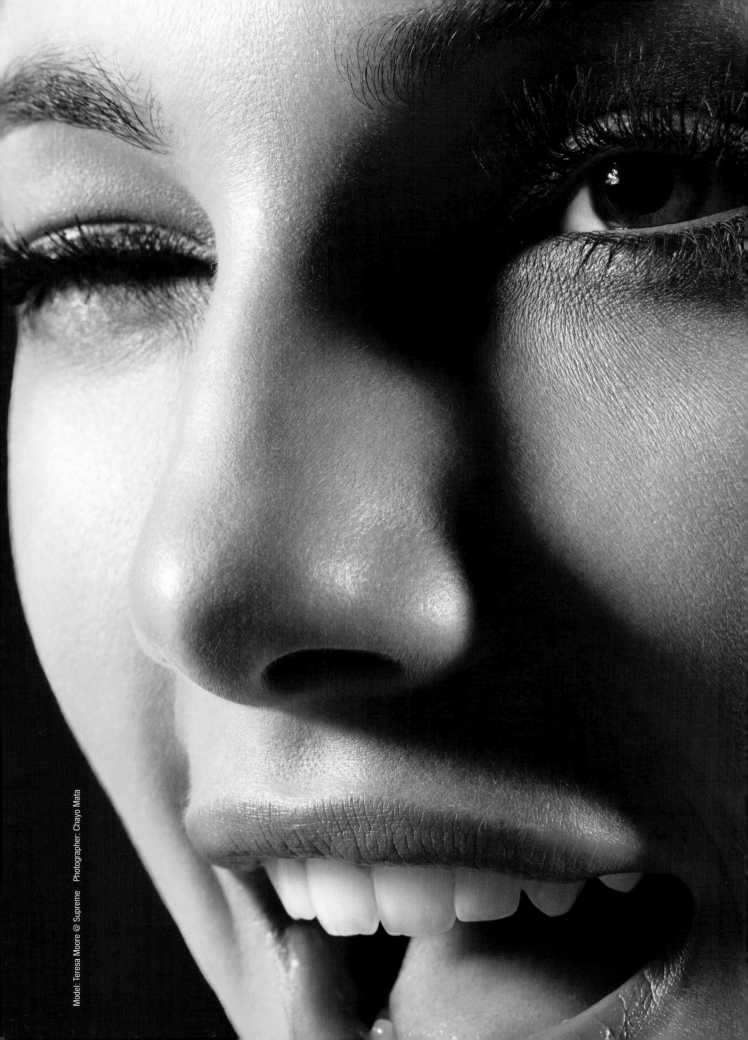

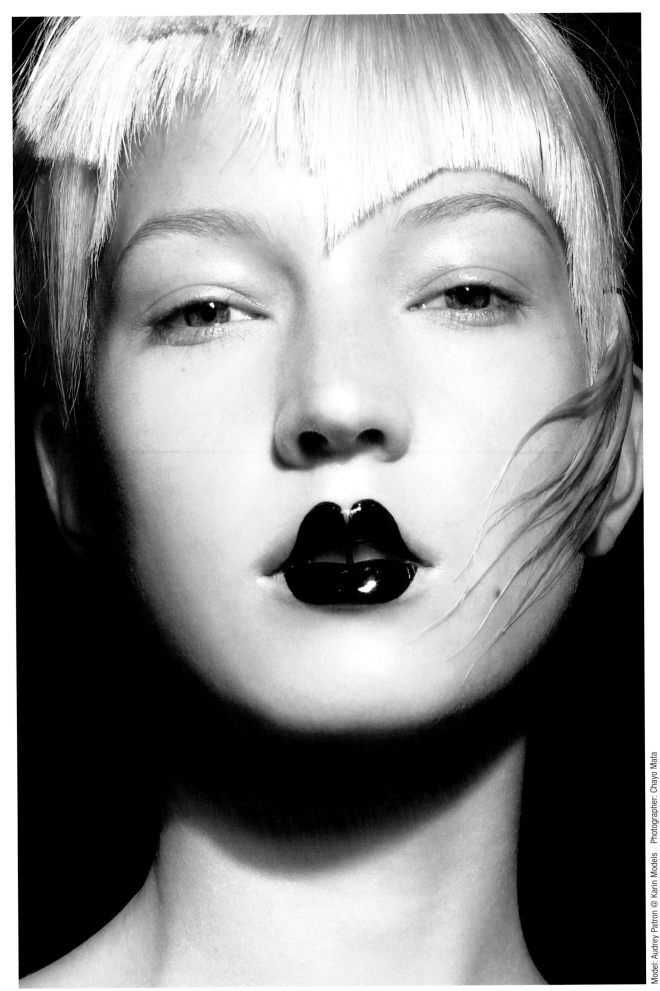

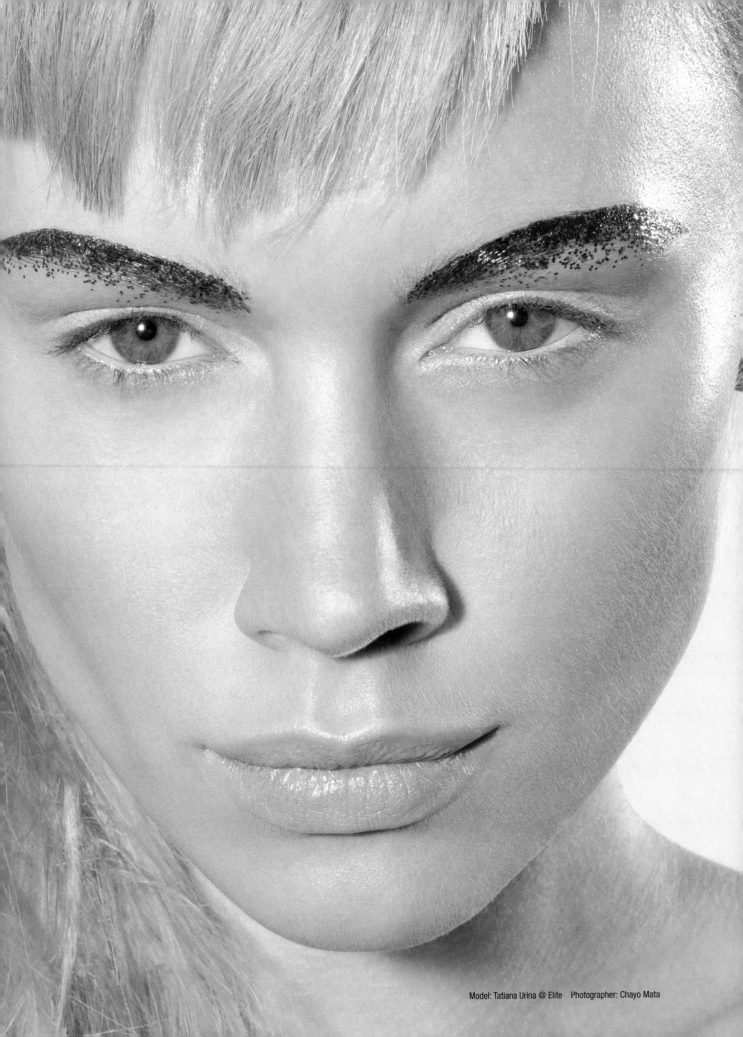

Model: Tatiana Urina @ Elite Photographer: Chayo Mata

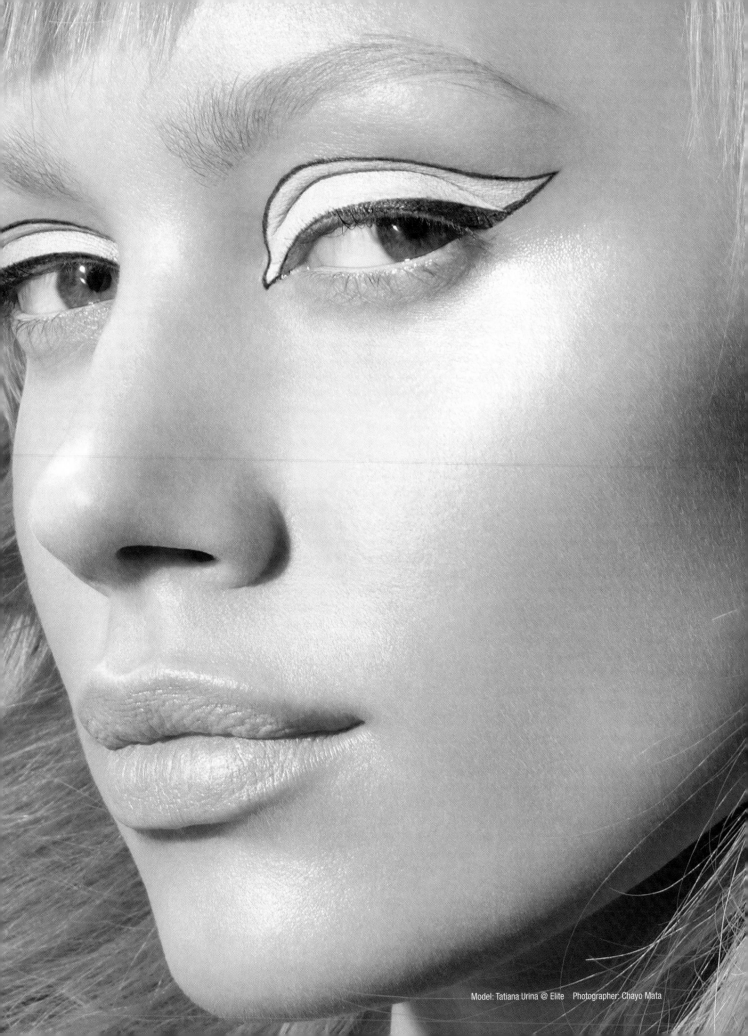

Model: Tatiana Urina @ Elite Photographer: Chayo Mata

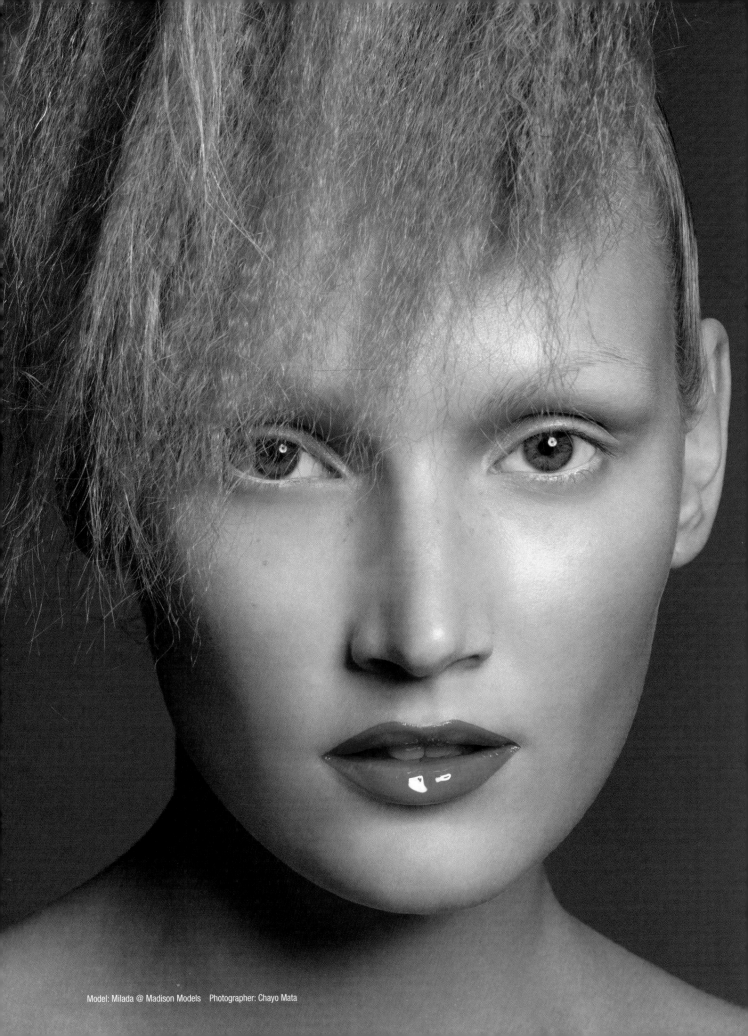

Model: Milada @ Madison Models Photographer: Chayo Mata

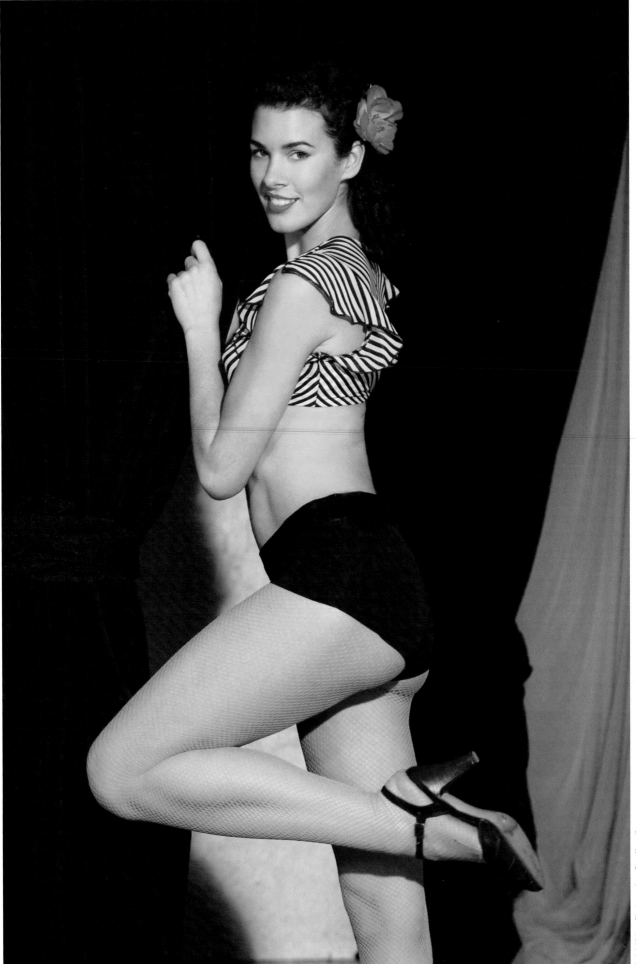

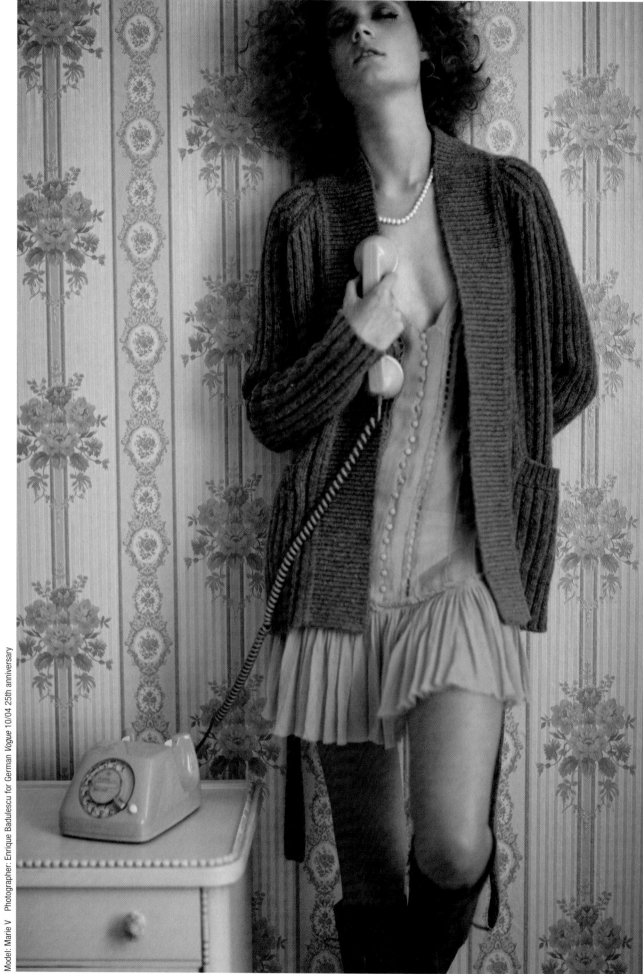

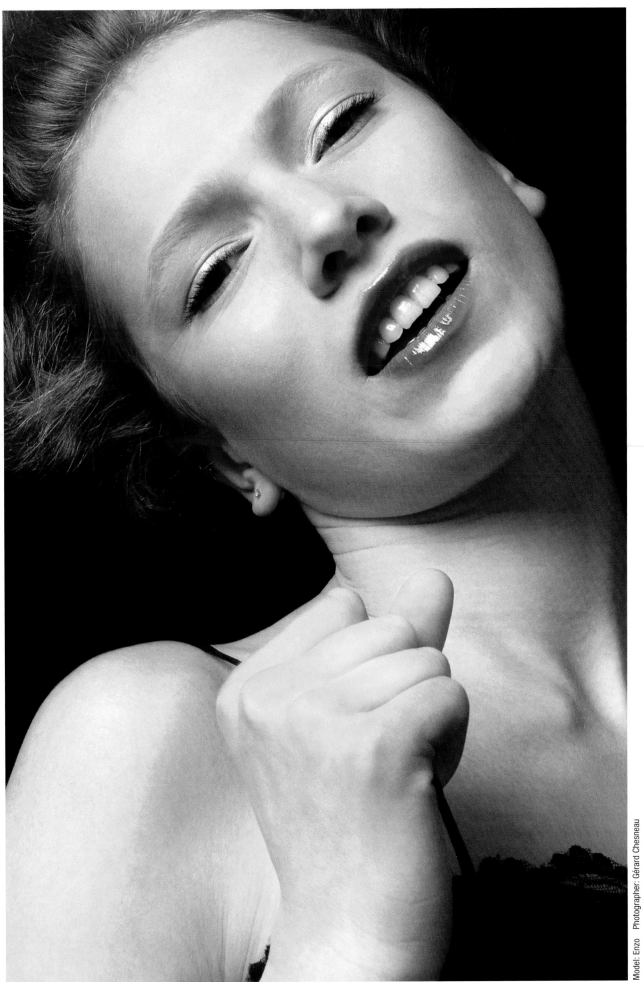

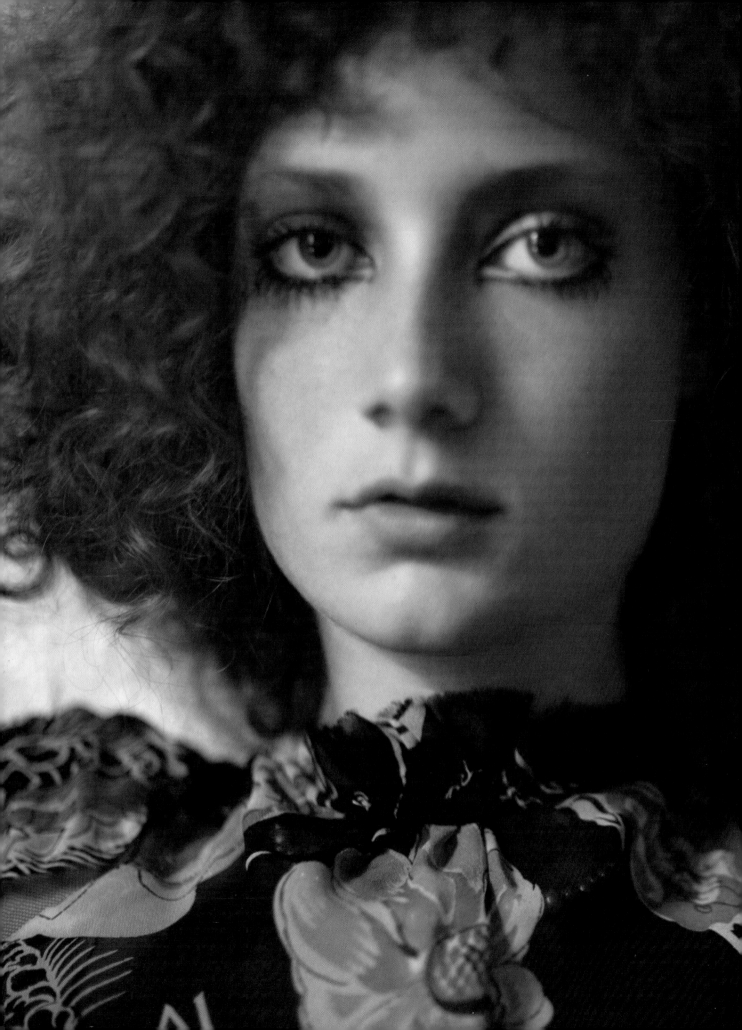

Model: Marie V Photographer: Enrique Badulescu for German *Vogue* 10/04 25th anniversary

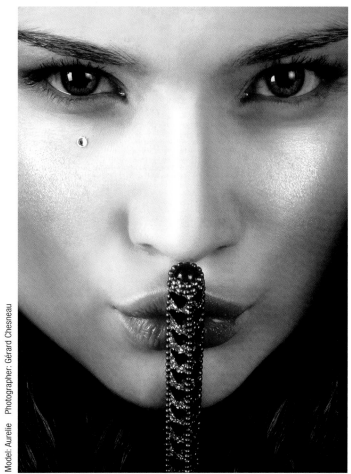

Model: Aurelie Photographer: Gérard Chesneau

Model: Anne-Solenne Photographer: Gérard Chesneau

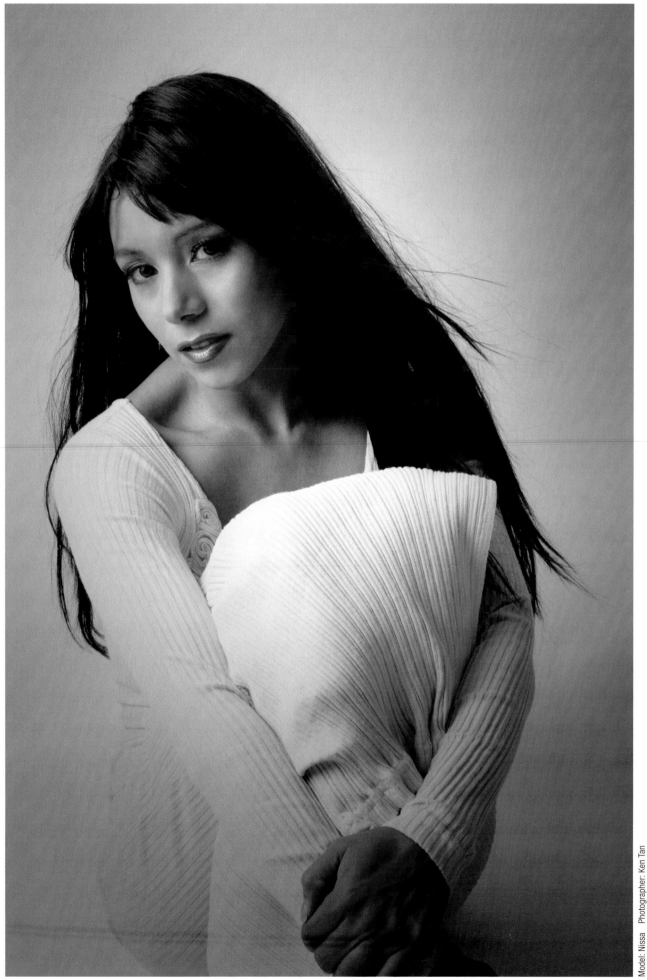

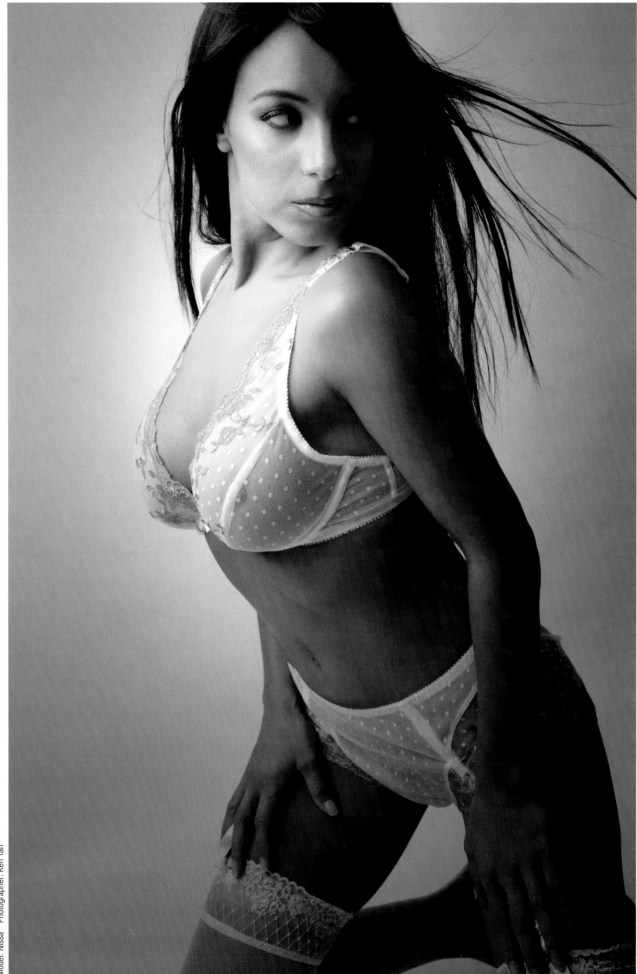

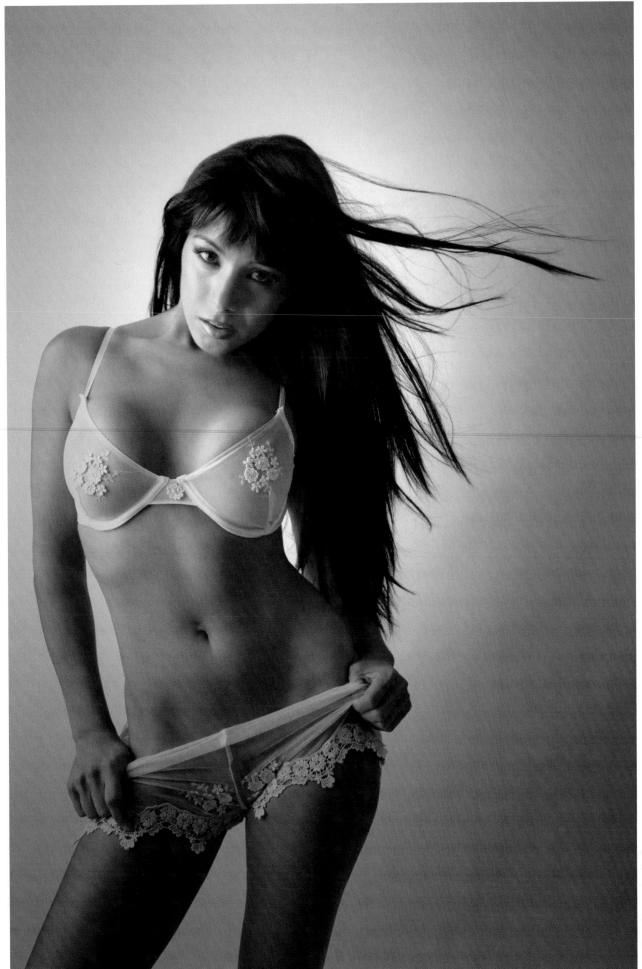

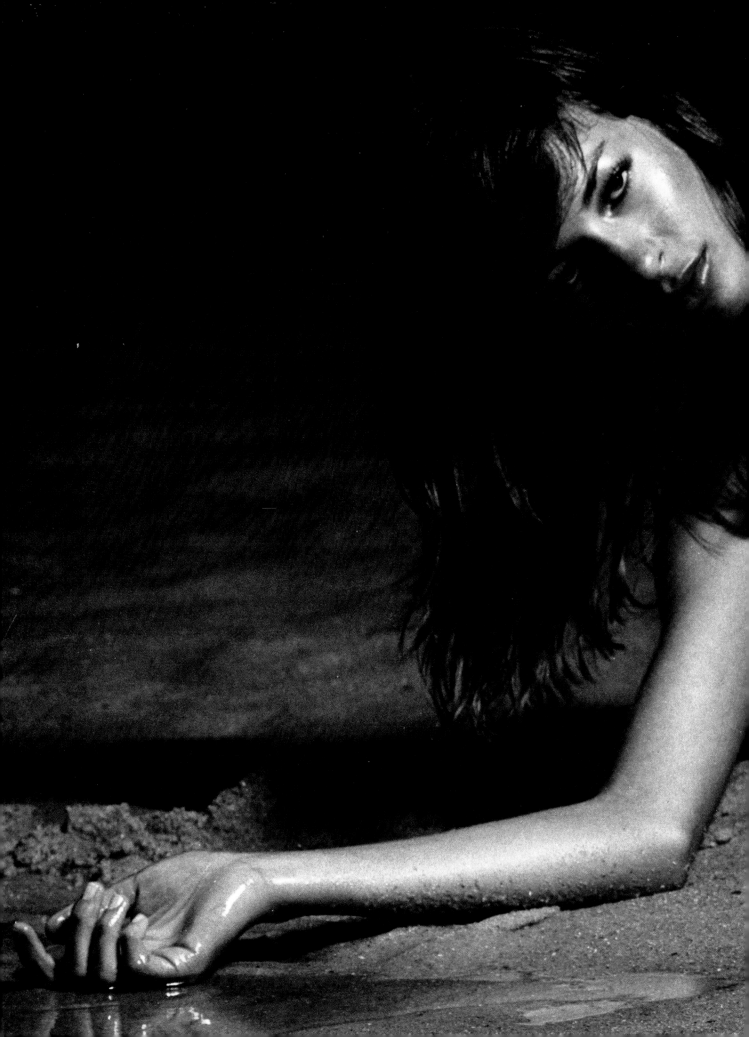

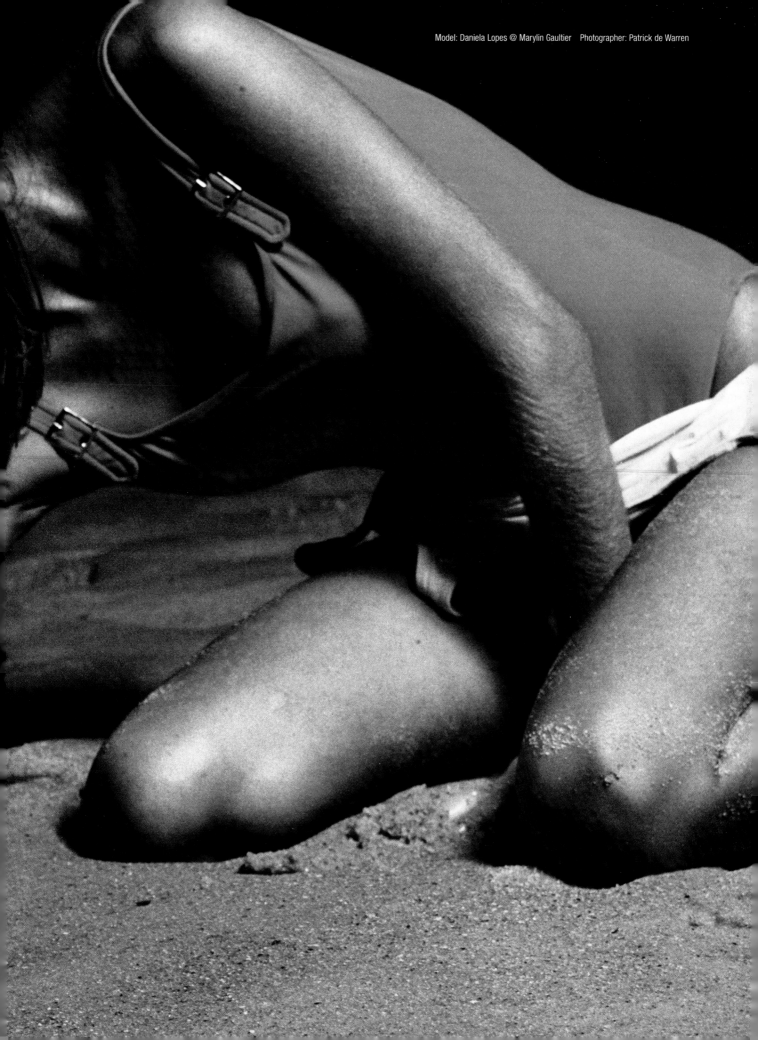

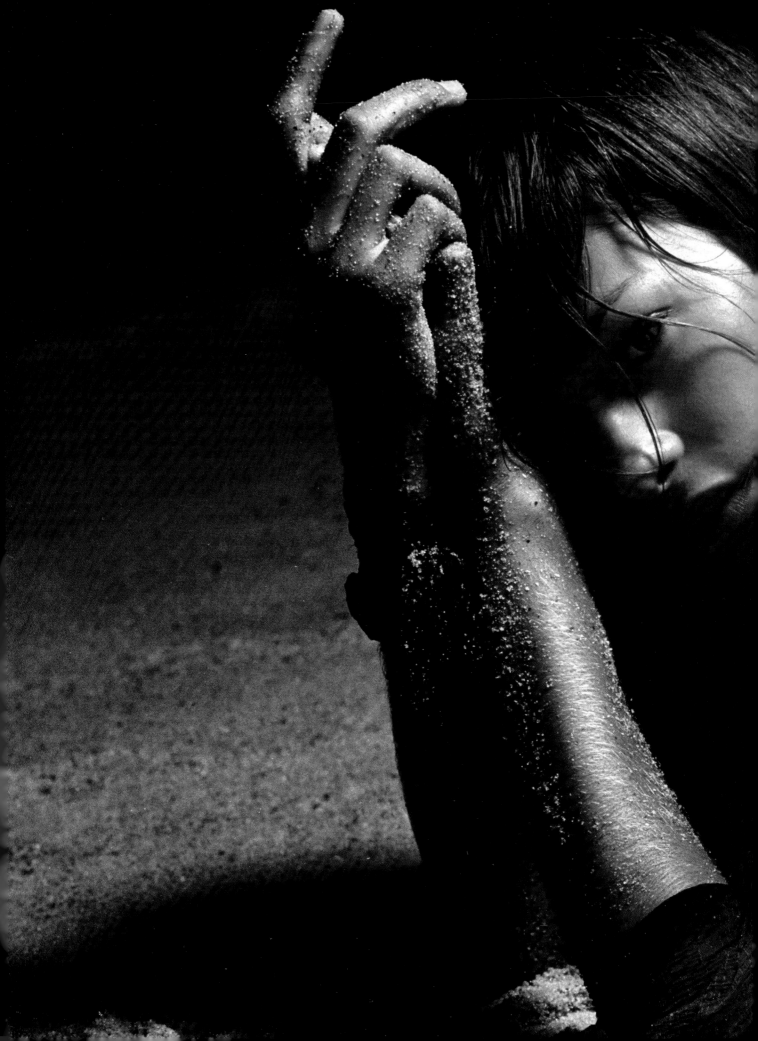

Model: Daniela Lopes @ Marylin Gaultier Photographer: Patrick de Warren

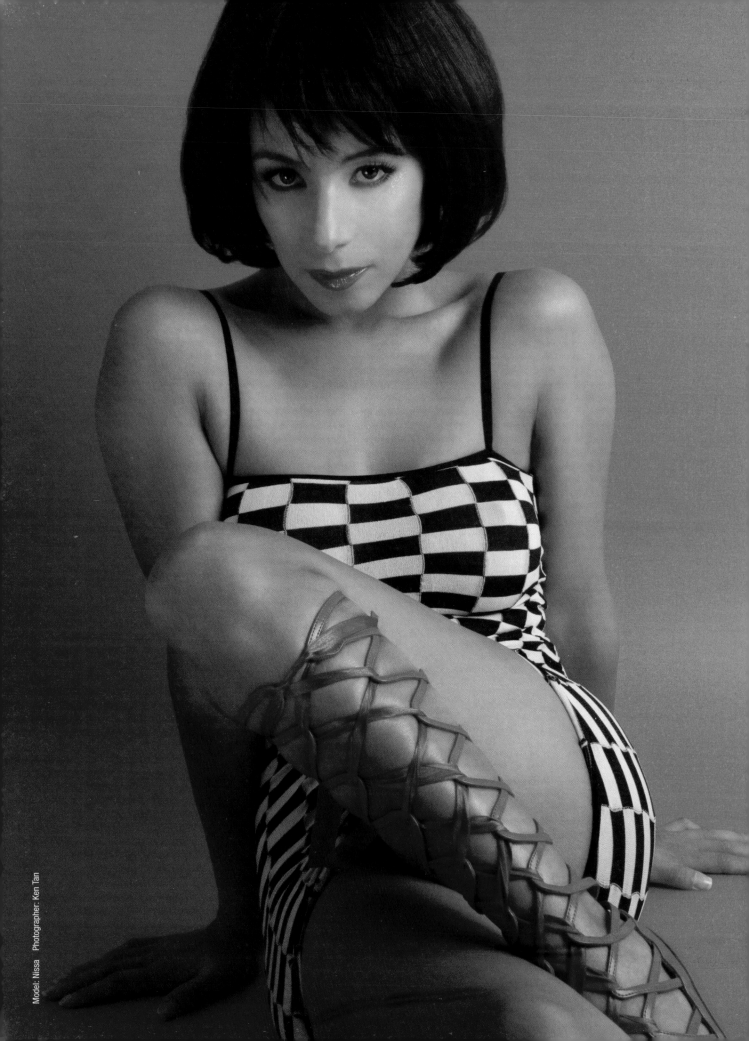

Index